ENCLAVES of EXCEPTION

T0204274

ENCLAVES of EXCEPTION

Special Economic Zones and
Extractive Practices in Nigeria

OMOLADE ADUNBI

INDIANA UNIVERSITY PRESS

This book is a publication of

Indiana University Press
Office of Scholarly Publishing
Herman B Wells Library 350
1320 East 10th Street
Bloomington, Indiana 47405 USA

iupress.org

Manufactured in the United States of America
First printing 2022

Library of Congress Cataloging-in-Publication Data

Names: Adunbi, Omolade, author.
Title: Enclaves of exception : special economic zones and extractive practices in Nigeria / Omolade Adunbi.
Description: First printing. | Bloomington : Indiana University Press, 2022. | Includes bibliographical references and index.
Identifiers: LCCN 2021033522 (print) | LCCN 2021033523 (ebook) | ISBN 9780253059581 (hardback) | ISBN 9780253059574 (paperback) | ISBN 9780253059567 (ebook)
Subjects: LCSH: Petroleum industry and trade—Nigeria. | Free ports and zones—Nigeria. | Nigeria—Foreign economic relations—China. | China—Foreign economic relations—Nigeria.
Classification: LCC ND9577.N52 A38 2022 (print) | LCC ND9577.N52 (ebook) | DDC 338.2728209669—dcundefined
LC record available at https://lccn.loc.gov/2021033522
LC ebook record available at https://lccn.loc.gov/2021033523

*In memory of Bilkis Ajayi Adunbi and Salami Adunbi Salawe,
whose kindheartedness and nurturing hands are greatly missed.*

*To Janet Remilekun Taiwo Williams and Omotayo Williams,
whose continuous support and faithfulness makes
spring flowers blossom in the heart of winter.*

CONTENTS

PREFACE

This book began as a project with a focus on Africa's new engagement with China in the twenty-first century. At the start of the project in 2014, there had been intense engagement between China and Nigeria. China's contemporary engagement with Africa began with the Forum on China-Africa Cooperation, held in the year 2000. At the forum, convened at China's request, several multilateral and bilateral engagements on trade, development, and economic cooperation were reached. This important milestone began to shape the ways in which policy analysts and scholars interrogate China's engagement with Africa. Within the first decade of this new interaction, scores of academic and policy studies had emerged with a focus on whether such an engagement is of benefit to China or Africa or both. Scholars took sides on the issue. Some were optimistic, proclaiming that the decade of engagement marked the beginning of a new African renaissance that would be shaped by greater economic development and technological advancement. Pessimists asked pointedly whether the world was witnessing a new scramble for Africa. Deborah Brautigam (2009) championed the optimistic school, while Margaret C. Lee (2006) asked the pointed question about the scramble. Considering that Nigeria has the biggest economy in Africa and is the top oil producer in Africa and the seventh in the world, it was not surprising that China would want to engage with Nigeria.

On my return to Nigeria in 2014 to begin fieldwork, I was thinking about these two interrelated perspectives on China's interest in Africa: pessimism and optimism. Pessimistic thoughts were driven by Africa's experience at the hands of more powerful countries, beginning in the fifteenth century with slavery and culminating in the eighteenth century with colonialism, finally resulting in a postcolonial state whose economic and developmental agenda is still being shaped by the former colonial authorities in many African countries. My optimism derived from my belief that, at some point, Africa would be able to get its act together and get it right. This belief is born out

of the notion that Africa always has its own agency and knows what is best for itself and that, with the right leadership, the continent might be able to negotiate good deals that could result in better economic and development cooperation.

The Chinese presence is highly noticeable in many parts of Africa. My field experience in Kenya in 2012 and 2013 researching environmental sustainability found clear indications of that presence. Chinese companies are working on road construction projects in many parts of Kenya, and the major highway that takes visitors out of Nairobi to other parts of the country was constructed by a Chinese company, with Chinese signposts at major intersections on the road. Scholars such as Anita Plummer and Bilal Butt have written extensively on this issue. I am also reminded of the cautionary notes sounded by many anthropologists about an image of "Africa" that depicts the entire continent as uniform, without cognizance of its unique contexts. While much scholarship about China in Africa tends to generalize in ways that see the continent as "one size fits all," I stress the importance of recognizing context and not overly generalizing findings from one site to another. This is the reason why, on arriving in Nigeria, I did not want to see all Chinese projects in the country as representative of China's engagement with Nigeria but rather to see the projects in terms of some of the ways in which Nigeria and China engage with the neoliberal dictum of free enterprise.

My interest is in understanding China in the context of other appurtenances of trading and extractive practices that go beyond China in Africa or Nigeria. This project therefore grew from the need to understand China's interest in Africa and Nigeria to the need for a proper understanding of trade and environmental practices that connect people, nation-states, interest groups, communities, and the environment. China and Chinese nationals are part of the many stories that I encountered in Nigeria during my years of fieldwork. While the book is about practices and processes of how power and sovereignty get reconfigured through a neoliberal fulcrum, the part of the story about China encapsulates the visibility and invisibility of the different layers of power in the postcolonial state. One form of visibility becomes apparent as one touches down at Nigeria's gateway to the outside world—the Murtala Muhammed International Airport in Lagos. Interestingly, as visitors disembark from aircrafts from many parts of the world, the Chinese presence becomes visible at the airport, which itself is a major construction site. A Chinese company is renovating and expanding it as well as building a new car park. Driving out of the airport into Lagos and other parts of the country, you cannot help but notice the visibility of China and Chinese companies and nationals even in the most rural of any part of Nigeria.

In the process of collecting data for the book, I visited many towns, villages, and cites in Nigeria. In the course of my travels, I saw many Chinese nationals doing business or working in the country. I also saw many Nigerians in their daily interactions with Chinese nationals. For example, on the streets of Lagos, you might see a Chinese person riding an okada motorbike just like Nigerians do on a daily basis. A visit to Chinatown in the Ojota area of Lagos will also show a first-time visitor how integrated Chinese nationals are in Nigeria's daily business and personal interactions. Ojota occupies a unique place in Lagos because it is considered to be the gateway to the entire state. Although there are other roads that lead to Lagos from other parts of the country, Ojota is unique, indicating a process that shapes trade in the entire state. Thus, locating a Chinatown in the area is suggestive of an attempt to place a market in a space where traders and shoppers can converge to shop for wholesale or retail goods before returning to whichever part of the country they may have traveled from. The fulcrum of China's engagement with Africa, especially Nigeria, is born out of the desire to partake in a neoliberal moment that liberalizes trade and investment opportunities for foreign enterprises.

The point of departure for this book began in the summer of 2015. I had returned to Nigeria to continue my research on China's growing interests when I took a detour to visit some of my former interlocutors in the Niger Delta. My intention was to see what had happened to many of the former insurgents, environmental groups, and communities that I chronicled in *Oil Wealth and Insurgency in Nigeria*. I had also been invited to be part of a conference, the Regional Research Convening on Natural Resource Governance in the Niger Delta, organized in Port Harcourt by the Social Development Integrated Center (Social Action) in partnership with the West Africa office of the Ford Foundation. The workshop brought together scholars, think tanks, environmental activists, and nongovernmental organizations "to examine current developments (politics, policies, practices and institutions) related to the petroleum industry that could inform social and environmental impacts in the Niger Delta." After the one-day workshop, I stayed in the Niger Delta for a few weeks, visiting oil-bearing communities, elders, and youth leaders.

However, what I saw in many of the communities that I visited began to reshape my ideas about this book. The visit opened my eyes to the bourgeoning artisanal refineries industry in the creeks of the Niger Delta. Several of the operators of the refineries were former insurgents, youth, and community leaders, many of whom I had interacted with while collecting data for my previous book. From Jones Creek in Delta State to the creeks of Bori in Rivers State and Okaiki in Bayelsa State, all in the Niger Delta region

of Nigeria, a thriving business had emerged in ways that have resonance with Chinese free-trade zones in Lagos and Ogun States. Artisanal refineries had become employers of labor in many communities. Retailers of artisanal refinery products marketed their wares—refined lubricants and gasoline—in the markets and streets of major cities, towns, and villages. Traders engaged in marketing strategies that placed a premium on the idea of the market as a space that provides livelihoods for practitioners. Operators of the refineries relished their ability to produce and market their products across states and national borders. By the time I finished interacting with my former interlocutors, there was no doubt in my mind that they had all become my interlocutors once again. Many of the stories they told me during my visits over a period of several summers shaped some of the ideas in this book. In my meetings with artisanal refiners, traders, consumers, and community members, I saw how they frame what they do as participating in a form of market economy that they felt should not be the exclusive preserve of the state. Framing their refineries as business enterprises and ventures made me draw parallels with how Chinese-operated free-trade zones also frame their engagement as enterprises and business ventures.

Therefore, at the heart of this book are the ways in which the environment interacts with questions of sovereignty, belonging, and neoliberal ideas of the market economy. China and Chinese nationals and firms are just one part of this story. The other part is the numerous artisanal refineries across the entire Niger Delta region of Nigeria. A major objective of the book is to bring all these actors together in a way that provokes debate about the concepts of sovereignty, market economy, informality, technologies of extraction, infrastructures, and the idea of capture. To make sense of all these ideas, I weave together through an ethnographic lens the particularities and complexities that define how various actors interpret their participation in trading practices in Nigeria. These trading practices straddle artisanal refineries, free-trade zones, and histories of technologies of extraction in resource enclaves.

The arguments that I offer in this book are shaped by my experience conducting fieldwork in many of the enclaves I describe. While the many stories of communities, businesses, individuals, and governmental entities are based on my years of interactions with them, any shortcomings are solely my responsibility. More importantly, except where individuals interviewed are already in the public eye and have given explicit permission for their names to appear in print, names of those interviewed have been concealed to protect the identity of my interlocutors.

ACKNOWLEDGMENTS

This book is a product of fieldwork in various locations in Nigeria between 2014 and 2019. The book benefited immensely from intellectual engagements with colleagues at universities in North America and Nigeria. Writing it would not have been possible without the generous support I received from numerous institutions. At the University of Michigan, I thank the Office of Research, the Department of Afroamerican and African Studies, the African Studies Center, the Mcubed program, the Undergraduate Research Opportunities Program, the Energy Institute, the Institute for the Humanities, the School for the Environment and Sustainability, the International Institute, and the Center for Chinese Studies. Research leave and the College of Literature, Science and the Arts Associate Professor Support Fund helped in shaping some of the ideas in this book, for which I am very grateful.

I am particularly grateful to Bilal Butt for his valuable feedback on some of the chapters and for helping to draw some of the maps and images used in this book. My sincere appreciation to my colleagues at the University of Michigan for their critical engagement: Kelly Askew, Matthew Countryman, Nesha Haniff, Amal Hassan Fadlalla, Mike McGovern, Adam Ashforth, Martin Murray, Elisha Renne, Derek Peterson, Joyojeet Pal, Yuen Yuen Ang, Damani Patridge, Anne Pitcher, Xiomara Santamarina, Howard Stein, Megan Sweeney, David Doris, Paul C. Johnson, Aliyah Khan, Frieda Ekotto, Angela Dillard, Sandra Gunning, and Ray Silverman. I thank the staff of the Department of Afroamerican and African Studies, particularly Faye Portis, Elizabeth James, Arielle Chen, and Wayne High, for their logistical support.

I am indebted to many colleagues in Nigeria, at the Archaeology and Anthropology Department at the University of Ibadan, University of Lagos, Obafemi Awolowo University, and Niger Delta University. In particular, I would like to thank Chijioke Uwasomba, Hope O'Rukevbe Eghagha, Babajide Ololajulo, and Elias Courson. This work would not have been possible without the support and encouragement of many individuals, community

leaders, and organizations. I am particularly indebted to Doifie Buokoribo, Ato Micah, Onyeisi Chiemeke, Asume Osuoka, Nadeem Chaudhry, and Chido Onumah for their invaluable friendship. Asume Osuoka made his office and staff available to me during my entire stay in the Delta, and I am grateful to him for his many years of friendship and invaluable support. I am also grateful to staff and volunteers at the offices of Social Action in Port Harcourt, Warri, and Bori. My environmental activist friends such as Kentebe Ebiaridor, Morris Alagoa, Patterson Ogon, Ken Henshaw, Damian Dogbara, Fyneface Dummamene, and Basil Nkpordee introduced me to some of the artisanal refinery networks in Delta, Bayelsa, and Rivers States. My thanks also go to Bashiru Adigun, Amina Salihu, Mike Kebonkwu, and Dayo Aiyetan, who introduced me to the various networks in Abuja.

I conducted research in many communities, villages, cities, and towns in Nigeria, and I benefited from the hospitality and friendship of many individuals, communities, leaders, and organizations. I am grateful to chiefs, elders, and leaders of Idashon, Imobido, Tiye, and other communities in the Lekki Free Trade Zone, Lagos; elders, youths, and chiefs of the Lusada and Igbesa communities in Ogun State; management and staff of the Lekki Free Trade Zone; management and staff of Ogun-Guangdong Free Trade Zone; management and staff of the Nigeria Export Processing Zone Authority in Abuja and Lagos; staff at the office of the Minister of Finance, Federal Ministry of Finance; and staff at the Federal Office of Management and Budget in Abuja.

In the last few years of working on this book, many colleagues at various fora have helped in strengthening the arguments in this book through their comments and feedback. I am particularly grateful to Lori Leonard, Akin Adesokan, Siba Grovogui, Jacob Olupona, Kristin Phillips, Kristin Doughty, Mike Degani, Brenda Chalfin, Jamie Cross, Erin Dean, Sara Byala, Jamie Monson, Lucia Cantero, Emily Riley, Nina Sylvanus, Helen Siu, Anita Plummer, Robert Blunt, Allison Alexy, Adeola Oni-Orisan, Doug Rogers, Katrien Pype, Paul Sabin, Karen Seto, Anne Biersteker, Davide Casciano, Kim Dionne, Wale Adebanwi, Ebenezer Obadare, Vikramaditya Thakur, Brian Minn, and Yolanda Covington-Ward.

Some of the chapters were presented at seminars and workshops at the University of Michigan. I am particularly grateful to participants at the Dow Sustainability Fellows Program of the Graham Sustainability Institute and the English Department's Critical Conversations seminar series, and I am thankful to Margaret Wooldridge, Katherine E. Hummel, and Sarah Kerwin. I would also like to extend my thanks to participants at seminars and workshops at the University of Michigan, Brown University, Cornell University, Yale School of Forestry and Environment, Environmental Humanities

at Yale, Michigan State University, University of Florida, the Department of Anthropology at the University of Bologna, Ife Institute of Advanced Studies at Obafemi Awolowo University, Georgetown, and the University of Pittsburgh. I am grateful to my editors at Indiana University Press, Gary Dunham and Ashante Thomas, for their support, and I am especially grateful to Dee Mortensen, who started the project at Indiana before her retirement.

Thanks to the three anonymous reviewers for their valuable comments and criticisms. Those comments ultimately helped to improve the arguments of this book. I thank the audience at the annual meetings of the American Anthropological Association and the African Studies Association, where various chapters were presented. I am grateful to research assistants Amanda Kaminsky, Maddie Bianchi, Marlotte De Jong, and the students in my graduate seminar Interdisciplinary Approaches to the Study of Africa; the Africa, China, and the Environment class; and the Violent Environments: Oil, Development, and the Discourse of Power class, especially Neal Mckenna, Marlotte De Jong, David Suel, Sadiyah Malcolm, and Amanda Ndaw. Thanks to my research assistants in Nigeria, Lateefat Sunmonu, Peace Agbo, and Joshua Ghereje. I am grateful to Segun Adegoke and Seufunmi Adegoke, who helped in preparing many of the images in this book. My gratitude also goes to my Undergraduate Research Opportunity students and Energy Institute summer research interns at the University of Michigan, many of whom have since graduated: Victoria Lucas, Olubisi Ajetunmobi, Angelice Floyd, Chinemelu Okafor, James Griffiths, and Shreya Patel.

This project would not have been possible without the support and encouragement of my family both far and near. I am especially grateful to Moyinlorun Akintuyi, Kayode Ijalana, Kenya Soluade, and Najeeb Abdussalam. Being away for many months over several years can be very hard on the family. My family continues to be my motivation and pillar of support; I am particularly grateful to Feyi, Derin, and Tomiwa. I am hoping that this work will continue to be an inspiration to Tomiwa and Derin and add to their optimism about a future devoid of environmental pollution, racism, and ethnic bigotry—a future that we can all be proud of. Tomiwa and Derin's optimism is a motivation to me, and I am more than proud of both of them, so this book is for them. Finally, some of the materials in chapters 3 and 5 draw on materials that I have previously published in journal articles. None of these have been reproduced in their entirety, and importantly, the arguments and substance have changed substantially, but I would like to thank *Africa: Journal of the African International Institute* at Cambridge and *Cambridge Journal of Anthropology* for allowing me to draw on these pieces in this book.

ENCLAVES of EXCEPTION

INTRODUCTION

Toward an Anthropology of Extraction: Oil, Environment, and Trading Practices in Africa

At the beginning of the summer of 2015, on my second day of conducting new research on China's growing interest in Nigeria, I sat in front of the porch of my host's home in one of the Niger Delta towns waiting for the vendor to bring us the day's newspapers. Suddenly, a motorbike known colloquially as an okada pulled up in front to drop off a passenger. Okadas are used as taxis in many towns and cities in Nigeria. Okada is also the name of a town in Edo State. The name comes from a 1980s airline, Okada Air, established by Chief Gabriel Igbinedion, a Nigerian millionaire from the town of Okada. The airline folded during a turbulent period when structural adjustment programs introduced in many African countries had led to economic collapse and rising unemployment. One result of the collapse of the 1980s was the emergence of motorbike taxis, mainly operated by those who had lost their jobs and needed new livelihoods. The use of Okada Air as a metaphor in the naming of okada motorbikes is not lost on many Nigerians—the economy is very fluid and can be susceptible to unforeseen circumstances when not managed well. That day, as the okada driver pulled over to drop off his passenger, the motorbike suddenly spoke in Chinese and then English. It said, "You have reached your destination," and these words, as I later understood, were meant to signal the application of brakes by the driver. The okada is imported from China, and many riders are fascinated by the fact that nonhuman okadas can speak. As I and my host ruminated on the okada that could talk, our vendor arrived, displaying all the newspapers he had for sale. As if he had overheard us, the vendor quipped in pidgin English, a popular West African adulterated English, "Oga, dat one na China okada ooo. Na im everyone dey buy now," meaning, "Boss, that's the motorbike most people buy now."

Motorbikes are not new to the Nigerian landscape. During the oil boom of the 1970s, the numbers imported rose significantly, but they were mainly from Japan. Japanese motorbikes such as Yamaha and Suzuki were commonly used by those who could not afford a car. The oil boom period witnessed the rise of the middle class across the broad spectrum of Nigerian society (Adebanwi and Obadare 2013; Adunbi 2015; Apter 2005; Biersteker 1983; Forrest 1977, 1993). Of course, motorbikes of the era were not used as taxis but were mainly for pleasure and were sometimes used by farmers (Apter 2005; Guyer 2002, 2004; M. Watts 2003). By the late 1980s, things had changed dramatically for many Nigerians with the collapse of the oil economy, which warranted huge borrowing and indebtedness to international financial institutions such as the World Bank, the International Monetary Fund, and the Paris and London Clubs of lenders and led to the implementation of structural adjustment programs, one of the stringent conditions for the loans. Today's motorbikes are mostly used as taxis, and Japanese Yamahas and Suzukis, while still present, no longer dominate the market. Talking Chinese bikes are now in vogue. Whereas the motorbikes of the 1970s indexed modernity, recreation, and global connection, the talking Chinese bikes of the present reference China's enormous role as a trading partner with Nigeria, representing one aspect of China's trading partnership with Nigeria in particular and the rest of Africa in general. As we shall see, China's partnership with Nigeria—nay, Africa in general—since the turn of the century has involved infrastructure financing, manufacturing, oil extraction, migration, and development aid. Thus, China's interest in Nigeria is largely defined by the setting up of free-trade zones (FTZs) as part of infrastructure financing, oil extraction through Chinese oil companies, and railway construction through Chinese railway corporations among others.

Therefore, this book is about China in Nigeria and at the same time not only about China. The practices described in this book are illustrative of the insertion of Nigeria into the neoliberal global economic system in ways that shape processes of extraction. While China and Chinese nationals and firms illustrate some of the neoliberal moments of enterprise formation and insertion, other extractive practices, such as artisanal refineries, also exemplify trading practices embedded in global capitalism. This book weaves together an ethnographic analysis of the relationship between state-centered economic activities and activities organized by those who live on the margin of the state. Thus, it is about special economic zones (SEZs) and their interconnectedness to the particularities of resource extraction in what I call "enclaves of exception."

I use the term *enclaves of exception* to describe the interconnectedness and interrelatedness of two types of enclaves in contemporary Nigeria—artisanal

refineries and FTZs—which share similar goals of making a profit and participating in the economy of the state. My use of the term *extractive practices* brings together two mutually inclusive categories: extraction of economic values through the setting up of FTZs and extraction of oil through the establishment of artisanal refineries. Both of these practices of extraction result in the establishment of special economic zones in enclaves of exception. Hence, my goal is to demonstrate a proper understanding of the insertion of Africa, particularly Nigeria, into contemporary neoliberal global economies through licit and arguably illicit processes represented by official and unofficial cultures of SEZs, especially in resource enclaves. Enclaves of exception follow what Agamben (2005) describes as the unusual way in which the state uses its power during periods of emergency and what Murray (2017) describes as urbanizing practices on a global scale that produce distended urban regions resembling assemblages of enclosed enclaves and discontinuous zones initiated at the prompting of the state. In borrowing from these ideas, I describe enclaves of exception as the processes that produce a systematic assemblage of enclosed spaces for the purpose of generating economic activities, both regulated and unregulated by the state. I use these new assemblages to complicate the meaning and intent of SEZs to encompass artisanal refineries and FTZs.

As the name suggests, special economic zones are sites carefully designated by the state for the production of economic activities. In the academic literature (e.g., Cross 2014; de Morais 2011; M. C. Lee 2006; Southall and Melber 2009; Zeleza 2008), SEZs encompass FTZs, specialized zones designated for manufacturing and other economic activities where cheap labor and tax holidays are generally granted to corporations and other business enterprises as a way to shore up the economy of the state. China and India embraced the practice of FTZs early on (Brautigam 2009; Cross 2014; Ong 2006), and now the same economic system is being exported to other countries that partner with China. China's exportation of economic zones has increased exponentially in recent years. There is hardly any country in Africa today without a Chinese-operated FTZ. Although the idea of SEZs did not start with China, as has been clearly demonstrated in the literature, China brings a new flair to organizing trade through bilateral and multilateral agreements anchored in infrastructure financing that includes resource extraction and FTZs. In the wake of the structural adjustment programs of the 1970s in Latin America and the 1980s in Africa, export processing zones (EPZs) were one of the pillars of new economic reform programs (Adunbi and Stein 2019; Cross 2014; Stein 1994). EPZs were aimed at encouraging countries in economic crisis to open up their economies by creating special economic zones for the sole

purpose of exporting mainly raw materials to countries in need of them. These EPZs were mainly encouraged and prescribed by the international financial institutions to which many of the countries, including Nigeria, were highly indebted. EPZs became one of the conditionalities clearly stated in the prescriptions of the World Bank and the International Monetary Fund (Adunbi 2019; Stein 1992). This way, tax holidays were granted in such zones. What is different today is that countries are willingly accepting the setting up of SEZs as an antidote to what I call "the permanency of economic retardation." In addition, unlike in the first iteration of EPZs, when countries created the spaces and invited investors, today's SEZs are from the onset established in partnership with foreign consortiums—in this case, China and Chinese entrepreneurs.

Central to the argument of this book is an analysis of the techniques of extraction that shape new processes of knowledge production. One form of knowledge production encompasses the use and deployment of different techniques of extraction in resource-rich sites. These techniques of extraction use different technologies of abstraction in the extraction of commodities of value that are human and material in ways that shape environmental practices in different sites in Nigeria and across Africa. I use the term *technologies of abstraction* to describe the process of contemplating and deploying new technologies for the purposes of extraction. This process sometimes starts as an idea but can later manifest into different technologies that are then used to produce items of value. In producing this form of knowledge, practitioners draw from social and cultural history, histories of how technologies travel from space to space, and the particularities of notions of innovation, belonging, and claims to property. Knowledge thus produced helps galvanize new ideas of production, enterprise, and community engagement and the invigoration of notions of property, environment, entrepreneurship, and rights that accompany them. Thus, this book draws a parallel between FTZs and the artisanal refineries that have been booming in the creeks of the Niger Delta in the last few years by asking, How do new techniques of extraction shape new environmental practices in countries rich in natural resources? The book offers a new way of thinking about the relationship between oil and technologies of extraction and their interrelatedness to local livelihoods and environmental practices. My claim is that, as much as the materiality of oil creates possibilities for the inception of oil capitalism dominated by big corporations, it also establishes parameters for the participation of local actors who contest the ownership of such resources by the state and their corporate partners. My use of the word *artisanal* recognizes its limits in ways that bear resonance with Jemima Pierre's (2019) cautionary note that we should not

see artisanal practices as constitutive of a system that renders its practitioners primitive or backward. On the contrary, my use of the term *artisanal refineries* renders the practice of oil extraction by transnational corporations and that by local actors comparable—that is, in the same field of analysis—allowing us to ask questions of each regarding how businesses that are not categorized as such operate. I go back into the history of extractive practices to show how artisanal refineries operate on a continuum in Nigeria's enclaves of exception. Contestations by local actors revolve around setting up artisanal refineries using technologies derived from the brewing of local liquor. As clearly demonstrated in chapter 4, the use of local knowledge in building new techniques of extraction borrows largely from the boom in the brewing of moonshine in the United States during the prohibition era of the 1920s. Moonshine, a liquor of choice, was to later become *ameereka*—a corruption of *America*—in many parts of the Niger Delta when James Iso, a Nigerian shipmate, took the technology back to his native Calabar. This innovation in technological knowledge coupled with the disenfranchisement of local communities from the benefits of oil helps shape the establishment of artisanal refineries as an economic zone in the creeks of the Delta.

This book uses humanistic social science inquiry to complicate the meaning and notion of special economic zones by looking specifically at (1) how a consortium of Chinese entrepreneurs, the government of China, and Nigeria collaborated in establishing the Lekki Free Trade Zone and the Ogun-Guangdong Free Trade Zone as large infrastructure projects to help revamp the economy; (2) how former insurgents and other youths in resource-rich communities in the Niger Delta mimicked the state by establishing a kpofire village, an artisanal refinery that resembles state-regulated economic zones; and (3) how the two enclaves—state-regulated free-trade zones and insurgent-organized artisanal refineries—have produced different environmental outcomes for the communities in which they are located. I demonstrate how such resource extraction practices by the state and the operators of artisanal refineries result in what I call "the social death of the environment," as shown in chapter 6. I use the term *social death of the environment* to describe processes that create different layers of vulnerabilities for communities whose livelihood and social life depend on the environment and to describe how oil and trade practices turn the environment into disaster zones for such communities. I argue that by mimicking state and corporate extractive practices, artisanal refineries pollute the environment with devastating consequences for the lived experiences of community members. My use of the idea of social death bears similarities to its invocation by Orlando Patterson (1982) in describing the condition of slaves in the Americas. Patterson (1982, 48, 51)

stresses that "although the slave is socially a nonperson and exists in a marginal state of social death, he is not an outcast" because "the essence of slavery is that the slave, in his social death, lives on the margin between community and chaos, life and death, the sacred and the secular. Already dead, he lives outside the mana of the gods and can cross the boundaries with social and supernatural impunity." I deploy a similar logic in describing the condition of the environment, community members, and livelihood practices of those who live in enclaves of extraction in Nigeria. The environment and the people who inhabit it, as a spiritual and temporal enclave, are consigned to a space of death by those who profit from its temporal predicament because of its conversion to an object of capital. Rather than the environment fulfilling a spiritual and temporal calling as a site where communities marvel at nature and all its appurtenances, it has become a site where the promise and fulfillment of profit trumps the serenity that it ought to provide. The environment and the people who inhabit it transform from being a site for the realization of social life to a site that is perpetually and continually condemned to social death. In the process of its social death, the environment is degraded, polluted, and dispossessed. Using interviews and participant observations as well as evidence of environmental degradation, I foreground how community members deal with such environmental disasters.

This book investigates how local communities are using ancestral land claims to assert their property ownership rights and galvanize citizens to oppose FTZ development. I explore how these emergent contestations over land and resource ownership are redefining and reproducing new forms of power, community, and belonging. Local indigenous communities in all FTZ sites and the artisanal refineries have a rich history of ancestral land ownership and ritual practices that long predate the postcolonial state. This book shows how the new FTZs are disrupting traditional power structures, cultural practices, and notions of sovereignty. I examine how these new structures fit within larger narratives of resource extraction and infrastructure development in Nigeria and throughout Africa. Through this language, I examine how claims of ancestral land ownership are imagined and articulated. Applied to the Nigerian free-trade zones, I explore the ways that local community members, deprived of and displaced from their ancestral lands, are employing environmental rights tactics in order to lay claim to the land and its resources. I explore what happens when these claims conflict with those of the state and how these new claims are constructed and deconstructed to produce new forms of practices and meanings.

Consequently, I extend the notion of energy as a state and corporate capture to include what I call "crude recapture." In most literature, energy

capture is described as a process by which the state and its corporate partners use wealth derived from natural resources such as oil for their own benefit. I extend this analysis to include crude capture and (re)capture as encompassing a system of energy techniques adopted by youths and former insurgents within resource enclaves of the Delta. These youths, dispossessed of property—oil—considered to be ancestral inheritance, engage in processes aimed at the repossession of the property from the state and its corporate allies who have captured it. This particular system of crude repossession produces artisanal processes and structures of extraction—extraction that reflects innovation and hybrid forms of knowledge. Crude recapture challenges the notion that oil production requires sophisticated technology exclusive to multinational corporations. I argue that through crude recapture, local technologies developed by youths can also create a system of energy practice similar to that of the multinational corporations in enclaves of extraction such as the Niger Delta. The shift from these practices to those of crude recapture through artisanal refineries has also meant a shift in the techniques of extraction, which results in the social death of the environment. In this space, the environment is constituted as a site within which profit and promises can be made—promises of development and social and economic improvement in people's lives. However, for those displaced and dispossessed from their social environment, the social life of the environment that they have known their entire lives has now become the social death of the environment that they are forced to accept. More importantly, artisanal refineries that mimic the state and its corporate partners borrow largely from techniques of extraction that have been with many Niger Delta communities for a very long time, and it is these technologies of extraction that are shaping innovation and helping establish economic zones that mimic the state and its corporate partners.

Artisanal Refineries and Special Economic Zones

Let me start this section with my encounter with a group of United States Agency for International Development (USAID) contractors I met in Port Harcourt on my return from the creeks in the summer of 2015. While I was sharing drinks with Niger Delta activists at a bar in my hotel, three men dressed in well-cut suits approached our table and asked if they could join us. The three men knew the activists because the activists had participated in some of the training programs organized by the contractors in the Delta. The training programs, activists and USAID contractors told me in 2015, were aimed at "empowering" youths to "think outside the box" in embracing

programs that could make them self-sufficient without having to rely on a supposedly "dysfunctional Nigerian state" that could not deliver services to its citizens.

The contractors were Nigerians but fervently believed that the state should be pushed out of the way for innovations to thrive—the typical neoliberal sentiment that dominates development discourse from Washington. One of the contractors, who claimed to be an "innovation leader," was the first to comment on the state of the Niger Delta.[1] He suggested that "the youth of this region are very lazy; they lack innovative ideas, and all they know is how to carry arms against the state and corporations doing business in the region. If they were innovative, they would have realized there are more opportunities than oil, but they all tend to focus on oil all the time." This comment generated a lot of debate, particularly among the activists at the table. While the activists acknowledged that the city of Port Harcourt was different from the creeks of the Delta, they also pointed out the contractor's limited knowledge of the crisis of environmental degradation and the absence of social amenities that could drive innovation in many communities.

What aroused my interest in the conversation was the emphasis on innovation and the shared perception that Niger Delta youths lacked the drive to innovate. Since the 1990s and early 2000s, innovation has been a major mantra of the neoliberal argument suggesting that free market economies drive freedom to innovate (Ferguson 2010; Ong 2006). Thus, innovation resonates with what Ong (2006, 2) sees as the attributes of neoliberalism, "conceptualized not as a fixed set of attributes with predetermined outcomes, but as a logic of governing that migrates and is selectively taken up in diverse political contexts." To the USAID contractor, innovation was the catalyst for growth, and Niger Delta communities were not growing because they were not innovative enough to meet the predetermined meaning of growth set by neoliberal standards.

However, contrary to the neoliberal dictum, what was missing in Niger Delta communities was not innovation but drivers of innovation such as the state, which does not invest in education in many of these Niger Delta communities. This is why it is unimaginable that contractors for a state-funded agency such as USAID would make the argument that the state constitutes a cog in the wheel of economic growth in the Niger Delta. However, as I show in chapters 4 and 5, even in the absence of state investment in education, innovation is not lacking in the Niger Delta communities as proponents of neoliberalism would have us believe. The form of innovation that is taking shape in the oil creeks of the Delta is youths' and former insurgents' attempt to participate in a neoliberal economic system. As described in chapter 1,

there have been moments in the annals of the Niger Delta when youths have taken up arms against the state in contesting the ownership and management of Nigeria's oil economy. The combined effect of these years of insurgency has been a negotiation with many of the militant groups, such as the Movement for the Emancipation of Niger Delta, Niger Delta People's Volunteer Force, and others, resulting in a payoff of the leaders of some of the insurgent groups in 2009 after a state amnesty program was initiated.

As I saw in many of the creeks of the Niger Delta, these former insurgents are today entrepreneurs in the management and dispensing of crude oil through crude recapture. Former insurgents and other youths now manage, organize, and construct artisanal refineries in the creeks of the Niger Delta. Crude recapture by youths and former insurgents, as I show in this book, has resulted in unintended consequences for many of the communities where such activities take place. The larger point is that mimicry of the state and its corporate partners isn't just about getting the benefits of oil but encompasses imitating the ways in which the state and its corporate partners disrupt life and livelihood in many of the communities where artisanal refineries are located. Disruptive as this may be to the social life of the communities where these innovations are taking place, the centrality of neoliberalism to many who participate in it cannot be wished away. Thus, if SEZs are aimed at building an economic system based on encasing of enterprises for the purpose of establishing economic activities in the state, artisanal refineries, I argue, qualify as one such encasing. The building of oil infrastructure using local technologies is an excellent example of how innovation drives an enclave of exception in the oil fields of the Delta.

While the state and its business partners engage in practices that disentangle communities from the benefits of oil wealth, many youths in the Delta derive benefits from oil fields in their area using local technologies in ways that also disentangle communities. The question then is this: Where lies the parallel that can be drawn between artisanal refineries and FTZs? Shifting our lens to China's engagement with Africa in general and Nigeria in particular will provide a better understanding of these new interactions.

AFRICA, CHINA, AND THE RESHAPING OF DEVELOPMENT

Since the beginning of the twenty-first century, there has been a profound increase in interactions and engagements between Africa and China. Significantly, these interactions became institutionalized with the formation of the Forum on China-Africa Cooperation in the year 2000 (Sina 2006). Since its institutionalization, the biannual forum has become a site where trade,

economic cooperation, instructional development, and financing deals are conducted between China and the African continent (Siu 2019; Taylor 2010). While interactions between China and various African countries are not new, and indeed have been well documented in the literature (Adunbi and Butt 2019; Alves 2013; Ayers 2013; Brautigam 2009; Carmody 2011; Monson 2009), what is remarkable is the rise in trade and investment deals between China and Africa estimated to be worth over US$222 billion (Ministry of Commerce 2015). These new modes of cooperation incorporate physical, economic, financial, and technical components (Alves 2013; Ayers 2013; Bodomo 2010; Foster, Butterfield, and Chen 2009; M. C. Lee 2006; Monson 2009; Siu 2019).

Within the literature on Africa-China relationships, many scholars have noted that Africa and China benefit mutually through economic cooperation because of the "infrastructure-for-resource loans" perspective (Alves 2013, 207). In these narratives, China extends loans for infrastructure financing as well as technical expertise for the construction of infrastructure in exchange for energy and nonfuel minerals (C. K. Lee 2015). As Alves (2013, 212) notes, "Chinese national oil companies have acquired oil equity in Sudan, Angola, Equatorial Guinea, Ethiopia, Gabon, Chad, Uganda and Libya. Chinese national oil companies are also prospecting for oil in several other African countries (Niger, Tanzania, Ethiopia, and Sao Tome and Principe)." Brautigam (2009) and Monson (2009) similarly remind us that China's interests and cooperation are not new; these engagements span over half a century, and African governments have benefited as much from Chinese investments as have the Chinese themselves. Others have noted that large infrastructure projects typically employ large numbers of Chinese workers and local workers (C. K. Lee 2009; Mohan and Lampert 2013; Mohan and Tan-Mullins 2009). Wedged within these narratives lies a popular discourse where the interactions between China and Africa can be thought of as neocolonial and as part of the "new scramble for Africa" (C. K. Lee 2009; M. C. Lee 2006; Moyo, Yeros, and Jha 2012). There is some discussion of this in both the academic literature (e.g., Carmody 2011; Frynas and Paulo 2006; Klare and Volman 2006; Moyo, Yeros, and Jha 2012; Ofodile 2008; Ovadia 2013) and in popular books and magazine articles (e.g., French 2014). For example, French (2014) describes Africa as "China's second continent" because over a million Chinese migrants are active on the continent in both small and large ventures. Across the continent, most large infrastructure projects are dominated by Chinese state-owned enterprises, such as China National Railways and Construction Company, China Road and Bridge Corporation, China National Offshore Oil Corporation, and China National Petroleum Corporation. In Nigeria, Chinese companies are involved in the redevelopment of

the Murtala Mohammed International Airport, the Lagos Light Rail Project, the Ogun-Guangdong Free Trade Zone, and the Lekki Free Trade Zone, among others. Several other examples can be found in Angola, Kenya, Tanzania, Niger, Togo, and South Sudan. This level of infrastructure development and financing is sometimes referred to as a new imperialism on the continent (de Morais 2011; M. C. Lee 2006; Southall and Melber 2009; Zeleza 2008).

However, while much of the literature focuses on Africa-China relations as a call for either optimism or pessimism, this book situates Africa-China engagements within dominant discourses on how development projects are the product of complex arrangements of local, state, and transnational interests, with various effects and consequences (Adebanwi and Obadare 2010; Escobar 2011). Using the specific example of Nigeria, the book characterizes Africa-China engagement in three specific ways. First, it examines the responses to and effects of infrastructure financing, foreign direct investment, and other neoliberal economic and political practices by both state and nonstate actors and institutions. This melding of infrastructure development and resource extraction shapes the practices of a growing network of largely Chinese transnational capital contesting for participation in the spaces of development in Nigeria through the establishment of FTZs. While there has been a great deal of research on how economic liberalization has attracted investors interested in oil, farming, and other forms of land-grab practices (e.g., Ferguson 2006; Odoom 2017; Ovadia 2016; Rupp 2013; Southall and Melber 2009), there is comparatively little research on how infrastructure and resource accumulation are becoming prominent modes of cultural and political communication about and contestation against such changes in different African contexts, including Nigeria's. As stated earlier, the indexicality of Japanese motorbikes in the 1970s and 1980s with the Chinese talking motorbikes of this era exemplifies such a shift in the politics of resource accumulation and extraction.

Second, the book ties together understudied historical and contemporary development infrastructures by demonstrating, through ethnographic analysis, how emerging discourses and practices of China's engagement with Nigeria affect local economies, the environment, environmental politics, and cultural productions (e.g., Monson 2009).

Third, the book explores how the contemporary responses to and effects of neoliberal practices are intimately linked to historical land use practices and thus become entangled to create new forms of contestation. The book analyzes how the vestiges of colonialism and postcolonial practices coupled with new infrastructure partnerships and investments enact violence in sovereign and frontier spaces. The building of physical infrastructure sites as FTZs belies the complex social and political relations between local peoples

and the state, which have taken place in the same sites. Development infrastructures can thus serve to erase local people's histories and result in violent contestations.

In interrogating the rise in China's infrastructure projects in Africa, Ana Alves (2013) suggests that we think critically about what Angola mode has done for the continent because the impact of deals on African development has been mixed. Alves (2013, 210) states that Africa "ranks at the very bottom of most infrastructure indicators" because investment has not kept up with demographic growth, which has created a large deficit, especially in the power sector, where there are frequent power outages and a lack of interconnectivity. The term *Angola mode* is used to describe the process of offering oil or, in some instances, other resources in exchange for infrastructure development by China. The solution to this infrastructure deficit lies with China's engagement with Africa, some would argue, but we have also seen that such engagement in itself produces practices that emphasize commodities trading (e.g., oil and strategic minerals). It is these phenomena—infrastructure deficit in Africa and the premium on commodities—that produce the African component of China's "'go-global' policy," of which the need for a steady supply of key resources is a "critical dimension" (Alves 2013, 209). The outcome is the incentivization of Chinese state-owned enterprises to "go out" through the provisioning of fiscal incentives such as tax exemptions and financial inducements such as highly subsidized credit lines (Siu 2019).

By rethinking the centrality of infrastructure in Africa-China relations, I bring to the fore the importance of interrogating the social, cultural, political, environmental, and economic interactions between Africa and China on the one hand and Nigeria and China on the other. In doing this, I shift attention from infrastructure as a physical thing to infrastructure as inhabited by and inscribed with social relations. Here I see sovereignty as not constitutive of the state alone but also inscribed in what I call "the sovereignty of dispossession." Building a free-trade zone is also not just about the construction of new manufacturing sites and special economic zones but also the violence enacted on local peoples who have been dispossessed through unclear property rights. In all these ways, a better understanding of the historicity of China's infrastructure financing in Nigeria through mutually collaborative schemes over time is unveiled.

ETHNOGRAPHIC FIELD METHODS

This book is based on extensive ethnographic field research in Abuja, the federal capital of Nigeria; Ibeju Lekki, a local government in Lagos State; Igbesa

and Lusada, two farming communities in Ogun State; and the creeks of the Niger Delta. The research took place beginning in 2014 and ending in 2019. In Abuja, the federal capital territory where the headquarters of the Nigeria Export Processing Zones Authority is located, I interviewed and interacted with several of the zone's officials, officials of the federal ministry of finance, and other government parastatals in order to understand the processes of China's engagement with Nigeria.

In Lagos, where the Lekki Free Trade Zone is situated, I spent time with officials and staff at the Lekki Free Trade Zone, community members around the zone, chiefs and elders of the Idashon community, market women and traders around the FTZ, officials of the Dangote Group, officials of many of the enterprises within the trade zone, youth groups, and nongovernmental organizations such as Social Economic Rights Action. In Igbesa, where the Ogun-Guangdong Free Trade Zone is located, numerous community members opened their doors to me. The Chinese and Nigerian officials of the FTZ welcomed me to the zone during my visits. Each visit was marked with several presentations on the development of the zone by the Chinese officials. When the leadership of the zone changed, the new leaders embraced me and never failed to answer my numerous questions. Staff at the zone—both Nigerian and Chinese—were very open-minded, even when my questions seemed to be probing into the details of their activities within the zone.

In the Niger Delta, several visits to the many oil creeks in Rivers, Bayelsa, Delta, and Ondo States became important to the arguments of this book. Many community members, chiefs and elders, former insurgents, nongovernmental organization leaders, and youth groups welcomed me to their communities and social life. I interviewed many of the leaders who were instrumental in setting up the refineries, and I observed the daily practices of those refineries in many of the creeks. Numerous artisanal entrepreneurs were interviewed in the cities of Port Harcourt, Rivers State, Yenagoa, Bayelsa State, Akure and Igbokoda, Ondo State, and Warri and Sapele, both in Delta State.

At the University of Ibadan, officials of the National Archives aided in gathering many of the materials that helped shape my understanding of the colonial-era prohibition that led to the blossoming of the production of ogogoro (local gin), also known as *ameereka* in some Niger Delta communities. Regarding the relationship between the technologies of ogogoro extraction and the artisanal refineries, many families in the Niger Delta told me stories of how their forebears encountered the technology that traveled all the way from the United States to the creeks of the Delta in the 1920s. Archival materials corroborated many of the stories I was told, and those stories

helped shape the construction of the arguments in chapter 4. The research involved archival work at the National Archives, semistructured interviews, and participant observation with and among a range of actors within and outside the research sites.

This research follows the logic of the case study, defined by John Gerring (2007, 13, 19–20) as "the intensive study of a single case where the purpose of that study is—at least in part—to shed light on a larger class of cases (a population)." Critical to any case study is the important question of what constitutes the case. Put succinctly, a case should be seen as an illustration of occurrences, of a theoretically defined class of events (Ragin 1992). When a case is examined with a critical lens, observed events presents us with a better strategy of dealing with the kinds of research questions that cannot be adequately addressed by variable-oriented statistical strategies, such as the ones that I engage with in this book (Ragin 2014, 15–16). In using case-based research to illuminate many of the stories told in this book, I offer fresh ideas that are a more promising tool than statistical studies for developing new theoretical insights and refining and elaborating existing ones. Cases illuminated in this book are very complex, and all embodied empirical realities that many of my interlocutors live through on a day-to-day basis. Thus, the complexity of the cases illustrates a unique broader phenomenon that should be studied and appreciated. The mesh of artisanal refineries and FTZs represents a case study that deals with complex and empirical realities that are connected to systems of rules and regulations that are promoted by the state but can be circumvented by youth groups and communities of extraction.

Theories guide research, but theories can be modified and interpreted within the context of each research endeavor. In the case-oriented approach that I adopted here, I take into consideration the diversity of interests while accounting for the peculiarity of each site studied. While I do not claim to account for all the deviations that may exist in the sites covered in these cases, I do take into account the possibility of divergence by offering theoretical explanations that provide a better understanding of the complex nature of the cases. Exceptions, anomalies, and aberrations enable researchers to modify and hence extend general theoretical arguments. Case studies typically have an open-ended, emergent quality that facilitates the discovery of both unanticipated findings and novel data sources. Robert Merton (1968, 157) referred to this quality of case-study analysis as the serendipity component of research and defined it as "the discovery by chance or sagacity, of valid results, which were not sought for."

It is here that I begin to fully grasp the foundational dilemma of case-study analysis—namely, how is it possible to construct a methodologically sound

approach that treats objects of inquiry simultaneously as unique and irreducible and yet as concrete examples of a class of like phenomena? Generally speaking, the presentation of the results of case-based research takes the form of descriptively rich narrative accounts that provide case histories and detailed analysis of the phenomenon in ways that are comprehensible to observers. Yin (2008) argues that case studies, like experiments, are generalizable to theoretical positions and yet not to populations or universes. As Flyvbjerg (2006) has argued, "the force of example" that the results of case study research provide is largely underestimated. Studying the impacts that two flagship projects—free-trade zones and artisanal refineries—have on surrounding communities conforms to the model of critical case studies (Flyvbjerg 2006) defined as having strategic analytic importance in relation to the general problem.

Designing research agenda requires having a coherent plan for getting answers to complex questions about a set of social phenomena. Thus, a good research plan serves as a guide that allows researchers to collect, analyze, and interpret data in a coherent and theoretically sound way (Geertz 1973, Burawoy 1998, 2009; Glaeser 2005). The research design for this book takes a methodological approach that considers the importance of ethnographic analysis in interpreting data. Such approach has received a great deal of attention in the research methodology literature (Geertz 1973, Burawoy 1998, 2009; Glaeser 2005). The extended case method is an ethnographic research method that engages in detailed study of concrete empirical cases to extract general principles from specific observations. The extended case method offers a more ambitious alternative to the descriptive case study by showing how a single case can yield theoretical leverage.

Rather than looking for exemplary cases that support an existing line of theoretical reasoning, the extended case method that I adopted here lends itself to helping build a theoretical understanding of how large-scale development projects such as FTZs and artisanal refineries produce displacement and how displacement leads to local contestation in historically specific circumstances, in ways that sometimes manifest in a high level of pollution and environmental disasters. Thus, as I describe in this book, the aim of fieldwork and ethnographic analysis is not to look for confirmation of our initial expectations but to refute what we initially thought of as true (Geertz 1973; Burawoy 1998, 20). In short, fieldwork involves a sequence of on-the-ground experiments that bring theoretical expectations into relation with empirical observations through a series of successive approximations (Burawoy 1998, 17–18) or what Geertz called "thick description" (Geertz 1973).

The logic of theoretical reasoning is crucial to how we interpret data obtained from participant observations. Theory serves as a guide for our

interventions into the field by telling us what to look for, how to approach our interlocutors, how to make sense of the interviews and interactions we had, and, most importantly, how we approach and understand the site we have chosen to research. Theory enables us to interpret situated knowledges (derived from careful investigation of diverse sources of information) into narratives of social processes. Finally, it locates those social processes in their wider context of social determination.

The extended case method involves three dimensions of social research: first, participant observation provides a point of entry into a concrete investigation of voices and social realities of our interlocutors (via interviews, archival recovery, and on-site examination); second, moving beyond this situational analysis involves the extension of observations over space and time as a way of exposing social processes (indicated by regular patterns of social behavior); third, looking at these microsocial processes helps find indicators of embedded forces of social structure to anchor seemingly abstract global forces in local circumstances. Therefore, extended case methods enable researchers to connect the macro with the micro dimensions of social life (Burawoy 1998, 21, 23).

In this book, I define the field of study as a multisited ethnography. These two cases, FTZs and artisanal refineries, were carefully selected because of their theoretical relevance as part of a deliberate research strategy (Yin 2008). As similar instances of social processes, these two cases provide privileged access to how global forces reshape local circumstances. These two cases are what Harry Eckstein (1975) called "plausibility probes"—that is, exploring them helps to establish whether something that exists empirically should be addressed theoretically.

As an anthropologist, I begin with the premise that this multisited field of ethnographic inquiry is not simply a geographic place waiting to be entered but rather a conceptual space with boundaries that are constantly negotiated and constructed through the interaction between researchers and the subjects of the study (Gupta and Ferguson 1997). The participant observation embedded in this approach allows researchers to (1) establish a direct relationship with social actors and the subjects of study, (2) operate in the natural environment of the social actors and subjects of study, and (3) participate in the everyday lives of these social actors/subjects in order to understand the meaning of their actions.

Therefore, three methodological strategies guide my ethnographic explorations of the relationships among FTZs, artisanal refineries, displacement, and contestation over land claims, oil benefits, and entitlement to resources. Ethnography brings together a family of methodological techniques "involving

direct and sustained social contact with agents" (Willis and Trondman 2000, 1). These three methodological strategies include intensive interviewing, on-site participant observation, and content analysis of relevant documents (including archives).

Following Ragin and Amoroso (2011), my ethnographic analysis uses a mixed-methods approach combined with a critical case study format (linked with the extended case method). Artisanal refineries and FTZs are two important examples of capitalist development that go hand-in-hand with the displacement of marginal communities. Therefore, the case study format functions best to understand the complexities and intricacies of these new styles of China's engagement with Nigeria shaped by different paths toward capitalist development. As Yin (2008, 45) also points out, a single case study allows researchers to "uncover very complex dynamics of one setting of interest rather than to look less deeply at more settings." The ideas interrogated in this book take the form of a "linear-analytic case study," with its emphasis on exploratory and descriptive purposes (Yin 2008).

ORGANIZATION OF THIS BOOK

What you find in this book are my many years of engagement with the interesting people and organizations I encountered in Nigeria. The stories of many of the communities that I interacted with in the course of this research begin in chapter 1, "Contested Enclaves of Profit: Interrogating Special Economic Zones and Extractive Practices," where I interrogate the meaning and structure of special economic zones in Nigeria by paying attention to how enclaves of exception can become contested sites of power. In this chapter, I shift our gaze from SEZs as being of the state to SEZs as outside of the state in ways that confer meaning to the systemic issue of artisanal refineries in the oil creeks of the Delta. At the same time, I do not neglect the original meaning of SEZs as representative of state regulatory practices. The focus on the meaning and notion of artisanal refineries helps shape a proper understanding of how artisans can build refineries when the original meaning of *artisan* did not include sophisticated technologies such as oil refineries.

In chapter 2, "Infrastructures of Convenience: China and the Configuration of Free-Trade Zones," I trace the genealogy of Nigeria's interaction with China and Chinese businesses, especially beginning with the opening of diplomatic relations in the 1970s. The chapter carefully maps how this interaction shapes the current engagement of China with Nigeria through the establishment of free-trade zones. Using the ethnographic examples of two such zones—the Lekki Free Trade Zone and the Ogun-Guangdong Free

Trade Zone—the chapter shows how such zones have become spaces for the exercise of political and economic power and domination in ways that create communities of extraction. The chapter concludes by demonstrating how free-trade zones create practices that are mimicked by former insurgents, youths, and other community members in establishing artisanal refineries in the Niger Delta.

Chapter 3, "'This Place Is Not Nigeria': Constructions of the Sovereign in Free-Trade Zones," ethnographically maps the divergent regulatory practices that govern the daily lived experiences of FTZs in Nigeria. By looking specifically at the ways in which the zones are considered to be independent territories, the chapter takes a cursory look at how FTZs are governed within an independent nation-state. It interrogates how the concept of a place not being Nigeria emanated from the idea of who is an expatriate and who is not. An expatriate is considered to be a highly knowledgeable émigré who is hired by an employer from another country—mostly Western countries—to use his or her knowledge at a workplace in a country considered to be under-developed. As such, in Nigeria, expatriates are highly regarded by many within the enclaves of exception. Thus, since FTZs are considered to be sovereign enclaves where the state selectively cedes part of its sovereignty to the zones—especially sovereignty over business registration, taxes, labor laws, and other regulatory practices—those who work in the zones therefore consider themselves part of a new sovereign. The chapter suggests that ceding part of the state's sovereignty to an enclave fits into the shifting meaning of the economy from a system of social practices and relations to an object that is determined by numbers and other regulatory practices that shape development paradigms through oil politics.

In chapter 4, "From Moonshine to Ogogoro: The (Re)Invention of Techniques of Refining and Extraction in the Creeks of Oil," I pay attention to the structures and practices of artisanal extraction by revealing historical links between old and new extractive practices. Using the connection between the brewing of moonshine alcoholic beverages in the United States and ogogoro local liquor in Nigeria, the chapter suggests that today's artisanal refining practices may have had an origin locatable within a particular colonial history of Nigeria. The chapter argues specifically that the name *ameereka*, a name by which ogogoro was known in the early 1920s in many Niger Delta communities, has resonance with the ways in which techniques of extracting moonshine travel across the world and within communities. By invoking the name *ameereka*, I suggest, community members are merely mimicking a particular technology that helped build the technology that produced a liquor that later became a liquor of choice. Tracing some prominent ritual practices

to construct this particular history of extraction, the chapter makes an important contribution by exposing, through archival and oral research, areas of historicity absent in many academic literatures—the relationships among the brewing of moonshine, ameereka, and crude oil. The chapter argues that artisanal processes and structures of extraction reflect innovation and hybrid forms of knowledge, including knowledge of extractive technology that emerged in the 1930s with the imposition of high taxes on imported gin and liquor by British colonial authorities. Technologies of ogogoro production, made popular by youth in the 1930s, have become useful in the production of crude oil by today's youth. The chapter argues further that this particular history of extraction shapes the practices of innovation and mimicry of state and corporate extractive practices in today's Nigeria.

Chapter 5, "Flames of Wealth: Crude Enclaves and Imitative Technologies of Extraction," examines the processes of refining oil used by former insurgents and other youth groups in the Niger Delta. The chapter shows how practices of extraction create a choreographed system of infrastructure construction that create an oil economy for the Niger Delta communities. This chapter further shows how such an oil economy mimics state and corporate oil extraction practices in ways that connect to what I call "local and transregional capitalism." It also shows how oil wealth produces a new culture in which the communities of extraction are imagined through claims to distinct regulatory practices and forms of ownership that mimic those of the state and corporations. By mimicking state and corporate entities, youths, community members, and former insurgents produce alternative forms of governance that compete with governance by multinational corporations and the state.

Chapter 6, "The Social Death of the Environment: Degradation, Infrastructure, Displacement, Trade, and the Complicated Technologies of Extraction," interrogates the environmental consequences of mimicking state and corporate extractive practices in enclaves of extraction. The chapter pays particular attention to how artisanal refiners' practices pollute the environment with devastating consequences for the lived experiences of community members in sites where the refineries are located. The chapter weaves together ethnographic stories and evidence of environmental degradation by describing how community members deal with such environmental disasters. It concludes by showing how such disasters compare to those resulting from state-regulated corporate practices.

The book's conclusion, "Revisiting the Ancestors: Claim-Making and the Crafting of an Oil Economy," discusses how an oil economy continually produces various structures of power within communities of extraction in

Nigeria. It further examines the implications of state-regulated SEZs and their relationship to communities of extraction by revisiting the idea of ownership claims in those communities, and it examines the implications of contested SEZs for democratic control of natural resources around the world.

The stories and histories in this book emerged from my interactions with various actors I encountered while carrying out this research, but I do not, of course, claim that these stories represent the entirety of China's interest in Nigeria nor that they completely represent youths' engagement with oil extraction in Nigeria. While this book is the outcome of many conversations with various actors and participants in the struggle for control of natural resources and land in Nigeria, I have no doubt that many of these participants will take issue with some of my conclusions. Moreover, I do not intend to come up with a definitive statement about FTZs and their relationship to artisanal refineries in Nigeria; issues of special economic zones cannot be one-size-fits-all because actors, peoples, and challenges are never homogenous. My intention is to sift through multiple perspectives on how various communities of extraction deploy different strategies to make claims to a particular landscape rich in natural resources.

By using my interlocutors' diverse narratives, I aim to describe unambiguous multiple trajectories that I consider to be characteristic of all ethnography. However, it should be noted that many actors and participants whom I interviewed for this work requested anonymity; therefore, except where interlocutors are already in the public sphere, I have refrained from using their real names. The outcome of this research and the quantity of interviews conducted were highly enriched by the relationships I was able to cultivate throughout my stay in Nigeria. The theoretical orientation, narratives, and methods used aim to reflect the various communities, organizations, and transnational networks and their complex forms of contestation. I hope this book will contribute, in no small measure, to the ongoing dialogue about special economic zones, transnational networks, the state, the international capitalist system, sovereignty, governance, and community engagement with oil corporations using the languages of capital, trade, entrepreneurship, and community interactions.

NOTE

1. The other contractors were fond of calling him an innovative youth leader because of his dexterity at developing what they considered to be innovative programs aimed at tackling social problems. However, despite further prodding, those innovative ideas were never disclosed during our conversations.

1. CONTESTED ENCLAVES OF PROFIT

Interrogating Special Economic Zones
and Extractive Practices

On May 29, 1999, Nigeria transitioned from many years of military rule to a civilian administration. Prior to the transition, the country had experienced barely a decade of democratic rule (1960–1966 and 1979–1983) because it had been mired in one military dictatorship or another. Indeed, the Nigerian state witnessed some of the darkest eras in its history during the period of military dictatorship—for example, a civil war from 1967 to 1970 that killed more than three million people. Added to this were periods of agitation for democracy championed by prodemocracy activists who were responding to global changes in the constitution of a new world order, especially in the 1980s and 1990s. Some of these protests led to the arrest, killing, and maiming of activists and other citizens by the military-controlled Nigerian state. Eventually, however, the military was forced to relinquish power in 1999.

Since its transition at the start of the twenty-first century from long years of military dictatorship to pluralist democracy, Nigeria has experienced substantial socioeconomic change. More importantly, the volatility in the price of oil in the global marketplace, especially in the 2010s, has meant increased tax revenues for the state budget in some years and decline in others. The state administration in Nigeria operates a centralized system in which federating state governments rely on huge oil revenues for service provision. Since the discovery of oil in 1956, the federal government has dispensed funds every quarter to federating states on the basis of a revenue ("sharing") allocation formula. Under the current formula, the federal government receives 52.68 percent, states receive 26.72 percent, and local governments collectively receive 20.6 percent. Further, of the 20.6 percent that goes to the local governments, 13 percent of derivation revenue is allocated to Nigeria's oil-producing states (Onuigbo and Innocent 2015). The revenue allocation formula is not

based on population density; hence Lagos, with the largest population in the country, receives less than a state like Bayelsa, whose population is far smaller. Also, states that are rich in oil resources, such as Bayelsa and others in the Niger Delta, benefit more from the revenue allocation formula. Thus, as the commercial capital of Nigeria, Lagos State, with an estimated population of over sixteen million, benefits disproportionately. However, following the 2016 discovery of oil in the Badagry area that launched Lagos into the group of oil-producing Nigerian states, this soon will change. Lagos's proximity to the coastal areas of Nigeria, as well as its position as the commercial hub of West Africa, positions the state as a site for many commercial interests. Similarly, Ogun State, which shares a border with Lagos, enjoys the same benefits because of its proximity to Lagos and its access to Lagos's ports. Yet despite these benefits, many years of oil revenue mismanagement have caused infrastructure deficits for Nigeria in general and the states of Lagos and Ogun in particular, resulting in numerous infrastructure development challenges for the country (Adunbi 2015; Apter 2005; M. Watts 2004b). However, in recent times, the governments of Lagos and Ogun States have embarked on huge revenue-generating infrastructure projects aimed at making the states financially self-sufficient and not dependent on revenue handouts from the federal government (Adunbi 2015; Adunbi and Stein 2019; Brautigam and Xiaoyang 2014).

In this effort to become self-sufficient, key stakeholders in new infrastructure development projects in Lagos and Ogun States have initiated the establishment of partnerships with foreign and local corporate investors in order to create new revenue streams. Since about 2010, an elite growth coalition comprising various international corporations, including the China-Africa Lekki Investment Ltd., the Zhongfu International Investment (Nig.) FZE, the (Nigerian-based) Dangote Group, and various multinational oil-extraction companies, has teamed with the governments of Lagos and Ogun States to construct two major industrial projects: the Lekki Free Trade Zone (LFTZ) and the Ogun-Guangdong Free Trade Zone (OGFTZ). The stated purpose of these zones is to transform Lagos and Ogun States (see map 1.1) into the primary hub of manufacturing not only in West Africa but in all of sub-Saharan Africa and to scale up their infrastructure in ways that could attract more foreign direct investments. The LFTZ and the OGFTZ have been deliberately designed to epitomize the vision of Greater Lagos and Ogun as world-class tourist and business destinations, following the model of Shenzhen, Pudong, and other Chinese special economic zones. The majority shareholders of both zones are Chinese companies. These large-scale projects are spatially located in the Ibeju-Lekki area of Lagos and the Igbesa

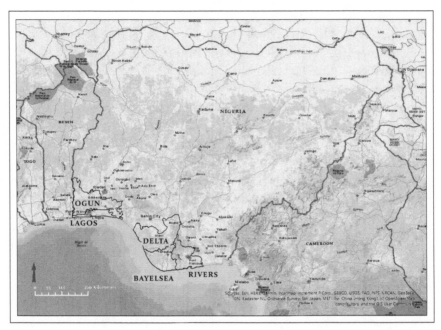

Map 1.1 Map of Nigeria with emphasis on Bayelsa, Rivers, Delta, Ogun, and Lagos States, all hosts to special economic zones. Sources: Esri, HERE, Garmin, Intermap, increment P Corp., GEBCO, USGS, FAO, NPS, NRCAN, GeoBase, IGN, Kadaster NL, Ordnance Survey, Esri Japan, METI, Esri China (Hong Kong), © OpenStreetMap contributors, and the GIS User Community.

area of Ogun State. The LFTZ and the OGFTZ are manufacturing and oil processing and refining sites resulting from a business partnership between a Chinese consortium and the governments of Lagos and Ogun. In addition to these, other infrastructure projects are being undertaken by various Chinese companies across Nigeria, such as the construction of airport terminals like the Murtala Mohammed International Airport, Lagos, and the building of a new metro line in Lagos and Abuja.

Nothing better illustrates China's engagement with Nigeria and how Nigerians respond to it than an image that appeared on many social media sites on September 8, 2018.[1] The image shows a Chinese man at a massive construction site making a phone call. It is not the presence of the Chinese man that makes the image noteworthy to many Nigerians who commented on it; it is the Nigerian police officer holding an umbrella to shield the Chinese man from an apparently scorching sun while at the same time holding an AK-47 rifle. The Chinese man, who has one hand in his pocket, seems to be concentrating on the call while the police officer looks on. Many

commenters on social media sites such as Twitter and the popular Nigerian blog *Nairaland* commented in a variety of ways, ranging from ridiculous to highly insightful. For example, one asked, "Is this not a semblance of how our forefathers were forced to carry the British colonial masters on their shoulders during colonialism? Are we witnessing that scenario again with all these Chinese people?" Another asked, "Was it raining or was the sun that hot? Or his [*sic*] the Chinese man having a fracture in his hands?" The commenter concludes in pidgin English, "Africans make una get sense."[2] (This literally means, "Africans, you all need to be sensible, and be responsive to issues that affect you.") But it did not end there. Some commenters compared the police officer's action to slavery, while many others saw it as being subservient to China as a result of the indebtedness of Nigeria and other African countries due to loans mostly aimed at infrastructure development.

What is striking in the many online comments is the idea of neocolonialism, which fits into many narratives about China's engagement with Africa (e.g., French 2014; M. C. Lee 2006; Plummer 2019). These narratives demonstrate clearly that there is a new scramble for Africa's natural resources. While many commenters may be oblivious to the deeper implications of China's engagement, the narrative that is constructed about how China is taking over all of Africa, as described in the introduction, seems to resonate with many. The image is indicative of a process that privileges China and the growing Chinese population in Nigeria. My encounter with one of my interlocutors in Lagos further illustrates this process of privileging China's infrastructure development.

I had been in the LFTZ for a few days in 2017 when I encountered Daniel, an engineer who had trained at the London School of Economics and Political Science. I had gotten to know Daniel well during my early research in Nigeria. When I saw him again, he was elated to welcome me back to Nigeria. While at the London School in the late 1970s, Daniel had joined a socialist group on campus, and on his return to Nigeria, he became a staunch socialist, active in many of the prodemocracy and antimilitary protests of the 1980s and 1990s. He still prides himself as a socialist; to him, the United States is an imperialist state, and all who reside there are agents of imperialism. Throughout my stay in Nigeria, he never failed to call me an imperialist, and when I sometimes offered to pay for drinks at pubs (popularly known as beer parlors in Nigeria), he would jocularly say, "Let me enjoy part of your imperialist money." Of course, Daniel meant it as a joke, but what was interesting was his fervent belief in China as a communist country that intended to outcompete the "imperial" United States on the way to establishing a socialist world that would give hope to all socialists across

the globe. Daniel was totally fine with all that China was doing in Nigeria and elsewhere around the world because, as he said, "we are going to build a socialist world, and China will lead the way."

On Daniel's return to Nigeria, he had worked briefly as an electrical engineer for a private company before setting up his own private enterprise. Daniel's engineering firm experienced a period of economic boom, but lately things had not been going well for the company, which he blamed on "the imperialists" who were squeezing all other countries dry. Daniel sometimes bids for government contracts to fix electrical problems or install new electrical circuits in government buildings across Nigeria. His most recent bid was for an electrical contract at one of the airports. Surprisingly, Daniel did not get the contract because it was awarded, according to him, to a Chinese company whose bid was far lower than his. While he was bidding for the contract, he approached several banks in Nigeria for financing but received a negative response. Daniel was not perturbed that a Chinese company outbid him for a job that could have served as a lifeline for his struggling engineering company. He said he would rather let the Chinese have it because that "would advance the socialist agenda." When I pointed out that the Chinese company that won the contract was doing it for profit and not for socialism, Daniel would not have any of that. To him, that was what the imperialists would want people to believe because they were "afraid of China." The idea that imperialists are afraid of China helps Daniel rationalize his fervent belief that China's growing influence across the world stems from its interest in building a socialist alternative to capitalism. As Ong (2006) points out, what China did and continues to do is make neoliberalism work on its own terms because, as Shever (2012) echoes, neoliberalism is never the same everywhere because of its level of fluidity.

Daniel's belief in China was not unusual. In a 2016 survey of Africans' perception of China in Africa, 63 percent of respondents thought China's economic and political influence in their country was positive (see fig. 1.1),[3] and many pointed to China's investments in infrastructure as well as access to cheap Chinese goods.[4] Daniel's belief in China's growing influence might be attributed to his fixation with China being a communist state—though of course China has been moving away from the idea of communism since it started its profit-driven "going out" policy, as described in the introduction. Understanding Daniel's optimism about China's influence and his fear of US imperialism is further complicated by a May 2020 policy document released by the conservative think tank Heritage Foundation. The report, authored by Joshua Meservey, its senior policy analyst for Africa and the Middle East, details how China's infrastructure projects might serve as a

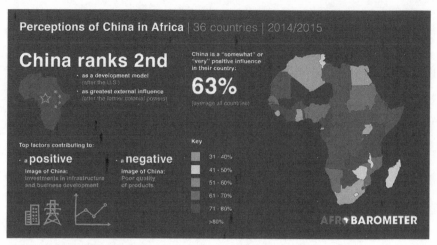

Fig. 1.1 Here's what Africans think about China's influence in their countries. October 2016. Image courtesy of Afrobarometer, https://afrobarometer.org/.

vector for Chinese surveillance. It contends that Beijing likely has better surveillance access to Africa because of the many infrastructure projects being undertaken on the continent, suggesting that such a practice may pose an imminent danger to US military and business interests. Meservey (2020, 1–2) argues further that Beijing's influence operations on the continent may be used to "recruit intelligence assets at senior levels of African governments; gain insight into U.S. diplomatic strategies, military counterterrorism, or joint military exercises and disadvantage U.S. companies competing against Chinese firms for Africa's growing economic opportunities." Therefore, the report concludes, "Africa may be the most permissive region on earth for Chinese spying and espionage. Beijing and its companies have enormous sway over many African governments, whether because of personal inducements to African leaders or because of African countries' economic enmeshment with China—something Beijing increasingly uses as a weapon. This suggests some African governments might hesitate to be appropriately skeptical of Chinese intentions" (Meservey 2020, 11).

While Daniel's concern might be the mitigation of the United States' sphere of imperialistic influence by China, even if he does not stand to benefit from China's influence in Africa, the concern for many Africans, especially Nigerians, is completely different. For many Africans and Nigerians, the visibility of China's infrastructure projects and cheap goods can connote different meanings and interpretations. Those who live within the vicinity of free-trade zones (FTZs) established by China see such Chinese infrastructure projects as being disruptive to their lives and livelihood. The projects are

disruptive to sacred sites, livelihood practices, and the social lives of many members of these communities. Beyond the disruptive nature of the projects, many are profit-driven and intertwined with the neoliberal capitalist model that the Nigerian state subscribes to. The projects fit into the larger imbrication of the many facets of the neoliberal economic system encompassing special economic zones. The FTZs and other infrastructure projects are aimed at maximizing profit for the enterprises within the zones. Daniel may see the FTZs and other Chinese interests as approximating his own ideas of development, but what lies beneath the projects is systemic displacement of populations, environmental degradation, and disruption of social life, including that of Daniel, whose business could not compete with a highly subsidized business from China.

However, concurrent with these projects, other forms of special economic zones (SEZs), specifically artisanal refineries, are also being constructed by youths and former oil insurgents in the Niger Delta. These artisanal refineries follow similar patterns of extraction as FTZs (see map 1.2). FTZs like the LFTZ and OGFTZ extract raw materials and labor power from the areas around them to create finished products for export to the larger global economy. Artisanal refineries also extract resources to create products for the local and global economy. While FTZs are licensed by the state to self-regulate, artisanal refineries self-regulate and carve out spaces of economic extraction based on knowledge of community landscapes and local socioeconomic and political interests.

CRUDE (RE)CAPTURE, ARTISANAL REFINERIES, AND THE COMPLEXITY OF SEZS

I turn to what I call "crude capture" to interrogate notions of SEZs in ways that complicate our understanding of their meaning and practice. I do so using examples of how artisanal refineries mimic state and corporate modes of extraction in some parts of the Niger Delta. My argument is that SEZs produce complex economic systems that lead to new processes of energy, resource, and material capture and recapture in enclaves of extraction. I expand the meaning and practice of SEZs such that they include but are not limited to state-regulated economic zones and other economic zones that are regulated by actors outside of the state, such as former insurgents, youths, and community members who make claims of resource ownership that compete with those of the state. Artisanal refineries, I argue, represent an emergent form of energy capture that transforms the creeks of the Niger Delta into islands of carbon sale and that challenges state and corporate power. Therefore, I suggest that a look at the new extractive practices in the

Maps 1.2a–1.2c (*this page and following*) Images showing similarities between artisanal refineries and Lekki Free Trade Zone. Source: Google Earth imagery, 2018 and 2020; Lekki, picture by the author.

Map 1.2b

聚焦启动期

Start-up Phases Focusing

Map 1.2c

creeks of Nigeria's Niger Delta clearly demonstrates the emergence of a new energy frontier that is defined by a form of capture. This form, embedded in new economic practices, is reshaping livelihoods, community relations, and governance in Nigeria. Thus, artisanal refineries represent an example of the hybridization of technologies of power that is illustrative of competing notions of extraction in an oil enclave such as the Niger Delta region of Nigeria.

Interrogating SEZs and contests around oil extraction by looking critically at the emergent oil infrastructure constructed by youths reveals both a new frontier in the struggle for the capture of energy in Nigeria and a reimagining of practices in global oil frontiers. I also argue that complicating the meaning and practice of SEZs in resource enclaves provides an opportunity to rethink innovation as producing specific knowledge about infrastructure practices in FTZs and artisanal camps in Lagos, Ogun, and the creeks of the Niger Delta. Artisanal processes and structures of extraction reflect innovation and hybrid forms of knowledge, including knowledge of extractive technology that aids in the development of new energy and resource practices. I contend further that these particular energy practices are engendering relational forms that disrupt the state's claim to ownership and total capture of

oil resources while creating opportunities for youth to establish structures that strengthen networks and cultivate support for their activities. The story of SEZs in Nigeria, I suggest, is one of how energy practices and their attendant infrastructures represent two forms of capture—one epitomized by the state and its corporate partners' attempt at monopolizing such practices and their benefits and another that emboldens youths to make claims to ownership of oil resources through institutionalizing new energy practices. These new practices result in the establishment of the phenomenon of the social death of the environment described in chapter 6.

Most scholarship on extractive practices in the postcolonial state focuses on the effects of resource extraction on communities and how communities respond to corporate practices, particularly the ways in which natural resources constitute part of state capture (Bayart, Ellis, and Hibou 1999; Mkandawire 2001). This scholarship shows how power circulates both in and beyond the nation-state, the constitution of postcolonial imaginaries, and the interrogation of development or the production of modern subjects (Adunbi 2015; Hicks 2015; Mamdani 1996; Shever 2012). While such scholarship shapes our understanding of the politics of extraction in postcolonial states, I expand it by paying attention to new energy practices that represent a process of capture and recapture—state capture and youth recapture of crude oil and its benefits. Capture and recapture symbolize a process through which extraction happens and how the process plays into articulations of power and the production of competition between actors within the nation-state (Adunbi 2015; Doughty 2019; Ellis 2016; Leonard 2016). State capture of crude, to many communities rich in oil resources, represents a form of dispossession, while the process of its recapture embodies a form of repossession of what the communities claim to be their property. As Butler and Athanasiou (2013) remind us, dispossession by others and by institutions, norms, and structures of language that preexist is a sort of existential given (all beings are dispossessed to some extent). Dispossession, Butler and Athanasiou (2013) note, may allow for greater connection and the development of social bonds. However, dispossession can also be a form of suffering for many, including the displaced, the colonized, the homeless, and the unemployed; this is because structures of power and neoliberal governmentality produce some people as properly human and others as not. Those who are not properly human are socially disenfranchised. In the Niger Delta, the dispossessed are the communities whose oil resources are captured by the state and its corporate allies. Dispossession, in this case, to invoke Butler and Athanasiou, can create a social bond in ways that produce a form of repossession through the recapturing of the oil captured by the state. Niger Delta

youths, dispossessed of their selves, their livelihoods, and the environment, engage in practices that embolden a process of repossession through crude recapture.

Nothing epitomizes my use of crude recapture more than the self-styled Captain Swagger, a member of the artisanal refinery staff in one of the creeks of the Niger Delta. One afternoon in the summer of 2018, I ventured into one of the artisanal refinery villages, where I met Swagger. He was holding a bottle of locally produced ogogoro (palm liquor or local gin) in one hand and a pack of cigarettes in the other. Swagger wore pants but no shirt and was drenched in crude oil. He was taking a break from his routine of pouring crude into the cooking pot (described in detail in chapter 5). He was about to light his cigarette when he saw me and came menacingly toward me. Swagger's first questions were "Who are you?" and "What are you doing here?" One of my guides told him I was one of them, to which he responded that I could not be. Of course, I had just arrived a few weeks prior from the long winter of 2018 and had yet to be scorched in the hot sun of the Niger Delta. My mission was later explained to him, and he smiled and offered me a cigarette and a drink, which I refused. I made him realize that my refusal was not born out of lack of respect for him. I do not smoke and only drink socially, but I also made it a matter of principle not to drink during the daytime because I believe drinking is for relaxation that can be reserved for the evening hours. He insisted that if I was not going to share with him, I would have to pay for both, and I willingly obliged.

The next day, on my arrival at the camp, Swagger called me aside, and we had a long chat about what he does, how he does it, and what his motivation is for doing it. Swagger told me how he lost his father to sudden death at a young age and how he and his mother had to be responsible for all his siblings. He left secondary school, could not afford college, and survived for a few years by fishing until he came across a friend who introduced him to the artisanal refinery business. Now, "I make good money, take care of myself and my other siblings. I gave my mom some money to start an ogogoro business, and I take care of my girlfriends," he quipped with a broad smile. When I asked how many girlfriends, Swagger retorted, "As many as I can take care of with my money." In a good month, Swagger is able to make between 30,000 and 50,000 naira, an amount far above the national minimum wage of 18,000 naira and sufficient to survive in the creeks of the Delta.[5] Swagger told me that what he and his colleagues are doing is taking what belongs to them. As he said, "We don capture our oyel from the state," meaning, "We have recaptured our oil from the state." In this sense, Swagger's use of "capture our oyel" denotes participation in the oil business that he thought the state

and its corporate partners had monopolized for over fifty years. Thus, capture becomes a way to explain the participation of many Niger Delta youths in the extraction of crude for refining purposes. Swagger is not alone in this.

Many of the youths I encountered told compelling stories of loss, recovery, and survival, often stories of the loss of a loved one and a livelihood, recovery from the loss, and access to survival through capture. Many of these stories reminded me of Rupp's (2013) view of energy as both a metaphor for and an agent of individual capability, where energy is seen by Ghanaians as an internal force that allows them to perform their daily activities and as an external product or service that allows technology and commerce to flourish. To Swagger, and to many of the youths in the creeks of the Niger Delta, crude serves as a means of survival, while the consumption of ogogoro at refinery sites provides the necessary energy and vitality that helps in the process of crude capture. Swagger made this clear when he said, "Ogogoro dey give energy. Anytime wey I take am, I go just dey bubble with plenty energy," meaning, "Ogogoro provides me with energy, and whenever I drink it, my energy and productivity increases." Ogogoro is thus a form of energy that reinvigorates the capture of another source of energy—oil—in special economic zones. While this is significantly different from state capture based on corporate and administrative ordering of oil resources through state regulatory regimes, crude recapture by youths represents a new moment in the contestation over energy use in the Niger Delta and Nigeria.

My use of the word *capture* is therefore embedded in two interrelated questions: What happens when state-licensed corporate practitioners organize rules of business engagement anchored in self-regulatory practices? And how might we understand processes of mimicking and imitating the state in ways that embolden youths and their allies to choreograph business practices that are like those licensed by the state but that are self-regulating in a semi-autonomous enclave? A clear understanding of this duality leads to the conclusion that while FTZs and artisanal refineries might look different in their conceptualization, the end goal of self-regulation and profit maximization in a complex economic system remains the same.

REGULATORY REGIMES, THE STATE, AND CRUDE CAPTURE

My interest here is to rethink complex economic systems as encompassing certain practices that can be of the state but that are not limited to the state. The economic system that is "of the state" refers to state practices that either regulate or deregulate the economic system of a nation-state, while economic systems that are "not of the state" indicates systems that incorporate

other economic practices within the nation-state. In some literature (Arjona, Kasfir, and Mampilly 2015; Christia 2012; Mampilly 2012; Staniland 2014; Weinstein 2006), these practices have been seen as either a form of shadow state—especially where insurgents organize economic practices outside of the state (e.g., Arjona 2016, 2017; Arjona, Kasfir, and Mampilly 2015; Christia 2012; Mampilly 2012; Reno 1999, 2001; Staniland 2014)—or as a system of informal sector (Davies and Thurlow 2010; Fapohunda 2012; Ihrig and Moe 2004; Meagher 1995; Wilson et al. 2009) participation in the state economic system. I want to move beyond seeing all economic systems that are outside of state practices as either constituting a form of shadow governance or merely participating in the informal sector of the economy. The words *informal* and *shadow*, in themselves, do not capture the character of the state and the institutions and practices that make up the state. Thus, interrogating the meaning and practices of special economic zones as an economic system by paying attention to state and nonstate regulatory practices and processes helps throw light on other economic activities that shape the nature and character of the state, especially in Nigeria.

More importantly, the notion of the informal sector is often used to describe an economic system that is not legible to the state. Being legible to the state in this sense suggests that the state would be able to map and have adequate knowledge of all its citizens, those who live within its territory, the kind of economic activities they engage in, and the visibility of those economic activities to state regulatory structures. The illegibility of certain economic systems to the state is invoked in relation to the markets. Formal markets are considered to be those that can be adequately accounted for by the state through the legibility of gross domestic products and gross national products. Markets that the state is not able to account for in this way often get categorized as informal markets or the informal sector. My intent is to question the utility of the notion of formal and informal by suggesting that markets such as artisanal refineries make important contributions to the Gross Domestic Product in particular and the economy of Nigeria in general, based on a neoliberal notion of the market. The shift in the meaning of the economy from a system embedded in wider social relations to an object that refers to a self-contained structure or totality of relations of production, distribution, and consumption of goods and services within a geographical space through the quantification of human and material relations coupled with the state's attempt to map populations (Mitchell 2011; Scott 1998) largely accounts for the designation of certain market practices as informal while others are categorized as formal. Nowhere was this phenomenon of relegating existing markets to the background more pronounced than during the colonial era in

many African states, where markets organized by African societies were not legible to the colonial authorities (Ake 1996; Bayart 1993; Mkandawire 2001). Yet these markets were legible to many participants and made important contributions to the building of an economy in many African states, including Nigeria.

In addition, when such informal markets fall under the regulatory regimes of insurgents and taxes are extracted, those regimes are, in most literature, considered shadow states (Arjona 2017; Arjona, Kasfir, and Mampilly 2015; Christia 2012; Mampilly 2012; Reno 1999, 2001; Staniland 2014). The phenomenon I describe in this book does not fall into the category of a shadow state, nor do I see FTZs and artisanal refineries as constitutive of different market regimes where one should be seen as formal and the other as informal. If there is any description that captures both, it is that they both operate under the rubric of a special economic zone that taps into the intricacies of neoliberal apparatuses. If neoliberalism can be fluid in its travels as Shever (2012) contends, FTZs and artisanal refineries are different assemblages of neoliberal market situations. While one is licensed and regulated by the state (FTZs), the other (artisanal refineries) basically self-regulates. Both function within the appurtenances of the neoliberal economic system that the state—in this case, the Nigerian state—buys into.

Therefore, exemplifying this form of economic system in Nigeria are the FTZs in Lagos and Ogun States as well as the artisanal refineries in the creeks of the Niger Delta. Specifically, illustrative of the practices of artisanal refineries in the enclaves of exception are the campsites located in the creeks of Bodo, Rivers State; Okaiki, Bayelsa State; and Omadino and Jones, Delta State. These three sites tell the story of how artisanal refineries are daily shaping everyday practices of a complex economic system that encompasses zones of exception in Nigeria. The practices of artisanal refineries can be compartmentalized into four interrelated fields of energy frontiers in Nigeria. The first is the process of tapping. Tapping connotes opening up and caulking back a well head with the intention of releasing crude oil into prearranged drums for transportation, to be either loaded into barges for the international market or emptied into cooking pots for refining. Tapping, therefore, suggests processes and practices of energy transfer that create a value chain for the commodity and those who claim to own it. Second, an oil well head where tapping is done is called *the point*; these are mostly owned by former insurgents who control most parts of the creeks.

Tapping into flows of energy is considered to be the most lucrative form of energy capture in the creeks because of the value chain it has the capacity to create—connection to international and local markets. The third

interrelated practice is the camp, within the fourth, known as the kpofire village. The camp is the site at which the actual refining takes place. The camp is anchored in the notion of innovation, a form of innovation that shapes infrastructure practices in the creeks where extraction occurs. While tapping is just about opening up the well head at the point, campsites are much more than that. Campsites are where the innovativeness of the youths who operate the refineries comes to fruition. Tanks are manufactured for cooking oil, pipes are connected with the tanks, and gas-flaring pipes are clearly designated for the emission of associated gas—similar to multinational oil corporations' practices in the area. Thus, the kpofire village epitomizes an economic system that builds a community of entrepreneurs, innovators, workers, and community members at the frontier of energy practices where techniques of regulation are constitutive of the daily lived experiences of the community's members.

Today, there are over two thousand artisanal refineries operated by youths in the Niger Delta. Many of the spaces where they are located are carefully crafted and demarcated by the youths as economic zones of extraction where practices that mimic the state and corporations daily produce objects of value. Bodo, Okaiki, Omadino, and Jones Creeks in the states mentioned above are some of the most prominent of such economic zones of value in the entire Niger Delta region of Nigeria. In particular, Okaiki's close proximity to the first site of oil export to the international market in Nigeria makes it one of the most remarkable of the enclaves of exception. Oloibiri is where the first commercial oil well was dug in 1956. There are over forty-seven such refineries currently in operation in Okaiki. Jones Creek is unique because it is host to one of the points where energy is daily being tapped into the frontiers of value chains in the Niger Delta. This point, as I show in chapter 4, is the site where crude oil is taken for onward transfer to refineries for processing; it is the most lucrative element in the business of oil refining within the enclaves.

During some of my visits to these zones, I interacted with youths who operate the refineries, Chinese consortium executives who run the FTZs, and community members in the creeks and sites of the FTZs. These experiences and the economic and energy systems they represent are presented in this book. *Enclaves of exception* represent what Bayart and Ellis (2000, 228) call extraversion in the postcolony, "whereby sovereignty in Africa is exercised through the creation and management of dependence," but at the same time, they are a form of extraversion that speaks to the place of the state in shaping economic practices (Bayart 2009; Bayart and Ellis 2000; Bayart, Ellis, and Hibou 1999; Harvey 2003; Phillips 2018; Worby 2000, 2003). For example, during one of my visits to the creeks and FTZs, I encountered youths who

act as surveillance officials to kpofire villages, Chinese nationals who serve as police officers within FTZs, and community members who extract taxes from patrons of artisanal refineries. I saw how the Okaiki community works in concert with the refiners through a youth network that operates as one of the layers of governance within the community. The leader of the youth group, Amaibi, and his assistant, Degbe, operate as the custodians of access to the community and the space demarcated for refining. I witnessed, during my fieldwork, how the youth group extracts taxes from patrons of the refineries as well as the refinery operators. For example, visitors to the refinery zone pay the equivalent of about six dollars as an entrance fee, and the refinery opera-tors pay about ten dollars for each drum of gas that is taken out of the refinery zone. The youth group serves as security for the community and as surveil-lance contractors to the zone. As visitors and patrons enter the zone, members of the security team lead them down a bush path to the bank of the creek, where a canoe conveys them to the refinery site. For example, every day when I went to the zone during my stay in the area, Amaibi and Degbe led me down the bush path to the creek with their weapons tucked under their jackets.

One significant feature of the creek is the striking smell of crude oil and a change in the atmospheric condition of the zone. While the impact of crude extraction on the village and the entire region is noticeable everywhere, I observed that the zone seems to be extremely hot and humid compared to the other areas of the Okaiki, Otuasega, and Egbelebiri communities. The zone, from my observation, spans up to about three to five miles in radius, with each portion of the refining site carefully demarcated by its individual own-ers. As in the state-regulated special economic zones such as the Lekki Free Trade Zone in Lagos, where each individual business carves out a portion of the demarcated land for its use, we also see the imitative extractive spaces carefully carved out by each individual owner in a well-choreographed man-ner such that each space is organized as an independent business enterprise within the artisanal refining zone.

Each of the forty-seven refining sites at this particular location is referred to as the camp, while the entire zone itself is known as the kpofire village. Each camp also has a dump, which is made up of a collection of tanks where the refining takes place. The dump is a reference to how crude oil is suppos-edly dumped into a tank for refining. There are a few tanks that make up a refinery; hence, names distinguish each tank from the others based on its functions. For example, the tank where the crude is dumped is known as the cooking pot. Interlocutors often described how the kpofire village is con-sidered to be a zone where they earn their living. During one of my visits, a refinery operator proudly announced as we disembarked from the canoe

that took us to the creek where the zone is located, "Welcome to our refinery, where we refine our crude oil for sale." With the phrase *our refinery*, the operator reiterated the notion that crude oil did not belong to the Nigerian state but to him and his community. As I sat down with him and other youths for an interview, he marveled at the infrastructure built by his team for the refinery. The building of oil infrastructure and crafting of a space of value using local technologies is an excellent signification of how innovation drives the practice of extraction in the oil fields of the Delta.

ZONES OF VALUE, SITES OF ECONOMIC CONCLAVES

In a 2011 World Bank report on SEZs, authored by Farole (2011, 25), the Africa Department of the Bank contends that the motivation behind SEZs is "to generate or participate in the economic transformation of [the] host country in a way that is faster or more effective than would be the case without them." The same report goes on to suggest that policy goals for an SEZ include attracting foreign direct investment, serving as a "pressure valve" to alleviate large-scale unemployment, supporting a wider economic reform strategy, and serving as an experimental laboratory for the application of new policies and approaches (Farole 2011, 25–26). Thus, since the early 2000s, there has been an exponential increase in the number of countries setting up SEZs as "spatially delimited areas within an economy that function with administrative, regulatory, and often fiscal regimes that are different (typically more liberal) than those of the domestic economy" (Farole 2011, 17).

In an extensive study of such SEZs, particularly in China, Ong (2006) notes that China employs SEZs to create zones of exception in which national space is reterritorialized to develop particular sites of capitalistic growth, separate from the socialist governance of the mainland. These zones have the capacity to attract and utilize foreign capital, forge joint ventures and partnerships between the mainland and foreigners, produce wholly export-oriented goods, and let market conditions—read: *not* politics—drive economic activity. To Ong, SEZs are zones of exception where the sovereignty of the state and freedom of the citizens could become tenuous. While Ong's concerns about sovereignty and freedom remain valid in many states that have instituted SEZs, another issue of concern to scholars has been the promise of accelerated development by SEZs. For example, Stein (2008) traces the modern history of the idea of SEZs to the establishment of the Irish Shannon Export Free Zone in Ireland in 1958. Stein (2008, 25) argues that the initial success of the strategy led to the United Nations Industrial and Development Organization popularizing it as a development model to be replicated by international development agencies and developing nations around the

world. Cross (2014) took the argument further by suggesting that in India, SEZs are sites of anticipation where politicians, bureaucrats, and real estate developers use the establishment of such zones to anticipate the development of capitalism. Such "anticipation of capitalism," Cross suggests, often pitches farmers and activists who are skeptical about the promise of capitalism against the state. Farmers whose lands are appropriated to give way to SEZs are courted by activists whose skepticism regarding the dream zones is driven by their desire to support vulnerable populations.

Though the first SEZ in India, Cross points out, emerged in the 1960s, today, the promise of accelerated development remains an illusion. By the 1970s and 1980s, SEZs had become an economic panacea prescribed by the World Bank and International Monetary Fund to many countries of the Global South. Many countries were encouraged by the international financial institutions to establish designated SEZs for the processing of products for export as a way to accelerate industrial development, attract foreign direct investments, and create rapid economic growth (Cross 2014; Stein 2008). Hence, export processing zones became special enclaves created within a country where firms, mostly foreign, may manufacture or assemble goods for export without being subjected to the normal customs duties on imported raw materials and finished products present in that economy (Afeikhana 1996, 25). The uptake of SEZs in the 1990s and early 2000s by many African countries has often been cited as, in part, a response to the United States' African Growth and Opportunity Act, which aimed to expand US trade with and investment in sub-Saharan Africa, stimulate economic growth and encourage economic integration on the African continent, and facilitate Africa's integration into the global economy (Newman and Page 2017).

Examining the contributions of SEZs to development, Aggarwal (2010, 31) argues that the success of SEZs should be evaluated based not only on quantifiable benefits but also on other nonquantifiable ones, such as structural change in the economy. According to him, SEZs' contributions to economic growth based on foreign exchange earnings, employment generation, and attraction of investments are not enough. Rather, what is of primary importance is the role they play in stimulating structural change in economic activity, principally by relocating resources from low-value-added to high-value-added sectors and thus imparting dynamism to the economy (Aggarwal 2010, 26). While Afeikhana's contention that it is difficult to evaluate the performance of SEZs is valid, Frick, Rodríguez-Pose, and Wong (2019, 38) suggest that "SEZs on the whole cannot be considered as a growth catalyst in emerging countries. Despite considerable variation in their performance across and within countries, their overall economic dynamism does not

exceed that of the countries where they are located, casting doubts about claims that portray them as a panacea for growth." Moreover, Zeng (2016) argues that global analyses of the direct impact of SEZs in driving economic and private-sector development vary significantly across countries and regions and that a lack of data hinders analyses of firm-level contributions. More important is the contention by some that SEZs offer a gradual "alternative to neoliberal shock therapy" and can promote wider economic policy reform by acting as "demonstration areas" or "catalysts" (Woolfrey 2013, 4), although, as Woolfrey (2013, 4) also claims, such shock therapy can also delay wider policy reform, creating enclaves that allow for the continued protection of inefficient domestic industries or "pressure valves for unemployment" that reduce the incentive to seek more far-ranging reforms.

In a 2003 International Labor Organization report, some examples where SEZs were embraced in ways that shifted approaches to economic development practice include countries such as Mauritius, which, the report suggests, used the zone strategy to shift from sugar exports to manufactured exports; Sri Lanka, from rubber and tea to garments; and Costa Rica, which diversified from coffee and bananas to garments and microprocessors. Recently, Costa Rica further diversified its exports by reducing its apparel export share and increasing its share of other manufacturers, such as pharmaceuticals and electronics (Milberg and Amengual 2008, 9). In the case of sub-Saharan Africa, Cling, Razafindrakoto, and Roubaud (2005, 26) found Madagascar to be the most successful, increasing the number of its products worth over US$1 million in exports from 38 percent to 70 percent. In addition, several SEZs are exclusively dedicated to the oil and gas, minerals, or other mining sectors in Africa, including zones in Angola, Gabon, Ghana, South Africa, and Zimbabwe (Newman and Page 2017). Special economic zones, therefore, are not just about the profit such enclaves generate; they are also about helping nation-states that develop them improve their infrastructure while creating employment opportunities for their teeming populations. Whether in dream zones in India (Cross 2014) or in export processing zones (Stein 2008) across many countries in the Global South, the goal is similar: to accelerate capitalist economic development. It is a form of capitalist economic development that creates sites of different contestations for businesses, resource extractive practices, and nation-state populations.

CONTESTED ZONES OF VALUE AND ENCLAVE INFRASTRUCTURE

Advocates of free-trade zones believe that accelerated capitalist development within the zones helps improve infrastructure and create an improved

business climate, resulting in an increase in technology transfer, leading eventually to an overall benefit to the host country and the communities where such zones are established. The Chinese model, which first came into force in 1988 and has since been seen as the exemplar for trade zones, saw the creation of several SEZs that employed more flexible economic policies and government measures in order to foster growth and foreign direct investment within those areas. For example, in an attempt to realize these stated objectives, the Nigerian state has licensed over thirty-eight SEZs, some of which are managed by a consortium of Chinese corporations and investors. The LFTZ and OGFTZ in southwestern Nigeria are examples.

SEZs and the regulatory regimes that guard and guide them are mostly seen as the exclusive preserve of the state. While much of the academic literature on SEZs focuses on state regulatory practices in their establishment, no attention is paid to similar practices that are not state regulated. Drawing on ethnographic fieldwork in Nigeria, I complicate the notion of the SEZ as exclusively a state regulatory practice. Using the example of artisanal refineries organized by youths in the Niger Delta, I seek to rethink SEZs and their relationship to oil extraction and the state. My suggestion is that if SEZs are zones of exception specially designated to have their own regulatory and fiscal practices that are different from state practices, we should also see regulatory practices of extraction by youths in the creeks of the Niger Delta as constitutive of zones of exception where special economic practices shape the daily lived experiences of residents and regard these, too, as SEZs. My contention is that disenfranchised citizens who are displaced from their livelihoods and dispossessed of resources they consider to be theirs can mimic the state and corporations in establishing SEZs. My second intervention suggests that if SEZs are aimed at boosting economies and helping build infrastructure where it is deficient, then we should also see SEZs established in the creeks of the Delta by disenfranchised and displaced youths as a form of oil infrastructure that mimics state and multinational corporations' oil infrastructure. Consequently, this book attempts to rethink contests around oil extraction by looking critically at the emergent oil infrastructures constructed by youths as demonstrative of the functionality of SEZs in the creeks of the Delta. Such oil infrastructures not only compete with state oil infrastructures in the production of crude oil but also engage in practices that clearly delineate zones of exception as not being the exclusive preserve of the state.

Therefore, I propose that we move beyond seeing such oil infrastructure and the selling of crude and refined oil as the theft of state oil and instead redirect our focus to the processes through which such infrastructure is built

to create zones of exception in the creeks of the Niger Delta. This emphasis, I argue, allows us to study how technologies of crude refining reshape extractive governance in resource enclaves and how artisanal refining is able to replicate and mimic state and corporate structures of extraction. I also seek to move beyond seeing the existence of local extractive processes and oil infrastructures as mere "survival strategies" (Ugor 2013, 271) adopted by youths in response to a criminal state (Bayart, Ellis, and Hibou 1999; Ukiwo 2011) that displaces them from their livelihood. I argue instead that artisanal processes and structures of extraction reflect innovation and hybrid forms of knowledge, including knowledge of extractive technology that emerged in the 1930s with the imposition of high taxes on imported gin and liquor by the British colonial authorities. These technologies of ogogoro production, made popular by youths in the 1930s, have become an important technique in the production and replication of state and corporate structures of extraction by youths in the Niger Delta.

I use the term *infrastructure* to describe a system of organization that revolves around the exploitation, production, marketing, and institutionalization of oil as a local and international business commodity that is at the heart of the state and of communities where the commodity is exploited. In conceptualizing infrastructure this way, I move beyond physical infrastructure to see oil infrastructure as a superstructure that facilitates the production, organization, and management of this commodity and its benefits by various actors within and outside the nation-state. *Infrastructure* therefore has resonance with what Chalfin (2017, 19) describes as "a focal point from which to track day-to-day practices, experiments, improvisations and replications, along with the tacit forms of consent and coercion that frame them." Thus, oil can both weld and disrupt. At the same time, it organizes and builds relationships that structure daily practices of actors who engage in managing, organizing, and using it.

As the lifeblood of a nation-state and the communities where it is exploited (Apter 2005; Ferguson 2006; Mitchell 2011; Rogers 2014; M. Watts 2004a, 2004b), oil shifts from being mere black crude into a valued commodity whose importance is shaped by its capacity to build relationships and to transform individual lives and the life of a nation-state. Oil has not only the capacity to build relationships but also the ability to shape environmental practices in spaces that I call *imitative enclaves of extraction*. Imitative enclaves of extraction are established by youths as spaces of economic activities that engage in resource extraction practices. Aided by knowledge of local technologies— for example, knowledge about how to construct boats and canoes and about refining techniques—Niger Delta youths engage in practices of managing,

operating, and extracting oil in ways that mimic the state and corporate organizations. As an interlocutor told me, "We know the youths who operate the refineries. For many years, the corporations would come and take our oil without giving back, and the state will support them. When the youths came and told us they can help us enjoy some of our oil, the entire community rallied around and threw their support behind them."[6] Many interlocutors corroborated this, and when asked about their perception of what the youths were doing, many responded thus: "The youths are not thieves. They are not rogues. It is the state and the corporations that are thieves and rogues. Who cares about the state and corporation anyway? As far as we are concerned, the youths are our sons, and they are doing the right thing for us."[7] Referring to the youths as "our sons" signals a relation of kinship between the youths and community members who see what the youths do as a benefit to the entire community. By operating these technologies of extraction, the youths insert themselves into the heart of the communities such that the relationships developed alter forms of governance; reshape lives; and reframe everyday practices, thoughts, businesses, and culture. Just like SEZs create the promise of employment and business opportunities in communities where they are located, artisanal refineries do the same, as we shall see in the chapters to come. Of critical importance to the effective functioning of SEZs and artisanal refineries is location. I use the term *location* to indicate not only a space where SEZs and refineries are situated but also the spatial configuration of practices and processes of creating extractive opportunities in the enclaves of exception.

In engaging with issues of special economic zones and their relationship to artisanal refineries and oil politics in postcolonial states, I present new arguments about spaces of governance and the establishment of alternative nodes of extraction in competition with state and corporate modes of extractive practices. In a clear departure from existing literature, I argue that there is a symbiotic relationship between state-regulated SEZs and artisanal refineries that creates spaces of competition with state and corporate extractive practices in Nigeria. While existing literature treats SEZs as state regulatory practices, I suggest a reexamination of practices that mimic state and corporate modes of extraction. For example, Ong (2006) illuminates how China establishes special economic zones within its socialist economy through which neoliberalism was deployed in specific ways to accelerate the process of foreign direct investments as a test case for a distinct economy. Murray (2017) examines the relationship between emerging new cities and Western notions of cities where new cities are seen as an exception in the making of new forms of infrastructure within nation-states. Irani (2019) reminds us to

pay attention to the ways in which particular state practices might shape how we view innovation as a social practice that produces what she calls *entrepreneurial citizens*, who recast social change as innovation, with innovators as heroes and craftspeople, workers, and activists seen as being of lower value or even as dangers to entrepreneurial forms of development. In casting state-supported innovation as a social practice in India, Irani (2019) shows how practices supposedly aimed at lifting people out of poverty end up illuminating contradictions in development such that those who either oppose such practices or do not buy in to them are viewed by the state and its allies as making little or no contribution to the growth of the economy. Similar trends define how the state views SEZs and artisanal refineries in Nigeria. SEZs are viewed by the state as innovative enough to add value to the state-regulated economy, while artisanal refineries—innovative as their designers and operators might be—are perceived as the complete opposite of SEZs.

In following these interventions, I utilize Chalfin's (2010) idea that neoliberalism should be viewed as an everyday practice that affects restructuring and integration of state bureaucratic apparatuses into the global economy in ways that diffuse notions of sovereignty to talk about the everyday practices of SEZs inside and outside the state. Sovereignty, I argue, can be bifurcated. SEZs as sovereign self-regulatory practices encompass Chinese trade zones such as OGFTZ and LFTZ, while artisanal refineries such as Okaiki, Bodo, Omadino, and Jones Creeks represent another form of sovereign where economic practices are regulated. In examining how nonstate actors produce regulatory practices that are as powerful as those of governments, and what Ferguson (2006) and Roitman (2005) call "extraction governance" that defines a new spatialization of order and disorder in Africa in ways that question the economic intelligibility of the state, I consider how nonstate actors engaged in everyday practices of extraction mimic the state and corporate practices of extraction in resource-rich spaces of value. This book explores an understudied angle of these everyday practices: how local community members, youth groups, and ex-insurgents collaborate and cooperate in producing sites of extraction that mimic corporate sites of extraction such as state-regulated special economic zones. In this regard, I examine how the construction and deconstruction of natural resource spaces of value produce new practices and meanings that often result in conflicting claims and counterclaims. The next chapter traces the genealogy of Nigeria's interaction with China and Chinese businesses, especially beginning with the opening of diplomatic relations in the 1970s. It carefully maps how this interaction helps shape the current engagement of China with Nigeria through the establishment of FTZs. Using the ethnographic example of two such zones—the LFTZ and

the OGFTZ—the chapter shows how such zones have become spaces for the exercise of political and economic power and domination in ways that create communities of extraction. It concludes by demonstrating how free-trade zones create practices that are mimicked by former insurgents, youths, and other community members in establishing artisanal refineries in the Niger Delta.

NOTES

1. See, for example, "Caption This," *Nairaland* Forum, September 8, 2018, https://www.nairaland.com/4722611/caption-photo-nigeria-police-holding.

2. Ibid.

3. In the wake of COVID-19, the outcome might be different if the same survey were to be conducted today. With fake news circulating around the world, especially in Nigeria, some Nigerians on social media tend to believe that COVID-19 was manufactured by China to control the world.

4. See, for example, "Here Is What Africans Think of China's Influence in Their Countries," Afro Barometer, October 28, 2016, http://www.afrobarometer.org/blogs/heres-what-africans-think-about-chinas-influence-their-countries.

5. The Nigerian national assembly recently voted to increase the national minimum wage to 30,000 naira per month. The president assented to the bill, but it has yet to be implemented because many states in the federation complain they do not have the resources to implement the new minimum wage.

6. Interview conducted at Bodo, Ogoniland, July 10, 2015.

7. This is a paraphrase of some of the interactions I had with some community members in Bodo on the afternoon of July 10, 2015.

2. INFRASTRUCTURES OF CONVENIENCE

China and the Configuration of Free-Trade Zones

This chapter critically examines how Chinese state-run business consortiums and developers are collaborating with state-run enterprises in Nigeria in using free-trade zones (FTZs) as a benchmark for the development of industry and infrastructure on one hand and to create a revenue stream on the other. Using the example of two similar FTZs—Ogun-Guangdong Free Trade Zone (OGFTZ) and Lekki Free Trade Zone (LFTZ)—the chapter interrogates some of the new regulatory practices that have given birth to the preponderance of FTZs in Nigeria. More importantly, I am interested in looking at the ways in which the articulation of infrastructure, what I call "infrastructures of convenience," becomes embedded in structures of power such that it creates the propensity for the political domination of communities of extraction in Nigeria. I use the term *infrastructure of convenience* to describe practices that are embedded in the notion of physical development that empowers the state in terms of increasing the possibility of revenue generation while displacing communities. My use of *infrastructures of convenience* resonates with what Anand, Gupta, and Appel (2018, 3) call the "promises of infrastructure" as a way to talk about how the making of infrastructure can create "fragile and often violent relations among people, materials, and institutions" because infrastructure itself promises "modernity and development." Hidden in this idea of modernity and development are the tension that infrastructure generates and the social inequality and denial of livelihood that it produces for communities. While it is convenient that the promise of infrastructure by the state and its allies can bring about modernity and its appurtenances, this promise in itself can also create a form of dispossession for communities. Therefore, the use of *infrastructures of convenience* does

two things: first, it shows how the meaning and use of *infrastructure* by the state can be fluid, and second, it also shows the utility of *infrastructure* as a convenient articulation of systems of economic and political domination within communities of extraction. For many communities, land and water—especially the Atlantic Ocean—have cultural meanings that go beyond their use for sustainable livelihood. Therefore, infrastructure that displaces communities from land and the Atlantic coast through the regulatory practices of the state and its corporate partners creates a form of deprivation that denies people access to their sacred spaces.

I see infrastructure of convenience as encompassing differing regulatory practices of the state and its corporate partners in spaces tied to ancestral and other cultural forms. For example, how have the new regulatory regimes associated with the free-trade zone model enabled the private owners of the OGFTZ and LFTZ to disengage from public oversight and establish new rules and regulatory practices for the spaces carved out as FTZs? What role have agencies at both state and national levels played in shaping practices that redefine citizenship and expatriate practices within enclaves of extraction? How is it that indigenous populations who fear displacement from their living spaces and socioeconomic livelihoods have begun to utilize claims to ancestral land ownership as symbolic expressions of cultural meanings and belonging that run counter to the property regimes associated with the OGFTZ and LFTZ projects? Fearing displacement from their homes and livelihoods, how are Igbesa and Lekki communities utilizing ancestral land claims to contest the erasure of their history and practices? Local indigenous communities have a rich history of ancestral land ownership and ritual practices that long predate the postcolonial state, hence the challenge to new forms of ownership instituted by the state in these zones. Therefore, I critically interrogate the interconnection between oil regimes, infrastructure development, and industrial development as a way to think about structures of power and belonging. To do so, I examine three interrelated issues—infrastructure, displacement, and belonging—with particular emphasis on FTZs as an example of huge infrastructure and industrial developments that displace people and create vulnerability in an otherwise impervious population.

Since the beginning of the LFTZ and the OGFTZ, both Lagos and Ogun States have produced different governors. For example, Governor Bola Ahmed Tinubu started the Lagos project, and since then, other governors such as Babatunde Fashola, Akinwunmi Ambode, and now Babajide Sanwo-Olu have carried it on. Therefore, as part of these infrastructure projects, on October 23, 2019, the office of the governor of Lagos State issued a press statement triumphantly announcing the signing of an agreement with

a Chinese company—China Harbour Engineering Company (CHEC)—to accelerate the building of a deep seaport within the LFTZ. The agreement, signed on behalf of the Lagos State government by the governor, Babajide Sanwo-Olu, was circulated to the press corps of the governor's office. In the circulated press release signed by the chief press secretary to the governor, Gbenga Akosile, the statement reads:

> Governor Sanwo-Olu described the development as "another milestone" for the State in infrastructural development and commerce, saying the signing of the agreements ended a period of uncertainty that had trailed the delivery of the project. He noted that the completion of the project would invigorate the Lagos economy and push it up in the index of largest economies in the world. He said: "This is a new beginning for us in Lagos. We have achieved another milestone in our efforts to transform the State and accomplish the 21st century economic ambition. As a government, we are fully in support of the project. We will do all we can to ensure the terms of the agreements signed today are delivered within 30 months as agreed and we expect the outcome would catalyze Lagos's fifth largest economy and take it higher in the index of largest economies in years to come."[1]

In building the deep seaport, CHEC and its Nigerian partner, Lekki Port Lekki Free Trade Zone, secured a loan from China Development Bank to the tune of $629 million. As part of the loan agreement, the port will be concessioned to CHEC for a period of forty-five years with the expectation that, as the chairman of LPFTZ, Biodun Dabiri, says, "the development of the seaport [will be] strategic for the growth of Lekki Free Trade Zone [and have an] 'immense impact' on the nation's economy by creating more than 200,000 jobs and generating about $350 billion in revenue for the State over the period of the concession."[2] The CHEC chairman, Lin Yichong, was reported to have said that "the Chinese engineering firm took interest to invest in the deep seaport to enable Nigeria to strengthen its maritime infrastructure and business by building the first deep seaport that would ease pressure at Tin Can Island and Apapa ports."[3] Tin Can and Apapa ports, located in the Apapa area of Lagos, are the only two functioning seaports in Nigeria. The chief press secretary's circulated statement was covered by news outlets such as the Chinese news agency Xinhua, *World Maritime News*, and many local newspapers in Nigeria, such as *Punch*, the *Guardian*, and *Thisday*. In addition, a picture of the signing ceremony with the governor, Chinese officials, and other government and business leaders was on the front page of some newspapers.[4] While the state government signed this loan agreement and concession with a Chinese company, CHEC, in continuation of its efforts to develop infrastructure in the LFTZ, missing in the entire conversation is what becomes of many of the communities whose livelihood practices depend on the ocean that will be dredged

and the farmland that will be destroyed to make way for all these infrastructure development projects. As I traversed the two FTZs, the inevitability of a displaced population struck me on several occasions. It was astonishing to meet many families and see how they responded to the daily pressure of being forced to relocate from an area they had known all their lives. As I describe later in the chapter, stories told to me by many of the families and individuals I encountered in the two FTZs exemplify the fears and economic and political anxieties that many members of the community live with.

However, it is worth noting that postcolonial development practices and the quest for industrialization are not particularly new. The centrality of ports to these development practices is anchored in the notion of connecting resource extraction to the easiest and fastest path to the international commodity market. For example, during the colonial period, an epitome of this form of practice could be seen in how the construction of roads, railways, and ports was intricately linked to access to the international commodity market. As Monson (2009) suggests, infrastructure connected to the construction of railways in East Africa was complexly linked to the ability of the state to redirect mineral wealth from the interior to the coast for easy access to a preferred international market. Constructed by the Chinese during the Cold War, the freedom railway in Tanzania, Monson argues, serves exactly that intended purpose. Thus, while Lagos and Ogun States might claim that their intention for these spatial infrastructure development projects is to expand the state's revenue base, such expansion is anchored in the ability of the states and their corporate partners—the Chinese—to produce materials that are capable of being shipped to the international market.

This is why these infrastructure development projects, as described in chapter 1, have involved the establishment of strategic partnerships between key stakeholders in Lagos and Ogun States and foreign and local corporate investors. For close to a decade, an elite growth coalition comprising various international corporations, including China-Africa Lekki Investment Ltd., the Zhongfu International Investment FZE, the (Nigerian-based) Dangote Group, and various multinational oil extraction companies, has teamed with the governments of Lagos and Ogun States to construct two major industrial projects: the Lekki Free Trade Zone and the Ogun-Guangdong Free Trade Zone. The goal of these zones is to transform both Lagos and Ogun States into manufacturing hubs for the entirety of sub-Saharan Africa and to scale up the infrastructure of both states to attract more foreign direct investments. Furthermore, the LFTZ and the OGFTZ have been deliberately designed to epitomize the vision of Greater Lagos and Ogun as world-class tourist and business destinations (see figs. 2.1 and 2.2)

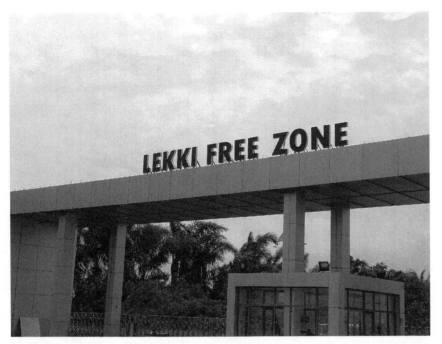

Fig. 2.1 Lekki Free Trade Zone, main gate and entrance to the entire zone. Source: Photograph by the author.

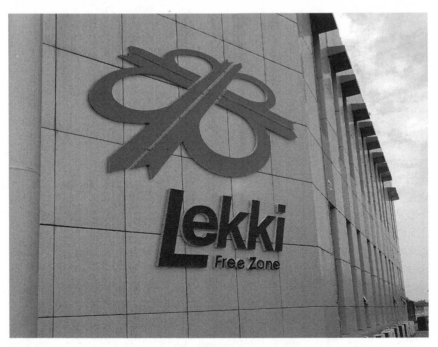

Fig. 2.2 Lekki Free Trade Zone front office administrative building, to which Nigerian customs, police and NEPZA officials are restricted. Source: Photograph by the author.

in line with the country's stated development goals (Ayanwale 2007; Yusuff and Akinde 2015) and following the model of Shenzhen, Pudong, and other Chinese special economic zones.

Unsurprisingly, given special economic zones' historical roots in China and the use of Chinese SEZs as models for their Nigerian counterparts, the majority shareholders of both zones are Chinese companies. Further, "the main investment sectors of the LFTZ are manufacturing, oil and gas (storage and distribution), real estate, tourism and infrastructure development. According to the Lekki Free Zone Development Corporation (LFZDC) website, the stated objectives of the LFTZ are to stimulate the Nigerian economy, create a global economic haven, create and encourage integration with foreign partners, generate employment opportunities, attract foreign investment, diversify the Lagos revenue base, 'ensure effective exploration' of Nigeria's resources, and create wealth for citizens" (Tagliarino et al. 2018, 19).

Nigeria is not an exception to these spatial development projects because the history of such projects, especially in postindependence Africa, indicates a form of continuity between the colonial extractive project and the postcolonial one. The bedrock such projects rest on is always the need to industrialize in order to shape a robust and functional economy. Thus, SEZs in the later postcolonial era became an epitome of industrialization for many countries.

SEZS AND INDUSTRIALIZATION IN AFRICA

Many countries in Africa won independence in the early 1960s (e.g., Nigeria, Cameroon, and Democratic Republic of the Congo in 1960; Uganda in 1962) with plans to move beyond their colonial experience through a form of industrialization that would create job opportunities for their teeming populations (Adunbi 2015; Forrest 1982; Stein 1992). Colonial industrial projects in many African countries had focused mainly on extractive industries in ways that turned African colonies into enclaves of raw materials production. Many postcolonial leaders therefore wanted industrial economies that could reshape and restructure the African landscapes. As Mendes, Bertella, and Teixeira (2014) point out, two important principles undergird the economic policies of many African states in the early postcolonial era: (1) creating space for rapid industrialization through foreign direct investment, and (2) making sure that profits from those foreign direct investments are ploughed back into the economy to create a value chain that establishes the state as economically stable. As Mendes, Bertella, and Teixeira (2014, 129) opine,

> The second guiding principle was an investment policy, for which the State defined three priorities: i) to make large investments in manufacturing; ii) to create and widen the basic infrastructure for the industry; and iii) to orient

towards basic investments through the creation of public institutions connected exclusively with industrial development. The purposes of these institutions were as follows: to stimulate foreign businesses to retain the profit in the country by reinvesting productively in the manufacturing sector, otherwise they would be controlled by the Government; to nationalize banks and insurance companies dominated by foreign capital; to gather and allocate domestic savings; and to manage official foreign aid and the projects funded within the scope of the aid.

Thus, industrialization as a policy anchored in economic development was one of the major preoccupations of many postcolonial African states in the early independence era. Mkandawire (2001, 306) argues, "The fact of the matter is that, in the immediate post-independence period, most African governments pursued what was known as 'industrialisation-by-invitation' strategies in which the attraction of foreign capital played a central role. Protective measures for industry were often part of the package of incentives demanded by or intended to attract foreign capitalists." This is exemplified by the many industrial estates established by the respective African states. For example, in Nigeria, Lagos and the entire coastal area became an industrial hub with the establishment of the Oluyole industrial estate at Ibadan, then headquarters of the western region. There was also the Ikeja industrial estate in Lagos. The industrial estates served as a cluster for many of the industries established by the state in partnership with foreign corporations. Mendes, Bertella, and Teixeira (2014, 129) show that "Nigeria, Kenya, and Zambia—of all the African countries—were the ones which became more industrialized; in the other countries, there was a slight industrial development in the sector of nondurable consumer goods, such as drinks, textiles, etc. It was only in Nigeria and Kenya that a qualitative performance of the manufacturing sector persisted, and the incipient industrial base slowly widened and included durable consumer goods, other intermediate goods, and some capital goods." Many of the products that emanated from these industrial estates served local and regional consumers.

The question is, What changed the trajectory of this form of industrial development for many African states? Stein (1992, 2008), for example, suggests that the introduction of structural adjustment regimes in the 1980s and 1990s in many African states could be said to have drastically affected the productive sector of the economy, particularly with the liberalization of the economic structure of the state in ways that made foreign goods cheaper than locally produced materials. For example, in the case of Nigeria, the boom-and-bust cycle of the international oil market in the 1980s and 1990s created a shock to the economy. The attendant result was huge borrowing to

account for the shortfall in the balance of payments with the expectation that loans from international financial institutions would be paid back as soon as there was another boom in the oil market. With the capacity of the state to pay back the loans declining and more loans piling up, "economic liberalization" became a catchphrase for getting the state out of the way through privatization and commercialization of the commanding heights of the economy (Adunbi 2015; Stein 1992). The consequence was the total withdrawal of the state from manufacturing and other important economic sectors. According to Mkandawire (2001, 293), "By the 1990s, the African state had become the most demonised social institution in Africa, vilified for its weaknesses, its over-extension, its interference with the smooth functioning of markets, its repressive character, its dependence on foreign powers, its ubiquity, its absence, etc. The state, once the cornerstone of development, became the millstone around otherwise efficient markets." The demonized state was categorized as lacking the capacity to structure developmental practices, hence the need for a new form of foreign direct investment that turned the state once again into enclaves of extraction and exception, where practices of SEZs became the new normal. For many African states, two drivers of SEZs, especially in the 1990s, were the newly crafted Africa Growth and Opportunity Act, signed into law by the Clinton administration to guarantee tariff-free entry for products made in Africa into the US market, and the move to attract Chinese companies to the continent, especially once the government of China had launched its "going out" policy to encourage its entrepreneurs to explore opportunities abroad (Adunbi and Stein 2019; M. C. Lee 2006; Newman and Page 2017; Renne 2015). From Lesotho to Kenya, Mauritius to Ethiopia, and Cameroon to Nigeria, FTZs today are of growing interest for many African states as a way to get back into the industrialization project. Unlike the industrialization project of the early independence era, which focused on manufacturing to strengthen the economy and encourage local production and consumption of goods, today's is largely driven by foreign interests whose objectives are completely different from early independence intentions. They are mainly organized by China and Chinese consortiums desirous of benefiting from the Africa Growth and Opportunity Act as well as expanding China's reach to markets outside of China. Zeng (2016, 6), for example, notes, "Assessments about the role of SEZs in industrial upgrading and technology transfer are mixed. Certain assessments have suggested that skill levels in zone workforces have not significantly increased over time." Exemplifying these practices are the LFTZ and the OGFTZ. While FTZs claim to be part of the state's two-pronged approach to industrialization and job creation, low-skilled jobs are what are often created, while the industrial

purpose of the zones remains far-fetched because they largely focus on extracting resources for the international market. The highly skilled workforce of the zones is mostly Chinese, while the low-skilled workforce is usually from the country where they are located. More importantly, as we shall see in the LFTZ and OGFTZ examples, the local workforce is not necessarily from the communities adjoining the zones. The proximity of the FTZs to ports is also an indication of their intent, which is to produce in sites where products can be easily shipped to the international market. FTZs are not primarily industrial projects that cater to the needs of the local population but rather industrial projects shaped in many ways by the practices of the colonial project in which the colonies were mainly developed into capillaries of extraction.

SEZs in Nigeria: Lekki and Igbesa

Located in the Ibeju-Lekki area of Lagos and the Igbesa area of Ogun State, the LFTZ and the OGFTZ operate as manufacturing and oil processing and refining sites. The areas where these zones have been established each have their own rich historical, social, and cultural contexts. Lekki is comprised of diverse communities within the Yoruba ethnic group, each with a unique history of migration and land ownership. Igbesa, a sleepy community in Ogun State just ten miles from the Lagos seaport, is a community that also claims membership in the Yoruba ethnic group but that, unlike the Lekki communities, shares a singular history of land ownership. The Lagos project sits on the Atlantic Ocean, which for many centuries has served as a cultural and commercial icon for those who live in the surrounding areas. The Igbesa project similarly sits in close proximity to an important cultural and commercial icon, an old industrial hub—Agbara industrial estate—a private industrial estate established by a businessman, Chief Adeyemi Lawson. It was acquired by the Ogun State government in 1976. Chief Lawson had wanted to create an industrial and residential estate close to Lagos that was also accessible to countries such as the Republic of Benin, Togo, and Ghana in the West African subregion. The proximity of the town of Agbara to Badagry, which borders the Republic of Benin's Cotonou, made economic sense considering that the Economic Community of West African States had been introduced in 1973 to facilitate easy business access for West Africans. The industrial estate thrived until it was devastated by the economic liberalization policies of the 1980s and 1990s that saw the introduction of the structural adjustment program. However, while the Agbara industrial estate thrived, the Igbesa community prospered in its farming activities while also providing needed support services to those who worked on the industrial estate. Thus, it was not surprising when the Ogun State government, in collaboration with a

Chinese consortium, decided to locate a free-trade zone in Igbesa as a way of building infrastructure and gaining a new revenue stream.

While these projects are economically beneficial to the respective states that partner with these multinational corporations, they have produced markedly different outcomes for communities. In both communities, these outcomes include the construction of an oil refinery, the clearing of burial sites to make way for infrastructure projects, the shipping of refined oil intended mostly for the international market, and the dredging of the Atlantic Ocean for the purpose of building a seaport to serve as a transit point for manufactured goods. The cost of these consequences to local communities ranges from environmental degradation as a result of the construction of oil refineries, to industrial waste from manufacturing outfits within the zones, to the destruction of ancestral sites such as places of worship and important ritual spaces. Further, the location of the LFTZ and the OGFTZ projects within these communities has resulted in the mass displacement of people from their livelihoods and homes.

FREE-TRADE ZONES AND THE NEOLIBERAL MOMENT

In the late 1980s and early 1990s, many African countries, especially Nigeria, witnessed an upsurge in both economic and political crises. The collapse of the former Soviet Union and the emergence of a new world political and economic order—coupled with a collapse in the prices of commodities in the international market—brought about the need for economic and political reforms (Adebanwi 2012; Adunbi 2015; Chalfin 2010; Reno 1999; Van de Walle 2001). The oil collapse of the mid- and late 1980s dramatically affected the economy of Nigeria. Consequently, Nigeria had to grapple with a changing economy, a rising debt profile, political instability as a result of incessant military coups, the collapse of the industrial sector, high unemployment, failing infrastructure, and a decrepit socioeconomic and political system (Adunbi 2015; Apter 2005; Renne 2015, M. Watts 2004a, 2004b). These crises forced a particular form of change in Nigeria's political system and economy, shaped by the application of neoliberal economic policies that centered on the implementation of structural adjustment programs (SAPs) and their consequences for governance, fueling debates on the efficacy of SAPs for reforming African states that dominated intellectual discourse in the 1980s and 1990s (e.g., Beckman 1992; Ferguson 2006, 2010; Van de Walle 2001; Young 1991). SAPs, argued their proponents, would make governance much more efficient by shrinking the government and empowering the private sector through privatization and commercialization programs. To their opponents, SAPs would further entrench a prebendal state (Chalfin 2010; Joseph 1987,

1996; Roitman 2005) that would be detrimental to the general population. More importantly, SAPs, an initiative of the international financial institutions, promoted a more business-centered approach to the privatization and commercialization of businesses, enterprises, and corporations owned by governments such as Nigeria's.

One of the cardinal principles of SAPs was the cultivation of foreign direct investments as a way to revamp the economy (Adunbi 2015; Renne 2015; Stein 2013). Advocates argued that in order to attract foreign direct investments to a suffering economy, the investment climate required a pool of cheap labor, a devalued currency, easy business registration, improvements in infrastructure, and the promotion of special economic zones in which tax holidays could be granted to foreign businesses. Thus, in the 1980s and 1990s in Nigeria, attempts were made by successive regimes to start free export processing zones (EPZs) as a component of its SAP. The first free-trade zone, known as the Calabar Free Trade Zone, was established in Calabar in 1989. However, to formalize the EPZ arrangement, the administration of General Ibrahim Babangida signed a decree in 1992 that proclaimed the Nigerian Export Processing Zone Authority an institution with the power to grant licenses to foreign businesses interested in establishing a manufacturing/business enterprise in Nigeria.

The decree, known as Decree No. 63, The Nigerian Export Processing Zones Act 1992, states,

> (1) The President, Commander-in-Chief of the Armed Forces may, from time to time by order, upon the recommendation of the Nigeria Export Processing Zones Authority established under this Decree, designate such area as he thinks fit to be an export processing zone, (in this Decree referred to as 'a Zone'). (2) The Zone established pursuant to subsection (1) of this section, may be operated and managed by a public, private or a combination of public and private entity under the supervision of and with the approval of Nigeria Export Processing Zones Authority established by section 2 of this Decree. (Section 1, Subsection 1–2)

Following this decree was the promulgation in 1996 of Decree No. 8, Oil and Gas Export Free Zone, which established the parameters for specialized oil and gas free trading zones in Nigeria. Consequently, the first oil and gas EPZ was established in Onne, Rivers State, in the Niger Delta, while a second was established by the new civilian administration of President Olusegun Obasanjo in 2003 in Olokola, Ondo State, a few miles from Lagos. Consequences of neoliberal economic policies for Nigeria were to continue with the transition to civil rule in 1999 after years of dictatorial rule by the military. The new administration of former military leader General Olusegun

Obasanjo continued the SAP under a new economic liberalization policy that put foreign direct investment and the establishment of FTZs at its core. The results of the new policy include the growth of FTZs in Nigeria from a single trade zone in 1989 to over thirty zones and counting in 2018 ("Free Zones," NEPZA). As table 2.1 and table 2.2 show, there are nineteen active zones and nineteen inactive zones currently licensed by NEPZA. Thus, neoliberal moments in Nigeria reshaped the meaning of economic policies and foreign direct investments in ways that prioritized oil and manufacturing. Consequently, neoliberal economic and political practices produced a form of transnational collaboration that is not just about multinational corporations but also involves economic collaboration among states. Such collaborative economic practices tend to fuse industrial development with the construction of infrastructure as the benchmark for development. One such collaborative economic practice is the establishment of the LFTZ and the OGFTZ, in Igbesa and Lagos, respectively, by different Chinese consortiums/organizations in partnership with the governments of Ogun and Lagos in the southwest of Nigeria.

Celebrating this neoliberal moment were officials of NEPZA at their headquarters in Abuja, the national capital, and at their Lagos office. While I was at the headquarters of NEPZA in 2017 to interview officials of the agency, many pointed out how the LFTZ and the OGFTZ were supposedly doing well even if many of the junior staff, as they told me, had never visited Lagos State or Ogun State. In the waiting room of the NEPZA director in Abuja during one of my visits to the office, I experienced how the agency sees itself as leading the Nigerian nation on the path to industrialization. Each day of my visit, the office was packed with many individuals with varying business interests waiting to see the director. As is common in Nigeria, the waiting room could sometimes provide a window through which to observe how many were thinking about the prospect of industrialization and development. One of the "big men" waiting to see the director openly boasted of his being "modern" by invoking his many trips to the United Kingdom, China, and the United States. In an attempt to gain entry to the office of the director before every other visitor, he claimed that he was not just Nigerian but also a citizen of the United Kingdom with business connections to China and beyond.[5] This is not unusual, since the idea of a big man in Nigeria connotes access to wealth and enormous economic and political influence. Of course, the big man was immediately ushered into the director's office ahead of the rest of us. As he was ushered in, some of the staff and a few others waiting echoed a common prayer in Nigeria, "Our time shall come," which basically means one day, we too will become wealthy and influential in society. It is

Table 2.1 Active Free Trade Zones in Nigeria

Name of Zone	Year Designated	Ownership	Activities/Products
Sebore Farms	2001	Privately owned by Vice Admiral Murtala Nyako	Horticulture (mango, watermelon, banana, passionfruit, vegetables), aquaculture, feed production, dairy and cattle farming, oil and gas, petrochemical
ALSCON EPZ	2004	Privately owned (ongoing conflict between Russian corporation RUSAL and American consortium BFIGroup)	Aluminum (smelting)
Calabar Free Trade Zone	2001	Federal government	Oil and gas, manufacturing (textiles, food items, steel, computer parts, pharmaceuticals)
Centenary City	2019	Joint venture with Centenary City PLC and Front Range Developers FZE	Residential, retail, infrastructure, offices for lease
Abuja Tech Village Free Zone	2007	Federal Capital Territory Administration	Manufacturing of communication technology, biotechnology, minerals technology, energy technology
Newrest Airlines Service and Logistics FTZ	1996	Federal Capital Territory Administration	Catering and related services to airlines operating in Nigeria
Maigatari Border Free Zone	2000	Maigatari Jigawa State government	Manufacturing, warehousing
Kano Free Trade Zone	1998	Maigatari Jigawa State government	Warehousing, logistic services, manufacturing (e.g., biscuits, bottle and sachet water, sacks, soy products)
Newrest Airline Service and Logistics EPZ	2003	Privately owned by Newrest (Schweiz) AG	Food processing and packaging
Dangote Industries Free Zone	2016	Privately owned by Dangote Group	Cement manufacturing, sugar milling, sugar refining, port operations, packaging material production, petrochemicals, salt refining

(Continued)

Table 2.1 Active Free Trade Zones in Nigeria (*Continued*)

Name of Zone	Year Designated	Ownership	Activities/Products
Ladol Free Zone	2006	Global Resources Management Limited	Oil and gas, logistics
Lekki Free Zone	2008	Joint venture between Lagos State government, China-Africa Lekki Investment Ltd., and Lekki Worldwide Investment Ltd.	Electronic products, textiles and garments, oil and gas, petrochemicals, warehousing and logistics
Nigeria Aviation Handling Company	2011	Privately owned by National Aviation Handling Company	Cargo handling, supply chain management, equipment leasing, logistics support
Nigeria International Commerce City (Eko Atlantic)	2003	Lagos State government and federal government	Residential, retail, infrastructure, offices for lease
Snake Island Integrated Free Zone	2005	Privately owned by Nigerdock PLC	Steel fabrication, oil and gas, seaport
Tomaro Industrial Park	2018	Privately owned by Integrated Oil and Gas (with support from grants from the US government)	Storage terminal, modular refinery, ship building/ship repair yard, oil rig fabrication plant
Quits Aviation Services FZ	2017	Privately owned by Quits Aviation	Airline and airport service provisioning
Pan African Catering Services FZ	2018	Privately owned by Servair	Catering, food packaging
Ogun-Guangdong Free Trade Zone	2008	Joint partnership between Ogun State government, the China Africa Investment Company, Guangdong Xinguang International Group, and CCNC Group	Research and development, manufacturing, commerce, logistics, real estate development, medical treatment, hotel and financial services

Table 2.2 Inactive Free-Trade Zones in Nigeria

Name of Zone	Year Designated	Ownership	Specialty
Ibom Science and Technology FZ	2006	Akwa Ibom State government	Science and technology
Olokola Free Trade Zone	2004	Ogun and Ondo State governments (with some private investment)	Oil and gas manufacturing
Living Spring Free Zone	2006	Osun State government	Manufacturing, trading, warehousing
Brass LNG Free Zone	2007	Federal government and private investment	Liquified natural gas
Banki Border Free Zone	Proposed	Borno State government	Manufacturing, warehousing, trading
Oils Integrated Logistics Services Free Zone	2004	Private (Pil Field Industry Support Service Ltd.)	Marine, logistics, support services for offshore oil repairs
Specialized Railway Industrial FTZ	2007	Ogun State government	Rail cargo transport
Imo Guangdong FTZ	2007	Imo State government	Manufacturing
Kwara Free Zone	2009	Kwara State government	Trading, warehousing
Koko Free Trade Zone	2009	Delta State government	Manufacturing
Oluyole Free Zone	2000	Oyo State government	Manufacturing
Ibom Industrial Free Zone	2012	Akwa Ibom State government	Manufacturing, oil and gas, trading services
Badagry Creek Integrated Park	2014	Private (Kaztec Engineering)	Metal fabrication
Ogindigbe Gas Revolution Industrial Park (GRIP)	2014	Private (Alpha GRIP Development Company)	Petrochemical, fertilizer, manufacturing, and gas processes–related activities
Ogogoro Industrial Park	2014	Private (Digisteel)	Oil and gas, metal fabrication, oil and gas vessels, logistics
Ondo Industrial City	2015	Ondo State government	Petrochemical, manufacturing

(Continued)

Table 2.2 Inactive Free-Trade Zones in Nigeria (*Continued*)

Name of Zone	Year Designated	Ownership	Specialty
Enugu Industrial Park	2015	Private (Enpower)	High-voltage power accessories, coal to fertilizer technology, project and value-added industrial clusters
NASCO Town Free Trade Zone	2017	Private (NASCO Group)	Manufacturing, warehousing, trading
Tinapa Free Zone and Resort	2006	Cross River State government	Trading, tourism

exactly the need to become wealthy and influential as a nation that drives the process of a form of industrialization that displaces people from their livelihoods in the LFTZ and the OGFTZ. It was also this influence and wealth that the director celebrated and brought to my attention when I was eventually allowed to see him after waiting for hours.

During my encounters with the director and many NEPZA officials both in Lagos and Abuja, they pointed to the perceived acceleration of China's development as a model they envisaged for the many FTZs they had licensed in Nigeria. "We are taking Nigeria to the age of industrialization," exclaimed one of the officials I met with. The official asked if I had been to China to see how they have been able to transform from an agrarian to an industrial society within a few decades. To the officials, partnering with China was a good thing because "unlike many Western countries who will not show us the way to industrialization, China is showing us the way."[6] China showing us the way was regularly invoked by many officials to demonstrate how FTZs can lead to an industrial economy for Nigeria to help the country dominate not only the regional market but also the sub-Saharan African market. When officials travel to China to negotiate deals, many take tours of major cities and other commercial centers, such as Shanghai and Beijing. Visits to these highly capitalized centers of Chinese industry give the officials a sense of pride in China's path to industrial development. What is missing in many of these visits is how China's industrial prowess also comes at the expense of its own population, which is often displaced without compensation to give way to emerging industrial centers. Those who visit, as with those who take many of these tours, are never shown the dark side of industrial development such as the communities in Ogun and Lagos are experiencing. In addition, missing from the narrative of Chinese industrial development that NEPZA and its officials invoke is the fact that the FTZs

Fig. 2.3 Golden Crown Commodity FZE, one of the enterprises in the LFTZ. Source: Photograph by the author.

currently being contemplated in many parts of Nigeria are constitutive of a process of economic and political dominance not only for the communities where they are situated but also for the Nigerian state. This form of domination is epitomized by the spaces where the FTZs are located in Lagos and Ogun States. Central to this economic and political system are the self-regulatory practices of the zone that relegate the state to the front gate of the zones (see fig. 2.3). For example, at the entrance to the zone, state disciplinary apparatuses such as customs, immigration, and police have offices, but the officials at these offices are never allowed into the zones because the zones, as I will show later, have their own regulatory practices, including systems of surveillance and policing.

Lekki Free Trade Zone: Of Political Zones and Economic Dominance

Nigeria established formal diplomatic ties with China in February 1971, and since that time, economic ties between the two countries have continued to grow. However, the last decade has witnessed an astronomical rise in Chinese investments in Nigeria; today, there are over thirty thousand Chinese people and over US$2 billion in investments there.[7] There are many more Chinese

businesses and corporations operating in Nigeria today than there were when diplomatic relations began in 1971 (Brautigam 2003; Harry 2016; Lawanson and Agunbiade 2018). Nowhere is this relationship more pronounced than in Lagos, the commercial capital. One such investment is the establishment of the LFTZ, a collaboration between China and the government of Lagos State. The LFTZ is "a 16,500-hectare area, about 60 kilometers east of central Lagos" (Mthembu-Salter 2009, 2) and a multibillion-dollar joint venture between the Lagos State government and other private and public entities. Work on the LFTZ began in 2006, "but progress in implementation has been uneven and slow" (Mthembu-Salter 2009, 1). The China Civil Engineering Company is the largest shareholder, with a 60 percent stake in the project, while the Lagos State government and Nigerian partner, Lekki Worldwide Investment Limited, split 40 percent with the LFZDC. The main sectors of investment at the LFTZ are manufacturing, oil and gas storage and distribution, real estate, tourism, and infrastructure development (Tagliarino et al. 2018). As table 2.3 shows, there are thirty-one enterprises currently operating in the zone. Touted as the "best place to invest your money," the project, as stated on its website, intends to "engage directly in the economic development of Nigeria by providing a choice for investors in the most conducive free zone business environment that will be recognized for setting standards of excellence" ("Our Vision," LFZDC). This notion of being the "most conducive" atmosphere for business is embedded in the ideology of the market economy and rooted in neoliberal ideas of fiscal government. By suggesting to investors that the LFTZ provides the best place to invest their money, the LFTZ calls attention to the unlimited possibilities that the zone provides (see fig. 2.4). These include the investors' ability to repatriate their profit without having to pay taxes to all layers of government in Nigeria, unlimited access to cheap and skilled labor, access to rent-free land, and a guaranteed 100 percent foreign ownership of business enterprises within the zone. All the listed characteristics define free-trade zones in Nigeria and elsewhere.

Advocates of free-trade zones believe they help improve infrastructure and the business climate, resulting in an increase in technology transfer, leading eventually to an overall benefit to the host country and the communities where such zones are established. The Chinese model—which first came into force in 1988 and has since been seen as an exemplar—saw the creation of several special economic zones that employed more flexible economic policies and government measures in order to foster growth and foreign direct investment within those areas. It is this model that the conceptualizers of the LFTZ had in mind when it was established. For example, Olusegun Jawando, the chair of the LFZDC, was quoted in *World Finance*

Table 2.3 Enterprises Operating in the Lekki Free Trade Zone

Name of Enterprise	Year Designated	Ownership	Products
Dangote Refinery	2013 (planned completion in 2021)	Dangote Industries Ltd.	Oil refinery
Bollore Transport and Logistics Nigeria	2014	Bollore Transport and Logistics	Transport and logistics operators
H&Y International FZE	2013	H&Y International	Artificial hair, wigs, human hair products
Candel Ltd.	2013	The Candel Company Limited	Agrochemicals, specialized fertilizers, allied inputs to farmers
Yulong Steel Pipe Investment	2015	Jiangsu Yulong Steel Pipe Company Limited	Steel pipe mills
Crown Natures Nigeria PLC	2013	Crown Natures Nigeria PLC	Clothing items
Huachuang Steel Structure Engineering	2015	Nanjing Huachuang International Economic and Trade Cooperation Co. Ltd.	Steel structures for factory buildings, logistics warehouses, high-rise buildings
Loving Home Furnishings FZE	2013	Loving Home Furnishings Ltd.	Office and home furniture
Lekki Port LFTZ Enterprise Limited	2015 (initiated)	Tolaram Group	Develop and maintain the Lekki Deep Sea Port
Sunshine Houseware Co.	2018	Privately owned by Zhang Yongjun	Plastic household goods
St. Nicholas FZE	2014	St. Nicholas Hospital	Hospital services
Sinotruk International	2013	China Sinotruk International Co. Ltd.	Heavy truck assembly
Golden Dream Commodity	2014	Golden Dream Ltd.	Diapers and insecticides
Aslan Nigeria FZE	2018	Aslan Ltd.	Furniture
Asia Africa International FZE	2015	Joint venture (Asia Africa International Co. Ltd. and Asia Africa Investment Holdings Co. Ltd.)	Assembly of vehicles

(Continued)

Table 2.3 Enterprises Operating in the Lekki Free Trade Zone (*Continued*)

Name of Enterprise	Year Designated	Ownership	Products
China Civil Engineering Construction Corporation Nigeria FZE	2015	China Civil Engineering Construction Corporation	Construction services
Zhi Jiang Nigeria FZE	2017	Zhi Jiang Ltd.	Construction services
Datang International FZE	2015	Datang Co. Ltd.	Furniture manufacturing
Boton Electric Nigeria FZE	2015	Boton Electronik GmbH Germany	Socket and switches manufacturing
ZCC Construction FZE	2015	ZCC Construction Ltd.	Construction services
Hidier Power	2015	Hidier Power Group Co. Ltd.	Generator assembly
Coral Beach Estate	2014	Coral Beach Estate Ltd.	Real estate
RWE Africa LPG Equipment FZE	2017	RWE Ltd.	Liquified petroleum gas containers
CNSS FZE	2015	Communication Network Support Services Ltd.	Mobile phone assembly
Jiangsu Geology and Engineering FZE	2017	JiangSu Geology Engineering Co. Ltd.	Construction services
PCCM FZE	2017	PCCM Ltd.	Spraying accessories
Longrich Bioscience FZE	2019	Longrich Bioscience Ltd.	Cosmetics
Henan FZE	2017	Henan Dinter Heavy Industry Machinery Co. Ltd.	Building materials
June Agrochemical Nigeria FZE	2017	June Agrochemical Ltd.	Agrochemicals
New Brilliant Manufacturing FZE	2018	New Brilliant Manufacturing Co. Ltd.	Footwear
Global Superior FZE	2018	Global Superior Ltd.	Electric fans

on September 4, 2014, as saying, "Nigeria is pivotal in West Africa, and other countries are dependent on our industries and exports. Lekki will facilitate this and strengthen our links within the region."[8] Strengthening links within the region, as Jawando mentioned, is a way to assert the dominance of Nigeria within sub-Saharan Africa in general and West Africa in particular. Such dominance, it is expected, will culminate in creating a market for Nigeria's oil and gas and other products manufactured in all the free-trade zones in the country. These potential markets would provide opportunities, they say, for Nigerians and patrons to make choices that will benefit them: choices of job opportunities, choices of economic possibilities for the state, and choices of technological advancement. Thus, the trade zone becomes a coveted object for the state and its Chinese partners but a despised object for those displaced from their land and livelihood. As we are reminded by Baudrillard (1996, 151),

> No object is proposed to the consumer as a single variety. We may not be granted the material means to buy it, but what our industrial society always offers us "a priori," as a kind of collective grace and as the mark of a formal freedom, is choice. This availability of the object is the foundation of "personalization": only if the buyer is offered a whole range of choices can he transcend the strict necessity of his purchase and commit himself personally to something beyond it. Indeed, we no longer even have the option of not choosing, of buying an object on the sole grounds of its utility, for no object these days is offered for sale on such a "zero-level" basis. Our freedom to choose causes us to participate in a cultural system willy-nilly.

In this case, the state's freedom to choose where to site trade zones and with whom to partner in constructing and configuring objects such as trade zones impedes the ability of others—particularly community members—to make choices such as preserving their ancestral heritage, livelihood, and land. While the LFTZ presents an opportunity for Nigeria and the Lagos State government to increase its revenue base, rebuild its failing infrastructure, and shape a new form of economic dominance in West Africa and beyond, missing in this narrative is how many communities whose land and livelihood depend on the areas marked for economic zones are faced with the choice of protesting against the state and developers before being displaced. (See map 2.1 for communities affected by the LFTZ.)

Many community members I encountered invoked the reality of displacement from livelihood practices by using the recent Nollywood flick *Alumooni*, a movie produced by Wumi Majesty Scene Production in 2018. *Alumooni* is a Yoruba word meaning "natural resources." Asking if I had seen the movie, Oladele, a youth leader in Idasho, pointed out how the town of Alumooni in the movie lost all its natural resources to another town, Olaju,

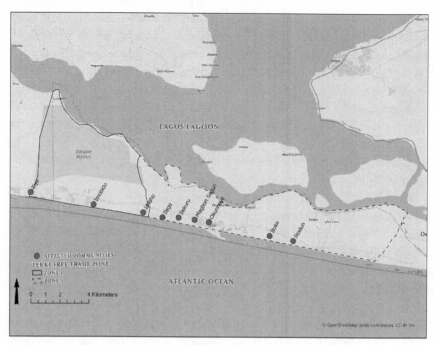

Map 2.1 Affected communities of the Lekki Free Trade Zone. Source: © Open StreetMaps (and) Contributors.

as a result of betrayal by the leaders of Alumooni. *Olaju* in Yoruba means "civilization," and in the movie, the modern town is depicted as predatory, always going to other towns and cities to exploit resources and people for the benefit of its king. I finally saw the movie on Libra TV, a Yoruba movie channel on YouTube, in November 2019. What is remarkable in this movie is the striking resemblance between the many communities around the FTZs and the town of Alumooni. In the movie, the town of Alumooni, rich in palm oil, was prosperous because many kingdoms from around the world would come to buy its palm oil. The town of Olaju noticed this and, rather than come to do business with the leaders of Alumooni, decided to corrupt a few of Alumooni's officials and transfer all Alumooni's wealth to Olaju. Alumooni became poor; all of its youths migrated to Olaju except those who could not migrate and instead became disillusioned. The king of Alumooni later died under mysterious circumstances. The king was said to have been depressed about how his community had been turned into a space where none of the resources and sacred sites were protected from the rush for resource extraction. The prosperity of the town of Alumooni that derived from palm oil never returned, and the entire population remained desolate. In the end,

members of Alumooni called on their ancestors to help deliver them from the hands of predatory Olaju. Olaju prospered, and some from Alumooni who became collaborators of Olaju also prospered, but at the expense of the majority of the population of Alumooni. To Oladele, the town of Olaju is an FTZ that has come to deprive his community of access to its palm trees, fishing, and other resources. While the movie is not particularly directed at the reality of many of the communities in the FTZs, its metaphor about Nigeria as a victim of predatory practices of big corporations, especially the oil corporations, is telling. As has been well documented in the literature (e.g., Adunbi 2013, 2015; Apter 2005; M. Watts 2003, 2004a), the Nigerian elite are in cahoots with oil corporations that operate in Nigeria. The few elites in power are the major beneficiaries of Nigeria's rich oil resources, while communities where the oil is extracted do not get the benefits. As described in chapters 4 and 5, many youths in the oil-bearing communities now devise different ways of getting the benefits of oil extraction as a result of state and corporate neglect. Oladele never fails to reference the larger predicament of Nigeria and Nigerians as victims of predatory capitalism ingrained in a new moment of neoliberalism in which vulnerable communities are subjected to new rules of governance that disempower them and harm their livelihood and sacred sites. When this happens, as in the case of communities living near FTZs, ancestral notions of ownership are often invoked to make claims about belonging and membership in communities of extraction.

"Our Ancestors Gave This Land and Resources for Us"

Many communities around the LFTZ and the OGFTZ belong to the Yoruba-speaking ethnic group of the southwestern part of Nigeria. As many scholars have written (e.g., Ade-Ajayi and Smith 1971; Apter 1992; Atanda 1980; Biobaku 1973), the Yorubas have a common ancestral heritage that traces its emergence to Ile-Ife, a city considered to be the cradle of civilization (Apter 1992; Atanda 1980; J. Olupona 2011). Thus, many communities within the trade zone trace their origin to Ile-Ife, from which their forefathers were said to have migrated. The journey by their forefathers from Ile-Ife and other Yoruba towns, such as Ijebu-Ode, a few miles from Lagos, marked the beginning of a life of fishing, farming, palm oil processing, and brewing that continues today. The form of agricultural practice in these communities is highly dependent on the Atlantic Ocean as well as the surrounding land, which many communities claim was bequeathed to them by their ancestors. Ancestral claims of the ownership of land and other natural resources are often marked by the ability of community members to trace their heritage to the

beginning of settlement in any particular location. This is exactly what members of the different communities in Lekki and Igbesa have done (Adunbi 2015), as ancestral claims to ownership help galvanize community property ownership in the face of opposition or incursion from outsiders: in this case, various governmental agencies and their Chinese partners. This is exactly the case made by the LFTZ communities that are staking claims to ownership of the area marked for development as an FTZ by the state.

In an attempt to reclaim what they believe are their ancestral land and resources, many communities within the LFTZ are collaborating through their organization, the Lekki Coastal Area Community Development Association (LCACDA), with a nongovernmental organization (NGO), the Social Economic Rights Action Center (SERAC). SERAC, an NGO with headquarters in Lagos, has been collaborating with the LCACDA since 2006. In the summer of 2016, I visited several communities within the LFTZ and interacted with members of the LCACDA in Ibeju Lekki. I also visited the offices of SERAC in the Magodo area in mainland Lagos, where I interacted with many of SERAC's officials who are involved with the LCACDA. Emmanuel, one of SERAC's attorneys, told me, "Our intervention started as far back as 2006, when the Lagos State government wanted to forcefully acquire the land and throw the entire community out of the place they have known as home for hundreds of years. It was a serious battle, never an easy task. Fortunately, the government yielded to our advice that they should sign a memorandum of understanding with the communities after many years of engaging with the state."[9] The Lagos State governor at the time, Bola Ahmed Tinubu, had initiated the LFTZ in collaboration with a Chinese consortium as his own way of "taking Lagos to a new height," said Emmanuel. SERAC's intervention was precipitated by Bola Ahmed Tinubu's attempt to forcefully take over land that belonged to about twenty-six autonomous communities in the Ibeju-Lekki area of Lagos to make way for the FTZ. The most impacted among these communities include Idasho, Okunraye, Idokun Itoke, Ilege, Ilekuru, Imobido, Magbon Segun, and Tiye. The Idasho community, for example, sits at the intersection of the dredging of the Atlantic Ocean and the construction of Dangote refinery. SERAC intervened and asked the government to give the communities due compensation. As Emmanuel narrated to me in the summer of 2015 in his SERAC office,

> They thought we were antagonistic at first. We had to visit the communities and had to sensitize them, educate them on what the government says is accrued to them. And it yielded positive result [sic]. It continued till the groundbreaking period in 2006. Along the line, the state government wanted to renege on their promises, and the people would cry to us. The government promised the

communities job opportunities within the trade zone, 10 percent equity share, make [sic] one of them the director within the trade zone, and give them land. We came up with a robust MOU [memorandum of understanding]. It was done in collaboration with the Ministry of Land and that of Justice. The then–attorney general of the state assisted, and there was an agreement between the communities, Lagos State government, and the free zone.

The antagonism mentioned by Emmanuel stems from the lack of trust that many members of the communities felt toward NGOs. As one interlocutor told me, "Some of these NGOs cannot be trusted. We cannot trust them because they sometimes collaborate with the government. We will rather stay and fight on our own than be deceived by an NGO that will go behind our back to stab us."[10] While many members of the LCACDA went along with SERAC in negotiating with the Lagos State government, members of the Idasho community opted out of the plan to negotiate. The Idasho community also left the LCACDA and formed its own Idasho Community Development Association (ICDA). The secretary of the ICDA mentioned that SERAC was becoming too cozy with the Lagos State government and that the ICDA thought its interest would not be best represented by such an NGO. As it turns out, the executive director of SERAC, Felix Morka, later joined the ruling All Progressive Congress—the party in power in Lagos—and declared an interest in running for office in Delta State. In an interview in the summer of 2017, an official of SERAC said Morka's political interest was never a factor in how the organization helped the communities negotiate an MOU with the Lagos State government, but some members of the community think otherwise. For example, in my interaction with the leaders of the Idasho community, many questioned Morka's neutrality. He was described to me as a stooge of Bola Tinubu, the former governor of Lagos and national leader of the All Progressives Congress. Tinubu is said to have an interest—a business interest—in the entire LFTZ project. Not surprisingly, the image of Tinubu looms large in Lagos, and many respondents have ascribed to him businesses that may not even be his because of his influence in both state and national politics.

SERAC helped negotiate an MOU between the Lagos State government, officials of the LFTZ, and twenty-six communities. Even though the MOU promised the communities a 10 percent stake in the LFTZ, this and other components were never implemented. Indeed, according to my interview with an official of the LFTZ, the Lagos State government is supposedly holding about a 20 percent stake on behalf of the communities. The MOU established by the government of Lagos State, the LFTZ, and the communities was comprehensive and touched on employment opportunities for

community members, compensation for acquisition of land, and business/ contract opportunities. Specifically, the MOU promised to make about 750 plots of land available to the communities. However, though the 750 plots were released, community members could not take physical possession because the land belonged to other communities that had opted out of the MOU arrangement for reasons ranging from the insincerity of the government to a lack of trust in SERAC to the idea that they did not want their community life disrupted. Consequently, no real substantial compensation for the takeover of community land in the area has been provided. As Tagliarino et al. (2018, 21) note, "It is doubtful, based on our survey research, that all community members were consulted and informed about the MOU prior to signing it. Nine communities, which are parties to the MOU, reside along the Lekki coast." The communities that reside along the coast were the first to be affected as a result of dredging the Atlantic Ocean to make way for a seaport and refinery—the LPFTZ and Dangote refinery. Dredging results in ocean rise, and when that occurs, homes along the coast are frequently flooded. There were some instances where a few community members were paid a small compensation for crops, but whether the amount paid correlated with the value of the crops is also in doubt (Tagliarino et al. 2018).

By virtue of the Land Use Act of 1973, all land and natural resources belong to the government, but people hold on to communal land through a tenure system. Hence, conflicting claims to land have oftentimes warranted the state forcefully taking land and forcing people from their livelihood and communal living. In the process, ancestral shrines, ancestral cemeteries, and other valuable community holdings are affected. One such example I encountered was the impending displacement of Veronica from her small palm oil processing business right behind the LFTZ.[11]

Veronica was in her midthirties and lived with her husband and five children. She had been living in the same hut since she was five years old and shared the compound with her parents, whose hut was adjacent to hers. In front of the hut were her grandfather's gravesite, a small fireplace used for processing palm oil, and a bunch of large cartons used for packaging the palm oil. In the surrounding areas were palm trees that Veronica used in making palm oil (see fig. 2.4). Veronica's father was the current chief priest and custodian of the community's traditions. The chief priest oversaw some of the shrines located a few meters away from the compound, which were marked to denote the steps the community's ancestors took to get to their present abode (see fig. 2.5). Therefore, the small compound sat on a tripod consisting of the small business that sustained the family, their sites of ancestral worship, and a space of community living. As I sat down with Veronica

Fig. 2.4 Palm trees in one of the communities affected by the LFTZ. Source: Photograph by the author.

Fig. 2.5 One of the community shrines behind the LFTZ. Source: Photograph by the author.

for an interview in July 2016, she put her right hand on her chin, gazed at her grandfather's grave, looked at the small amount of palm oil that she had just finished making that afternoon, and gave a long sigh. She then asked, "What will happen to my grandfather's gravesite? What will happen to all these palm trees, my business, and my heritage?"[12] As Veronica pondered these questions, she looked back and saw the huge fence of the LFTZ behind her and suggested to me that very soon, "they [the LFTZ] will come with their bulldozers to clear the entire area without thinking twice about my livelihood, my community, and the future of my children and extended family. Where will I go, and what will I do?"

Veronica's worries are not misplaced. In 2014, the then-governor of Lagos State, Babatunde Fashola, had taken a businessperson, Alhaji Aliko Dangote, to meet with several Ibeju-Lekki community members to inform them of Dangote's intention to build an oil refinery as part of the LFTZ development project in the area. At the meeting, Fashola, who spoke in Yoruba, asked if the community wanted the refinery or not and if the community wanted the businessperson to take the refinery to another state. Fashola's question to the community members appears more like a threat than a question deserving of an answer from the communities. Many community members said they feared a loss of livelihoods that depended on palm oil, fish, and other agricultural produce. The refinery and other LFTZ infrastructure would result in cutting down all the palm trees; dredging the ocean, which would potentially drive away fish; and losing farmland, which would reduce their ability to produce sustainable food for their families. Governor Fashola responded to the fears of the communities by threatening that they all would be displaced by force and that if there was any protest, that would also be crushed with force.[13] At the end of Fashola's speech, many community members showed discontent but also understood that the state would carry out its threat. This was exactly Veronica's worry, and as we sat down to chat that hot summer afternoon in July 2016, she pointed to many of her fellow community members who had already been displaced to make way for the construction of the oil refinery and other businesses within the LFTZ. When asked about the MOU, Veronica responded by suggesting that it was not just about the MOU but also about how her livelihood and all that she had known would disappear. For Veronica, there seemed to be a sense of emptiness, even with the promise of rapid infrastructure development and industrialization by the management of the LFTZ and the state.

While Veronica was concerned with the loss of her livelihood and the grave of her grandfather, Korede,[14] a twenty-five-year-old fisher, was much more interested in the effects of the dredging of the Atlantic Ocean on his

small fishing business. To make way for a seaport and an oil refinery in the FTZ, the Dangote Petrochemical and Oil Company was dredging the Atlantic Ocean. In response, in October 2015, Korede and other youths in the Ibeju Lekki area organized a protest against the FTZ. The protest led to the death of an executive of Lekki FTZ, and the state responded by deploying troops. The fracas that followed resulted in the deaths of some community members and the destruction of property in the area. The outcome of this was the arrest and detainment of many youths who were alleged to have participated in the protest. When I met Korede in the summer of 2017, he relived his experience at the hands of the police, suggesting that he nearly lost his life. He said, "We had gathered to protest the loss of our land and livelihood in a peaceful way. We were more than three hundred gathered in the Idasho community, and people had come from communities such as Tiye, Ilekuru, Magbosegun, and Ilubere to protest this injustice; suddenly, the police came and fired tear gas into the crowd." Korede claimed that he was lucky to have escaped arrest but worried that he might no longer be able to practice his trade—fishing. When asked about the MOU, Korede corroborated the responses of many interlocutors: FTZs, framed as part of the state's infrastructure and industrial development, would eventually result in the loss of livelihood and the life that the communities had grown used to. Many feared that oil refining within the FTZ would replicate many of the challenges of resource extraction in the Niger Delta, including polluted water and a devastated environment.

MOUs have become a standard-bearer in the ways in which corporations—particularly those in the business of oil extraction—engage with the communities that host them (Adunbi 2013, 2015; M. Watts 2004a, 2004b). In many instances, the signing of MOUs with communities where resources are extracted serves the purpose of making promises that are never fulfilled, even though community members also recognize the futility of an MOU. One fact recognized by many interlocutors is the MOUs' futility in addressing many of the challenges they face, including loss of livelihood, displacement from their community, and devastation of their environment and ancestral land and resources, which corporations tend to take away from them. The lack of access and the experiences of displacement shape communities' relationships with businesses and the state—and, in this case, with the management of the free-trade zones and the state. The state and big businesses always frame their response to community development through the notion of rapid construction of infrastructure, industrialization, and development. Thus, development and industrialization become a one-size-fits-all approach. As Arturo Escobar once reminded us, the field

of development economics is based entirely on the development trajectory of the West, meaning that "modernity . . . remains primarily a European experience that has sought to become universal" (Escobar 1988, 438). While China does not claim to model its development practices on those of the West, it has become clear that Chinese development practices—through the establishment of economic zones—are modeled on a particular form that portrays rural dwellers, at least in Escobar's telling, as underdeveloped and in need of techniques of change and industrialization. Hence, China and Nigeria subscribe wholeheartedly to the pursuit of economic expansion at the expense of communities' loss of livelihood and ancestral practices. In the case of Veronica and the members of her community, the economy as an object disenfranchises the population. The trade zones are legitimized as an answer to what the state sees as a need for rapid industrialization and development as a gateway to modernization. Therefore, following Mitchell (2011), I suggest that in this particular example, the economy as an object replaces the economy as a practice that caters to the needs of the entire population.

"Economy as an object" translates to the ability of a state to attract foreign direct investment, diversify its economy, and improve its gross domestic product and gross national product in ways that conform to the norms of econometrics. The emphasis on diversification is always the mandate of export processing zones, which FTZs represent, but, as Harry (2016, 31) shows, "for EPZs to contribute meaningfully towards economic diversification in Nigeria, value addition levels in EPZs exports must be reasonably high. Clearly in Nigeria, EPZs have not helped in the diversification of the economy. Nigeria is still a monocultural, oil-based economy, getting about 90 percent of her export earnings from oil exports." While Harry goes on to point out why diversification has become a mirage for Nigeria, the reasons he adduces, such as inadequate market information and lack of technological know-how, do not explain the intricacies of FTZs and their inability to help diversify the economy as their mission indicates. Adunbi and Stein (2019), for example, show clearly how the government of Nigeria's intent to diversify the economy, expand the manufacturing sector, and integrate EPZs/FTZs into its strategic approach to industrialization is problematic because handing management and control of some zones to the Chinese might look good politically (for China and Nigeria) but is far less important from an economic perspective than putting policies in place to attract foreign direct investment and domestic investors and ensure that their activities enhance development. Thus, Harry (2016, 32–33) suggests that "to achieve economic diversification of the country through the zones, there is a need to rapidly increase

the level of value addition in the production processes and volume of exports of manufactured/assembled goods from the zones to at least 50 percent of total national exports."

However, an increase to 50 percent of total exports is not only a mirage at the moment, but an export-oriented economy does not necessarily lead to a buoyant economy. There are two interrelated issues that need unpacking here. First, the idea of an economy represented by numbers misunderstands the centrality of the economy to human participation. Numbers such as gross domestic product or gross national product may go up without necessarily leading to an improvement in the lives of the population because quantification, in the particular case of FTZs, measures how many goods are produced and sold to the international market. The composition of enterprises within an FTZ as an independent business enterprise that exists within an autonomous entity is an indication that profits may not necessarily be ploughed back into the economy of the Nigerian state. If the profits made are repatriated to the home country of the enterprises, then the benefit to Nigeria remains largely superfluous. If the benefit to the state is superfluous, that to the community is even less. For many members of the community, what they get from the FTZ is not the promise of expanded exports but devastation, loss of sacred spaces, and social disequilibrium. This way, infrastructure for the community is turned into what Hecht (2018) calls "toxic infrastructure" as a way to describe how attempts at modernity can have unintended consequences for those who are expected to benefit from such infrastructure development. While Veronica and Korede might be concerned about the loss of their livelihoods, other community members who feared erosion of their traditions are much more concerned. As the chief priest of Idasho, Chief Samuel Babatunde, Veronica's father, told me, "There are many sacred sites that only those initiated are allowed to see, but when bulldozers come, the FTZ people have no iota of respect for that, and this is disheartening. We are not only losing land but also our customs and tradition."[15] Pointing at some of the trees wrapped with palm fronds and painted red and white around their roots, the chief priest, who is considered the custodian of Idasho traditions, told me how community members had to protest when the trees were going to be felled. After much opposition, the trees were left alone, but he said he was sure they would come back for them. The trees are not just standing trees with green leaves on their stems but are also sacred, and every year, certain rituals are performed around the trees to appease the gods and the ancestors. As noted earlier, part of the rituals marks the migration of the community to the present location. Many of the trees are right behind the fence of the LFTZ. There are also other sacred sites around the LFTZ, and I was told that

some are situated on the shores of the Atlantic Ocean. Many of the rituals performed around these sacred sites include rituals of sustainability aimed at bringing abundant food to the community. As I was told, when those rituals are not performed, it could portend bad omens such as famine and absence of rain for the entire community. The performance of these rituals entails making sacrifices to the ancestors, who are credited with giving the land and ocean and all the resources therein to the entire community. Thus, rituals of sustenance, of abundant food production, and of healthy living not only celebrate how the ancestors made all these possibilities a reality for the communities but have also become a way of maintaining the communities' sovereignty over the land and other natural resources. It is this sovereignty, taken away first by the colonial state and later by the postcolonial state, that has now been transferred by the postcolonial state to the FTZs. Sovereignty therefore becomes a highly contested terrain that pitches the communities of extraction against the state and its corporate partners. It is this new form of extraction that has transformed a community that has prided itself as a leader in fishing, palm oil cultivation, and processing into a community that now waits for rescue by its ancestors from the hands of a marauding state and its corporate partners. This transformation of a land strewn with palm trees into a land encased in an FTZ is what creates a new meaning of belonging and membership in a nation-state and a sovereign FTZ and, hence, the idea of a space in Nigeria not being part of Nigeria, as we shall see in the next chapter.

NOTES

1. Copy of press statement obtained by email on October 24, 2019.

2. Ibid.

3. Ibid.

4. See, for example, "Nigeria Accelerating the Development of First Deep Sea Port through Chinese Investment," World Maritime News, October 24, 2019, https://worldmaritimenews.com /archives/285294/nigeria-accelerating-development-of-first-deep-sea-port-through-chinese -investment/.

5. The Nigerian constitution allows for dual citizenship.

6. Interview conducted in Abuja, at the offices of NEPZA, July 26, 2017.

7. For more on this, see, for example, "China-Nigeria Relations," Embassy of the People's Republic of China in the Federal Republic of Nigeria. 2004. July 8, 2004. http://ng .china-embassy.org/eng/zngx/cne/t142490.htm.

8. Sandra Kilhof, "Lekki Zone Set to Transform Nigeria's Fortunes," World Finance, September 4, 2014, http://www.worldfinance.com/infrastructure-investment/lekki-free-zone-set-to -transform-nigerias-fortunes.

9. Interview conducted at the offices of SERAC in Lagos, June 20, 2016.

10. Interview conducted in Idasho, one of the communities in the LFTZ, July 27, 2016.

11. Not her real name. I met Veronica at her palm oil processing hut right behind the LFTZ in the summer of 2016.

12. Interview conducted in the LFTZ, July 15, 2016.

13. See, for example, "Governor Fashola Threatens Residents of Ibeju-Lekki over Location of Oil Refinery," Sahara TV, February 27, 2014, https://www.youtube.com/watch?v=x04jCXuMCrk.

14. Not his real name. Korede is a common name in the area, and I use it here to protect the identity of my interlocutor.

15. Interview conducted in Idasho, July 10, 2017.

3. "THIS PLACE IS NOT NIGERIA"

Constructions of the Sovereign in Free-Trade Zones

This chapter ethnographically maps the divergent regulatory practices that govern the daily lived experiences of free-trade zones (FTZs) in Nigeria by looking specifically at the ways in which the zones are considered to be independent territory. It interrogates how the concept of a place not being Nigeria emanated from the idea of who is an expatriate and who is not. Since FTZs are considered to be sovereign enclaves where the state selectively cedes part of its sovereignty—especially over business registration, taxes, labor laws, and other regulatory practices—those who work in the zones consider themselves part of a new sovereign. This chapter suggests that this ceding of the state's sovereignty fits into the shifting meaning of the economy from a system of social activities and relations to an object that is determined by numbers and other regulatory practices to shape the development paradigm through oil and other natural resource politics. The social history of the area is germane to understanding the intricacies of these practices and their connection to extraction. The chapter begins with the history of Lagos, host to Lekki Free Trade Zone (LFTZ), and Igbesa, host to Ogun-Guangdong Free Trade Zone (OGFTZ). This particular history shows how communities rich in natural resources such as palm oil and other agricultural produce became a target for colonial extractive practices. The chapter reiterates how Lagos, for example, served as a port for shipment of human bodies to the international slave market, then became a port for shipment of palm oil and other agricultural produce when slavery was prohibited. This, I show, is a form of historical continuity that is anchored in resource and human extraction in ways that transfer the wealth of one enclave to another—in this case, the wealth of Lagos and its surrounding areas to the British and their partners. Such transfer gets replicated in the postcolonial state of Nigeria with the

establishment of FTZs. However, I argue that today's FTZs are embedded in the ideation of sovereignty as a technique for the management of extraction in communities where they are located. This form of sovereignty, I argue, is bifurcated in ways that translate to the transfer of regimes of regulation from the state to the FTZs, a form of bifurcation that suggests the loss of sovereign sites such as sacred shrines and other ancestral sites in communities where the zones are located. Using the particular examples of the LFTZ and OGFTZ, the chapter shows how consciousness of this historical continuity can shape a better understanding of today's extractive practices in Nigeria. The chapter concludes with a discussion of what it means to be sovereign in an FTZ through an interrogation of the different claims of what and who constitutes an expatriate there.

Changing Trading Practices and the Construction of Communities of Extraction

As noted in the previous chapter, among the Yoruba-speaking ethnic groups of southwest Nigeria, communities are united by a common heritage and historical claim to the land. Many scholars (e.g., Ade-Ajayi and Smith 1971; Apter 1992; Atanda 1980; Biobaku 1973; J. Olupona 2011) have noted the importance of ancestral heritage among many Yoruba communities, who trace their migration to the Atlantic coast from a city called Ile-Ife. Many communities today justify their control of and claim to the land by tracing ancestral ownership claims back to the original settlers from Ile-Ife, considered to be the cradle of Yoruba civilization (Adunbi 2015; Atanda 1980; Biobaku 1973; J. Olupona 2011). This claim, as I demonstrated in my previous work on the Ilajes of Ondo State, extends to oil resources in the ocean (Adunbi 2013, 2015). This particular form of civilization includes the institutionalization of kingship and chiefship practices that today predominate in many Yoruba communities. Kingship is embedded in the sacredness of tradition and customs that make all land and the resources therein the property of the ancestors but owned communally by all in the community. Thus, agricultural produce, nature and all its affordances, and the environment and the resources inhabiting it are made possible by the ancestors who blessed the communities with them (Adunbi 2015). Since land and other resources are inheritances from the ancestors, their value, maintenance, and use are important to how communities organize their daily lives. The organization of daily lives in places such as Igbesa is rooted in agricultural production and other farming practices. The kings or chiefs of each community are considered representatives of God on earth and therefore the custodians of all that the ancestors made possible for the community. Today, land is no longer considered to be communal

property because of a law that transfers ownership to the state. Herein lies the predicament of the communities who are hosts to FTZs and whose lands have been transferred to such FTZs by the state. The question is, How were those communities organized around kingship practices prior to the emergence of the colonial and postcolonial state? What can we learn from the extractive practices of the colonial state? How is it that the colonial form of extraction is carried over to the postcolonial state and is today further cemented by the presence of FTZs? I take a long look at the history of extraction in Lagos and other towns in close proximity to it, such as Igbesa and Ijebu-Ode, to deconstruct the connection between palm oil extraction and today's form of extraction anchored in trading practices in the FTZs.

Illustrative of these ownership practices is a particular tradition of kingship for which many Yoruba communities are noted. This kingship tradition extends from Lagos to Epe in today's Lagos State, where LFTZ is situated, and Igbesa and Ijebu-Ode towns in Ogun State, where OGFTZ is located, which, though poles apart in terms of distance, have many things in common. All the towns consider themselves part of the larger Yoruba ethnic group that inhabits the entire southwest of Nigeria and some parts of West Africa, such as the Republics of Benin, Togo, and Ghana. As documented in the literature (e.g., Ade-Ajayi and Smith 1971; Akinjogbin 1992; Akinjogbin and Ayandele 1980), the Yorubas developed a sophisticated kingship system over several hundred years prior to the emergence of colonialism. The process of creating this system heralded a period of migration, warfare, and the development of communities across the subregion (Ade-Ajayi and Smith 1971; Akinjogbin 1992; Akinjogbin and Ayandele 1980). Importantly, Lagos, for many decades during the trans-Atlantic slave trade, served as a major port city for the shipment of human cargo to the new world (Echeruo 1977; Gale 1979; Hopkins 1964; Mabogunje 1968; Mann 2007; Peil 1991). Instructively, Lekki, the name of the free-trade zone in Lagos, is the indigenes of that area's way of pronouncing and spelling the name of a Portuguese slave merchant, Lecqi, after whom the entire area is named. Mann (2007), for example, notes how Lagos became transformed from a lesser, unknown Yoruba town in the seventeenth century into an important port city and a significant participant in the trade in human commodities. Significant to Mann's (2007, 1) study is that when the trade in human cargo ended in the mid-nineteenth century, Lagos quickly transformed from a slave port into a noteworthy port for a new mundane commodity: red oil derived from palm kernels. Thus, Lagos and other towns and communities in proximity to the Lagos port became intricately connected to the extractive practice that linked production of commodities such as palm oil (red oil) and other agricultural produce such as

cocoa to the international commodity market. By 1861, Lagos had become a colony of the British colonial authorities, while adjoining towns and villages in the Yoruba-speaking area had become a protectorate of the British empire (Ade-Ajayi and Smith 1971; Akinjogbin 1992; Akinjogbin and Ayandele 1980). Becoming a colony and protectorate automatically transferred control of local extractive processes to the British overlords who controlled the trade that emanated from the production, sale, and control of all agricultural produce.

By the time colonial rule crystalized in 1914 through Frederick Lugard's amalgamation of the northern and southern protectorates of Nigeria and the colony of Lagos (Adebanwi and Obadare 2010; Adunbi 2015; Akinjogbin and Ayandele 1980; Lugard 1907), trading practices had been completely transformed through the establishment of plantations such as the Moore Plantation, established in 1921 in Ibadan, headquarters of the western province. The objective of this plantation was an increase in the agricultural production of cocoa, palm oil, and other products as a result of the rise in demand on the international commodity market. Colonial records indicate how kings and chiefs in many towns and villages across the southwestern part of Nigeria began to advocate for more seedlings either for themselves or their subjects in order to increase production. For example, archival records show that on January 6, 1936, the resident of Oyo—a title used by colonial officers—province requested assistance to supply oil palm seedlings to Ibadan farmers by 1937. The resident requested the support and assistance of the United Africa Company Ltd. (UAC), one of the early conglomerates in colonial Nigeria, and urged the company to supply three thousand free seedlings from its plantations at Sapele in the Niger Delta for distribution to farmers who wished to start oil plantations. The previous year, the UAC had supplied the Government Agricultural Department with several hundred thousand selected seeds at no cost; hence, the UAC responded to the request by referring the resident of the province to the Moore Plantation, Ibadan, for the supply of seedlings to Oyo. The UAC could not meet the demand for seedlings from any interested parties during that year because it had also acquired—forcefully, I would argue—about two thousand acres of community land in the Benin area to establish oil palm estates in 1936. A land tenure system existed in many communities in the southwest and throughout the country, hence colonial authorities' forceful dispossession of communal lands to make way for estates producing this emergent commodity—palm oil. Thus, palm oil extraction and exportation to the international commodity market, for many communities such as those around the LFTZ, represent another phase in a process through which those communities have become

an enclave of extraction for the benefit of businesses and individuals outside of the communities. Inhabitants of places such as Idasho, where LFTZ is situated, also became commodities whose labor can be extracted for the production of palm oil meant for the international market.

However, it should be noted that many community members who did not work as laborers on the established plantations were also able to get seedlings to plant their own palm trees. Individual farmers who planted palm trees used them not only for palm oil intended for the international market but also to make palm wine or red oil for local consumption. Thus, palm trees created dual possibilities for many farmers, especially during the boom in ogogoro (local liquor) production that relied on palm wine (see chapter 4, on moonshine and ogogoro, for more details). In some instances, colonial records show, community members would convert palm trees to make wine and harvest palm kernels used in making palm oil from the established plantations owned by corporations such as the UAC. This was due to the land tenure practices in many of the communities. The land tenure system was a serious handicap to the development of palm oil planting in the southwestern provinces of Nigeria because it specified that the owner of the land was ipso facto the owner of any palms growing thereon (Oyo prof. 1, file 2026, vol. 1, 201). For example, many kings and chiefs in the southwest recognized the handicap posed by the land tenure system that created a distinction between land and agriculture produced on the land. This distinction suggests that the community owns the land regardless of who plants seedlings on it. Many community members exploited this customary practice to harvest palm kernels from plantations and sometimes palm wine from the trees. One of the revered kings in the southwest, the *Ooni* of Ife, himself a keen agriculturist and a planter of oil palms, recognized the restrictions imposed by existing custom and expressed the intention of removing the difficulty by declaring that it would not be an offense "to permit a tenant to plant oil palms on one's land. To plant oil palms and harvest the fruit on another man's land, having first received proper authority from the land-owner, and the ruling made known among the people [allows] a big obstacle [to] be removed" (from a letter written by D. Brown, agricultural officer, Oyo-Ondo province, Moor plantation Ibadan in 1936 to the district officer, Ife) (Oyo prof. 1, file 2026, vol. 1, 201).

The problem, however, was not limited to community members harvesting palm kernels from plantations but also involved the use of palm trees for palm wine making. The colonial authorities considered this a major threat, hence the report of a botanist in 1941 on the dangers of cutting trees and pruning leaves to make houses—leaves were useful in making thatched roofs and in palm wine tapping.

In 1941, the oil palm botanist began an experiment at Aba to determine the effect of leaf pruning on the yield of oil palms. His results revealed that severe leaf pruning, as was frequently done by farmers to provide fencing or thatching materials or to permit intercropping, had a disastrous effect on yield. In the experiment, the yield of bunches was reduced by over 50 percent in the first year after treatment. The Agricultural Department of Ibadan wrote in response,

> Heavy leaf pruning of oil palms is common in Oyo and Ondo provinces and even in these days of maximum production, I do not quite see how the practice can be avoided. Farmers usually know which of their palms produce the most bunches, and it might be worth while making the bad effects of heavy leaf pruning so that at least the heavy yielding palms may be treated more gently. The experience of farmers in this area is opposed to the finding of the oil palm Botanist. Further it would appear that palms or food crop farms are pruned in order to allow more sunlight to penetrate to the crops. It would, I think, be impossible and unwise to restrict to any great extent the pruning of palms, the leaves of which are used so largely for thatching and other purposes. Hitherto, people have always thought that by neglecting the "clearing" of palm trees the yield was adversely affected. However, if the Agricultural Officer is sure that yield would be increased by non-pruning, efforts will be made to break down the age-long custom of pruning. (Oyo prof. 1, file 2026, vol. 1, 54–57)

The then-oni of Ife, Sir Adesoji Aderemi, added,

> It is a difficult matter, for if leaf pruning becomes forbidden, there is bound to be a heavy shortage of food. My only suggestion is to make it known widely to the farmers the extent to which leaf pruning of oil palm adversely affects its yield. This of course will appear contrary to their age-old experience; but the agricultural assistant and co-operative inspectors will have to take special interest to explain it very fully at the farmers meetings and shall do all that is possible to explain also in usual way. We may be sure then that in any bush left to lie fallow, oil palm will be left alone. (Oyo prof. 1, file 2026, vol. 1, 59)

A great number of trees were felled for palm wine; incidentally, the consumption of palm wine in Ibadan for the first quarter of 1943 was considerably greater than the consumption for the entire year of 1942. West, the agricultural officer of Oyo Province, explained that a palm tree was very rarely cut down except for its wine. In fact, he had never seen it in this province. If thinning out on certain farms was necessary, a permit could be applied for, and, if necessary, a forestry officer could grant exemption from payment of treats. Moreover, the native authority made an order that no person shall cut, fell, or in any way injure lands without the prior consent of an agricultural officer. Any person who contravened this order would be liable, on conviction, to a

fine of twenty-five pounds or to imprisonment for six months or to both fine and imprisonment (order by the Ibadan Native Authority–Preservation of oil palm order 1943). The order did not stop the practice because of the high demand for palm wine in making ogogoro as well as the demand for palm fronds for making thatched roofs. The order was made in response to a new demand for palm trees in making local liquor, which had been booming in many communities, as we shall see in chapter 4. The concern of the colonial authorities was mainly about their inability to increase the production of palm oil meant for the international market. The history of palm cultivation is tied to the particular extractive practice that turns spaces of nature into spaces for the production of commodities aimed at profit making and intended for consumers beyond the shores where the resources are extracted. Lagos and its environs, especially Lekki, Ijebu-Ode, and other towns and villages that stand in proximity to the greater Lagos area, represent an enclave where there is continuity in the ways in which resources are extracted.

LEKKI AND ITS PARTICULAR HISTORY OF EXTRACTIVE PRACTICES

Ijebu-Ode has a close affinity with Epe, a few miles from the Lekki Free Trade Zone. Many of the communities that inhabit the site of the FTZ in Lekki trace their heritage to Ijebu-Ode and were said to have migrated from Ijebu-Ode to their present abode hundreds of years ago. While the reason for their migration is not the subject of this chapter, it is important to illustrate how this form of migration shapes their relationship to the land and livelihood practices.

Lekki and its adjoining areas cannot be discussed without looking at the zone's relationship with the town of Epe, with whom it shares close proximity. Epe is north of Lagos Lagoon and considered to be inhabited by the Ijebus. Early records show that the town was mostly populated by fishers and actually served as "presumably originated as a settlement for fishers" (Smith 1969, 7). The prominence of Epe as a town that borders both the lagoon and the Atlantic Ocean suggests an early forming of trading relationships with nearby towns and cities such as Lagos, Abeokuta, and Benin as well as many communities in the Niger Delta. Epe's close proximity to many of the villages and settlements around its area also suggests that those settlements played an important role in making Epe and Lagos what they later become—a point supported by archival records.

Two events shaped this particular telling of the relationship that connects Epe and Lagos to Lekki. Both events are connected to trade, migration, and power. First, the history of the area is connected with that of Epe, a town

said to have a connection to the *Awujale* (king) of Ijebu-Ode. For example, a local dispute in Epe was said to have warranted the Awujale to cause a dispersal of the population within Epe in the mid-1800s. The dispersal and migration toward the uninhabited land that later became the villages adjoining Epe were said to have resulted from what the Awujale of Ijebu-Ode considered to be an alleged insubordination and the disrespect of his subjects in the town of Epe. The dispersed population was said to have found refuge in the adjoining uninhabited land to the south of the waterway, toward Lagos Lagoon on the border of the Atlantic Ocean (Lyn 1982, Smith 1969).

The second event is connected to the struggle for political power in the city of Lagos. Specifically, in 1851, Kosoko—a prince of the Lagos royal family who was battling other princes to ascend the throne of the port city—led his followers, who had been displaced from Lagos, to settle in Epe with the approval of the Awujale of Ijebu-Ode (Mann 2007). Kosoko and his more than twenty thousand followers, archival records show, became the dominant force in the waterways east of Lagos and instituted control over Epe. Kosoko's foray into Epe was said to have provided the impetus that helped establish social and political cohesion for the emergence of native administration in the Epe area. Kosoko was able to establish dominance in the waterways around the region (Falola and Avoseh 1995; Mann 1991). As Smith (1969, 3) noted,

> In the middle of the nineteenth century the lagoon was disturbed by a feud between two claimants to the Lagos throne, Kosoko, who reigned from 1845 until 1851, and first Akitoye, who had been expelled from the throne by Kosoko in 1845 and six years later re-instated by the British, and then Dosunmu, Akitoye's son and successor. After his overthrow, Kosoko took refuge at Epe on the north shore of the eastern, or Lagos, lagoon, some thirty miles from Lagos. Epe was in the territory of Ijebu Ode, and thus the Ijebu had a part to play in the quarrel, as had also the Egba to the north whose main trade route was the river Ogun which enters the lagoon some eight miles north of Lagos island.

In order to gain the support of the Awujale, Kosoko was reported to have presented to the Awujale many gifts, including palm wine, slaves, and other valuable items (Falola and Avoseh 1995; Law 1983; Smith 1969). While in Epe, Kosoko consolidated trade in slaves and control of the entire area that borders the lagoon. It should be noted that the British were not completely absent during the struggle for power among the princes of Lagos. In fact, the British had intervened, making the claim that their intervention was motivated by the need to avoid bloodshed and eradicate the slave trade in which Kosoko and the port of Lagos were major players (Lyn 192; Smith 1969).

These two events converged to help establish a thriving population of fishers and farmers along the lagoon corridor that stretches from Epe through many of the communities in Lekki on the way toward Lagos, important trading posts that the British coveted.

Neighboring Orimedu, on the coast, known in early records as Palma, became the point at which Kosoko found access to the sea and established his own port; today it has a considerable community of people descended from those who were part of the twenty thousand people that followed him from Lagos to the Epe area. But with Lagos becoming a British colony in 1861 and Kosoko himself advancing in age, archival records show, the battle for the control of Lagos, a major preoccupation of Kosoko, became a mirage. Kosoko had always thought that he would one day return to the city to ascend the throne of his forefathers, seeing his residency and control of Epe and its adjoining areas as temporary. The British wanted access to the Epe area in order to control an important trading route, especially for palm oil, hence the need to intensify negotiation with Kosoko to cede the area and part of his power to them. Smith notes that the British signed a treaty with Kosoko containing several articles, one of which was for him to forgo returning to Lagos for the throne in exchange for a promise of a stipend and a percentage of the royalty emanating from palm oil trade. More importantly, Smith says, "Article five stipulated that an export duty should be levied on Kosoko's behalf of one head of cowries for every puncheon of palm-oil and two strings of cowries per pound on all ivory exported from Palma. The last article provided that the agreement should enter into immediate force and be binding until annulled by the British Government. The signatories were Kosoko and fifteen of his chiefs on the Epe side, and Campbell and Miller for the British, the rest of the Consul's party acting as witnesses" (1969, 22).

While the treaty did not end Kosoko's ambition of returning to Lagos—he actually continued to fight until he was later allowed to return not as king but as a chief with influence in one area of the city—the intent of the British to declare sovereignty and have control over the new trading practices and access to the trading routes materialized. As we see in the next section, declaration of British sovereignty over the territory of Lagos and its environs can be likened to the claim of sovereignty by FTZs today. British sovereignty over the territories provided an opening for trading in palm products and the emergence of many European trading posts in the entire area. The manifestation of the new trading practices included the emergence of Lekki and its adjoining villages and settlements as an important palm oil plantations and ports of entry for many other valuable products aimed at the international commodity market (Tijani 2007; Falola and Avoseh 1995; Law 1983; Lynn 1982; Smith 1969).

While the annexation of Lagos and the subsequent control of Epe and its surroundings by the British took hold, land in rural and urban areas in Epe were still held by families, despite British's attempt at claiming ownership and control through the cession treaty signed with Kosoko in Epe and the Oba (king) of Lagos. The interest of the British and other Europeans who opened firms and warehouses in the area were tailored toward extraction of agricultural produce. Families who held land became cultivators of palm trees for the purposes of producing palm oil, which came to replace slave trading. Major beneficiaries of the land tenure system were those who had traveled from Lagos to Epe with Kosoko and the Ijebus who had remained in Epe and its surrounding settlements and villages. Though many of the areas between Epe and Lagos were not occupied until the dispersal, arable land suitable for the planting of palm trees helped in accelerating the settlements along the shores of eastern and western Lagoon. Archival records show that land ownership was such that the lands in urban Epe were divided between the extended families of those who migrated from Lagos with Kosoko and those who could trace their roots to Ijebu-Ode, hence the notion of Ijebu-Epe and Lagos-Epe—both terms signifying the migration pattern. Archival records show that rights to land in the adjoining settlements, in the area known as Lekki today, were vested in the family head at Epe. The British colonial record, in justifying annexation and occupation of the land, had claimed that while rights to land remain communal, people in the area never showed interest in land ownership other than for planting small crops for food sustainability. Yet to suggest that the "amount of interest shown in the land is not great" diminishes the ways in which many communities in the area view land as important to their livelihood practices. Land in the area is plentiful but not of poor quality, as colonial records would want us to understand. Suggesting that much of it had never been tilled shows a reconstruction of the history of land in the area by the British colonial powers because not tilling a particular plot of land does not suggest its lack of use in the future. In addition, such suggestion of lack of interest also contradicts the fact that trade in commodities such as palm oil grew astronomically when the British and their European trading allies along the shore of the lagoon shifted emphasis from trading in slaves to trading in palm oil and other agricultural produce.

Archival records show how district commissioners, operating under the cession treaty of Epe, attempted to grant land to those who had resettled in the Lekki area. The British had thought they were exercising their rights over land even when communal holding still held sway in the area. Records often show imprecise description of land allocation practices by the British around the area, but the indirect rule system of administration adopted by

the British granted the *Baale* (chief) the rights to a crop of the plantation and subsequently permitted the colonial native administration to benefit from the small fees charged for these rights (Smith 1969; CSO 26: 14962 *Papers Relating to the Family Dynasty in Lagos*, Exhibit D [M. H. Macaulay Evidence] 1933). The change in trading practices also meant that the economy of the area came to depend on the production and sale of palm oil through the Epe and Ejirin markets as well as the trading port at Epe. Land rights could be transferred from one family to other or in some instances to those who are strangers in the community as a matter of courtesy (CSO 26: 14962 *Papers Relating to the Family Dynasty in Lagos*, Exhibit D [M. H. Macauly Evidence], 1933). While the practice of transferring communal lands to those new in the community for the purpose of subsistence farming persisted, farming was still geared toward the production of tradable commodities that the British and European firms operating in the area needed, such as palm oil. Where family land is limited, the appearance of individual rights sometimes applies to tracts where the cultivation of annual crops has been attempted, shown in colonial records, though for ordinary purposes, land in the Lekki area has a negligible exchange value (Lynn 1982; Law 1983; Smith 1969; CSO 26: 14962 *Papers Relating to the Family Dynasty in Lagos*, Exhibit D [M. H. Macaulay Evidence], 1933).

However, the idea that land in the area has a negligible exchange value never stopped the colonial state and its postcolonial successor state from trading in commodities produced there. The land in the area earmarked for commodity production such as palm oil today serves a different purpose: the construction of an FTZ where the entire zone and those who work in it consider themselves to be engaging in trading and work practices in sovereign enclaves.

Just as colonial officials considered themselves expatriates of the British colonial government, today's participants in the labor force of the FTZs also consider themselves expatriates irrespective of their country of origin—Nigerians included. More importantly, the entire area demarcated as an FTZ today bears semblance to the ways in which Lagos became a colony of the British empire in 1861, thus signaling the transformation of Lagos from a slave port where labor was extracted, turned into human commodities, and shipped to the new world into a port for the extraction of labor and agricultural produce for the international commodity market. As the Lagos colony was a form of sovereign at the behest of the British, today the FTZs in Lagos and Ogun are a form of sovereign at the behest of the Chinese consortiums and their corporate partners who claim ownership of the entire zone. This is the main reason why many, when asked what they think about the zone,

would respond thus: "This place is not Nigeria." The space of the FTZs is, of course, Nigeria, but the ways in which FTZs are organized and how they become sovereign entities within a sovereign state leads many interlocutors to believe they do not look like Nigeria. As one interlocutor retorted to me in a popular Yoruba saying, "Orúkọ ọmọ ní í ro ọmọ, oríkì a sì máa ro ènìyàn" (meaning, "Name can reflect a person's character just like it can also reveal a person's action"). While the interlocutor is not specifically using the aphorism in reference to any individual, as it is with many Yoruba words, the interlocutor's interpretation is about the name Lekki and its association with the FTZ. Such Yoruba aphorisms can sometimes be used in reference to places, and, in this instance, my interlocutor is invoking the aphorism in reference to two interconnected events and spaces. The first is the name Lekki. As I stated earlier, Lekki is how indigenes in the area pronounced the name of a Portuguese slave merchant, Lecqi, during the era of trading in human commodities. Lecqi's tombstone today sits in front of Obafemi Awolowo Institute of Government and Policy Museum, while some relics of the slave trade lie in view inside the museum. Obafemi Awolowo was the first republic politician and anticolonial activist who was detained in the place in the 1960s because of his political views.[1] The second reference is the idea of a trade zone that is free of state encumbrances. Connecting the idea of a place named after a slave merchant to a zone where practices of extraction dispossess people of their lives and livelihood is, to many interlocutors, reminiscent of a particular form of historical continuity—yesterday's slave ports becoming today's commodity ports. This form of continuity results in the same outcome—dispossession and denial of livelihood. This form of dispossession is anchored in the idea of a place becoming sovereign in order to fulfill its role as a site of trading practices connected to the international capitalist system. The practice of FTZs as sovereign is not particular to Nigeria. In all the countries where FTZs have been established—Laos, India, China, and others—they always follow a system that defines different operational rules and regulations. The subjection of the FTZs to different rules and regulations makes them look more like a foreign entity than an entity that is locally operated, as we will see in the next section.

"This Place Is Not Nigeria": Free-Trade Zones and the Construction of the Sovereign

What best captures the FTZ as an economic and social system is its abstraction as part of the broader special economic zone (SEZ). This is why, for example, Laungaramsri (2015) argues that SEZs in Laos operate as one form of "self-imposed extraterritoriality" tailored to foreign investors, particularly

the Chinese. Using the case of the Golden Triangle Special Economic Zone, Laungaramsri (2015) examines the paradox of the desire to civilize and the will to survive within the border zone of northern Laos. Laungaramsri (2015) investigates the means and mechanisms that facilitate the process of the civilizing mission by the Chinese investor, arguing that commodifying sovereignty has contributed to the creation of the space of exception necessary for new economic possibilities to reshape the "wild zone" and its people into a productive resource. As Laungaramsri (2015, 30) suggests, "SEZs in Laos have been created to hasten the 'turning resources into capital' process by renting out various border areas at cheap prices for large scale foreign investment with unlimited access to natural resources and long term and renewable concession." This process has resonance with what Lyttleton and Nyíri (2011) call "soft extraterritoriality," which is the practice of having a form of control over resources and people while at the same time evading local juridical practices. Soft extraterritoriality, Laungaramsri (2015, 31) argues, can be likened to a "self-imposed extraterritoriality," a state-capital collaborative project in which a "weak state such as Laos has chosen to sacrifice its own sovereign right in exchange for national prosperity." In order to create a zone of exception (Ong 2006), land and livelihood practices are not only threatened but also denied because, Laungaramsri (2015, 39) suggests,

> As a zone of exception, the Golden Triangle Special Economic Zone has attracted a number of the border people who found themselves fitting well in this "out of state" place. Flexible as it is, there is no need for these people to declare their national ID card, which some of them might not have, and there is no problem for them to cross the border back and forth between Laos, Myanmar, and China. The advent of Special Economic Zone has thus turned the border into a neo-liberal space where sovereignty has given way to the force of market.

Thus, sovereignty becomes a commodity that is of value where the will to govern is invested in corporate entities and their state partners. Territories defined as SEZs become sovereign spaces where exceptions govern the rules of engagement. In such circumstances, those who work in the zones then consider themselves not of the state that has overall territorial control over the entire region but of the entities that control the enclaves of exception, hence what Guangwen (2015) calls "graduated sovereignty" and "geographical differentiation" in the application and practice of SEZs.

The notion of FTZs not being Nigeria first appeared in one of the conversations I had with the Nigerian workers in the zones during the summer of 2016. We had gathered at a lunch table in one of the restaurants inside the area demarcated for some of the Nigerian staff of the OGFTZ in Igbesa when

suddenly one of my interlocutors uttered the words, "This place is not Nigeria." I became curious to know why such a statement was important to that interlocutor and others with whom I interacted in the FTZs. The concept of a place not being Nigeria emanated from the idea of who is an expatriate and who is not. An expatriate is considered to be a highly knowledgeable émigré who is hired by an employer from another country—mostly Western countries—to use his or her knowledge at a workplace in a country considered to be underdeveloped. As such, in Nigeria, expatriates are highly regarded by many whom I interviewed. Since FTZs are often seen as sovereign enclaves where the state selectively cedes part of its sovereignty—including business registration, taxes, labor laws, and other regulatory practices—those who worked in the zone considered themselves to be part of a new sovereign. Furthermore, the ceding of part of the state's sovereignty to an enclave fits into the shifting meaning of the economy that moves from a system of social practice and relations to an object that is determined by numbers.

As Mitchell (2011, 125) claims, there was a shift in the meaning of *economy* in the nineteenth century from a system embedded in wider social relations to an object that refers to a "self-contained structure or totality of relations of production, distribution, and consumption of goods and services within a geographical space." This shift was such that the word *economy* became "an object whose management was the central task of government, requiring the deployment of specialist knowledge" (Mitchell 2011, 125)—a form of specialist knowledge that, in this case, is only imbued in the managers of free-trade zones and their state collaborators. In Nigeria, the abundance of oil resources automatically translates to the potentialities of oil revenue, which in turn shape the development practices that give rise to the establishment of economic zones that mediate human interactions. The state's discussion of the leveraging of oil revenue—an invisible object in and of itself—through other technological objects such as free-trade zones and oil refineries affords an avenue to understand how oil mediates political and business interactions in states such as Nigeria. These neoliberal affordances shape the practices that allow marked areas of the country—free-trade zones—to become their own sovereigns, hence an interlocutor's repeated notion that "this place is not Nigeria."

The question is, What makes this place not Nigeria? The answer is the specific practices that distinguish trade zones from the rest of the country. For example, the Corporate Affairs Commission registers all limited liability and other business enterprises in Nigeria, with the exception that the FTZs regulate and register enterprises by themselves through the offices of the Nigeria Export Processing Zone Authority (NEPZA). As one interlocutor

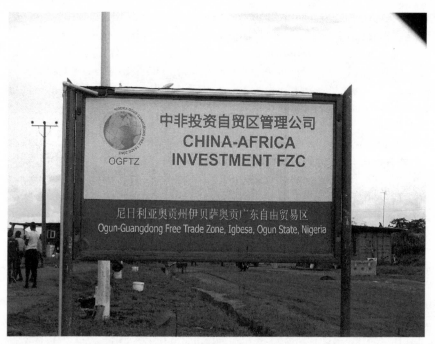

Fig. 3.1 Hewang Packaging and Printing FZE, one of the enterprises in the OGFTZ. Source: Photograph by the author.

told me, "The free zone is like a mini city. It is considered not to be part of Lagos or Ogun. Once you are in the free zone, you are out of Nigeria because this place is not part of Nigeria."[2] The free-trade zone has three major areas: the living quarters, the manufacturing zone, and the oil and gas sector. All members of staff are expected to live within the zone, but not all the staff quarters have been completed, so many Nigerian staff live outside the zone, while the zone provides all amenities. Although many parts of the LFTZ are still under construction, some companies are already operating within it (see fig. 3.1). The same is true for the OGFTZ, where, as table 3.1 shows, there are twelve enterprises currently in operation. For example, the zones, especially the OGFTZ, parade their replicas of a functioning police force and other disciplinary apparatuses of the state. The regular state disciplinary apparatuses are confined to the entrances of the LFTZ and the OGFTZ. In the case of the OGFTZ, the commander of the police is a Chinese official who is assisted by his Nigerian officers. While Nigerian police, customs, and immigration officers are positioned in the offices at the entrances of the free-trade zones, the exercise of power lies with the officials inside the zones. The presence of the Nigerian officials is mainly symbolic because the FTZs have and do exercise

Table 3.1 Enterprises Operating in the Ogun-Guangdong Free Trade Zone

Name of Enterprise	Year Designated	Ownership	Products
Goodwin Ceramic	2011	Goodwill Ceramic Co. FZE	Ceramic wares
Hewang Packaging and Printing Co.	2010	Sunway Industry FZE	Packaging materials
Panda Industry	2015	Panda Industries FZE	Iron and steel products (steel strip coil, galvanized pipes, C-type steel)
China Glass	2016	China Glass Holdings Limited	Float glass and online solar control glass
Wangkang Ceramics	2013	Wangkang Group	Ceramic wares
Sun Ceramics Kitchenware	2016	Sun Ceramics Co. FZE	Kitchenware products
Lee Group	2015	Lee Group	Steel, footwear, plastics
Wingham Furniture	2014	Wingham Furniture Co. FZE	Furniture
Green Power Utility	2013	Green Power Utility Co. FZE	Diesel fuel engines
Far East Steel	2015	Far East Industries Nigeria FZE	Iron and steel plant
Flying Horse Aluminum	2016	Flying Horse Aluminum Co. FZE	Aluminum products
Federated Steel Group	2014	Federated Steel Mills FZE	Architectural and structural metals manufacturing

their own regulatory practices, hence the notion among many interlocutors that living or working inside the zone is like being outside of Nigeria.

There are three interrelated ideas around sovereignty that define each of the FTZs in Nigeria. These are surveillance, trading practices, and overall organization of the zone. I witnessed during my stay in Igbesa that these three ideas are intertwined. In what follows, I use the examples of three interlocutors to discuss the interconnectedness of sovereignty with FTZs in Nigeria. At the entrance of the OGFTZ is a huge gate with the inscription, "Welcome to OGFTZ." Manning the first gate to the FTZ are OGFTZ security personnel, officials of the Nigerian Customs Service, the Nigerian police force, and immigration officials. The Nigerian security personnel's role is completely restricted to the first gate, while the main gate that leads to the

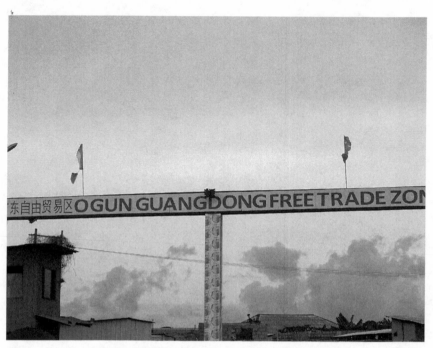

Fig. 3.2 The main entrance of the Ogun Guandong Free Trade Zone. Source: Photograph by the author.

zone is manned by the OGFTZ security personnel. This is also the practice in the LFTZ. As visitors approach the gate, they are expected to register with the security official who is the first point of contact. This is when the visitor is expected to give their identity for verification. Once this is done, the gate is opened for the visitor to drive in, park, and proceed to the gatehouse, where a further security check will be performed (see fig. 3.2). This security check includes calling the central security office to confirm the identity of the visitor, then checking with the unit within the zone where the visitor is headed. Once the check is complete, the visitor is handed a badge that they are expected to wear as a sign of recognition within the zone. I participated in this daily ritual during my visits. What I observed, however, is that the surveillance does not end there, as one is constantly surveilled by plainclothes security officers within the zone. More important is that the security personnel are referred to as "the police," and all their patrol vehicles and motorbikes have the insignia "OGFTZ Police." This is not just surprising but also confirms the notion of a sovereign within a sovereign because it is only the Nigeria police force that can be legally referred to as "the police" in Nigeria by virtue of the Nigerian 1999 constitution.

The performance of the role of the police within the zone while the state-recognized police are relegated to the entrance of the zone shows how surveillance as a form of sovereignty is tied to the organization of security and disciplinary apparatuses of an FTZ such as the OGFTZ. For the police officers, their day starts with an early-morning drill, followed by posting to different units within the zone. The chief of police is a Chinese official who, I was told, had previously worked as a police officer in China before being hired by the operators of the zone. He supervises the entire unit and oversees the surveillance room located within the zone. He is assisted by a Nigerian who also claims to be a retired police officer. Many of the other police officers are Nigerians, and most hold associate degrees and college diplomas. One of the officials is Segun, who prides himself on being one of the most reliable surveillance officers in the zone. Segun lives in a section of the zone designated for Nigerian expatriates. He holds a diploma in marketing but could not secure a marketing job, hence the choice of being a security officer when the opportunity came. When he is not on night duty, he wakes up at about 5:00 a.m. to organize the early-morning drill, which takes place every day in an area very close to the main gate. For police officers, before work starts, there has to be a short parade, enlightenment of the security officers about best security practices within the zone, and distribution of security men to their various posts, says Segun. The police officers wear uniforms and are assigned ranks. For example, ranks are assigned in the following way: three stars for captains (heads of the shifts), two for supervisors (second in command to the head), and one star for soldiers (the junior officers who take orders from the supervisor and the captain). The captains or the supervisors go on patrol with their bikes to check the security men posted to different locations in the zone. The security men may accost and question those who do not have tags and are found loitering around the zone. The only officers who are not in uniform are the undercover officers, those in the control room, and the chief of police. Segun also mentioned that not everyone participates in the early-morning drill because "you cannot keep your eyes closed every time." "Keeping your eyes closed" was his own way of explaining why some have to be on patrol while the drill goes on. The drill itself shows clearly how the security apparatus of the zone mimics the state police system, which engages in daily drills as a way to constantly check the fitness and preparedness of its personnel.

Segun hailed from a town in Ogun State (not Igbesa, where the zone is located). On being recruited, he and his fellow officers were all trained in issues of security, surveillance, evaluation, and monitoring. He is assigned a motorbike that he uses for patrol, but more importantly, he said he was

satisfied with his job. When asked if he was a police officer or a security officer, he responded in the affirmative: "I see myself as a police officer within the jurisdiction of the OGFTZ. I have the power to arrest and detain anyone that violates our rules and regulations." When asked if he had ever exercised his power to arrest, he told me that he had done that several times, including the day before our interview. He said, "There was a guy who came to transact business but was proven difficult for our boss [he pointed at a Chinese man passing by], I immediately swung into action, arrested him, put him inside our patrol van, and transported him to our interrogation room." Though Segun never mentioned what offense the man committed, he relished his enormous power to arrest and interrogate. He jocularly told me that if I wanted to test his power, I should commit an offense, and he wouldn't hesitate to get me arrested. We both laughed over it, and he jumped on his bike and zoomed off.

The central control room was managed by Josh, a graduate of arts and design from Xi'an University. Josh described himself as someone who has the capacity to multitask. He managed and supervised construction as well as the IT department, where he was in charge of the computers, CCTVs, and other apparatuses of surveillance for the zone. Josh said he didn't like the English language and only started learning it after he came to Nigeria in 2014. He was learning fast because his Nigerian friends who live in the zone were helping him; in return, he taught them Chinese. After work, he played with his computer, watched YouTube, and sometimes played Ping-Pong with other Chinese residents in his area of the zone. Part of his motivation for getting the job was his aversion to cold. The cold in his part of China could be harsh, said Josh, but Nigeria is a tropical country where the weather is warm and pleasant all year round. To him, because of the weather, Nigeria was better than China: "If I can, I will stay here forever." The only issue for Josh was that he had no family in Nigeria. Sometimes he felt lonely and missed the Chinese food at home. The zone provided Chinese food, but he didn't think it was comparable to the food in China.

Josh was consoled by the fact that his loneliness was manageable because there were people from Xi'an in the zone, and he cherished the opportunity to interact with them and other people from other parts of China. His daily routine varied depending on what was at stake on a daily basis. The control room was manned by other personnel, and this allowed him to do his other tasks in the zone, which included supervising the construction of new enterprises. Josh relished the ability to monitor the entire zone from his Techno (one of the phones produced by Chinese companies for the African market) mobile phone.[3] Occasionally, while walking around the zone, Josh would bring out

his phone to check for security alerts he needed to respond to. When asked if there was cooperation between his office and the Nigerian police, Josh responded, "Not at all. We are more sophisticated than they are. Again, we have our own rules here that we follow."

Officer Wang was the chief enforcer of those rules. Wang was the chief of police, and he was often seen around the zone, smoking a cigarette and sometimes being chauffeured by one of his police officers. Wang appeared very reclusive and hardly ever answered questions directly when I interviewed him. His usual referent was to point at things or refer me to other officials for answers to my questions. Many of the Nigerian expatriates who were police officers would call him "the boss." Doing so showed the enormous power he had over surveillance, but at the same time, it also showed some racial tension that sometimes existed between the Chinese bosses and their Nigerian subordinates. For example, one afternoon, I observed how one of the Chinese officers talked down to his Nigerian subordinates when he was addressing a gathering of these subordinates. The Chinese officer had pointed to two of the Nigerians standing at alert, saying, "Look at this lazy moron. Is this how to stand at alert? Haven't I taught you several times how to do it? Look at their ears. As big as these ears are, you don't use it to listen. What do you use it for?" The officer chuckled with his cigarette alight. When I asked the Nigerians if this happened all the time, they all chorused in the Nigerian parlance, "He is the boss. What can we do?" Not knowing what to do was how many Nigerians would respond to superior and oppressive power relations. For many of them, questioning the authority of their boss even when the boss was abusive meant losing their job and not being able to find a new one.

While Wang, Segun, Josh, and other security and police officers exemplify how sovereignty is performed within the zone, it is the business of the zone that renders it sovereign. Licensing, inspection, and registration of businesses in the zone also define how sovereignty is measured. Imported and exported goods enjoy special status in the zone. For example, while the OGFTZ still uses the Nigerian port in Apapa, the LFTZ is building its own port. When containers belonging to any of the FTZs arrive in the Nigerian port in Lagos, they are not subjected to any form of inspection as is the case with other imports. As soon as the containers arrive, the customs office at the gate of the FTZ conducts an inspection. The inspection is basically cross-checking the imported items with what is stated in the import documents. Once the documents align with what is in the container, that is where it ends. The container then proceeds to the FTZ, and the power of the Nigerian state over it ends because it then enters the jurisdiction of another sovereign and is free from the regulatory systems of the Nigerian state.

NEPZA, the agency of the Nigerian state that licenses FTZs, also maintains an office in front of all the FTZs, but their officials are not allowed inside the zones. The zones are expected to notify NEPZA officials of all activities, but that is where it ends—just notification for their records. One of the logistics and operations staff of a steel and consumable industry inside the OGFTZ explained to me the practice of the logistics operations during several meetings I had with him in the zone. Chen had a degree in business administration from China and prided himself on being a good English speaker. He was interviewed on Skype for the job of logistics manager after his brother, who also worked in the zone, helped submit his résumé. Chen's impeccable English was what endeared him to the operators of the zone. Chen's brother was the general manager, while Chen was in charge of logistics. The company that he worked for produces hollow pipes and some other related things, he said. They just produce there and send the products to Apapa port for shipment to the international market. The port is about forty miles from the zone. The materials they produce in the zone rely heavily on imported raw materials from China; hence, Chen told me, "We get 100 percent of the raw materials from China. It's quite impossible to get the raw materials in Nigeria because there is no steel-producing company here in Nigeria." When packing and loading containers, he said, they had to do some paperwork, which they submitted to the management of the zone, who in turn submitted it to NEPZA and the customs office at the gate of the zone. Chen's job was to prepare all the paperwork from his enterprise and take it to the zone's management office located close to the control room for endorsement. Once that was done, the shipment was loaded and transported to the port in Apapa and shipped to the international market. Chen explained the process this way in an interview: "You write all the information of the products to be loaded, drop copies of the documents for all of them, and you have to make sure the account must be balanced at the end of the day and all must tally. The papers are taken from the management to the customs and then NEPZA. After NEPZA, the management office will return the documents to you with a final permission to load your stuff." Each enterprise had its own operations and logistics office that liaised with the logistics and operations office of the zone. The logistics and operations office of the zone acted as the clearinghouse and go-between for Nigeria and the FTZ. Here lies the notion of sovereignty at play. My encounter with Gina helps clarify the process and reify the interplay of sovereignty within the FTZs.

Gina was in her early twenties, a recent college graduate with a degree in English from the University of Architecture in China. Gina's Nigerian friends named her Omolola, a Yoruba name that means "child of wealth" or

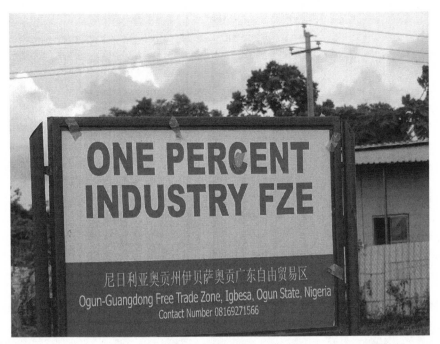

Fig. 3.3 The signpost in the main entrance of one of the enterprises in Ogun Guandong Free Trade Zone. Source: Photograph by the author.

"child is wealth." Gina cherished her name, though the name itself connotes many meanings in Yoruba. While its modern meaning equates it with wealth, wealth among the Yoruba is not predicated on financial well-being. Wealth among the Yoruba, as has been documented in the literature (Ade-Ajayi and Smith 1971; Akinjogbin 1992; Akinjogbin and Ayandele 1980; Guyer 1995, 2004) could mean having good health and a strong social network. However, her friends naming Gina Omolola is an indication of her power to control wealth and of the assumption that she must have been rich to have been able to relocate to Nigeria for wealth. It is also a demonstration of the social and racial hierarchy that exists within the zone, where Chinese expatriates are considered to be of higher status than their Nigerian counterparts. This is shown clearly in the demarcation of housing within the zone. To return to logistics, Gina's role was in crafting and managing the zone's logistics operation, helping to register new enterprises, collating documents, which include the packing list—a list of items to be shipped by any enterprise—and informing the customs office and NEPZA of new goods arrivals before opening them. There are many enterprises in the zone (see fig. 3.3), and this made Gina's job of coordinating paperwork one of the most important. Gina told me,

"The work of the operations department is to perfect our paperwork before products are exported and sold because most things produced here are sold out of Nigeria, for example, plastic wastes/scrap which is produced by Henghui Recycling Resources." Gina also mentioned that most companies in the zone recruited people from China. My encounter with Gina did not end without her telling me a little about her social life, which she said was boring in the beginning because she missed her family and friends but that she had been able to overcome that. Gina chuckled when she told me she now has a boyfriend who lives in the zone. When asked if her boyfriend is Nigerian or Chinese, she responded, "Chinese, of course, but I wouldn't mind dating a Nigerian." Gina loved Nigeria and appreciated her Nigerian friends, some of whom mostly worked in the Chinese quarter's canteen. Gina was one of the few Chinese women who worked in the zone. Some of the men told me their spouses were back in China and that they regularly communicated through Skype, and they also sent money home to their families. The privilege of working in the zone included being chauffeur-driven whenever one had to go outside the zone, mostly to Apapa port in Lagos. The condition of the road was terrible and could sometimes result in traffic jams, especially when it rained. Those who suffered the consequences of the terrible road were the farmers and traders from Igbesa who used motorbikes and bicycles but now competed for the use of the road with the FTZ's trucks. According to many Igbesa farmers, the road was mainly damaged by the big trucks, and they saw the FTZ as a threat to their livelihood practices.

While the FTZs enjoy their sovereignty, the same cannot be said of the Igbesa community, host to the OGFTZ. Igbesa, a community of about eight thousand people, mostly farmers and traders, is in the Ado-Odo/Ota Local Government area of Ogun State. The many farmers and other residents of Igbesa, those whose farmland has not been taken to make way for the FTZ, now suffer the jeopardy of not being able to go to their farms because the road to the farm is like a road to hell. Adenrele is one of the farmers and community leaders of Igbesa who lost part of his farmland to the FTZ without compensation. The little parcel of land he is left to farm with is now under constant threat of flooding whenever it rains, coupled with bad roads that make it impossible for him to transport his produce to the market. As he said, "All our farmers have been impoverished by the situation of our roads, as they can no longer transport their market produce easily."[4] Many in the community would say it is not as if the Chinese companies do not help in the rehabilitation of the road, but they would want their efforts to be complemented by the state, which brought the Chinese to their community. One of the elders, Chief Lawal, stated, "While the Chinese industrialists who had

come to our community to site industries were willing to assist in rehabilitating our bad roads, they expressed concern that the state is not doing its bit, as such, and became reluctant in fulfilling their promise. This is because they see leadership as security."[5] Seeing leadership as security, in the interpretation of many community members, means not ceding your sovereignty to a foreign entity and not displacing your population to make way for a foreign entity to occupy the space used for livelihood practices by your citizens. The catchphrases for FTZs include "infrastructure development," and many in Igbesa and other communities near FTZs often lament the absence of basic infrastructure, such as functioning hospitals and clinics. For example, in Igbesa, many told me that the only community primary school there operates in dilapidated structures that are disasters waiting to happen.

Therefore, FTZs are constructed as autonomous zones that are independent from the state through their regulatory practices. These zones operate in ways that resonate with what Trouillot (2016) calls "the state-effects." State-effects indicate the use of state mechanisms of control and rule and, in the examples of FTZs, the setting up of a separate security department, proposed offshore banking operations, a customs department, and the ability to engage in business transactions and other self-regulatory practices outside the purview of the state. Such practices create what I call "the effect of a state within the state." Thus, the organization of the FTZ, particularly its workforce and regulatory practices, projects a neoliberal notion of freedom while at the same time extenuating a new moment of colonial practices in the postcolony in ways that resonate with Jauch's (2011) likening of Chinese investments in Africa to a new moment in colonialism. For example, all workers, as I was informed and observed while there, are considered to be expatriates. The notion of expatriates suggests that the workforce is foreign, and since the space of the FTZs is also considered foreign, the tag *expatriates* seems to project the notion of sovereignty within a sovereign nation. While all the workers are considered to be expatriates, there are also different categories of expatriates within the zone. For instance, Nigerian expatriates are mostly subservient to Chinese expatriates in deeds and practice. Living quarters for Chinese expatriates, who are mostly senior or management staff, are in an exclusive part of the zone with better layouts and amenities, whereas those of the Nigerians are not. Living quarters are also demarcated in a way that articulates a class distinction, which brings back memories of such distinctions in colonial Nigeria, where Government Reservation Areas were exclusive to colonial administrators, whereas Nigerians who worked for the colonial authorities were relegated to the rest of the country (Adunbi 2015; Apter 1992; Mann 1991, 2007; Watson 2013). For example, in colonial Lagos, the

British lived in Ikoyi and Victoria Island, a highbrow area of Lagos, whereas the Nigerian staff lived in designated quarters in Yaba and Surulere, an area considered to be for low-income workers. Similar colonial practices were replicated in all the major cities and towns in colonial Nigeria. In the postcolony, multinational oil corporations have also shaped such practices through housing classifications, as Adunbi (2015) observed in the city of Port Harcourt.

One of the important regulatory practices of the state is the management and disciplining of international banking and financial transactions. The deregulation of international banking and financial transactions within the FTZs can also be read within the framework of new colonial practices. For example, the state regulates how banking and financial transactions are conducted within its territory. Financial services and transactions come with appurtenances of taxation on foreign transactions and other monetary transfers that companies can undertake. However, this is different for the zones, particularly for the LFTZ. For example, one of the regulatory practices enacted in the LFTZ is the establishment of offshore financial and banking operations. The use of offshore banking and financial services allows corporations and businesses to shield transactions from the prying eyes of the state, avoid paying taxes on profits, and create a form of secrecy (Shaxson 2014; Stiglitz 2008; Unger 2009). While the establishment of an offshore banking system within the FTZs is envisaged to facilitate easy access to financial support for businesses within the zones, this will further legitimize the claim that the zone is not Nigeria, as the term *offshore* in and of itself suggests that it is foreign or completely detached. As one interlocutor noted during our interaction, "With offshore banking in our zone, we will no longer be required to process our financial transactions through the Central Bank of Nigeria."[6] Since the Central Bank of Nigeria is the apex regulatory institution of the state in banking and financial services, bypassing it creates a sovereign space for the FTZs in which they can self-regulate and enforce their own regulatory practices away from the prying eyes of the state. Therefore, offshore banking provides a platform that allows the zones to produce, manage, and deploy their profits in ways that protect them from state regulatory practices. The infrastructure of offshore practices, combined with the disciplinary practices of the zones, creates an environment of sovereignty in such a way that the zone becomes a state detached from the larger state.

THE SOVEREIGN ZONES: OFFSHORE BANKING AND THE CONSTRUCTION OF AN INVESTMENT CLIMATE

The infrastructure of offshore practices embodies the ideation of sites of financial transactions that are outside the shores of state jurisdiction. The ability

to offshore money and financial gains is highly coveted in the business world since it indicates the ability to evade state-sanctioned tax regimes. Nothing exemplifies this moment of sovereignty of offshore financial transactions for the FTZs more than an investors' meeting at the LFTZ in Lagos in the summer of 2017. I had arrived at the zone in the morning for a regular meeting with some of the officials of the zone when my host decided to take me on a surprise tour of some of the new enterprises in production that day. My host was always desirous of showing me how effective the zone has been since its inception; hence, my visits were usually marked with a display of some of the accomplishments of the zones. However, that day in June 2017 was a little different. A group of investors was paying a visit to the zone to ascertain the veracity of what they had been told in their correspondence with the zone's management. The investors were largely from China or were members of the Nigerian-German Chamber of Commerce or the Nigerian-American Chamber of Commerce as well as a few local businesses. In attendance were also a few journalists from some of the major newspapers in Nigeria. The investors' meeting was chaired by the Lagos state commissioner for commerce and industry with support from the managing director of Lekki Worldwide Investments Ltd.—a major partner of the Chinese owners of the zone—and the management of the zone. The meeting, as I later understood, was held to encourage more businesses to buy in to the free-trade zone project. After the managing director of Lekki Worldwide Investments Ltd. and the commissioner were done with their presentations, one potential investor asked what the benefits were for the new investors. The managing director's response was that the zone represents a site where investors will be guaranteed 100 percent return on investment because the zone is a self-regulating entity devoid of the "state bureaucratic bottlenecks because it takes minutes to get businesses registered at the zone. With offshore banking facilities, you do not need to worry about state banking regulations because of easy access to foreign exchange." Many of the investors were thrilled by the potential of keeping 100 percent of their profits and being able to bypass state banking regulations.

At the end of the meeting, I joined a tour of the zone organized for the investors where some of the enterprises already in operation were showcased. The investors were ushered onto three waiting Toyota coaster buses outside the zone's conference center. Our first stop was at Crown, a garment manufacturing enterprise within the zone. The manager of the enterprise, who introduced himself as Mr. Benson, showed the group some of the products being manufactured at the factory. Mr. Benson explained some of the benefits of operating in the zone as including access to the US market through the Africa Growth and Opportunity Act. He further explained that

his enterprise was a few steps away from being certified to be able to export its products to the United States, which he considered to be the major target of his enterprise. Benson explained how he had just returned from Ghana, where a meeting about using the Africa Growth and Opportunity Act was convened at the American embassy in Accra. The meeting, he said, focused on steps to certification in exporting products to the US. Ghana, Benson said, had been designated the West African hub for all industries interested in exporting products to the US, hence the reason why the meeting took place there. Benson also said the meeting was one of the several he had attended in Ghana. After his initial interaction with some of the potential investors, Benson took us around the small factory—an open space with over three hundred sewing machines—where he showed some of the products manufactured, which were mainly fez caps. There were a few people in the factory, all women. When I asked Benson about the makeup of his workforce, he said that his enterprise employed mostly women because "women can sew, and many of them are from the local communities." While some of the women were from the local communities, many also came from outside the area. What was striking was the fact that some of the company's officials made it clear there were certain jobs women could do; the idea of specific jobs for women reverberates around the FTZs, where women work mostly in garment jobs or restaurants. The idea of specific jobs for women resonates with notions of patriarchy that are still prevalent in Nigeria and widely touted by people within the trade zones—Chinese and Nigerians alike. When asked why more women are not employed in other sectors within the zones, my Nigerian and Chinese interlocutors would often avoid a direct answer. Sometimes, the answers were, "Oh, women do not apply for these kind of jobs"; sometimes they were, "Oh, we have a lot of women here." Answers such as "having a lot of women here" were sometimes followed by pointing at women in the area, who were mostly working as receptionists and restaurant attendants or packing produced materials into boxes. These answers remind me of the then–US Republican presidential nominee's infamous response about women at a campaign event where he said, "I have binders full of women." The zones have "binders full of women," but the women are only visible in garment factories. Participants at the investors' forum also had a similar problem because the program itself was dominated by men, with a handful of women—mostly journalists—participating.

Other enterprises I visited included a truck assembly plant with about four trucks displayed outside, a mop manufacturing enterprise, and an insecticide enterprise. The truck assembly plant didn't show any indication of being able to manufacture more than four trucks. What this shows is the benefit

of having a sovereign space where you are far away from the prying eyes of the Nigerian state regulatory system. As I was told several times, whatever is imported or exported is not subject to state control; hence, trucks could be imported from China, their labels changed to say "Made in Nigeria," and be exported to the international market. Offshore banking within the zone means the transaction starts and ends in the zone, while the ability to repatriate 100 percent of your profit also means all benefits do not necessarily reside in Nigeria but rather outside of it.

Bataille (1991) reminds us not to view sovereignty through the lens of the state because sovereignty can be disentangled from the state, especially when the sovereign is engaged in a form of consumption that does not originate from his labor but from that of others through the production of surplus. Thus, what is sovereign can only come from the arbitrary because sovereignty is never truly objective but only objective in response to what Bataille (1991, 237) calls our "clumsiness, which cannot arrive at the subject except by posting some object which we then negate, or destroy." Therefore, to Bataille, the sovereign man lives in the moment, just like the sovereign FTZ lives in the moment of conspicuous change in the organization of the economy in ways that transfer some aspect of state sovereignty to a new body, such as the FTZ. While this practice in itself is not new—colonial forms of extraction followed this pattern—what is new is the way in which the new system of economic organization is endorsed and sanctioned by the state and its elite rulers. As we will see in the next chapter, sovereignty can also entail a form of self-sacrifice inscribed in how technologies of extraction travel. When technologies of extraction travel, new innovative systems that support change in livelihood practices emerge. How these new systems of innovation interact with the environment such that they change the spaces of extractive enclaves is important to my analysis.

NOTES

1. Obafemi Awolowo was one of the leaders who fought for Nigeria's independence from colonialism. When Nigeria won independence from Britain in 1960, Awolowo became the leader of the opposition in Nigeria's first republic. He was later charged on a trumped-up allegation of planning to overthrow the government and sentenced to a prison term. The Lekki area was mostly swampy and only occupied by the indigenes. Awolowo was sent to the area as a way of isolating him from public life. On Nigeria's return to civil rule in 1999, the new administration of Lagos State decided to transform the isolation house into an institute for the study of governance. Ironically, placing the tomb of a slave merchant in front of a building where a freedom fighter was jailed is instructive.

2. Interview conducted at the LFTZ and OGFTZ between June 20 and July 15, 2016.

3. Techno phones are very popular in Nigeria and many other African countries. They are imitations of the iPhone.

4. Interview conducted in Igbesa town, July 18, 2017.

5. Interview conducted in Igbesa town, July 18, 2017.

6. Interview conducted at the Lekki Free Trade Zone, July 2017.

4. FROM MOONSHINE TO OGOGORO

The (Re)Invention of Techniques of Refining and Extraction in the Creeks of Oil

Ordinarily sipping locally brewed bootleg whiskey popularly known as Ogogoro in the Niger Delta has for ages been seemingly a harmless indulgence, until it turned into a nightmare that claimed the lives of scores of persons in Bonny island, Bodo, Woji and other parts of Rivers State.

Kelvin Ebiri and Ann Godwin (2015), Guardian[1]

Follow your dreams and passion, no matter what happens, and at some point, you will achieve your dream. This was what one of my interlocutors, Jimmy, told me on our first meeting at an artisanal refinery site in the summer of 2016. As a teenager, he had helped his father set up his small ogogoro business in their village. As he says, "My father was already doing ogogoro refining while I was a young primary school boy. Every morning, he would wake up at about five a.m. to set up the day's refining. By noon all is done, and shortly after my mom would start welcoming customers to pick up their ogogoro consignment."[2] By the time Jimmy was in secondary school, he had mastered a few science subjects and was able to use that knowledge to help his father improve on the technology of ogogoro refining. Jimmy's ambition was to become a scientist and an oil merchant; his teenage nickname was "Einstein the oil mogul." Today, Jimmy boldly told me, "I may not have become a scientist, but I can proudly say I am an oil mogul." When asked if his high school classmates still refer to him as Einstein the oil mogul, his response was that some of them who were still around in the village would occasionally call him that. Jimmy's nickname cannot be said to be an accident of history because he had his mind focused on one thing while growing up: deriving benefit from the oil that he says his community is blessed with. Connected to this idea of deriving benefit is how Jimmy sees the importance of Ògún, the god of iron, in crafting technologies of extraction. As Jimmy

told me, "If Ògún had not made the invention of iron possible, we would not have been able to use iron in casting sheets for our refinery today. I give praise to Ògún and all our ancestors for bestowing this legacy of oil, ogogoro, and its technology on us."[3] Jimmy recognizes the importance of ritual practices for how technology is understood in his part of the Niger Delta, hence his invocation of the relationship between Ògún and the use of iron in artisanal refineries. Now, his knowledge of the technology of ogogoro production is what he deploys, alongside his business partners, in building artisanal refineries in one of the creeks of the Niger Delta. While Jimmy the Einstein and oil mogul's dream of becoming a renowned scientist and oil merchant may not have materialized in the way we would see it from a Western perspective, his dream of becoming an oil trader can be said to have materialized in another way. Jimmy is one of the most sought-after artisanal refiners in the creeks of the Delta, and this is because of his knowledge of an old technology that he uses in building a new technology that helps him set up an extractive practice. The practice of artisanal refining can best be understood through the social and technological history of ogogoro. This social and technological history is ingrained in ogogoro's three uses—as a ritual form, as a stimulant that galvanizes action for work, and as a form of innovative application of technological practice. Jimmy encompasses all three. Every morning, before commencing operations at his refinery, he pays homage to Ògún while at the same time making ogogoro abundantly available to members of his staff. In what follows, I show how the social and technological history of ogogoro is important to our understanding of the use of innovative technology in building artisanal refineries by youths such as Jimmy and many others in the creeks of the Niger Delta.

This chapter interrogates the structures and practices of artisanal extraction by linking old and new extractive practices. Drawing a connection between the brewing of moonshine in the United States and ogogoro local liquor in Nigeria, the chapter suggests that today's artisanal refining practices may have had their origin within a particular colonial history of Nigeria. The chapter argues that artisanal processes and structures of extraction reflect innovative and hybrid forms of knowledge, particularly in technologies of ogogoro production, which have become useful in the production of crude oil by today's youths. This hybrid form of knowledge that produces a particular method of extraction in the Niger Delta is locatable within two important tropes. The first is the specific history of production of palm wine, palm fronds, and palm oil as an important element in certain ritual practices in many Niger Delta communities in particular and in Nigeria in general. For example, among the Yoruba of West Africa and the diaspora, these ritual

practices are central to the myth of Ògún, the Yoruba god of iron. Ògún is a highly revered god worshipped by many in West Africa and the diaspora, and palm fronds, palm oil, and palm wine production and extraction are central to the ritual practices of its devotees. More importantly, one of the essential ingredients of ogogoro is palm wine. At the same time, the making of ogogoro has also meant its insertion into some ritual practices that palm wine has hitherto been used for, such that both are sometimes combined. For instance, ogogoro and palm wine are used for funerals, naming ceremonies, marriages, and making connections to gods. The second trope is weaved around the specific history of the connection between moonshine and ogogoro production. To illustrate this connection, the chapter maps how technology travels by looking at the ways in which the prohibition act in the United States led to a boom in illegal brewing of moonshine in many households such that a Nigerian shipmate traveling in the United States in the 1920s got wind of the technology and introduced it to Nigeria on his return. While the chapter does not foreclose the presence of brewing in Nigeria prior to the shipmate's visit—for example, palm wine has been around for a long time—it is the innovation that he introduced into the techniques of brewing in Nigeria that is important to my analysis. This new technique produces a new liquor that is known in some communities as *ameereka*, a corruption of the name America. The connection between the shipmate's travel and exposure to moonshine in the United States and the naming of a drink after ameereka, I argue, is not a mere coincidence but a historical fact that is often ignored in the literature. Central to the introduction of this new technique of brewing liquor is the innovation that it brought into many communities that today is used in developing new technologies of extraction—the refining of crude oil in the Niger Delta.

The chapter further shows how technologies of extraction travel across time and space in ways that incorporate local and transnational knowledge networks into production and delivery methods. Technologies of liquor extraction, especially when declared illicit by the state, travel to communities across the globe—to the United States, Russia, Britain, and others—in ways that demonstrate how subject populations can circumvent the state in producing an extractive practice. In the specific case of Nigeria, techniques of extraction are interwoven with the making of moonshine, the introduction of techniques of moonshine to an existing brewing technology, and a particular colonial history that spans travel across the Atlantic and shapes the practices of innovation and mimicry of state and corporate extractive practices. When technology travels, it can reinvigorate a sense of community and business enterprise and can provide sustainable livelihoods for communities and individuals. A clear understanding of how technology travels is

embedded in how moonshine became, at one time, a liquor of choice in the history of the United States. First, though, I look at the importance attached to palm wine in Nigeria through certain ritual practices associated with it. These rituals are embedded in a particular history that includes the use of palm wine, palm trees, Ògún the god of iron, and techniques of extraction in the crude creeks of oil.

Ògún, Rituals, and the Duality of Palm Wine

Palm wine has its own history rooted in ritual practices that connect it with iron, palm oil, and palm fronds. The making of liquor, especially palm wine, is not new in Nigeria. For example, palm wine is central to the myth surrounding the history of Ògún, the god of iron in Yoruba mythology. Among the Yoruba of West Africa, especially Ògún devotees, palm wine serves as a wine for oblation (Lawuyi 1988; Lindon 1990). While palm wine as a liquor is not particularly new, what is new and innovative is how it became transformed from a wine derived mainly from the palm trees into a liquor that adds other ingredients to its production, as we shall see in the next section.

In many Yoruba communities, Ògún is regarded as the god of iron. Barnes (1989), for example, calls the centrality of iron to Ògún practices "the sacred iron complex," by which she refers to the sacredness of iron to the rituals of Ògún, the place of ironworkers as devotees of Ògún in Yoruba history—in West Africa and the diaspora—and the use of iron workplaces as ritual shrines. This resonates with the idea of Ògún as god of iron epitomized in Yoruba mythology. In one such myth, Ògún was said to have visited a town known as Ire after one of his military exploits. He was said to have been the commander in chief of Oduduwa's armed forces. Oduduwa was the progenitor of the Yoruba (Adunbi 2015; Apter 1992; Ayandele 1966). On his arrival in Ire town, he was said to have met the entire town in a festive mood and was shocked that no one offered him food and drink or gave him any attention. In anger, he drew his sword to kill the people. Ògún's son, however, intervened and offered him palm wine, food, dogs, snails, and palm oil, after which he became calm and allowed the festivities to continue. Ever since, these items have been central to how his devotees worship him (Berger 1968; Lawuyi 1988, 134; K. Olupona 1983). In some Ògún devotee ritual practices, palm wine, palm oil, snails, and dogs are offered as sacrifices to Ògún. Ògún's shrines are usually covered with palm fronds because it is believed that when Ògún was in this world, he would cover himself with palm fronds while holding all his instruments of warfare made of iron. In many communities that I visited, I saw shrines that bore resemblance to this description of the ritual practices.

More important is the centrality of palm wine as a healing mechanism. For example, in some communities it is believed that palm wine has the ability to cure all kinds of illness, especially fever. In Ila-Orogun, a Yoruba community, there is a popular saying: "Ìlá ò lóògùn, ẹmu funfun lòògùn Ìlá." This translates as "Ìlá does not have any medicine, but palm wine is the only known medicine that Ìlá has." It is often stated, too, that "ẹmu funfun lòògun ibà," meaning "palm wine is the cure for fever." Some of my interlocutors would say to me that when one is down with a fever, a cup of palm wine can magically cure it. In addition to drinking palm wine alone to cure fever, many interlocutors told of how it can be mixed with herbs to treat other ailments, such as chicken pox and measles. One mother I interviewed told me of how a healer mixed certain herbs with palm wine to rub on the body of her son when he was afflicted with chicken pox. As she described it, "The herbs are soaked in a pan of palm wine for a few days, after which it is rubbed on the body of the child several times a day. This helps dry the pox and prevent itching. Part of the mixture is also taken as a drink three times a day to purge the disease from the bloodstream."[4] For many who may not be able to afford hospital expenses or who live far away from medical facilities, this process becomes an antidote to many ailments. This is an old practice that predates modern medicine, and many community members still believe it is effective for treating ailments.

I did not conduct any medical or scientific study to test the efficacy of these claims; my interest lies largely at the intersection of these practices with extraction and how old ways of doing things tend to lead to new ways of organizing society. My interpretation is that while palm wine may not cure fever, one of the stimulants in palm wine may have the capacity to invigorate an individual who consumes the wine when weak with fever. The duality of palm wine—a liquor and an object of ritual that also serves as medicine—is what makes it an important element in rituals among many communities in the Niger Delta and across the West African subregion and the diaspora. Palm wine, palm oil, and palm fronds are all engrained in the duality of palm wine as a ritual obligation among devotees of Ògún and those who use palm wine as medication in many communities. At the same time, this duality is also embedded in the belief in the potency of palm wine as an antidote to ailments. Thus, palm wine is not just a liquor; it is also an essential element of rituals associated with the god of iron and has medicinal attributes. More importantly, palm wine has the capacity to be used in innovative techniques of extraction. It is this innovation, brought about by new technologies of extracting ogogoro, and how such techniques of extraction interact with crude oil that is important to my analysis. These new techniques of

extraction can also illustrate how technologies travel across time and space, as we will see in the next section.

What's in a Name? Death, Palm Wine, Ogogoro, and the Techniques of Extracting Ameereka

In June 2015, in the *Guardian* newspaper, one of Nigeria's leading news outlets, correspondents Kelvin Ebiri and Ann Godwin outlined how approximately seventy people had died in communities across the Niger Delta after taking a sip of ogogoro, the local gin.[5] The report was signposted by two pictures, one showing the face of a bewildered youth leader and the other showing large quantities of plastic drums used in packaging the gin, popularly known in Nigeria as "jerry cans." The report showed how the death of these seventy youths from the gin led to the police confiscating jerry cans of ogogoro across the Niger Delta to forestall "further harm" to youths in the communities. However, the report did not end there. It also quoted the president of a youth organization on Bonny Island, the site of Nigeria's largest liquefied natural gas plant, Simeon Wilcox, as saying,

> In Bonny people take local gin to keep warm just as the Russians do with vodka. It is habitual. People in the Niger Delta drink kai-kai a lot, especially now that it is raining. The reason why the figure is high is because of the raining season, otherwise the figure could have been minimal. We lost a lot of youths due to its consumption and this is because of joblessness. We need the government to be aware that Bonny is still a part of Nigeria. NLNG [Nigeria Liquified Natural Gas] alone contributes six per cent to Nigeria's GDP. The Shell terminal exports 30 per cent of Nigeria's oil export. Yet there is no federal presence.[6]

Wilcox is the president of Bonny Youth Federation, an organization devoted to the promotion of the interest of youths in the Bonny area of the Niger Delta. Wilcox connects the death of the seventy youths who drank the local liquor to the state of the economy, joblessness, and the perceived marginalization of the community and the youths of the area, specifically by multinational corporations such as the Shell Petroleum Development Company of Nigeria—one of the operators of the liquified natural gas plant. But absent from Wilcox's narrative is the fact that ogogoro consumption predates oil exploration in the region.

Earlier in the year, a similar episode happened at Ode-Irele, a town in Ondo State, one of the Niger Delta states where scores of mysterious deaths were reported. On April 21, 2015, in the *International Business Times*, reporter Morgan Winsor wrote about how Nigeria's string of mysterious deaths was linked to contamination in the processing of ogogoro.[7] Interestingly, the

picture displayed in that report shows two men in protective gear carrying what looks like a dead boy. It was clear that the picture was not taken at the site of the incident but was instead used to illustrate how the scores of deaths resonate with the 2013 Ebola outbreak in Guinea and Sierra Leone. As Winsor reported, "Although the symptoms were reportedly different than those of Ebola, health officials last week were utilizing the same protective gear used during the deadly West African outbreak to handle patients and victims. Residents of the Ode-Irele's Ikale community, a sub-ethnic group in Ondo state, were afraid to touch the dead for fear the illness was indeed Ebola, which has killed more than 10,500 people in Guinea, Liberia, and Sierra Leone since 2013."[8] The picture categorized the entire West African region as having similarities regarding disease outbreak and response systems and further illustrates how diseased bodies are managed and discarded in a completely detached and unencumbered way that is suggestive of how black bodies are often treated in sites where black populations live. The mysterious deaths had initially been attributed to the deadly Ebola virus by many local inhabitants, but they were later confirmed to have been caused by contaminated ogogoro. The effect of the widespread deaths occurring across this region was the prohibition of the production of the local gin by the federal government of Nigeria through executive fiat. Many retailers and families who relied on the product for their livelihood resisted the prohibition and insisted on its continued sale and consumption.

While perhaps seeming unrelated to the larger themes of this book, these narratives of ogogoro contamination and death actually reproduce discourses of extractive practices in Nigeria. Wilcox, the youth leader in the example above, sees consumption of liquor that leads to deaths of young people in his community as resulting from particular ways in which extractive practices by the state and its corporate allies can be disenfranchising and lead youths to turn to alcoholism. Further, the *International Business Times* report illustrates how news about Africa can often be couched in language and images of a dangerous continent in need of careful management. However, what is missing from these two interrelated reports about the use, production, and consumption of ogogoro in the Niger Delta specifically and Nigeria and West Africa in general is the particular history of extraction that connects its production to the materiality of wealth, ritual practices, modes of extraction, and sustainable livelihoods in the region. When asked about the incidents described by these various outlets, many interlocutors told me that the reporters did not know the history of the liquor, nor did they understand the intricacies of its production, use, and consumption. One elder in a community in the Niger Delta stated this during one of our interactions in

the summer of 2016. Johnbull is in his early seventies—as he told me—and he made it clear that he is old enough to know a little bit of the history of palm wine and its intricate connection to ogogoro in the Niger Delta. Johnbull's family still maintains a small ogogoro business in the village. He is considered the patriarch of his family, which consists of two wives and several children. When asked how many children he has, he made it clear that numbers of children are never disclosed in his community.

"Papa," as Johnbull is fondly called by many in the village, started in the ogogoro business in the 1950s, a business he inherited from his father. As he told me, the 1950s marked a turning point in the ogogoro business in his village when many youths began blending fishing—a common profession—with brewing ogogoro because of an increase in demand for the liquor as well as the ability to make more money from it. The business he inherited from his father, he claims, cannot be responsible for the deaths attributed to it today. More importantly, Papa describes a particular history of the extraction of ogogoro that resonates with palm wine extraction and other ritual practices among Niger Delta communities elucidated by Leis (1964). For example, Leis (1964, 830) contends that among Niger Delta communities, a rite of passage for youths is observed at the age of sixteen: "It occurs at about the age of sixteen when he climbs a palm-oil tree and cuts down his first bunch of palm fruit. He brings the fruit to a man or woman who extracts the oil from the berries and rubs the youth with the oil. At that time, the novice is encouraged to continue being fearless in obtaining palm bunches. Parents want their sons to experience this ritual and to learn the traditional activity of producing palm oil before going on to any other occupation." While these rites are no longer observed in many communities today, the connection to the primacy of harvesting palm fruits to make palm oil as well as being able to climb palm trees to extract palm wine used in making ogogoro is still in place. Papa explained that prior to the transition to making ogogoro, many in the community relied on palm wine, but his father was said to have traveled to another community in the early 1940s, where he encountered the new techniques of turning palm wine into ogogoro. According to Papa, "My father told me he went on a fishing expedition to some communities outside our own. One evening, he was entertained by a drink that looks different from palm wine, and when he asked what the drink was called, my father was told it is called ameereka."[9] Many people I interviewed in the Niger Delta confirmed the name ameereka among the several names that the new liquor was known by. Among the Urhobos of the Niger Delta, in the 1930s and 1940s, the drink was popularly known as "udi ameereka"—meaning "American drink" or "white man's drink"—and in other parts of the Niger Delta and

Nigeria, the drink is sometimes referred to as "craze man drink," "push me I push you," or "Sapele water" (Ayandele 1966; Felix Forae 2013; Korieh 2003).

Sapele is a major port town in the Niger Delta, and it served as one of the centers of colonial power in Nigeria. The town is connected to many other Niger Delta communities through various roads, creeks, and waterways. Colonial records indicate internal trading and travel practices through the waterways in the entire Niger Delta region. The Urhobos and many other ethnic groups, such as the Itsekiris and Isoko, inhabit Sapele. Many whom I interviewed there alluded to the fact that the liquor is still interchangeably referred to as ameereka or ogogoro. At a local bar in Sapele in the summer of 2018, I asked about the origin of ogogoro. One of my interlocutors narrated how his late maternal grandmother told him that some people call the drink ameereka, while others call it Sapele water or "push me I push you." He said,

> I used to ask a lot of questions back then when I was a teenager in the 1970s. I will sit in front of the porch where my grandmother sells the drink. I will see many people come to patronize my grandmother. My grandmother brews the drink by herself, while my grandfather will provide the palm wine and other essential ingredients. Some customers will ask my grandmother to give them ameereka, and some will ask for ogogoro. I became curious, and I asked if there is any difference between the two, to which my grandmother responded no.[10]

In my interlocutor's telling, his grandmother's account of ameereka is premised on how the grandfather made a transition from the palm kernel and palm oil trade to that of ogogoro after his many travels around the creeks selling palm oil. On one such trip, which was usual for many in the Niger Delta communities, he was said to have encountered a new technology that could fetch more money for the family than mere trading in palm oil. With this new technology, he was able to turn palm wine into a new liquor based on new extractive practices. Other people interviewed in several of the communities told a story of how a particular individual introduced the new technique to the communities based on his sojourn in the United States. There are accounts that suggest that the individual was a white man from the United States. Several accounts and archival materials show clearly the connection between the United States and the new technique of brewing ogogoro.

Many villagers learned this new technique of turning palm wine into ameereka through a process described by Leis (1964, 832) as encompassing boiling palm wine

> in a 44-gallon drum which has been laid on its side. At the top of the drum, two long pipes are permanently attached to capture the vapor and conduct it through split, hollowed out logs. The logs are kept filled with cool water to

condense the vapor; the distillate drips out at the other end of the pipes. The process must be repeated twice before the distillate—the gin—is of the proper strength. Since, on the average, 11 gallons of palm wine yield only one gallon of gin, a man builds his distillery in the swamps to be near the palm wine trees.

My interlocutor's grandmother's history of ameereka and ogogoro connects with Johnbull's (Papa's) account of how ogogoro was encountered by different communities in the Niger Delta through travel. In Sapele, where ogogoro is still popularly known as ameereka today, the centrality of the port and the trading history of the town is important to how a particular history of ogogoro is imagined. In this way, two interpretations can be adduced for the use of the name *ameereka* for a liquor of choice for many in the community in the early 1930s and 1940s. The first suggests that the name connects with the ways in which moonshine travels around the world. How moonshine traveled to colonial Nigeria is associated with James Iso, a shipmate who went to the United States in the 1930s, where he was exposed to the moonshine industry that was booming as a result of prohibition. On his return to Nigeria, as described below, he was credited with introducing the new techniques of brewing to the country.

My claim is that the story about a particular person coming from the United States to introduce the new technique resonates with James Iso's visit and exposure to moonshine, hence the name *ameereka*. The foreignness of the technique, I argue, leads many to suggest that it must have been introduced by an American, contrary to the fact that it was actually introduced by a Nigerian who visited the United States during the moonshine boom.

The second interpretation is the notion that when technology travels, it takes on a life of its own, and naming is one way that could happen. Naming helps distinguish between the old and the new. The old, in this case, would be the palm wine that many communities were already used to. The new is represented by the many names ascribed to ogogoro as a new form of liquor that is completely different from palm wine. This way, as with every new technology, palm wine becomes ordinary, while ogogoro or ameereka becomes a sophisticated drink. The question is, how do technologies travel, and what impact does this have on the new techniques of extraction in Nigeria? To answer this question, the next section focuses on the global appeal of moonshine and the ways in which prohibition in the United States interacted with the technologies of extraction in Nigeria.

When Moonshine Becomes Ameereka or Ogogoro: Travels and Techniques in the Making of a Liquor of Choice

In a study on the relationships among moonshine, money, and liquidity in rural Russia, Rogers (2005) describes the important role that the liquor of

choice plays in oil-rich postsocialist Russia. Rogers traces the intersecting circuits of moonshine, rubles, labor, and US dollars to outline an approach to exchange that concentrates on the politics of liquidity—conflicts and inequalities rooted in the relative degrees of exchangeability associated with different transactables in rural Russia. According to Rogers, in many areas of rural Russia after socialism, moonshine served as a local currency. This in itself is not surprising because, in Rogers's telling, the antialcohol campaign of the socialist state under Gorbachev in the 1980s led to an astronomical rise in the production of moonshine as a liquor of choice. As Rogers (2005, 66) writes, "In contrast to the preponderance of store-bought vodka during much of the Soviet period—at least until Gorbachev's anti-alcohol campaigns of the mid-1980s—rural moonshine production soared across Russia in the 1990s, reaching a level high enough to figure in the market forecasts of international sugar concerns." Rogers shows how, just like the people of the Niger Delta who revel in the local origins and importance of ogogoro, townspeople in Sepych, a rural area of Russia, would marvel at the local origin of moonshine. For example, "Townspeople in Sepych . . . often played up the local origins of moonshine, noting that its provenance in the kitchens of their friends and neighbors bespoke a sense of communal trust that they did not always find present in monetary exchanges or even in the bottles of vodka—often alleged to be of dubious quality—for sale in Sepych's stores" (Rogers 2005, 64). Since the production of moonshine does not require a lot of technical know-how, it was easy for rural folks in Russia to produce it as an alternative to regular liquor. After all, all that it requires is "granulated sugar, yeast, water, a pressure cooker of one sort or another and, often, secret ingredients" (Rogers 2005, 66).

It was not just rural Russia that benefited from how moonshine making travels around the world. Accounts in the literature also show how other communities across different countries saw the utility of producing moonshine (e.g., Maurer 2013; Peine and Schafft 2012; Rosko 2015). From the Appalachian mountains in the United States to Britain, Ireland, and the Middle East, moonshine travels in a variety of ways as the simplicity of its production makes it a liquor of choice in evading state regulatory practices. For example, Maurer (2013) describes how the history of moonshine making is as complicated as its relationship to the state that regulates alcohol use during different historical epochs. Maurer (2013, 31) claims that this history is often embedded in a notion of patriotism and pride, as many claim that moonshine originates from their country:

> Some researchers, perhaps spurred on by patriotism and national pride, have
> reasoned that the still originated in Ireland—where it could have originated

with complete propriety—because the modern word whiskey seems to be derived from the Irish Gaelic *usquebaugh*. Certainly, its early popularity there (the British in 1556 imposed the death penalty on all but the Irish nobility who operated stills) strengthens this legend. Other more objective writers, however, have traced the use of the still through the Arabs to ancient Egypt, and it is possible that it goes right on back from there. Europe seems to have acquired it from the Arabs. There is also some evidence of its origin in China and India.

England, whose early interest in regulating alcohol use was due to the revenue it generated, found it difficult to regulate what was then considered illegal distilling of moonshine, especially in rural areas. Collecting taxes in towns and urban centers has always been easier than in far-flung places where the state may not have its control mechanisms in place (Maurer 2013; Scott 1998). Registration of distilling was one of the ways in which England tried to regulate it, but as Maurer (2013, 33) notes, "Many of the farmers in northern and western England never did register their stills or conform to the tax laws. . . . Eventually, as successive kings increased the taxes, those independent distillers who were discouraged by too close a contact with their collectors began to migrate to areas more hospitable to their ancient craft." Thus, moonshine became a rural liquor of choice for the people of England.

In the United States, the Prohibition Act of 1919 and the Enforcement Act that followed opened the floodgates to moonshine distillation across the length and breadth of the country. To trace this history, we begin first in the mid- to late 1800s, when many religious organizations advocated for the prohibition of alcoholic beverages in the United States. Prominent among these groups were the American Temperance Society, the Women's Temperance Christian Union, and the Anti-Saloon League. While some of these organizations initially advocated for abstinence from alcohol, as consuming it was considered to be antithetical to Christian values, their advocacy was later turned into a campaign for outright prohibition (Douglas 2001; Maurer 2013; Murphy 1994; Peine and Schafft 2012; Rosko 2015; Slack 2015). By the turn of the century, specifically in the early 1900s, the campaign gained momentum, and Congress seemed to have listened when, on January 19, 1919, it ratified the Eighteenth Amendment, banning the manufacture, sale, and transport of alcoholic beverages. Despite the ratification of this amendment, alcoholic beverages were still consumed across the country, a phenomenon that was attributed to the lack of enforcement mechanisms. Hence, in October of the same year, Congress passed into law the Volstead Prohibition Enforcement Act, which delegated responsibility for policing the Eighteenth Amendment to the commissioner of internal revenue in the Department of the Treasury.[11] One consequence of the passage of the Eighteenth Amendment and

the Volstead Act was the rise in underground distilling of alcohol across the United States, leading to the birth of moonshine and bootlegging.

During the era of prohibition, crime went up in urban areas. For example, organized criminal gangs illegally supplied America's demand for liquor. As Slack (2015, 13) reminds us, "This outlawing of alcohol also caused a spike in crime in urban cities such as Chicago and Louisville which created an environment that allowed bootleggers and gangsters to thrive. For Louisville in particular, a thriving underground market formed for alcohol with some police precincts reporting as many as eighty-three raids in one week to root out bootleggers." The enforcement of prohibition enabled different ethnic groups and women to benefit by engaging in practices that encouraged the manufacture and sale of moonshine (Murphy 1994, 175). Not only that but "at one end of the bootlegging chain were children who collected empty bottles outside dance halls and sold them back to moonshiners or who discovered bootleggers' stores and pilfered a few bottles of liquor to sell on their own" (Murphy 1994, 184). Moonshining, then, involved individuals from all levels of society.

The relationship between mining and moonshining becomes important here because of how the alcohol of choice was consumed and how it was produced and distributed. In the Appalachian region, especially in states such as Tennessee, moonshiners would locate their production sites close to the entrances of mining caves for two important reasons: distribution to customers, who were mainly miners, and shielding production from the prying eyes of the state. Douglas (2001) describes how distillers typically worked close to the cave entrance where they located their roughly built square or semicircular stone furnace to heat whiskey mash—typically a mixture of corn, barley, and water—in an enclosed metal cooker. Next to the furnace, a stone platform supported a thumper keg and a barrel filled with water. The steam from the vapor from the heated mash flowed from the cooker through a metal tube to the thumper, which filtered out remaining solids, and then through a twisted pipe, known as the "worm," which was submerged in the cooling water. In the worm, the vapor condensed into precious liquor for the miners and other consumers.

Peine and Schafft (2012) show how moonshine emerged as both a significant cultural referent and as a vehicle for social integration and cultural reproduction within Appalachia. Moonshine as a vehicle for social and cultural reproduction has resonance with the use of ameereka/ogogoro in the Niger Delta region of Nigeria as described in the previous section. The ability of ameereka to compete with state-regulated liquor, and its eventual prohibition by colonial authorities, defines its utility among the people. The utility of

ogogoro and the technology and innovation it provides to many communities has resonance with artisanal practices in the Niger Delta today. As with artisanal refineries in the Niger Delta, the criminalization of moonshine became linked with the marginalization of rural Appalachian populations. The reliance on it for livelihood and survival in rural areas and its prohibition in the United States by Congress resulted "in a particular construction of the Appalachian region as a 'problem,' a place that is lawless, backward, and somehow pre or anti-modern" (Peine and Schafft 2012, 94).

Therefore, moonshine in the United States, especially in places such as East Tennessee and other Appalachian regions, is historically tied to a greater narrative of economic depression, exploitation, and adaptation (Durand 1956; Peine and Schafft 2012). Farming in the region was difficult due to rocky soil—farming is similarly difficult in the Niger Delta as a result of oil exploration—so farms were usually small and not able to support large families (Durand 1956; Hsiung 1992). Even more, transporting crops to the nearest market for sale was nearly impossible in the mountainous terrain, and farmers often lost money on this venture (Stewart 2006). Given the lack of alternative livelihood opportunities, many residents in East Tennessee and Appalachia sought moonshine as an exchangeable commodity for financial support (Peine and Schafft 2012). Here, a positive identity emerged surrounding moonshining, one that was seen as a "legitimate and meritorious occupation" (Hatch 2004; Stewart 2006).

A parallel exists between the proliferation of moonshine in the United States during this epoch and the emergence of ogogoro in Nigeria in the 1900s. What does the spread of moonshine in the United States have in common with ogogoro in Nigeria? The answer is not far-fetched. First, just like moonshine was a liquor of choice for the working-class population in the United States, ogogoro turns out to be a liquor of choice for many Nigerian peasants, farmers, and fishers. Just like producing moonshine became illegal in the United States with the promulgation of the Prohibition Act, the British colonial authorities in Nigeria also considered producing ogogoro an illicit and illegal business.

The significance of moonshine to life and livelihoods in the Niger Delta region of Nigeria can be traced to how it traveled all the way from the United States in the early 1900s to Nigeria. More importantly, the techniques of extracting moonshine in the United States became prominent in devising techniques for extracting oil for refining purposes in Nigeria today. Though not called moonshine in Nigeria, its legibility in the techniques and practices of extraction occupies a prominent place in how the history of local liquor is told, not only in the Niger Delta region of Nigeria but across the entire West

African region. This particular history of how moonshine travels is anchored in shipping and travel across the Atlantic Ocean from one continent to the other—the African continent connecting with the Americas. In order to understand these particular historical processes, I turn to extractive practices that connect communities, creeks, and the technopolitics of oil refining in ways that create sites of reinvention and production of techniques of crude oil production.

REINVENTING OLD TECHNOLOGIES: OGOGORO AND THE TECHNIQUES OF REFINING AND PRODUCING CRUDE OIL

Having to contend with the energy-sapping heat and humidity of the climate, Nigerians from time immemorial have drunk alcoholic beverages to satisfy their craving for stimulants. In some areas of the country, drinking indigenous alcohol was almost a necessity given the brackish nature of many streams. Ogogoro, the local gin brewed in Niger Delta communities, provides a window into understanding the process of crude refining in Nigeria. The local brew became popular during the colonial era (Ayandele 1966; Felix Forae 2013; Heap 2008; Korieh 2003; Leis 1964). The history of local gin distilling is told in two parts. The first part, as narrated by my interlocutors and closely observed during my many years of research in the Niger Delta, started when local brewers specializing in brewing palm wine used their products during the celebration of harvests, funerals, marriage ceremonies, and other important community events. The second is told through the lens of colonial history dating back to the 1930s (Adunbi 2017; Heap 2008), when colonial authorities imposed taxes on imported spirits, making them unaffordable for many consumers. It should also be noted that prior to the emergence of ogogoro as a liquor of choice, many communities had grown used to palm wine, usually tapped by farmers. Also popular were spirits and other distilled wines and liquor, often imported by licensed liquor companies such as Messrs Patterson Zochonis and Co. Limited, PZ, a multinational corporation that operated in the colony. When Christian groups in the US opposed to liquor consumption advocated for its prohibition, many Christian groups in colonial Nigeria followed suit. This attempt at prohibition was mainly advocated by missionaries in many of colonial Nigeria's provinces. Reasons ranged from alcohol being responsible for sexual immorality to increases in convictions for drunkenness. Liquor was the most significant import in terms of volume and value in the colonies of Lagos, Oil Rivers Protectorate, Niger Coast Protectorate, and Southern Nigeria, all of which were eventually integrated into the Southern Provinces of Nigeria in 1914 (Ayandele 1966; Felix Forae 2013; Heap 1999; Korieh 2003; Leis 1964). The weakness of the

local liquor was that one could not get drunk except by drinking considerable amounts, while in contrast, a small amount of the imported liquor could get the drinker drunk. Such a contrast was turned on its head by critics of the liquor trade, however, who inferred that the taste for alcohol was already in place in Nigeria and that imported liquor's much more potent strength could result in widespread drunkenness and destruction in the near future. Spirits can be divided into two classes: potable and nonpotable. In the process of distilling potable spirits, nonpotable ones are created and must be separated off. Were the spirits being imported into Nigeria drinkable ones, or were they contaminated with nonpotable elements? The Good Templars of Lagos felt sure of their life-threatening properties:

> Spirits imported in such large quantities are of the most inferior quality, and that they are actively injurious that they ought to be labelled 'POISONS'. And some of them are poisonous enough. It will be remembered that an English firm here, not long ago, imported a kind of Gin into the Colony which was so potent in the destruction of human life that the natives termed it 'Erebe', from its razor-like action on the liver. How many perished in the interior by drinking that abominable compound of turpentine and other stuffs it is impossible to say. (Heap 1999, 30–31)

Worries about alcohol being "not a wholesome beverage" surfaced in 1902, when Lagos government chemist Ralston found a sample that contained "the poisonous proportion of 4.4 per cent by weight of fusel oil" (Heap 1999, 31). As Heap noted further in his analysis of alcohol consumption during the colonial era, "14 fusel oil, or amyl alcohol, is a valuable by-product of spirit distillation that is collected and sold separately and can be used to make varnish. The concentration of high fusel or amyl in alcohol can have unintended consequences for those who consume it. When drunk in small concentrations, up to about 0.5 percent, it is not harmful, but proportions higher than this are dangerous to health" (1999, 31). Thus, in 1903, the colonial government prohibited the importation or sale of liquor containing more than 0.5 percent of fusel oil. The prohibition law remained a dead letter, however, with no prosecutions whatsoever. In fact, the colonial government practically prohibited alcohol through increases in the customs duty, especially by adding burdensome additional charges to the price of spirits. The additional charges that pure spirits attracted made the import of alcohol unprofitable. Once the customs duties were shaped to favor milder spirits, highly alcoholic spirits faded from the import lists; hence, a better class of weaker spirits came to replace most of the poorer, stronger imports.

For example, in Ibadan, in the Western Province, colonial records at the National Archives Ibadan show that the district officer received a letter

from a resident of Oyo province requesting that a report of the effectiveness of the Ibadan Native Administration Liquor Licensing Rule be developed. This incident clearly demonstrates the pervasiveness of the idea that the rules being enforced should also be written. This report, the officer stated, should include the number of applications for wine and beer off licenses for the years 1933, 1934, and 1935, and the number of persons who were presently selling liquor in Ibadan town in contravention of the rules (Oyo prof. 1, file 1375, vol. 2, 280). In colonial records, off license permits the licensee to sell alcohol, but customers cannot consume the alcohol at the premises where it is sold. In contrast, licensees who have both on and off license are permitted to sell to customers for the purposes of consuming at the premises or otherwise.

The assistant district officer for Oshogbo, a few miles from Ibadan, and the district officer for Ibadan were copied in the response to the letter, which stated that no persons had been found contravening the rules. To test the strictness of the liquor rules, ordinary citizens would often apply for liquor licenses. For example, one Mr. Johnson was reported to have applied for and received an off and on license (wine and beer) by the native administration (Oyo prof. 1, file 1375, vol. 2, 284). On discovering that Mr. Johnson did not need a license, colonial records show that the *Baale* (chief) of his town was instructed to write to him to cancel the license and to warn him never to consume wine or beer on his premises. In addition to granting licenses to colonial subjects who were interested in selling liquor, the secretary of the Southern Province Ibadan wrote on March 30, 1936, to the resident of Oyo province dictating that the acting chief commissioner had decreed that the branches of European firms in Nigeria should also be licensed under the Liquor Ordinance (Vide section 20 cap. 131, Law Volume ii page 1244). The hope behind this request was that the new licensing rule would increase the revenue base of the colonial administration.

The following is from the minutes of a meeting of the Oyo Province Liquor Licensing Board held in the Residency, Oyo, on March 31, 1953:

> The chairman called upon the missionary representatives to state their argument against the free distribution of liquor with particular reference to the application of Messres P. Z. and co, Limited for a general wholesale liquor license at Ilesha. The missionary representatives dilated on the evils caused by drinking alcohol, viz, sexual immorality, increase in conviction for drunkenness, loss of self-control and other social evils connected with drinking. People are becoming more drink-minded and the more opportunities are given for drinking. The Liquor Licensing Board should help the country by seeing to it that money is not wasted on liquor. The agent John Holt did not see how these statements affected the application of Messrs P. Z. and co, for a wholesale license; the firm had spent money on their store at Ilesha. A bottle of beer a

day, was said, could do no harm to a person. Other members of the Board were of the opinion that the control and sale of liquor could only be achieved at the retail level not the general wholesale. The matter was then put to vote and all except the two missionary representatives voted in favour of the application of Messres P. Z. and co. Ltd. The application was therefore approved.

The Anglican clerics who argued fervently for prohibition based their judgment on what was considered to be the danger inherent in liquor's consumption. Clerics such as Canon S. I. Kale and Reverend F. H. Longley quoted in support of their arguments the following authorities:

- For their argument that alcohol is harmful: alcohol, its action on the human organism, by a committee originally appointed by the central control board (liquor traffic) and later reconstituted by the Medical Research Council H. M. Stationary Office, 1938.
- For their argument that people were drinking more: Nigeria Government Trade Returns, which shows, for instance, that Nigeria imported as much beer in gallons in January 1953 as in the whole of 1935 when none was brewed locally.
- For their argument that fewer licenses meant less drinking: example from Carlisle (reported by the *Manchester Guardian*, December 30, 1948) and Ontario (reported by "The Christians," June 12, 1947).

In particular, the license rule was intended to stop the large amount of gin drinking that occurred, but the outcome for traders whose businesses revolved around the selling of gin was more devastating than expected. These were mainly petty traders who had made a transition from other businesses to selling ogogoro during the boom era. Their business suffered as they lost many consumers who would usually patronize them. The loss of businesses by the petty traders also had consequences for family livelihoods, but as colonial records show, this was not a concern for the colonial authorities. Section 6, subsection ii of this rule read: "No holder of a General Retail Liquor License Permit (petty traders) to be supplied with more than 24 cases a year of spirit, or beer or both the initial and every subsequent supply the supplier to sign and endorse stating the numbers of cases supplied. The permit to be produced on the demand of police or Akoda or any other authorized agent." Many people did not know whether the liquor licenses were being introduced sequentially for the purpose of revenue collection or to restrict the sale of liquor. In this specific case, a proposal was written by the senior resident of Oyo province in 1928 to the honorable secretary of Southern Province, Lagos, requesting that a provision stipulating a smaller fee for a petty traders' license be included in the law because the larger sum of fifteen pounds would undoubtedly preclude many petty traders, mostly women, from earning a living by the sale of liquor. The senior resident stated further "that their annual

sale was so small that they simply could not pay a license of fifteen pounds" (Oyo prof. 1, file 1375, vol. 1, 110).

On February 21, 1927, the *Alaafin* (king) of Oyo Kingdom wrote, "I consider with my chiefs that what the men and women who are trading on gin and beer are paying is sufficient, even though this is new to them. Our traders are poor people." The Alaafin seems to have recognized the effects of such policies on his subjects, hence his reference to how they would suffer under the new rules.

The native authorities were threatened by the colonial administrators that if they would not accept the bylaws, the government would declare the province a licensed area, and so the chiefs accepted the resident's advice and approved the bylaws. The feelings of the people on the subject were not gauged to see if they would agree with the new bylaw. This goes to show the tension that often existed between colonial administrators, who were mostly white men posted to Nigeria by the British government, and the native authorities, who were local chiefs incorporated into the colonial administration through the indirect rule system of government (Adunbi 2015; Ayandele 1966; Mamdani 1996). Chiefs and kings were ordinarily responsible for their subjects, but the colonial power often put them in the difficult position of having to choose between siding with their citizens or the colonial administration. Thus, only native traders who were educated understood the dynamics of the new trading regime instituted by the colonial administration with respect to the new licensing regimes. For many others, especially those who lived in rural areas and who were largely uneducated in the colonial system, having to pay fifteen pounds a year for a license to sell spirits was strange. Many, colonial records show, were not even aware of the new payments that had to be made until the implementation stage. The majority of those affected were women—elderly women—who had been engaged in the trade for a very long time.

Colonial records show that the small traders protested against the imposition of the licensee fees because they were exorbitant, and the traders' inability to pay might end their businesses. On the other hand, traders who were wealthy and could easily pay the fees saw an opportunity for competition with European traders in addition to being able to push small traders out of the market in ways that could result in a monopoly. The onset of the introduction of the off and on licenses and the collection of tributes had just begun in the city of Ibadan.

The outcome of the introduction of the off and on licenses was a tense situation in the entire southern province of Nigeria due to the belief that there might be a new tax in the offing. This belief was not unfounded because

a year later, new taxes were introduced in the eastern part of the southern province, triggering the 1929 Aba women's protest against colonial authorities (Ade-Ajayi and Crowder 1971; Ikime 1980a). At the same time, many colonial subjects also frown at the introduction and enforcement of new rules in the first month of a new year, as that was when many people returned to their farms or businesses after the Christmas and new year festivities. That led to opposition to the plan from the chiefs, who believed that January 1928 was not the best time to initiate the new tax. Also, colonial records show that while the intent of the new rules was to mitigate what the colonial administration consider to be drunkenness and disorderly conduct among adults, many colonial subjects did not see that as the case. Many of the letters written to the district officers clearly demonstrated that the intent of the new rules to limit alcohol consumption would fail without the support of the people. Some wrote in their letters that they found little or no evidence of people being drunk or engaging in disorderly behavior in their communities as a result of alcoholic consumption, and thus they wanted the colonial administration's priorities to shift to something else. Some of the letters in the archives questioned the moral rationale behind imposition of new rules and saw it for what it was: an attempt by the colonial authorities to generate a new stream of revenue to support the colonial project. Still, some were also sympathetic to such an extent that they advocated for a reduction of the fees or an opportunity for those interested to take out licensees during festivals, when sales are usually on the rise. Section 7(2) of Cap. 131 (regulations) provides the opportunity to take out a license for six months. The senior resident of Oyo province suggested that this section might be included in the bylaws and that temporary liquor licenses be added to section 4 because a fee of fifteen pounds was very high for those petty traders who lived by the sale of a few cases a month. Every chief expressed opposition to what they considered an additional tax on trading. An order in council was prepared to make Ibadan Township a licensed area.

In the bylaws made by the *Ooni* of Ife under section 21 of the Liquor Ordinance chapter 131, the terms *intoxicating liquor* and *liquor* mean any liquid that, if used as a beverage, may have an intoxicating effect on the consumer. These bylaws included wine, beer, and spirits but did not include native liquor. No license issued under these bylaws authorized the sale of liquor on Christmas Day, Good Friday, or Sunday, except between the hours of 12:30 p.m. and 2:00 p.m. and 5:00 p.m. and 7:00 p.m., or any other day except after 8:00 a.m. and before 8:00 p.m. The fact that ogogoro and palm wine, both considered native liquor, were not included in the bylaws increased their production and consumption.

It's a Family Business: Shifting from Ogogoro (Ameereka) to Refined Crude Oil

In the early 1930s, distillation of native spirits, a practice adopted from America, was common in Nigeria (Heap 1999). Simple equipment was used for distillation, including a kerosene tin, a water pot, and a couple of lengths of metal piping (Heap 1999; Isidore 2001). Due to the economic downturn of the 1930s, and the cheapness and availability of ogogoro, it found its way into economic and social life and became widely popular. With these factors holding for the rest of the decade, Heap noted that homemade spirits took root, and a rapid transfer of technology occurred across the country, spreading northward from the south (Heap 1999, Isidore 2001). This made alcohol accessible to all Nigerians instead of just to chiefs and traders. Class distinctions can be ascertained from attitudes struck toward drinking ogogoro. For the poorer classes of Nigerian society, illicit liquor retained the attractions of a fiery nature and low cost. But, at the other end of the social scale, one would never imbibe ogogoro if one could afford imported gin. Thus, by 1936, the poor and those with low taste regarded illicit gin as a liquor of choice at funerals and marriage ceremonies. Imported gin acquired a better reputation, impressing on middle-class Nigerians its power "to be good for the body" (Ayandele 1966; Heap 1999; Leis 1964). Ironically, far from understanding the harmful nature of illicit spirits, many people purchased them in the genuine belief that they were of medicinal value for rheumatism, colds, and other illnesses.

Ogogoro is widely considered a spirit drink distilled from palm wine by local producers in many parts of Nigeria (Heap 1999, Odeyemi 1980). The drink has considerable historical significance in Nigeria because colonial administrators banned it in an attempt to control the West African liquor trade in the early part of the last century (Isidore 2001). While palm wine was originally the drink of choice in Nigeria, it was replaced by rum and schnapps during the period of the slave trade (Ayandele 1966; Heap 1999; Leis 1964). Therefore, many who consume alcohol favor distilled spirits over palm wine because spirits are thought to be stronger than palm wine or beer.

There was a wide supply of crude alcohol in the 1930s, and this proved dangerous and detrimental to the health of the population. The colonial government at the time frowned on the consumption of this crude liquor. As Isidore (2001) noted, there were worries about the increase in consumption patterns of Nigerians such that over eight thousand gallons were said to be consumed per day of an alcohol that was considered dreadful and injurious to health. As a consequence, the colonial government made a formal

pronouncement that the native liquor was dangerous to health and did more harm than good as it led to drunkenness and insanity.

The nakedness of the gin—that is, the way in which it was produced, without being diluted with water, making it stronger—was considered a health hazard by the colonial government, which speculated that it has the potential to cause blindness and barrenness in women and therefore prohibited it. In response, local Nigerian people wrote letters to the colonial authorities, stating why ogogoro should be allowed. Lucky for them, as the years passed and the anticipated public health disasters did not materialize, colonial officers reexamined their warnings and concluded that the illicit gin was not poisonous after all. If taken moderately, alcoholic beverages provided stimulation to Nigerian drinkers, not danger.

For some time, ogogoro was relatively ignored by the colonial government. In the 1920s, "due to general prosperity in that decade, gin imports increased dramatically. But in the depressed economic conditions of the 1930s, when farmers found their export produce selling for unprecedentedly low prices and imported liquor priced beyond their reach by high customs duties, ogogoro supplied an immediate want" (Heap 2008, 576–77). With the economic depression of the 1930s, the colonial administration saw imported spirits as an opportunity to raise revenue for the colonies and their home government, hence the high tariff on imported products. Heap (2008, 576) suggests that attempts at brewing local gins started with "Stocky James Iso, a 35 year old native of Calabar," who learned the "illicit art of distilling moonshine" during his sojourn in the United States. On his return to his native Calabar in 1924,[12] he began distilling gin. Shortly after his return, Iso sold the secrets of distilling to others interested in brewing spirits around Calabar. But Iso's secret recipe generated interest, and as the *Nigerian Echo* newspaper reported in the 1930s, "Illicit distillation sprouted up like mushrooms overnight in Calabar province and it has spread all over the country to such an extent that there is hardly any province that can plead absolute innocence of this evil" (Heap 2008, 577).

The brewing of ogogoro became a way to display the innovativeness and ingenuity of the local producers. Blacksmiths, palm wine tappers, and farmers who cultivated sugar cane provided the necessary skills and materials for brewing the local gin. Blacksmiths would make pipes and connect them to drums, palm wine tappers would provide the wine from palm trees, and farmers would provide sugar cane. As described earlier, to make ogogoro, local brewers connect a pipe to a drum, which is in turn connected to another drum that holds water before passing into a third drum, where the distilled gin will settle after hours of burning in the first drum (Heap 2008; Leis 1964).

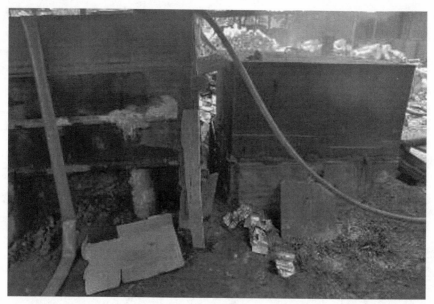

Fig. 4.1 Ogogoro refining in one of the Niger Delta communities. Source: Photograph by the author.

As Heap (2008, 582) suggests, "Treating the distilled alcohol with burnt sugar engineered a spirit similar in bouquet and appearance to whisky, while adding tobacco juice made it brandy colored." The production of ogogoro gin, which started in the Niger Delta in the 1930s, continues today (see fig. 4.1). There is hardly any community that does not know or has not heard about ogogoro, and in many communities it is still considered an essential drink at festivals, funerals, weddings, and other celebrations.

Jimmy's family has been in the ogogoro business for a very long time. Jimmy, who is in his late twenties, narrated how he grew up being part of the ogogoro business in his village. His grandfather told him how his great-grandfather was an Ògún devotee and a palm wine tapper who was one of the earliest people to make the transition from tapping and selling palm wine to brewing ogogoro in the village. Over time, it became a tradition passed from one generation to the next. His grandfather passed the tradition to his father, who in turn passed it to him. The only difference today is that Jimmy has succeeded in using the same ogogoro refining technology in the making of artisanal refineries. In Jimmy's compound, where his father still lives,[13] there is a small space designated as an Ògún shrine in one corner of the compound. The shrine is composed of iron and other materials. Interestingly, Jimmy told me they are all Christians in his family but that members of his

family also believe you cannot forget your family heritage; hence, they still worship Ògún but also go to church on Sundays. Jimmy has his own house but spends most of his time at his family compound when he is not working. The importance of the shrine to the work he does, Jimmy says, is that "Ògún takes part in our everyday activities. Ògún owns all the tools we use in making ogogoro as well as the tools we use in building infrastructure for our refineries. Remember, Ògún is the god of iron. In fact, he made the bike that brought you here possible."[14] While Jimmy has become an oil mogul, as he likes to call himself, one of his brothers still helps in sustaining the ogogoro business in keeping with the family tradition. Jimmy's mother is one of the several women who sell it in the village.

Interestingly, there is a gender-based division of labor in terms of the brewing and selling of ogogoro. While the men brew the product (I should also note that there are a few women who also brew because it is mainly a family business), the women sell it in their shops or market stalls. The same parallel, as I explain in the next chapter, is also applicable to refined oil. Men mostly work in refining the crude, while women mostly work in the retail part of the business. Remarkably, in Jimmy's village, I also saw many women display ogogoro simultaneously with engine oil, which is a by-product of the refined crude oil. In some instances, gasoline would also be displayed for sale by the women who sell ogogoro. It should be noted that ogogoro and gasoline (including engine oil and kerosene) are not displayed side by side because of the inherent danger in doing so. The women who have mastered the trade know very well that putting both products together on the same stall could create health problems. Thus, you might find two tables far apart with one table hosting ogogoro while the other might host engine oil and gasoline in kegs. The social and technological history of ogogoro, to many of the practitioners of both trades, are intimately connected.

More importantly, this particular social history of ogogoro is not lost on Jimmy "Einstein the oil mogul," who today draws a parallel between the technologies of ogogoro extraction and artisanal refineries in the creeks of the Delta. To Jimmy, if you understand the social history of ogogoro extraction, its connection to palm wine, and how Ògún the god of iron made the technology visible through his powers, you would understand why the technology is prominent in how we extract oil for refining. Instructively, a parallel can be drawn between ogogoro extraction of the colonial period and today's artisanal practices of crude oil extraction. Both are (or were) considered illicit. Just like the colonial administration considered ogogoro an illicit trade because of its impact on the colonial revenue base, the Nigerian state and its business partners consider the extraction of crude the theft of

state property due to its ability to affect state revenues. As Van Schendel and Abraham (2005) remind us, the illicit—that which is socially perceived as unacceptable—can also be historically changeable and contested. While the state sees the extraction of crude oil as an illicit act that must be punished, the youths who have built their livelihoods around it contest the illicitness of their actions by emphasizing how their own hybrid knowledge combines the complexity of tapping and caulking with the practice of ogogoro production, which helps navigate the sophisticated demands of extraction. Important to this process of tapping, as we shall see in the next chapter, is the role played by many who had previously worked for oil corporations as contract employees. Contract employees, what Appel (2019) succinctly describes as the contract form in the licit life of capitalism, occupy a rare position of knowledge in the scheme of extraction. Contract employees are often hired by a third party to work for oil corporations, and they have no job security and are not entitled to benefits. Many of these contract staff will end up teaming up with other youths in the communities using the knowledge acquired from their sojourn in the "life world of oil corporations" (Appel 2019; Leonard 2016) in the service of the artisanal refineries. As one interlocutor said, "We use our local knowledge base to turn crude oil into refined oil. The state and corporations will say we are stealing oil, but to us, we are merely tapping from what the state has illegally taken from us."[15] The sophistication of the crude refining techniques of today emanates from the knowledge base of youths who worked as employees or subcontractors of the oil corporations and from local knowledge of ogogoro production. These former employees, in alliance with other youths who are skilled in boat construction, combine to provide a space where crude oil is turned into refined oil.

The techniques of extraction deployed in the region to sidestep what locals consider obnoxious colonial laws prohibiting the production of local gin have become useful tools for circumventing the state and multinational oil corporations' extractive practices in the Delta today. The specific technologies of ogogoro extraction have also been modified to facilitate techniques of oil extraction and refining (see fig. 4.1). As Kenule, one of the youths in the Niger Delta engaged in artisanal oil refining, told me during an interview, many youths in the region have, at one time or another, been involved in the processing and extraction of ogogoro, highlighting that the technology is not new to the area. According to Kenule, "After fishing and farming, ogogoro extraction is a popular mode of earning income in our community. Many see this as a family business, so you are trained from early on in the process of extracting and producing it." Many interlocutors corroborated Kenule's assertion by reiterating that ogogoro production is considered a family

business in many parts of the Niger Delta. Of course, evidence to corroborate this abounds, as many of the households I visited had a small-scale ogogoro extraction business that they relied on as a familial income supplement in addition to fishing and farming. However, just like the shift from the production of palm wine and palm oil as a result of new techniques of extraction signaled new modes of income generation and participation in trade within many communities, today, new innovation has also brought a shift from ogogoro production to that of crude oil extraction. The new technologies employed are much more sophisticated than those deployed during the colonial period. Ogogoro extraction is mainly performed by families and within the household, while crude extraction today has taken on a life of its own. The creeks epitomize not only the sophistication of this extraction process but also a system that encompasses networks of participants, including youths, community members, international networks, and local patrons.

As we will see in the next chapter, the innovation brought to turning ogogoro into a liquor of choice is being deployed in a sophisticated way in refining crude oil in many creeks of the Niger Delta. The centrality of ameereka to the new techniques of extracting oil cannot be overemphasized. The connection between ameereka and crude refining is important to our understanding of how technologies travel across the world. When technologies travel, they take on lives of their own, which are often shaped by naming practices and adaptation. The newness of ogogoro and its association with James Iso's sojourn in the United States resulted in the name *ameereka*. Artisanal refineries have adopted the same tradition of associating names with the significance of a practice by adopting *kpofire* as the name of crude refining in the creeks. As described in the next chapter, *kpofire* signifies the loud noise that crude oil makes when it is poured into a very hot cooking pot used in refining it.

NOTES

1. K. Ebiri and A. Godwin, "Death in Bottle: The Ogogoro Saga in Rivers," *Guardian*, June 14, 2015, https://guardian.ng/sunday-magazine/death-in-bottle-the-ogogoro-saga-in-rivers.

2. Interview conducted in Igbokoda, Ondo State, July 17, 2016.

3. Interview conducted in Igbokoda, Ondo State, July 17, 2016.

4. Interview conducted in Akure, June 17, 2017.

5. See Ebri and Godwin, "Death in Bottle."

6. Ibid.

7. Morgan Winsor, "Nigeria's Mysterious Epidemic Linked to Contaminated Alcohol and Methanol Poisoning, Not Ebola," *International Business Times*, April 21, 2015, https://www.ibtimes.com/nigerias-mysterious-epidemic-linked-contaminated-alcohol-methanol-poisoning-not-ebola-1890564.

8. Ibid.

9. Interview conducted in Yenagoa, Bayelsa State, July 25, 2018.

10. Interview conducted in Sapele, Delta State, June 20, 2018.

11. See, for example, "18th Amendment 1919 (National Prohibition Act)," Bureau of Alcohol, Tobacco, Firearms and Explosives, September 28, 2016, https://www.atf.gov/our-history/timeline/18th-amendment-1919-national-prohibition-act.

12. Calabar is the administrative headquarters of Cross Rivers State. The state recently lost the last of its oil wells to Cameroon after the International Court of Justice, in a judgment delivered in 2002 at The Hague, transferred ownership of the disputed Bakasi peninsula to Cameroon. Nigeria effected the transfer in August 2008.

13. In my several conversations with Jimmy, he would often refer to his father as one of the best makers of ogogoro in the entire Niger Delta. While I do not have a way of knowing whether this is true, what I did find to be true is that Jimmy's father is a highly respected elder in the village. In many instances, I found villagers deferring to him when it comes to some important decisions in the village.

14. Interview conducted in Igbokoda, July 20, 2016.

15. Interview conducted in Bodo, Ogoniland, July 21, 2015.

5. FLAMES OF WEALTH

Crude Enclaves and Imitative
Technologies of Extraction

It was noon on a quiet summer day in June. The sun, as usual, was out early, and the city of Warri was bustling. The okadas (bikes used as taxis) were revving around town, picking up and dropping off passengers at every street and intersection in the city. Warri is known as "the oil city" because of the abundance of oil both offshore and onshore. As many Warri residents say, "Warri no dey carry last" (Warri strives to be the best)—an affirmation of the fact that Warri is bustling with life all the time and is a city that prides itself on being arguably the most fascinating and livable one in Nigeria. On this day, I had set out early in the morning in preparation for a meeting with one of the operators of artisanal refineries in the creeks of the Niger Delta. Moving around Warri, you will quickly notice the heavy presence of soldiers and other military personnel from the Military Joint Task Force (JTF). They are everywhere in the city, but that does not stop people from moving around and conducting their businesses in the city's unique pidgin English known as Waffi, popularized by comedians such as Alibaba and Real Warri Pikin, who is one of the most famous female comedians in Nigeria. As I disembarked from the okada in front of my interlocutor's house, he was already waiting for me outside with a small bottle of ogogoro in hand. "My friend, welcome to Warri," he said in typical Waffi pidgin, to which I responded, "Thank you." He quickly picked up his bag and some bottles of ogogoro from the woman selling in front of the house, and he waved goodbye to the children playing outside. Thus began our journey to the refineries around Jones Creek on the outskirts of Warri. We walked to the nearest intersection, were picked up by one of his allies in a 2006 Toyota Corolla, and drove past a JTF checkpoint, where the soldiers waved at us and he waved back. As we began to drive toward the bank of a creek where we would board a canoe, Fela Anikulapo Kuti's 1979

album *Vagabonds in Power, V.I.P.* was playing on the car's stereo, and my interlocutor said, "You know say Fela na prophet?" (meaning, "You know Fela is a prophet?"). I nodded. Fela had sung in reference to how the Nigerian elite use their power to oppress the people while noting that power itself is not only transient but circulates everywhere. In some of the lyrics, Fela sang,

> Very important person, Mean say na power, na so so power, But everybody get im power everywhere, Omolanke pusher, im get im power over im Omolanke everywhere, Molue bus driver, im get im power, over im bus and conductor everywhere, Businessman nko, im get im power, over employee and employer everywhere, Head of State nko, im get im power over im country and the people, everywhere.

> [Translation: Very important person means someone with power, and there is power everywhere. Cart pusher has got his own power over his cart, so also is a bus driver who has got his own power over his bus and his conductor. In the same vein, a businessman has got power over his employees as an employer, so also the head of state has power over his country and his people.][1]

As the music played, my interlocutor suggested that as Fela's lyrics stated, he as an artisanal refinery operator had power over his employees as a businessman just like the oil corporations and the Nigerian state had power. Looking back at the soldiers as we drove on, he said the soldiers had their own power too. But, he quipped, "all these soldiers you see here are friends to us just like they are friends to the corporations too. I guess they are beginning to understand that in business, you have to be friendly with all your customers." To him, the soldiers were in business just like the corporations and the artisanal refinery operators because one's ability to pay the necessary bribe determined how successful one's business would be. He looked in my direction and said, "We pay the soldiers, the oil corporations pay them, their employers, the state pays them too, so as Warri no dey carry last, these soldiers no dey carry last too" (As Warri strives to be the best, these soldiers also strive to be the best too). Fela may not have had the artisanal refineries in mind when he sang his song about the use of power by the Nigerian elite, but many of the artisanal refinery operators in the creeks, as I show in this chapter, recognize and understand the meaning and uses of power. They recognize the meaning of the power they have over the environment and the tools they use just like the corporations and Nigerian state broadcast power over the environment and people. As we approached the bank of the river, he told me to brace for the journey through the creeks, and I responded with an emphatic answer: "I am ready."

In the last two decades, struggles to control the oil resources of the Niger Delta have continued to be defining moments of political organizing

in Nigeria. Multinational corporations such as Chevron, Shell, and Mobil, as well as the Nigerian state, engage in practices that result in the production of centralized power to strengthen the state's hold on oil resources. However, local-level citizens and groups increasingly challenge the marginalization of their oil-producing communities. As their human and environmental rights are suppressed, they adopt alternative means of negotiating survival and other forms of power to assert communal control over their land and resources. In many communities across the Niger Delta region, state control of natural resources has led to the complete erosion of the customs, traditions, and cultures around which the people of the region once organized their lives. Sacred sites designated as religious worship centers have been relocated to new sites or destroyed to give way to oil platforms, flow stations, and pipelines. To many Niger Delta communities, these examples of oil infrastructure represent impending wealth (Adunbi 2015).

The struggle for oil resources in the Niger Delta has included some spectacular moments, such as the era of insurgency spearheaded, first in the early 1960s, by the late Isaac Jasper Adaka Boro. The rebellion led by Boro—Niger Delta Volunteer Force—who has been transformed into an iconic figure and a martyr by several subsequent rebel movements in the Niger Delta, marked the beginning of a long process of ownership claims to oil resources by the people of the Niger Delta. A second spectacular moment also produced an iconic figure, Ken Saro-Wiwa, who projected himself as a nonviolent agitator and used his local and international influence to rally a section of the Niger Delta, the Ogonis, against the activities of the Nigerian state and its multinational oil collaborators, such as Shell, using the Movement for the Survival of Ogoni People as a platform (Adunbi 2018). A third moment was the revitalization of insurgency in the early 2000s with the formation of various insurgency groups, such as Movement for the Emancipation of Niger Delta, the Niger Delta People's Volunteer Force, the Niger Delta Vigilante Movement, and, recently, the Niger Delta Avengers. At its formation in 2016, the Niger Delta Avengers, in a statement signed by spokesperson "Col" Murdock Agbinigbo, the group claimed to have the capacity to cripple the economy of Nigeria.[2] In several other public news releases, including through its website, the group stated that its mission was to secede from Nigeria and actualize the sovereign Niger Delta Republic, where the region's oil would be solely used for the benefit of the entire Niger Delta. The new militant group stated, "We shall no longer sacrifice oil to feed all, nor are we willing to subject our environment to pollution while the proceeds are used to beautify [non-]oil producing states."[3] It is worth noting that there was a pause in insurgency between 2009 and 2015 because of an amnesty program instituted by the

Nigerian government where many insurgents were co-opted through various programs that literally paid them off (Adunbi 2015, 2018; Onuoha 2008, 2016). In this way, many former insurgents became surveillance contractors for the Nigerian state, whereby they were contracted to police oil infrastructures across the Niger Delta. Today, we are witnessing a new moment in the struggle for control of Nigeria's oil resources with the preponderance of artisanal refineries in many Niger Delta communities.

Thus, the new extractive practices emerging in the form of artisanal refineries in the Niger Delta, I argue, reshape and reproduce the return to what I call other forms of violence—violence that combines its physical attributes with its invisible attributes. Visible and invisible attributes of violence are determined by the ways in which violence is used in its crudest form in refining oil such that it results in the social death of the environment described in the next chapter. Navigating these critical spaces of engagement and violence produces outcomes such as reverting to old technologies of extraction—ogogoro production—in developing new technologies, innovative as they may be, for the production and refining of crude oil. At the heart of this innovation in technologies of extraction is the claim to ownership of oil as community property in ways that enable participants not only to legitimize their claims to ownership of those spaces but also to devise means of engaging with the state and corporations that may benefit the individuals involved in the struggle of the Niger Delta people. Today, many former insurgents, other youths, and community members are entrenched in the process of reclaiming land and control of resources located in these enclaves through artisanal refining processes. This long history of contestation has enabled the emergence of a form of resource politics that continues to define and redefine the relationship of the local people to the land, oil, and political and socioeconomic configurations within and outside Nigeria since the time of Isaac Adaka Boro, continuing through the time of Ken Saro-Wiwa, and now to the period of armed rebellion by the Movement for the Emancipation of Niger Delta and the Niger Delta Avengers and the setting up of artisanal refineries in over two thousand locations within the creeks of the Niger Delta. Important to this analysis is the centrality of economy as a habitus (Adunbi 2017; Bourdieu 1977, 1994; McGovern 2010; Mitchell 2011) that shapes daily interactions in resource-rich enclaves. Economy as a habitus has resonance with the attitude of enclave communities toward the emergence of youth-organized infrastructures of oil refining. Thus, oil refining infrastructure constructed and managed by youths echoes that of state-regulated free-trade zones constructed and managed by corporate partners of the state, as described in previous chapters.

This chapter examines the processes of refining oil engaged in by former insurgents and other youth groups in the Niger Delta. The chapter shows how practices of extraction create a choreographed system of infrastructure construction that produces new practices to create an oil economy for the Niger Delta communities. This chapter further shows how such an oil economy mimics state and corporate oil extractive practices in ways that connect to what I call "local and transregional capitalism." The chapter interrogates how oil wealth produces a new culture where the communities of extraction are imagined through claims to distinct regulatory practices and forms of ownership. In so doing, youths, community members, and former insurgents produce alternative economic systems that mimic state-regulated economic systems such as the free-trade zones established by Chinese consortiums in parts of Nigeria. This alternative economic system, I argue, is entrenched in broader state economic systems. The chapter suggests that the embeddedness of the artisanal refineries in Nigeria's economic system cannot be ignored.

CRUDE OIL REFINING AND ITS COMPLEX HISTORY

The history of oil refining in Nigeria began with the construction of the Port Harcourt Refinery in 1965, seven years after the first shipment of crude oil to the international market. Known as the Port Harcourt Refining Company Limited, the company was established to "optimally process hydrocarbon into petroleum products for the benefit of all stakeholders."[4] With the discovery of oil in Nigeria in 1956 and the shipment of about five thousand barrels of the black gold to the international market in 1958, attention quickly shifted toward establishing a refining company in the country for the purpose of satisfying local demands for refined oil. Today, the Port Harcourt Refining Company is made up of two refineries: the old refinery commissioned in 1965 with a current nameplate capacity (intended full load capacity of the refinery) of 60,000 barrels per stream day (BPSD) and the new refinery completed and commissioned in 1989 with an installed capacity (intended production capacity) of 150,000 BPSD. This brought the combined crude processing capacity of the Port Harcourt Refinery to 210,000 BPSD, which at that time was comparable to the daily refined capacities of many oil-producing countries.[5] Growing demand for petroleum products such as refined oil as well as an upsurge in the population of the middle class occasioned by the upsurge in oil production and oil windfalls resulting from the Arab oil embargo of the 1970s prompted the construction of more refineries. Two more were constructed—one in Kaduna, in the northern part of the

country, and one in Warri, in the Niger Delta. By 1974, the Nigerian National Petroleum Corporation had decided to start the construction of the second and third refineries located at Warri and Kaduna, respectively. By early 1975, in view of the fuel shortages experienced then, the federal government decided that work on the third refinery should be advanced. It was envisaged that the refinery would be a simple hydro skimming type in order to meet the fuel demand at that time. In this sense, a simple hydro skimming suggests a configuration that requires little or no conversion process without losing its production capability to meet immediate demands. The Nigerian National Petroleum Corporation, in making the decision to build more refineries, carried out feasibility studies to gauge the need for such refineries: "Based on the feasibility studies carried out, which took into consideration the consumption of the various petroleum products within the Northern Zone, and adequate means of disposal for the surplus products, a Refinery with crude oil capacity of 42,000 barrels per stream day (BPSD) could be easily justified. Hence, the refinery was designed for a capacity of 60,000 BPSD. It was much later that the Federal Government decided that the capacity for any refinery in Nigeria should not be below 100,000 BPSD."[6] One of the federal government's main reasons for increasing the capacity of the refineries was a significant increase in consumption of gasoline and its by-products. Increased capacity is considered to be another value added in addition to the refinery's ability to maximize output and produce by-products such as decant oil and propylene-rich stock. These refineries, in the last few decades, have been confronted with problems ranging from operating below capacity due to lack of proper maintenance to sometimes not being able to produce at all. Coupled with a growing population and an astronomical increase in petroleum products consumption, these refineries are no longer able to meet the daily consumption needs of the country.

Things became worse in the early to mid-1990s because of a combination of many factors, including a national strike embarked on by the National Union of Petroleum and Natural Gas Workers (NUPENG) and the Petroleum and Natural Gas Senior Staff Association of Nigeria, who joined forces with prodemocracy and human rights organizations to press for the actualization of the June 12, 1993, election that was annulled by the military. NUPENG and the Petroleum and Natural Gas Senior Staff Association of Nigeria are two of the most potent labor organizations in Nigeria because of their centrality to oil, which is the mainstay of the Nigerian state. NUPENG members are in charge of collecting and distributing refined oil across the country. With the power to transport and distribute refined oil, NUPENG has the capacity to use sabotage to cripple the economy and make demands

on the state (Adebanwi 2012; Adebanwi and Obadare 2010; Mitchell 2011). This was exactly what happened in June 1994, when NUPENG, led by its general secretary, Frank Ovie Kokori, decided to embark on a general strike to demand an end to military rule and a return of power to civilians based on the outcome of the June 12, 1993, election, presumed to have been won by Chief M. K. O. Abiola. The strike crippled the entire country, with long queues of cars at gas stations in major cities. Kokori and Abiola were both arrested and detained by the military government of General Sani Abacha. Their arrest and detention did not end the strike; military leaders decided to begin a process of circumventing the strike by importing refined crude oil to meet local demands.

This Oil Smells Bad: Of Subsidy Regimes and the Importation of Refined Oil

The Abacha military junta's response to the persistent scarcity brought about by the NUPENG strike was to import refined premium motor spirit in order to meet local demands. To actualize the new importation regime, the military government purchased hundreds of tanker trucks, all painted in the national colors: green-white-green. Hundreds of drivers were hired to operate the "national" tanker trucks across the country. Apapa Port, the only functioning port in the country at the time, was flooded with imported ship tankers ready to have their contents offloaded into the national tanker trucks for distribution. Within a few days, the military government was able to break the strike, while Frank Kokori, the general secretary of NUPENG, remained in detention. Daramola, a resident of Apapa where the port is located, told me in an interview in the summer of 2016, "I remember waking up one morning in August to the sound of so many trucks painted in the same color. The trucks followed each other in their hundreds to the port. As there were no cars on the road as a result of the NUPENG strike, we started wondering where they got their own fuel from. We were to later realize that they were Abacha trucks."[7] Those trucks took imported fuel from the port straight to gas stations across the country. There was speculation that some of the imported fuel came from Côte d'Ivoire. Daramola again remembered a particular episode when there was a foul smell across Apapa Port and many parts of Lagos, said to have come from the imported fuel. Corroborating the presence of foul fuel, Busayo, a resident of Lagos who worked as a gas station attendant, told me,

> When the fuel was delivered at our station, as it was being discharged into the reservoir, we knew something was wrong. The smell was so bad that you could throw up if your mouth is not covered. Our station manager told us it

was Abacha fuel and advised us to use a handkerchief to cover our mouth when dispensing to customers. The smell stayed around for a few weeks, and when new fuel came, it just disappeared, but we will never forget that period. In fact, many in Lagos started joking that Abacha fuel smells like shit.[8]

While Abacha's smelly fuel became the butt of jokes in Nigeria, the importation of fuel served its immediate purpose. Within a few weeks, the strike collapsed because of the intervention of the state taking over the distribution of refined oil in NUPENG's place. By the time the strike was called off, the Abacha government had shown that importing refined crude was an effective way to siphon off state funds through phony contracts for importation and distribution. The refineries in Port Harcourt, Warri, and Kaduna were completely neglected. In previous years, regular annual maintenance was carried out by the Nigerian National Petroleum Corporation to ensure the full functioning of all the refineries. Annual turnaround maintenance became a mirage that received fund allocations but was never carried out. New businesspeople became importers of petroleum products and instant millionaires and billionaires, leading to the emergence of a scandalous oil subsidy regime.

Although the Nigerian state had always maintained a subsidy regime to keep the price at the gas stations across the country bearable for consumers, with the Abacha military regime and the civilians who took power after a successful transition in 1999, subsidies assumed a new dimension in Nigeria's checkered oil history. Between 2009 and 2011, during the administration of President Goodluck Jonathan, an audit uncovered over $6.8 billion fraudulently paid as oil subsidies to contractors. As Reuters reported, the fuel subsidy regime was fraught with "endemic corruption and entrenched inefficiency." Whereas Nigeria consumed a little over 250,000 barrels per day, oil marketers and contractors had been paid for 380,000.[9] In 2011 alone, $16.46 billion was said to have been spent on fuel importation, and the number of importers grew from 5 in 2006 to over 140 by 2011.[10] The oil subsidy scam, dwindling economy, pervasive corruption, and general insecurity in the country were some of the major reasons the Jonathan administration lost the presidential election to Muhammadu Buhari in 2015 (Adunbi 2016; LeVan 2019). The defeat of Goodluck Jonathan by Buhari, who ran on a platform of integrity, anticorruption, and economic prosperity (LeVan 2019), heralded the uncovering of other corrupt practices by members of the administration, particularly the oil minister, Diezani Allison-Madueke. The oil minister was arrested in London by Britain's National Crime Agency and taken to court on charges of money laundering and corruption. While in office, Allison-Madueke had been celebrated as an oil reformer who would turn things

around for Nigeria's troubled oil industry by financing various projects to revamp the refineries and revitalize the entire industry. Prior to becoming an oil minister, she was employed by the Shell Petroleum Development Company of Nigeria. Her reforms never happened. Instead, she was accused of embezzling close to $20 billion in oil money.[11]

While promises of revamping the refineries remain in the air, and local consumption continues to increase, something new has started brewing in the Niger Delta region—a preponderance of artisanal refineries operated mainly by youths and former insurgents. The refineries are constructed using local materials assembled by the youths. While the refined crude produced by these refineries is of low quality, with unintended consequences for car engines and other uses to which it has been put, it is a response to a growing need for cheaper petroleum products. These products have also been instrumental in meeting growing local and regional consumption demands. They are sold in many Niger Delta communities as well as in some neighboring countries, such as the Republic of Benin. More importantly, as I describe later in this chapter, the artisanal refiners have perfected a system that imitates the state and corporations that, for many years, had exclusive control of extraction and distribution of petroleum products. This form of imitation derives from a particular history of extraction that shapes relationships with the environment and people in the Niger Delta. Today, Oloibiri, the site where oil was first extracted and exported in 1958, no longer bears oil, but its footprint is seen all over the place. When the youths of the Niger Delta see what Oloibiri has become, the message is clear—the state and its corporate partners will use you and dump you, hence the need to take possession of what belongs to you. Thus, Oloibiri provides two interrelated lessons for the oil refiners and the refineries that litter the Delta: the first is that use by the state and its corporate partners can lead to abandonment and total neglect, and the second suggests that rather than let the state turn the oil into its private property, youths can partake in its exploration and expropriation to benefit themselves and other community members. Both paths lead to the same end result—exploitation of oil to the detriment of the environment and the humans who live there. But how did Oloibiri end up like this? The answer lies in a brief history of the small Oloibiri community—a few miles from many of the thriving artisanal refineries in the Niger Delta.

PITFALLS OF AN OIL WELL: OLOIBIRI AS A METAPHOR FOR CRUDE EXPLOITATION

On a Google Earth map from 2013, the entire mangrove area of Okaiki, a town approximately ten to fifteen miles from Yenagoa, the Bayelsa state

capital, looked green with evidence of water running through the creeks. While traces of the devastating impact of oil exploration could be seen in some pockets of the map, it was clear that there was no consistent human activity in the creeks other than their use as waterways for transportation from one community to another or for fishing purposes. By 2018, the entire area had been completely transformed (see map 5.1). A new look at the Google Earth map shows significant changes in the landscape of the creeks, with patches of human activity noticeable throughout the entire mangrove forest. As will be shown later, the changes were a result of transformations wrought by artisanal refineries with different enterprises buying space for their operation. The creation of these refineries should have been expected, considering many of the factors described above. In addition, the presence of crude oil presents youths with an opportunity to tap into the business of refining as a way to derive benefits from what they consider to be their property—oil (Adunbi 2015). A cursory look at the history of nearby Oloibiri will further attest to why youths have been setting up refineries as a way to meet local consumption demands and benefit from what they claim to own.

Oloibiri is located a few miles away from the city of Port Harcourt in Rivers State, a stone's throw from Yenagoa. It is locally known for sharing the same local government of Ogbia as the town of Otuoke, where Nigeria's former president, Goodluck Jonathan, was born. Jonathan served as the governor of Bayelsa state before becoming vice president and later president of Nigeria. As described in the previous section, the small Niger Delta town of Oloibiri is also widely cited as the birthplace of the country's oil story. The significance of Oloibiri to the development of Nigeria's modern economy cannot be overemphasized. Between 1907 and 1956, colonial Nigeria was engulfed in a frantic search for black gold. These efforts were first led by the Nigerian Bitumen Corporation, a subsidiary of a German company. Soon, the industry was dominated by Shell D'Arcy— a precursor to what is now the Shell Petroleum Development Company of Nigeria (Adunbi 2015; Apter 2005; M. Watts 2003). It wasn't until 1956, however, that oil was discovered in commercial quantities in Oloibiri. In 1958, Nigeria made its first shipment of oil to international markets. What began with the production of five thousand barrels of crude oil a day was transformed into an industry producing more than two million barrels a day within two short decades. The growth of that industry is something on which the Nigerian economy remains precariously and detrimentally dependent.

Maps 5.1a–5.1c (*this page and following*) Images showing transformations as a result of artisanal refineries. Source: Google Earth 2013 (shows landscape before artisanal refineries were constructed), 2018 (shows impact of artisanal refineries on the landscape), and 2020 (shows the intensity of artisanal refineries).

Map 5.1b

Map 5.1c

That oil and the people of the Niger Delta have contributed immensely to the development of modern Nigeria is not a contestable question. But if the now-discarded town of Oloibiri is any example—Oloibiri only lasted from 1958 to 1978, when its oil wells dried up and ended the town's importance to Nigeria's ruling elite—the Nigerian people, too, are merely resources to be used up and eventually discarded. Today, Oloibiri has become a metaphor for what is wrong with Nigeria. As Ferguson (2005) notes, there is a "usable Africa" and an "unusable Africa." Usable Africa constitutes those territories with immense natural resource deposits, such as oil, limestone, diamond, gold, coltan, and the like. Unusable Africa constitutes the rest of the continent and its people. The very recent history of Oloibiri suggests that the Nigerian situation is not far removed from Ferguson's depiction. Once a usable part of Nigeria, Oloibiri has today become an unusable space. This has been the sad but unsurprising result of economic and environmental plunder by Nigeria's ruling elite and its multinational collaborators, including Shell, Chevron, ExxonMobil, and TotalFinaElf. During Oloibiri's twenty-year life span, its oil wells produced approximately twenty million barrels of oil, which generated millions of dollars for the Nigerian government. Today, Oloibiri has nothing to show for the fortune it generated for the Nigerian state. Water

pollution, soil erosion, and abandoned oil infrastructure are all that remain. Poverty levels in Oloibiri today are comparable to those found throughout Nigeria as a whole, in which over 50 percent of the population was living on less than two dollars per day in 2018.[12] The people of Oloibiri, however, were not always poor. Farming and fishing industries once thrived there, leading to a relatively prosperous community of people with a wide variety of occupations and diverse economic opportunities. The unpleasant irony, of course, is that the prosperity brought to Nigeria's ruling elite by Oloibiri's oil led to the degradation of the natural land and marine resources that had once allowed this town to flourish.

While Oloibiri has been abandoned by the Nigerian government and its allies among the various international oil companies, ordinary people have had to bear the brunt of environmental degradation, high poverty levels, impassable roads, and lack of access to education and quality health services. Life expectancy in the Niger Delta averages just forty years, compared to fifty-three to fifty-five years within Nigeria as a whole. The lack of clean air and water and the absence of economic opportunities and critical infrastructure, such as schools, health care facilities, roads, and electricity, are rarely at the forefront of official state and oil corporation discussions concerning the Niger Delta. Today, when unusable youths see their usable environment benefiting others without providing any assistance to their own communities, they resort to other means of engaging with the environment by setting up artisanal refineries in the creeks where the oil wells have yet to dry up. The bleak landscape of Oloibiri epitomizes their worst fears for their families, their communities, and the Niger Delta. On one hand, the Niger Delta is rendered usable through the extraction of millions of barrels of black gold, which account for more than 80 percent of Nigeria's government revenue and 40 percent of its gross domestic product. On the other hand, the landscape of the Niger Delta is devastated, and the inhabitants must wake up every day in abject poverty to see the oil industry operating all around them while never helping their communities. To address this perceived injustice, many youths who build their own refineries would say they are creating jobs, meeting the needs of their communities, and creating a pathway to avoiding the pitfalls of Oloibiri. Many community members never benefited from the abundance of oil in their midst while corporations operated the wells. Thus, today's artisanal refineries clearly represent an attempt by youths and community members to create a system where the wealth from oil wells benefits themselves and members of their community. Wealth is carved out in the creeks that become economic zones of extraction where individuals interested in investing in refineries are allotted plots to establish their business enterprises.

Oil Creeks of Competition: Imitative Enclaves and Complex Refinery Practices

Currently, there are more than two thousand artisanal refineries operated by youths in the Niger Delta (see fig. 5.1). Many of the spaces where the refineries are located are carefully crafted and demarcated by the youths as economic zones of extraction where practices that mimic the state and corporations daily produce objects of value. One of the most prominent of such economic zones is in the suburb of Yenagoa, the capital of Bayelsa State, a few miles from Oloibiri. Another is in the creeks of Okaiki, close to Otuasega in the Egbelebiri area of the Ogbia Local Government Area of Bayelsa State. Okaiki is about ten miles from the city of Yenagoa. In Okaiki, there are about forty-seven refineries in operation.

As stated earlier, in 2013, the creeks of Okaiki were green with mangrove forest on a Google Earth map of the area. The human use of the creeks as seen on the map involved transportation with canoes, fishing, and provision of fresh drinking water for members of the communities in the region. By 2018, things had changed drastically because the entire creek had been allotted to business enterprises using the space for refineries. In the summers of 2017 and 2018, I spent time with many of the youths who operate refineries in the area in order to understand how spaces of value are crafted and turned into economic zones.

In Okaiki, I saw the complexity of the idea of the market and how it interacts with communities, people, and livelihoods. The entrance to the town is not demarcated in any particular way, but what is striking is the ambience of crude extraction as you approach it. This ambience connects directly to the idea of the market in ways that show how community members interact with the operators of the artisanal refineries across the creeks of Okaiki. The youth group that acts as the custodian of the community and liaison between refiners and elders/chiefs is central to how the market functions there. My first few weeks in Okaiki were devoted to understanding the practices that define the rules of the market. In one such instance, as I was introduced to the chief, the first comment the elders made was, "We do not know anything about artisanal refineries." This was quickly followed by, "I have a meeting in the governor's office, so I cannot talk to you now." The chief left immediately, but this did not come as a surprise to me. I was able to interact more closely once I earned the trust and confidence of community members.

As described earlier, the Okaiki community, like many other artisanal refining communities in the creeks, works in concert with the refiners through a youth network that operates as one of the layers of governance within the community. The layers of governance include levying of taxes on crude products

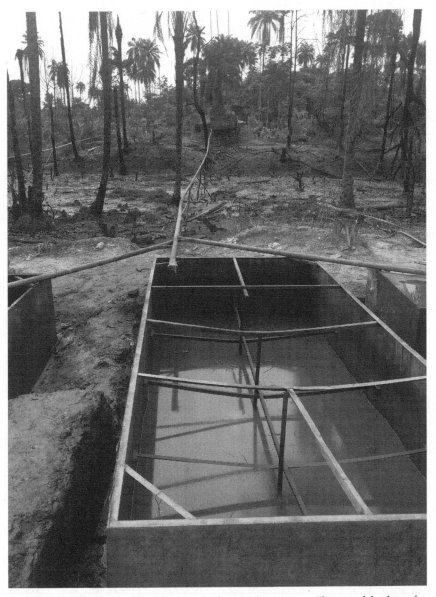

Fig. 5.1 One of the enterprises at an artisanal refinery village. Source: Photograph by the author.

refined in the community, and these taxes come in different layers. For example, as described earlier, visitors to the refinery zone pay the equivalent of about six dollars to enter it, while refinery operators pay about ten dollars for each drum of gas that is taken out. The youth group provides security for the community and surveillance for the zone. As visitors/patrons enter the zone, members of the security team lead them down a bush path to the bank of the creek, where a canoe conveys them to the refinery site. Every day when I went to the zone during my stay in the area, Amaibi and another youth named Degbe led me down the bush path to the creek with their weapons tucked underneath their jackets.[13] Sometimes the terrain can be dangerous for patrons, especially when the alliance between the military JTF—described in detail in the next chapter—and the refinery operators breaks down. Breakdowns of the alliance can lead to sporadic gunfights between the two groups. For instance, one afternoon, as we embarked on the journey to the creeks in canoes, Degbe and Amaibi asked if I was prepared for an unintended consequence of visiting the zone. I asked what they meant. They told me how the JTF invaded their camp one night after one of their go-betweens failed to pay the bribe that he had been asked to pay. This led to a sporadic gunfight that lasted for hours. When I asked if there were casualties, Degbe, full of emotion, told of how he lost his best friend in the fight: "My friend was shot in the head. He died instantly." Degbe lowered his head for a few minutes, almost to the point of sobbing. Amaibi consoled him, then looked at me and said, "My brother, may that thing that happened that day never happen again, and if it were to happen, may you not be here because if you are here, the JTF guys don't usually ask questions before they start shooting." Then Degbe quipped in pidgin English, "Dem soldiers too like money, my brother," with emphasis on *money*. As I was told, the JTF can arrive in the dead of the night when the alliance is not respected. The alliance resonates with what Roitman (2005, 21) calls a process where regimes of power and wealth compete "in so far as they undermine official regulatory authority," a form of power normalized through military-commercial alliances.

The normalization of the military and refiners' alliance shapes the coordination between the youth groups, the elders and chiefs, and the artisanal refiners in many communities in the creeks of the Delta. Significantly, the alliance helps coordinate a market shaped by resource exploitation by the youths in ways that bear semblance to the coordination that takes place between corporations, the state, and the market. Just like the state serves as the administrative organ of corporations (Sawyer 2004) in the complex arrangement between oil corporations and the state, elders/chiefs and the youth network fulfill that role for the refiners. One significant feature of this

coordination is the leveraging of the knowledge of the terrain in constructing zones of exception in the creeks. While the impact of crude extraction on the village and the entire region is conspicuous everywhere, the zones constructed are layered with various levels of infrastructure facilities that make the refineries function as a zone of exception where economic activities take place. Sometimes, the span of the zone can range from three to five miles in radius, with each portion of the refining site carefully demarcated by its individual owner. Each zone has unique features, demonstrating the idea of refineries as business enterprises that can be owned by individuals in a market-based economy.

Many of my interlocutors, especially those who were individual owners, referred to themselves as business owners. On one occasion, when I prodded one of my interlocutors about what he meant by calling himself a business owner, he responded, "You are from the US. Don't tell me you do not know the meaning of business owners. Any time I watch CNN, they are always talking about small business owners, so I see myself as a small business owner too." To my interlocutor, the American matrix of what defines the market fits into the larger narrative about the insertion of oil into the international capitalist system. Here, small business ownership by individuals, in clear distinction to large oil corporations, is what defines the mode of capitalist system that many refiners would like to see themselves in. Imitating the state in ways that bear semblance to the insertion of the state in the world capitalist system, they see America's CNN as the legitimating outlet for how individuals can participate in the capitalist network defined by an oil economy such as Nigeria's. Nothing symbolizes this more than the forty-seven refineries known as the "camp" in Okaiki.

If free-trade zones are zones of exception where individual ownership of business enterprises regulated by the state in a capitalist economy thrive, we should also see each of the forty-seven refining sites at this particular location referred to as kpofire village as an epitome of capitalist organizing. One of the oft-promoted ideas of capitalist organizing is the notion that innovation drives business infrastructure, especially for those businesses engaged in the process of manufacturing, oil extraction, refining, and distribution. The licit life of capitalism, as eloquently described by Appel (2019), shows how important oil infrastructure is in the process of its extraction such that its licitness and contract form with neoliberal appurtenances produces legitimation for its practitioners. Hence, oil infrastructures and refining practices are masked with legal regimes that make them function in a neoliberal market in ways that are replicable internationally and domestically. Using similar logic, the building of oil infrastructure and crafting of a space of value using

local technologies is an excellent signification of how innovation drives the practice of extraction in the oil fields of the Delta.

OIL INFRASTRUCTURE AND THE TECHNOLOGIES OF EXTRACTION AND PRODUCTION

These technologies include the construction of boats from wood, makeshift refineries made from corrugated iron sheets, and fabricated pans as well as pipes and drums. Local welders, carpenters, and masons are instrumental to the construction of the oil infrastructure. Materials are sourced from within the community and nearby cities such as Port Harcourt and Yenagoa. Welders convert metal into pipes that are connected to tanks where oil is refined (see fig. 5.2). Carpenters construct the boats that are used in transporting drums of crude oil to the dump site. The design of the dump is such that three big tanks are stationed close to each other and a fourth tank is located a short distance across from the three tanks. The fourth tank serves as the cooking pot with a pipe atop that serves as the gas-flaring pipe.

As many interlocutors described it, the functionality of the local technology of extraction involves four intertwined sites: the dump, the point, security, and the market. The dump is the refining site, which is mainly owned by individuals; the point is where the crude is obtained through a process called tapping. Security is the protection of both the dump and the point, and the market is used in describing the process of negotiating sales with potential wholesale or retail buyers. The dump employs the most labor, since you need between eight and ten people working different shifts; hence, each dump may have up to fifteen to twenty-five workers depending on the quantity of gasoline produced. The dump operates three times a week with one day reserved for maintenance. Refining takes place at night, and during the process of refining, the creeks appear to be lit up from afar. This process is similar to when a corporation's extraction activities flare gas into the atmosphere. Hence, the youth say that their refining process is similar to that of the oil corporations. Important for understanding the functionality of these zones are the connections between the point and the camp. The youth access crude oil at the point through a practice known as tapping. Tapping denotes the process of perforating existing oil pipelines to access crude oil. This is where a welder becomes important to the extraction process. Many of the welders who helped build tanks and pipes for the refining process are previous contract staff or employees of corporations such as Shell, AGIP Oil, or TotalFinaElf. The skills acquired by local welders in helping corporations build and manage pipelines have become important in tapping oil for the artisanal refining process.

Fig. 5.2 The different pipes connected to tanks in an artisanal refinery. Source: Photograph by the author.

Crude oil is tapped from the pipelines at night, and speedboats are used to transport the tapped crude to the zones where it is refined (see figs. 5.3 and 5.4). Sometimes speedboats are leased by the youths for their operations. One of the most prominent leasing businesses is owned by a woman who has many canoes. One of the operators told me, "She is a very strong woman with business acumen. We lease speedboats and wood canoes from her regularly to do our business. That way, we are able to minimize cost of business because rather than invest in new boats, you just lease when you need them."[14] While most women I encountered in the creeks were involved in the retail part of the business as I describe shortly, the leasing "company" operated by this particular woman was an exception. I made efforts to meet with her while conducting this research, but many of my interlocutors made it clear that she was not interested in speaking and that whatever information I needed, the interlocutors could provide because all she does is lease boats and canoes, nothing more. We did speak on the phone a couple of times, but she never disclosed more than many interlocutors had already mentioned. As I later understood, she started with a small fishing business, but over time, she was able to make a transition to leasing boats to those who need them. In the refining business, she now leases canoes to those who buy their products from former insurgents who mainly operate the points.

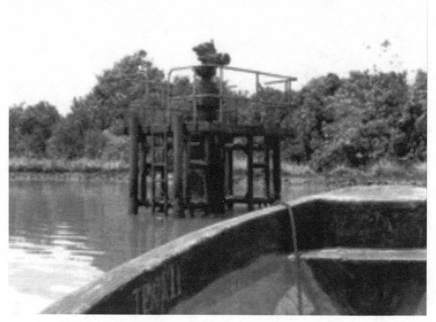

Fig. 5.3 A boat approaching a tapping point. Source: Photograph by the author.

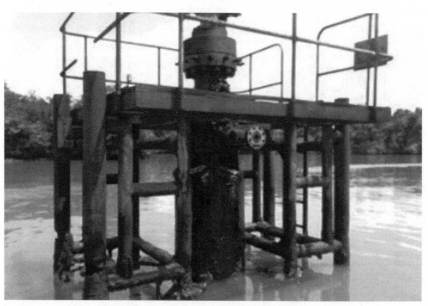

Fig. 5.4 A point in one of the creeks of the Niger Delta. Source: Photograph by the author.

In most cases, the former insurgents who are hired by the state as surveillance contractors to police the pipelines are also those who make ownership claims to points. Their knowledge of the terrain as well as their privileged position of being former insurgents who negotiated an amnesty program that transferred the power of surveillance to them becomes important. As one interlocutor told me, "We usually start our operation around midnight. We know the terrain very well. We have lived all our lives here, and some of us had worked for the corporations as welders before, so we know how to open and caulk pipes. The process is easy. We open the pipes with our tools, load the crude into drums, and then caulk the pipe back when we are finished."[15] Points are owned by ex-militants. In order to set up a point, operators dig through the swamps, connect a pump hose to a perforated pipeline, bury the hose about ten feet under the swamp, and extend it about twenty to thirty meters to where a valve and still pipe is inserted. Once oil is pumped through the pipeline by the corporation that owns it (e.g., Shell), part of the pumped crude from the main flow station will have a stopover at the point, where the point's owner can dispense it to customers. One such tapping station is located in Jones Creek in Delta State. As one of my interlocutors told me, the point can be used to load oil onto multiple barges for shipment to the international market. While loading, different hoses can also be connected to load drums meant for artisanal refineries. The point is not open for business every day; the customers' purchasing quantity and regularity usually determines whether a point owner will tap on any given day. Customers who are well known can easily contact point owners whenever they need their supplies.

What makes the tapping point interesting is the network it builds over time. This network is not limited to artisanal refineries alone. For example, for barges loaded with crude oil, there is a supply chain network that involves traversing different creeks before entering the nautical miles considered to be outside of Nigeria's territory. I was told that once barges are loaded at any tapping point, the supply chain starts with surveillance officers escorting the barges from the creeks of Delta State to the creeks in Ondo State. Once the barges enter the creeks in Ondo State, the supply chain network changes to those in charge of surveillance in the Ondo State creeks near Igbokoda, and it is from here that the surveillance officers escort the barges to the Lagos creek through Ijebu-Ode. From the Lagos lagoon, the barges enter the international waterways for their onward journey to wherever the shipment is headed. Payments are made at each entry point until a barge reaches the international waterways, defined by the treaty governing international waterways as fourteen nautical miles outside the territorial waters of Nigeria.

The same process is applicable to the inland transportation of refined crude oil. Gasoline trucks (popularly known as "petrol tankers") are loaded with refined crude and transported across state lines. Sometimes those trucks also make it across the Nigerian border to countries such as the Republic of Benin and Niger Republic. Those who engage in transporting finished products across state lines already know the time of night when friendly police patrol teams are on duty. For instance, for each truck, transporters may have to part with approximately 100,000 naira (equivalent to $220) to get to their destination, whereas if such a truck were to travel when friendly patrol teams were not on the road, the cost could go as high as 1 million naira (equivalent to about $2,200), which could drastically reduce the profit margin on each truck. The capacity of each petrol tanker is about thirty-three thousand liters (approximately nine thousand gallons). The cost per liter of gasoline in Nigeria is between 125 and 147 naira.

When asked about the destination of the barges, many interlocutors mentioned that they were not in any position to know but that all they could tell was that many of the international operators of the barges were Eastern Europeans or Chinese and other Asians. As one told me, "We do not ask about nationalities when selling our product." The interlocutor quipped, "Does the Nigerian state ask about the nationalities of their customers when they sell oil? My friend, this is business, and in business you look at your profit and not the ethnicity or nationality of your customer."[16] Suggesting that looking at profit matters more than the nationality or ethnicity of customers fits into the larger narrative of capitalism as a system that is devoid of racial, ethnic, or national categories. This way, capitalism, especially oil capitalism, presents itself as a system that only follows the rule of the market. This fits clearly into what Mamdani (1996) demarcates as the problematic establishment of market-based identities in ways that position the market as having the capacity to interact with the population without prejudice regarding race and ethnic categories. While many of my interlocutors seemed to be interested in inserting their artisanal processes into a market-based identity by making claims about the rule of the market, the same market rules are used to embolden corporations that pollute and plunder the resources many community members would claim as their property. In the crude creeks of extraction, point owners represent the highest echelon of the market, but, more importantly, when drums are sold to artisanal refineries by point owners, such drums still go through a similar supply chain network of surveillance and escorts until they get to their destination.

Next are the end users of the refined products. The refined products are carted from the camp to places like Abonnema Wharf in Port Harcourt,

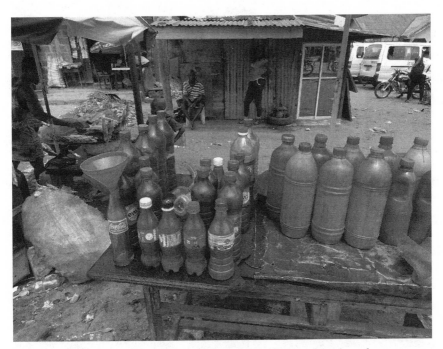

Fig. 5.5 The refined gasoline for sale by a retailer. Source: Photograph by the author.

Yenagoa, and other parts of the state. Customers come from far and wide to purchase refined crude from the zones (see fig. 5.5). Some retailers are seen everywhere in the major towns and cities in the Niger Delta and elsewhere in Nigeria displaying gasoline in kegs for sale. Many interlocutors also told me that some of the gas stations often patronize the zones, but they mix the products with those purchased from state-regulated retailers before dispensing them at their outlets. Interestingly, for many retailers, smoke becomes an important parameter for identifying the availability of refined products. For example, several of the retailers told me that whenever they are looking for product to buy, they look into the sky at night; if they see a very thick smoke, it indicates that refining is going on. Most small-scale retailers are women. While many of the women are already established as independent marketers, they usually follow the lead of thick smoke in the search for product, unlike the larger retailers, who may be able to pay a bribe to some officials of the state security apparatuses for protection. For example, in Omadino community in Delta State, many interlocutors described waking up at midnight to check the sky for smoke. Once they locate the smoke, they usually know who is producing it, which helps in planning the trip to get supplies in the morning. The use of the term *independent marketers* to describe the retailers falls into the

specific lexicon of the oil trade in Nigeria, where independent marketers are those indigenous operators in the downstream sector of the oil industry. It was not surprising to hear the retailers use such language to describe themselves.

Okaiki, Jones, and Omadino Creeks represent just some of the operational centers of the crude oil business in the Niger Delta. Next, I turn to Bodo Creek, located in the Ogoni area of Niger Delta. In the example of Bodo, we see how the youths insert themselves into the processes of technologies of extraction in ways that help navigate and develop new relationships that are at the heart of the communities and that alter forms of governance to reshape lives and frame everyday practices, thoughts, and culture. Bodo is a town at the heart of Ogoniland, a site of oil protests against the state and corporations in the 1990s.

FROM THE HEART OF RESISTANCE TO THE CENTER OF EXTRACTION: BODO AND THE CREEKS OF EXTRACTION AND PRODUCTION

Bodo, located in the Gokhana Local Government Area of Rivers State, is one of several communities that make up Ogoniland in the Niger Delta region of Nigeria. Bodo is a few kilometers from Port Harcourt, the capital city of Rivers State, and has about sixty-two thousand inhabitants living in thirty-five villages. In the past, fishing and farming were mainstays that created employment for over 60 percent of its population, with trading, metalwork, masonry, and carpentry accounting for the remainder. The community is also host to the Shell Petroleum Development Company of Nigeria. The activities of Shell have rendered many inhabitants of Ogoniland unemployed as a result of loss of livelihood, polluted waters, and oil spills on farmlands. This is particularly true for people in Bodo, who engage in fishing and other agricultural enterprises. Bodo was also one of the centers of mobilization by the Movement for the Survival of the Ogoni People. The late Ken Saro-Wiwa, who was killed by the military regime of General Sani Abacha in 1995, led the organization in its battle against Shell and the Nigerian state (Apter 2005; Okonta 2008; Okonta and Oronto 2001). The Ogonis sought compensation for their polluted environment. In 2011, the United Nations Environment Programme issued a comprehensive report on pollution in Ogoniland, which suggested that "oil pollution in many intertidal creeks has left mangroves denuded of leaves and stems, leaving roots coated in a bitumen-like substance sometimes 1 cm or more thick" (United Nations Environment Programme 2011, 10). Today, in the midst of these polluted environments where fishing and farming have become extremely difficult, many youths have resorted to constructing and managing oil infrastructure with support from community members.

In the summers of 2015 to 2018, I conducted ethnographic research in the creek of Bodo, where there are thriving artisanal refineries. The creek, located in the Bodo West oilfield where Shell operates, has only one access road to the community. During the period of my research, I came to understand the processes and practices of crude oil capture employed by the youths who operate artisanal refineries in the area. Three such youths are Naaton, Kenule, and Biebari. The three men operated within the community on their motorbikes, and when it was time to go to the creek, they used a speedboat. Kenule, Biebari, and Naaton were in their early thirties, midtwenties, and early twenties, respectively. As described elsewhere (Adunbi 2015), the idea of youth is very fluid in Nigeria, and many who are not so young can also claim membership in the youth category. Naaton had scars on his face and arm, which he told me were a result of an injury sustained when one of the refineries caught fire in 2014. Kenule described himself as a veteran of the 1990s Ogoni struggle against Shell Petroleum. Visitors to the creek of Bodo West will notice the smell of crude oil and the presence of black expendable crude that looks like big stones. At the site were makeshift tankers, drums, cooling spots, pipelines, and a fireplace for refining oil—all locally constructed. In Bodo, artisanal refining is called kpofire. During my first visit, as we approached one of the refining tanks, Naaton announced, "Welcome to our refinery, where we refine our crude oil for sale." With the phrase *our refinery*, Naaton reiterated the notion that crude oil did not belong to the Nigerian state but to him and his community. As I sat down with him and other youths for an interview that day, he described how the refinery functions and the mode of governance used to manage the oil infrastructure. As Naaton was describing the process, Kenule nodded in agreement while also occasionally reiterating some of the points Naaton made. Three layers of governance can be deciphered in the management of the oil infrastructure in Bodo Creek. These three layers are intertwined and interconnected.

My use of the term *governance* is an attempt to problematize everyday practices that structure relationships and organizations anchored in economic and political choices at state, community, and corporate levels in ways that shape the environment and all resources associated with nature (Adunbi 2015; Bonnafous-Boucher 2005; Chalfin 2015; Ferguson 2005). By problematizing everyday practices, I show some of the shape and character of the management of oil resources and the political choices made in the practice of resource governance that create alternative systems of production within extractive communities. This alternative system of production results in the molding, construction, and reproduction of practices that confront and consolidate knowledge and power in a variety of ways. These include building community

Fig. 5.6 A car getting gas from an artisanal refinery retailer. Source: Photograph by the author.

relationships as a way to access resources, using local knowledge in building infrastructure that is aimed at accessing natural resources while at the same time using the resources for one's own benefit and the benefit of the community, and contesting ownership of resources with the state and corporations. This form of contestation produces three layers of governance. The first is associated with those who have stakes in the local oil infrastructure but no presence in the creek. These are people at the top echelon of the artisanal refining business who are sometimes unknown to the youths who carry out the day-to-day administration of the creek. The operational principle of this category resonates with the principle of indirect rule, where leaders can be heard but not seen (Adunbi 2015; Lugard 1907; Mamdani 1996). I call this category "the near-invisible governance model." With the near-invisible model, I problematize the concept of invisible governance by suggesting that those governing might not be visible, but their actions are visible to those who live by their rules.

The second layer is the direct governance of the creek. This mode of governance is organized around the youths who operate the artisanal refinery business on a day-to-day basis. It is this second category that is at the heart of this chapter. These youths construct, manage, and operate the local oil infrastructure in Bodo and other creeks of the Niger Delta. The layer of authority

in this second category is well structured. For example, Naaton, Biebari, and others perform surveillance roles, which enable them to take up the role of chief security officers of the creek. They had to welcome me and every other visitor sanctioned by their leaders at the entrance to the community. There is also the leader of the creek, who is sometimes called the chairman and sometimes the godfather and who is accorded a lot of respect. The appropriation of such titles as *chairman* and *godfather* illustrates the hierarchical system in operation within the creeks, where the chairman is seen as the symbol of authority. The chairman not only presides over meetings but also, in consultation with his cabinet members, makes business and administrative decisions for the group. To make the administrative duties of the chairman easy, he has a cabinet with positions such as vice chairman, general secretary, finance secretary, and security secretary.

The final layer consists of the community members who cooperate with and support the two previous categories—the invisible layer and the direct governance layer. The cooperation and support of many community members is anchored in the direct benefits they derive from participating in the management of extraction in the creeks. Members of the Bodo community participate in the governance of extraction in two ways. First, many serve as local distributors and marketers of refined petroleum products (Naanen and Tolani 2014; Social Action 2014; Ugor 2013). During my visit to Bodo, jerry cans filled with refined oil for sale were displayed in front of houses within the community. Some members would also transport their products to nearby cities for sale (see fig. 5.6). By participating in this way, members of the community make the claim that they are benefiting from oil they "own." This also arguably improves the economic conditions of many community members who have been displaced from their livelihood by oil prospecting in the community. The second mode of participation is based on free kerosene that is distributed for domestic use. This is a form of what Rogers (2014, 131) calls *petrobarter*, which he describes as "discourses and practices that feature the exchange of oil for all manner of goods and services without the direct intervention of money." Since many people have young family members who participate in the extraction process, they all become beneficiaries of this free kerosene, a by-product of refined crude oil used mainly for cooking. The price per gallon of kerosene is higher than that of petrol, so its distribution is an important way for youths to firm up support for their operations in the creeks. Household members not only use free kerosene for cooking but also sometimes sell it in nearby communities to earn cash to support their families. Free kerosene helps build relationships with community members to guarantee loyalty, goodwill, and support. In return for the kerosene, many

members of the community provide different kinds of support, such as not providing any information about the activities of the youths to the state. As one interlocutor mentioned during our interaction, "Sometimes the state will send their agents here to ask us questions about who is behind the refineries. We will respond with a categorical 'no.' Why should we give our sons and brothers away when we know they are doing the right thing for the community and us? We will never and can never do that."[17]

Community members help local operators conceal construction of artisanal refining infrastructure projects from the prying eyes of the state, since resource infrastructures are the property of the Nigerian state according to the Petroleum Act of 1969 and other subsequent laws, such as the Land Use Act of 1973 (Adunbi 2015, 2017; M. Watts 2004a, 2004b). In addition, many agents of the state are also complicit in concealing the construction of the refining infrastructures because the operators often pay them off. While the youths had the necessary skills to build and manage these infrastructures, the near-invisible participants mentioned earlier are in most cases the financiers of the projects. Some of the near-invisible participants are politicians who belong to the All Peoples Congress, the party in government at the center, and the People's Democratic Party, the ruling party in Rivers State, and some are senior officials of some of the security agencies.[18] The chairman and a few of his cabinet members who are also privy to the presence of the near-invisible participants render returns in terms of profit made from sales to those participants.[19] Thus, the three layers—those who are not directly present in the creeks, those who have direct control of the creeks, and members of the community—all participate in a relationship that is defined by crude oil and entwined in the benefits of its extraction.

CAPTURE AS INNOVATION: ARTISANAL REFINERIES, OIL INFRASTRUCTURE, AND THE TECHNOLOGIES OF EXTRACTION AND PRODUCTION

In the last few decades, innovation has been a mantra of neoliberalism (Ferguson 2010; Ong 2006). Innovation resonates with what Ong (2006, 2) sees as the attributes of neoliberalism, which are "conceptualized not as a fixed set of attributes with predetermined outcomes, but as a logic of governing that migrates and is selectively taken up in diverse political contexts." Therefore, what youths in Bodo Creek have been engaging in as drivers of new energy practices is a form of innovation that taps into neoliberal economic practices. Artisanal practices are a form of innovation in the Niger Delta communities because if neoliberalism is about letting loose human ingenuity, then the building of oil infrastructure using local technologies is an excellent example

of how innovation drives human ingenuity in the oil fields of the Delta. While the state and its corporate partners engage in practices that disentangle communities from the benefits of oil wealth, many youths in the Delta, particularly in the Bodo community, have devised ways of deriving benefits from oil fields using local technologies. As I have previously described, these technologies include the construction of Cotonou boats and speedboats from wood, makeshift refineries made from corrugated iron sheets, and fabricated pans as well as pipes and drums. Cotonou boats are large boats used for carrying large drums of oil. The boat is named after Cotonou, the commercial capital of Republic of Benin. The boat got its name from its use for shipping oil drums through the international waterways to Cotonou, a port city in the Republic of Benin.

Local welders, carpenters, and masons are instrumental to the construction of the oil infrastructure. Materials are sourced from within the community and nearby cities such as Port Harcourt. Welders convert metal into pipes that are connected to tanks where oil is refined and build tanks using corrugated iron sheet and metal. Carpenters construct the boats that are used in transporting drums of crude oil to the refining site. Because of the size of Cotonou boats, which have the capacity to hold between one hundred and six hundred drums of crude oil, they cannot be used to transport drums of crude to the refining site; therefore, they are stationed at a site where navigation is easier. When crude oil is refined, speedboats are used to transport it in drums back to where the Cotonou boats are located, and the Cotonou boats are used to transport the finished product to consumers.[20] Many of the oil infrastructures, particularly tanks and pipes, are located at the refining sites in the creeks. The design of the refinery is such that two big tanks are stationed close to each other, both connected to pipes.

In Bodo Creek, there are about four such refining sites within a short distance from one another. One tank functions as the site where the crude oil is deposited, while another serves as a reservoir for the refined product. There are about four pipes connected to the tanks; each serves its own function. For example, one pipe processes the crude into gas, another processes crude into diesel, the third processes crude into kerosene, and the last pipe transfers the waste product into a pond that serves as a cooling tank. The tanks are elevated above a huge fireplace that performs the role of a refining burner. This is where the notion of kpofire originates, as the term refers to the process of throwing crude oil into the tanks where refining takes place. When crude is emptied into the tank, it makes a sound, *kpo*; hence, the youths christened the refining process *kpofire*. When it is thrown into fire, the crude is allowed to burn for hours unattended until it becomes a finished product, after which it will be allowed to cool before it is packaged into drums for transport to the Cotonou boats.

Access to crude oil is never an issue for many of the youths who own enterprises in the village. Crude is purchased from the former insurgents who operate the artisanal refineries. The former insurgents use their surveillance contracting with the state to their advantage by opening up tapping points to their customers. For example, a 2018 report by Stakeholders for Democracy stated, "A private pipeline surveillance company called Labrado Security Services is owned by Pastor Reuben Wilson, aka 'General Pastor,' a former commander of the Movement for the Emancipation of the Niger Delta (MEND)" (xxi). The company is said to have over two hundred employees from Bille, the majority of whom were formerly engaged in the sourcing and refining of crude oil. Each earns not less than 70,000 naira per month, mostly as a sit-at-home allowance. Farah Dagogo, also a former commander in Movement for the Emancipation of Niger Delta, runs Konfiyibi Nigeria Limited with members of his gang, which holds another major pipeline surveillance contract in the Akuku-Toru/Asari-Toru area, flowing through the Cawthorne Channel. Dagogo has been the target of raids, when usually he would be the one vested with the power to decide the fate of other camps. In Ogoniland, the same sort of arrangements for pipeline surveillance are also in place, but instead of ex-agitators, they are often awarded to cult gang leaders. In spite of the surveillance contracts with these powerful indigenes, the pipelines under their watch are still being vandalized. In some cases, they become part of the problem they are trying to stop; for example, two notorious cult gangs (Deebam and Deewell) have a tight grip on pipeline vandalism and crude oil sales in Ogoniland, and their demands to refiners for cash are becoming unreasonably excessive.[21] Tapping is not limited to pipelines alone. As Naaton explained to me, the youths also "break into wellheads, installing their own pumps and using hoses to load oil onto barges" (Social Action 2014, 24; Ugor 2013). Such operations demonstrate the dexterity and resourcefulness of the youths and their ability to innovate.

Many in Bodo and other Niger Delta communities who participate in the practice of oil refining combine a form of hybrid knowledge of local practices with the knowledge acquired through learning from the corporations to produce a distinct method of extraction and production of oil. The practice can be described as the art of caulking and piping through a process assimilated from corporate practices of extraction and combined local technologies and knowledge of siphoning oil from pipelines and flow stations in the Niger Delta. What becomes clear is the fact that technologies of extraction, innovative as they are, rely heavily on the participation and incorporation of local technological practices that have been with Niger Delta communities for several decades. Such practices include blacksmithing, welding, and metal

extraction. It is the reuse of an old technology of metal extraction, black-smithing, that helps consolidate today's new energy practices. Many of the households I visited used small-scale fishing and agricultural production for subsistence and as an income supplement for the family. Moreover, the shift from these practices to that of crude capture through artisanal refineries also meant a shift in technologies. The new technologies are much more sophisticated than those deployed in the past. Oil production today has taken on a life of its own, and the creeks epitomize not only its sophistication but also a system that encompasses networks of participants, including youths, community members, international networks, and local patrons.

Oil and its materiality have been engulfed in different contestations over the last few decades. These have sometimes involved struggles for its control and the distribution of benefits that accrue from its extraction. While oil has been instrumental in connecting countries rich in such resources to the international capitalist system, its ownership has often generated conflictual politics in the enclaves where the resource is located. No other enclave defines such claim-making politics better than the Niger Delta region of Nigeria. The techniques of extraction deployed there to sidestep what locals considered obnoxious extractive practices that deny them the benefits accruing from oil exploration have been reinvented to create spaces for new energy practices.

More importantly, a parallel can be drawn between extractive practices used by the state and its corporate partners who, through capture, use oil for their own benefits and the ways in which youths in the Delta now use the same logic of capture to engage in artisanal refining practices. Both are (or were) considered illicit. To the state and its corporate partners, what the youths are doing is considered to be illicit and a form of transgression against the Nigerian state. To the youths, the mere capturing of what they consider to be the property of their communities through tapping and refining cannot be illicit; rather, the state's claim to ownership is to be considered illicit. The participation of the youths and others in the creeks in what they consider to be a capitalist enterprise, to many interlocutors, is not illicit. As I mentioned in chapter 4 using the example of ogogoro extraction, the illicit is never a fixed category. The participation of the youths in what the state considers illicit bears historical relevance to how the materiality of resource extraction functions. What is illicit to the state is considered licit by the youths who participate in it. Such participation is seen as an investment of small businesses owned by individual entrepreneurs who are investing in the economy of the state. Thus, the use of entrepreneurship to describe the process of participation in an economy of affection—an economy that connects communities with new livelihood practices—shows the malleable way in which the

capitalist ethos can be invoked, produced, and reproduced. The reproduction of the capitalist ethos in this way demonstrates clearly how livelihood practices can change over time. Change in livelihood practices, as we have seen, is rooted in the hybridization of knowledge that combines the complexity of tapping and caulking with the practice of oil refining and production that helps in navigating the sophistication of extraction. As one interlocutor said, "I am working for an entrepreneur who invests in the business of oil refining. Our ambition is to one day be able to set up our own refinery business. The ambition of every worker in the kpofire village is to make it."[22] In the Nigerian social fabric, the phrase *to make it* is often deployed to describe being successful or rich. Just as every American aspires to the American dream, to an average Nigerian, the future is always anticipated as one where he or she will make it. Many of the staff members of the enterprises aspire to make it in such a way that they will be able to eventually set up their own enterprise. Many have learned the rudiments of the crude refining techniques and are eager to continue to be active participants while keeping in mind that they too can make it, just like their employers.

As this chapter shows, the Niger Delta has a long history of innovation and technologies of extraction and production. Technologies of extraction, in the historical annals of the Delta, have been epitomized by innovation that drives resistance to outsider influence and dictates. It is this innovation that produces the artisanal refineries that litter the landscape of the Niger Delta. More importantly, close analysis of the artisanal refining process refutes any simplistic dismissal of these activities as unorganized or fueled solely by brigands and bandits. Instead, the politics of crude oil governance in Bodo community reveals a solid and complex structure, embedded in local relationships that allow for an integrated amassing of resources, both technological and cultural, coming together to create a vibrant socioeconomic infrastructure. Technologies of extraction, innovative as they are, also borrow from local technological knowledge that has been with Niger Delta communities for several decades. Extraction in the Delta did not start with oil, and old practices of extraction have been innovatively embedded in today's extractive practices. It is the reuse of old technologies of distilling local wine and liquor such as ogogoro, borrowed from moonshine, that helped consolidate today's refining processes.

However, the immeasurable effect of artisanal refineries in the creeks of Niger Delta is mapped in the next chapter. The effects of artisanal refineries result in some of the worst effluence in oil-rich spaces around the world. The environment is a victim of the egregious polluting practices of artisanal refineries. In many creeks of the Niger Delta where artisanal refineries thrive,

such practices have become sites where vulnerable communities, the environment, livelihood practices such as fishing and farming, and the people are condemned to a form of social death.

NOTES

1. Fela Anikulapo Kuti, "Vagabonds in Power," 1979. This lyric is an abridged version of the entire song.

2. For more on this, see, for example, Emma Amaizie and Perez Brisibe, "Who Are the Niger Delta Avengers," *Vanguard*, May 15, 2016, http://www.vanguardngr.com/2016/05/niger-delta-avengers.

3. See, for example, "We Shall No Longer Sacrifice for Peace," Niger Delta Avengers, February 12, 2016, http://www.nigerdeltaavengers.org/2016/02/we-shall-no-longer-sacrifice-for-peace_12.html.

4. See, for example, "Warri Refining and Petrochemical Company (WRPC)," Nigerian National Petroleum Company, accessed August 7, 2019, https://www.nnpcgroup.com/Refining/Pages/WRPC.aspx.

5. Ibid.

6. Ibid.

7. Interview conducted in Ikeja, Lagos, June 15, 2016.

8. Interview conducted in Ikeja, Lagos, July 2016.

9. For more on this, see, for example, "Factbox: Nigeria's $6.8 Billion Fuel Subsidy Scam," Reuters, May 13, 2012, https://www.reuters.com/article/us-nigeria-subsidy-graft-idUSBRE84C08N20120513.

10. Ibid.

11. See, for example, Cahal Milmo, "Diezani Allison-Madueke: Behind the 'Reformer' of the Nigerian Oil Industry's Arrest," *Independent*, October 7, 2015, https://www.independent.co.uk/news/world/africa/reformer-of-nigerian-oil-industry-diezani-alison-madueke-arrested-on-bribery-charges-a6685146.html.

12. See, for example, World Bank Group, 2020. "Poverty & Equity Brief: Sub-Saharan Africa, Nigeria." April 2020. https://databank.worldbank.org/data/download/poverty/33EF03BB-9722-4AE2-ABC7-AA2972D68AFE/Global_POVEQ_NGA.pdf.

13. All names used in this chapter are pseudonyms in order to protect the identity of my interviewees.

14. Interview conducted in Port Harcourt, June 25, 2018.

15. Interview conducted at Bodo, Ogoniland, July 10, 2015.

16. Interview conducted in Warri, Delta State, June 30, 2018.

17. Interview conducted in Bodo, Ogoniland, July 15, 2015.

18. For more on this, see, for example, a report by Stakeholders for Democracy, "'More Money, More Problems'—Economic Dynamics of the Artisanal Oil Industry in the Niger Delta over Five Years," accessed December 13, 2019, http://www.stakeholderdemocracy.org/aorpressrelease/.

19. During the period that I was there, I tried several times to learn the exact profit they made and how it was distributed, but they never shared that information with me.

20. I use the term *consumers* to denote those who purchase the finished products from the youths and not necessarily those who are the end users of the product. Sometimes consumers are the go-betweens who purchase the products and sell them to their international partners, who oftentimes wait for their consignments in the middle of the Atlantic Ocean.

21. For more on this, see, for example, a report by Stakeholders for Democracy, "'More Money, More Problems.'"

22. Interview conducted in Bodo, Ogoniland, July 21, 2015.

6. THE SOCIAL DEATH OF THE ENVIRONMENT

Degradation, Infrastructure, Displacement, Trade, and the Complicated Technologies of Extraction

In many communities around the Lekki Free Trade Zone (LFTZ), Ogun-Guangdong Free Trade Zone (OGFTZ), and artisanal refineries in the creeks, one pertinent question runs through the minds of community members: What are the consequences of these gigantic projects and the artisanal refining that occurs alongside them? This chapter interrogates the environmental consequences of artisanal refineries mimicking state and corporate extractive practices in enclaves of extraction. It pays particular attention to the ways in which artisanal refiners engage in practices that pollute the environment with devastating consequences for the lived experiences of community members. It weaves together stories and evidence of environmental degradation by presenting how community members deal with such environmental disasters. The chapter concludes by showing how such disasters compare with similar ones that often result from state-regulated corporate practices. I begin by considering the dangers and promises of the kind of development that is cultivated in free-trade zones (FTZs).

NIGERIA IS LIKE EIGHTEENTH-CENTURY
CHINA. WE CAN HELP CHANGE THAT

One afternoon, after I spent several hours with my interlocutors at the OGFTZ, my Chinese host invited me to lunch at one of the restaurants in the zone. My research assistant, Faith, whose car we used for transport, was asked to drive along while I joined my Chinese friends, James and John, in their chauffeur-driven car. Along the road, James and John pointed at some of the sites being developed by new enterprises that had just been licensed

to operate in the zone. James mentioned that since the construction work was at an advanced stage, very soon these new enterprises would come online and add to the number already manufacturing consumer products. The ride took about five minutes, and as soon as we alighted from the car, many of the staff on the ground stood up to welcome me and my Chinese friends to the restaurant. James and John are two of the bosses in the zone, hence the respect accorded them by the Nigerian staffers at the restaurant. Shortly after, we settled in for lunch, mainly Chinese food, prepared by Nigerian chefs.

As soon as lunch was served, I reminded James and John that we needed to continue the conversation we started in their office, where I had asked them what they saw as the advantages of doing business in Nigeria. John responded with a very curious answer: "Nigeria is like eighteenth-century China, and we are here to help fast-track its movement to the twenty-first century." Curious as this assertion might be, it reminded me of Worby's (1998) and Brautigam's (2010) takes on the dangers of development and Africa's "Eastern promise," respectively. Worby points out the dangers of state-inscribed development for communities through the example of Zimbabwe, particularly in the Gokwe region, where new agricultural practices were introduced as part of the state's interest in fast-tracking development that provided little benefit to the population. In the same vein, John's comment about transforming Nigeria, which resembles eighteenth-century China, into a modern world represents what Brautigam calls Africa's "Eastern promise," a phenomenon that the West could actually learn from if Westerners continue to do business on the continent. The notion of an African Eastern promise, a term variously used to describe the new engagement with China, seems to fit well with John's narrative that Africa—nay, Nigeria—is still in the eighteenth century and requires some foreign interest or power to rescue it and move it forward to the era of modernization. While John seemed oblivious to the deeper meaning of his comment, the actions and inactions of practitioners in free-trade zones are not lost on many independent observers. It is exactly this that Worby highlights in his analysis of the contradictions inherent in development practices using the example of the rural village of Gokwe in Zimbabwe. Gokwe and Igbesa, where the OGFTZ is located, have two things in common—both are rural and agrarian. As Worby (1998, 60–63) shows, post-1980 Gokwe is demonstrative of "the rhetoric of planning," where the newly elected leaders of postindependence Zimbabwe attempted to use the agricultural extension department's mandate to actively reorder knowledge "to draw attention to the form in which the object of knowledge takes shape . . . and the recurrent practices set in motion to constantly reproduce it." In this case, these practices were the institutionalized

procedures of data production for Agritex—an agency of the government of Zimbabwe—and the continued promotion of development.

Ultimately, through the years, the continued inscription of a social geography of Gokwe took many different forms, but they all "made possible its reconception as a plausible object of incorporation for the state" (Worby 1998, 63). The subordination of people seen in the first two periods—pre- and postindependence—shifted into differences between places in Agritex's defined regions that could render the planning apparatus of the state virtually invisible and could thus continue to tame the frontier of Gokwe for the postcolonial state. Still, Worby (1998, 64) concludes, "The representational modes characteristic of these different periods nevertheless shared features in common: Both treated Gokwe as though the identities it contains have existed outside of time. Both figured the district as the repository of peoples affixed to the landscape, people that exist as eternal attributes of the place they live within. And above all, both established the grounds upon which state domination, in the name of a civilizing process, could be seen as justifiable and necessary."

Though Rhodesia no longer exists, these narratives, structures, and discourses of development still carry through the postcolonial state and into the hearts of the "natives" their use was intended to displace (Worby 1998, 64). Though Worby does not explicitly mention relations between China and Zimbabwe, his interrogation of the thin line between danger and development illustrates how past subordination and historical colonial mechanisms and rhetoric were used in Zimbabwe to further the state's development. This can also be seen in how narratives of development are weaved around the ideation of FTZs in Nigeria today.

While Worby complicates development and its inherent dangers, Brautigam seems favorably disposed toward the ways in which China and Chinese firms are engaging with Africa, hence her assertion that such engagement holds promise for the entire continent and should serve as a model for Western engagement with Africa. In "Africa's Eastern Promise: What the West Can Learn from Chinese Investment in Africa" (2010), she challenges Western views of what Africa needs in order to develop and Western opinions about China's aid in Africa while discussing China's economic policies in-country and its economic engagement in Africa. Abiding by neoliberal practices, Western knowledge of development insists on liberalizing markets and promoting democracy (Brautigam 2010, 1). Alternatively, while the United States views China's aid as having no strings attached and propping up pariah regimes, China argues that it is promoting state intervention and economic incentives to attract private investment, replicating processes that assisted

it in moving hundreds of millions of Chinese people out of poverty over the past few decades (Brautigam 2010, 1–2).

The first prong of Chinese investment that Brautigam (2010, 2) discusses is resource-backed development loans, inspired by China's trading history with Japan. She uses Angola as an example, describing how the war-battered country "has been helped by three oil-backed loans from Beijing, under which Chinese companies have built roads, railways, hospitals, schools and water systems" (Brautigam 2010, 2). In addition, she points to the use of resource-backed loans in Nigeria, Ghana, and the Republic of Congo (Brautigam 2010, 2). While these loans are desirable, since they often come with fewer requirements than those offered by Western institutions like the World Bank or International Monetary Fund, there are concerns about the ability of African governments to maintain infrastructure investments and about the lack of environmental and social regulations used by China. As Brautigam (2010, 2–3) details, "Chinese construction companies often bring in Chinese manpower . . . reducing opportunities for Africans. When they do employ locals, Chinese firms often offer low wages and low labor standards." Many countries in Africa are working to mitigate these risks by driving better-informed bargains with China.

The second prong of Chinese investment discussed in the article is China's assistance in building special trade and economic cooperation zones in Africa (Brautigam 2010, 3–4). At the time that this piece was written, seven of these zones were in the works, with hopes to draw Chinese firms to Africa. Overall, Brautigam (2010, 5–6) argues, "the early stages of industrialization might bring pollution, low wages, and long workdays, especially if the Chinese zones are successful. But like China's resource-backed loans, the planned economic zones promise to provide African countries with some things they very much want: employment opportunities, new technologies, and badly needed infrastructure." Though she argues that it is necessary to acknowledge China's success in moving hundreds of millions of people out of poverty, it is also necessary to look at the environmental and social sacrifices that were required to make that happen. Those sacrifices resonate with the social death of the environment in Nigeria. Many communities face the consequences of losing their land and their livelihood to development practices such as the ones undertaken by the Chinese consortium and its Nigerian partners.

"Who Wants the Refinery?": FTZs, Land, and Livelihood at the Heart of the Ocean

Many who use their land for farming, including those in Igbesa and the fishers and farmers around Idashon in Lekki, face displacement from their land

and livelihood as a result of the construction of FTZs in those spaces. As many community members in Idashon confided during one of my visits to the area, the life they live today is comparable to life in hell. When asked why hell, one interlocutor, Mrs. Adebisi, popularly known as Mama Jummy (mother of Jummy), told me one morning while I was having breakfast with her family, "Although we have never been to hell . . . from what we learn, it is not a habitable place. It is a place reserved for those who have offended God, and they are expected to spend eternity there."[1] Mama Jummy may never have been to hell, but her understanding of it and its resonance with the daily lived experiences of members of her community seems apt. An important episode that many members of the community recalled during conversations about the FTZ was the threat by the former governor of Lagos State, now the minister of works and housing, Babatude Fashola, during his visit to the community in 2014.[2] While speaking to some leaders of various communities in the area in the Yoruba language, Governor Fashola stated that whoever did not want the refinery, one of the major projects of the FTZ to be sited in the area, should leave. He asked in Yoruba, "Who wants the refinery?" In a video published by Saharareporters, there seems to be an overwhelming "we do not want it" from the crowd, and the governor's response is, "Whether you like it or not, the FTZ and the refinery will be built." To Mama Jummy and many community members, this obvious threat has been incrementally carried out since 2014, with the displacement of many in the area to make way for the refinery. Mama Jummy is a trader who sells small items often needed by community members in a shop by the main road to the palace of the chief of the community. Close to Mama Jummy's shop are several other small stalls—some sell food items, while one operates as a restaurant that sells breakfast to elementary school students on their way to school. The location is usually a beehive of activity in the morning hours. On most mornings, seated in one of the shops, I observe how the kids going to school queue up in front of the restaurant to buy akara and eko (pap and bean cake), a popular breakfast delicacy for people in the area. As the kids wait to be served, truckloads of heavy equipment meant for the various ongoing projects within the FTZ traverse the road. Cars and buses convey workers to the site. As these trucks pass by, I gaze at the faces of community members who are hanging out in the vicinity. Some hiss, while others just smile and murmur in Yoruba, "Won tun ti de" (meaning, "Here they come again"). The main road is thus a site that tells two different stories. It is a site of bewilderment, where movements of trucks and people who work in the FTZs remind members of the community that they are in the process of losing their livelihoods and homes to state-organized development practices.

It is also a site of befoulment, as the injection of different chemicals into the area as the Atlantic Ocean is dredged to make way for the port and refinery constantly pollutes the air and water.

As many interlocutors narrated, with the dredging, it has become virtually impossible to fish because the fish no longer come close to where many fishers would typically find them. Mama Jummy's brother is a fisher, a profession he inherited from their father but now finds difficult to practice. For example, he told me, "In the past, I would wake up early in the morning, head to the ocean with my fishing nets, get in my canoe, and return with a bounty of fish, which will be given to my wife to sell at the nearby fish market." That has since changed in two important ways. First, he can no longer fish in the area because if his canoe approached the area being dredged, he would be arrested on the pretext that he was disrupting work. Second, in order to get more fish, he would have to redirect his canoe to another area of the ocean, and it would take hours before he would be able to return to shore. To him, this presents a number of challenges, as those who come to the community to buy fish know that fishers would typically return from the ocean by 7:00 a.m. with their catch. If they have to travel a few more miles and thus return later, their business will be affected and trade slowed down. Third, once they are displaced from their home, they may not even be able to fish anymore.

The promise of the refinery, owned by Africa's richest person, Aliko Dangote, located within an FTZ where enterprises are not encumbered by state regulatory practices, is illuminating. On the one hand, the FTZ is a collaboration between a Chinese consortium and the Lagos State government. On the other hand, Dangote is allowed to site his refinery within the zone as part of Lagos State's investment strategy. As highlighted in chapter 3, FTZs present certain benefits that are not available to enterprises located outside their bounds, hence the motivation for Dangote to locate his refinery within an FTZ. Yet, the FTZ's promise of employment opportunities for members of the community has proven to be a mirage, as many of my interlocutors told me. What *has* become a reality for them is pollution and displacement. Moreover, by the time the refinery comes online, pollution from the refinery will combine with pollution from other enterprises to double if not triple pollutant levels within the FTZ. Oil refineries are said to cause smog and air pollution because they emit about a hundred different kinds of chemicals every day. Among these are metals like lead, which hinder brain development and make it hard for children to learn, and very fine dust particles called PM10 that get deep into our lungs and harm our ability to breathe. Refineries also emit gases like sulfur dioxide, nitrogen oxide, carbon dioxide, carbon monoxide, methane, dioxins, hydrogen fluoride, chlorine, benzene, and others.

The health effects of these chemicals can be devastating to humans, caus-ing permanent damage like respiratory problems (such as asthma, coughing, chest pain, choking, and bronchitis), skin irritations, nausea, eye problems, headaches, birth defects, leukemia and other cancers, and even death. Young children and the elderly are the worst affected.[3]

When I told many of my interlocutors about the impacts of the FTZ, especially the refineries' effects on their individual health and the health of their communities, many reiterated Mama Jummy's assertion that they now live in hell. As one teenager retorted, "What could be worse than hell? You think we do not know what hell looks like? Can those who are building the refinery live here? Of course not! So, we are left with all of these. They just want us to die a slow death."[4] Herein lies what I call "the social death of the environment." In this space, the environment is constituted as a site within which profit and promises can be made—promises of development and social and economic improvement in the life of the people. The prom-ise of social and economic improvement leads to profit maximization, but in order for profit to be maximized, the environment has to be sentenced to a social death. The social death of the environment bears unintended con-sequences for the environment and the people who inhabit it. For Mama Jummy and others displaced from their social environment by the LFTZ and the OGFTZ, the social life of the environment that they have known their entire lives has now become the social death of the environment that they are forced to accept. The significant social and environmental costs that these investment strategies initiated by China and its business allies pose to Afri-can nations are enormous, and nowhere are the consequences for the envi-ronment more conspicuous than in Nigeria.

In addition to the social death of the environment, communities of ex-traction face forms of jeopardy that are woven into each other. First, these communities all want development. But ideas of development as propagated by the state and its acolytes have a complicated history that is embedded in a form of exploitation that began with colonialism and continued into the postcolonial era. For example, many colonial territories in Africa were turned into sites of extraction. When postcolonial states emerged in Africa in the 1960s, those who took power continued the extractive practices initi-ated by the colonial state but now with the support and connivance of their foreign allies. Second, those who inhabit these communities of extraction want employment opportunities for their youth, but at the same time, those job opportunities are often inaccessible to their wards. Those who engage in extractive practices respond to criticisms regarding limited opportuni-ties for local communities by citing resource community members' lack of

adequate skills for the necessary tasks. In order to mitigate the absence of these required skills, expatriates and workers from outside the communities are utilized. When members of the community are employed, their jobs are limited to things like cleaning, clearing of bushes, and other unskilled labor. Third, communities of extraction all want a clean and sustainable environment, but as has been shown numerous times, a clean and sustainable environment is often antithetical to the practices of extraction that emit carbon and other chemicals that are dangerous to community health and the environment. Considering these three interrelated jeopardies together, free-trade zones and artisanal refineries present a complicated relationship between practitioners and the communities they purport to serve. The Eastern promise that plans to transform an agrarian community like Igbesa into an industrial powerhouse, as described by Brautigam (2010), creates twenty-first-century environmental problems; however, as I show below, artisanal refineries' attempt to innovatively mimic state and corporate practices of oil refining and distribution also ultimately mimic and exceed this dangerous twenty-first-century problem, emitting into the atmosphere dangerous chemicals that are often more damaging than those inflicted by corporations. More importantly, the emitting of gaseous substances into the atmosphere by artisanal refiners runs contrary to the ideals of Ken Saro-Wiwa, progenitor of the Niger Delta struggle for a better environment.

Damn the Environment: Crude Negotiation in the Creeks of Oil

Crude oil contains relatively high quantities of sulfur. When crude oil is heated to produce fuel, the sulfur is converted into a colorless gas called sulfur dioxide (SO_2) with a very strong smell akin to rotten eggs. Exposure to very high concentrations of SO_2 (e.g., when there are accidental leaks at a refinery) can result in painful irritation of the eyes, nose, mouth, and throat; difficulty breathing; nausea and vomiting; headaches; and even death. Some of the health effects from daily exposure to outdoor levels of SO_2 include tight chests, worsening of asthma and lung disease, and the narrowing of air passages in the throat and chest. People with asthma are more sensitive to SO_2, and exposure to the gas can provoke asthma attacks. SO_2 also mixes easily in water, including moisture in the air, to form an acid, resulting in acid rain and early morning acid dew that causes severe damage to metals, stones, and the environment. This situation can be exacerbated when oil is refined in crude and unsophisticated ways, as is typically done in the thousands of artisanal refineries that litter the Niger Delta.

While artisanal refineries thrive in many places across the Niger Delta, there also exist many challenges that can turn the refining process into a nightmare for the environment and neighboring communities. First, the social deaths of the environment experienced in the areas where artisanal refineries are located are more severe than those of the FTZs in terms of scale. This constitutes challenges for the practitioners and inhabitants of resource enclaves. Two of these challenges occur when members of the Joint Military Task Force, popularly known as the JTF, confront operators of the artisanal refining business. This confrontation often results in JTF officers setting the entire refineries on fire and engaging the refinery operators in gunfire at whichever location the JTF visits. The attendant result is that all crude oil found at this location is emptied into the creeks, causing enormous pollution of fresh water sources for community members. Second, when refineries are in operation, operators emit more carbon dioxide into the atmosphere than the corporations do because they lack the corporations' sophisticated technologies. The emission of more carbon dioxide into the atmosphere results in the prevalence of soot in many communities, a problem I return to later.

The JTF was established by the Olusegun Obasanjo administration in response to incessant attacks on oil infrastructure by militants in the Niger Delta (Adunbi 2015). Tagged Operation Restore Hope by the federal government of Nigeria, the unit drew members from the Nigerian army, navy, air force, police, and state security services. The unit has the objective of combining surveillance, intelligence gathering, and rapid responses to attacks on oil infrastructure. Sunday Amaechi was a military officer who participated in the initial operation of the JTF in the Niger Delta.[5] I first met Amaechi in the summer of 2015 at the headquarters of the JTF in Warri. During our subsequent meetings, I was able to win Amaechi's confidence and, occasionally, to accompany him and his officers on their usual inspection tour of the region. Amaechi arrived in the Niger Delta in January 2006 at the onset of an oil insurgency against the Nigerian state and multinational oil corporations in the region. He was one of the first officers deployed to restore peace and enforce the law in the region. His role involved arresting, taking into custody, and processing for trial suspects from the different institutions that were charged with violating those laws in the region. The experience, as Amaechi narrated, was quite varied, as at the time he arrived, "there was high incidence of crime of different dimensions: from armed robbery, burglary, militancy which involves kidnapping and destruction of oil companies, pipeline vandalization, oil bunkering, and so on. So, in a nutshell, that was the situation, almost a case of anarchy as the militants had reduced daily oil production substantially and myself and my men were asked to restore hope

to the people and the nation." Yet, as it turns out, Operation Restore Hope did not necessarily restore hope to the people whose environments were being degraded and condemned to social death. Rather, it was about restoring the hope of the state's revenue drive. With the end of insurgency and the emergence of a new mode of engaging the state by Niger Delta youth—the production of oil through artisanal refining—Operation Restore Hope was once again called on by the state to "restore hope." However, this time, that phrase served as a mantra for the tragic death of the environment.

The JTF today is tasked with the mission of ending artisanal refineries that the state considers to be illegal. The JTF has a broad mandate, but one aspect is to halt youth restiveness in the Niger Delta and create a conducive environment for multinationals. This is considered the central objective of the force because of the strategic importance of the region to the Nigerian economy. Thus, a typical day for the men and women of the JTF involves targeting areas earmarked by the commander for operations in the region. The JTF structure is made up of three battalions spread over three states where, it is assumed, the majority of the artisanal refiners operate (i.e., Rivers, Delta, and Bayelsa States). These battalions are given an area of responsibility so that the battalion commander knows where to deploy operatives. Apart from those that work in the headquarters, who control and coordinate the affairs of the JTF, the workings of the task force depend on where each battalion is assigned. If there is a threat to oil infrastructure—namely, when it is envisaged that youths are planning to tap a point for crude oil—the commander uses the opportunity to deploy troops there. As one of the men in Amaechi's battalion told me, "On a typical day, in the morning, you are assigned a duty that may include either surveillance or intelligence gathering or going to the field for operations with your men." While in the field, officers liaise and interact with community leaders for intelligence gathering. To do so, many military personnel told me, you must first identify who the leaders are and invite them to have a dialogue. If they are willing to engage with you, you allow them to state their grievances. In the operations, one of the officers continued, if it is determined that operators of the refineries are armed, the type of arms determines how JTF officials will assess the threat and the response it warrants. This is the crux of the issue. Many refinery operators are armed, and, when they engage officers of the JTF, it can sometimes lead to casualties—including more than human losses. In one instance in early 2019, over 300 "illegal refineries," 156 locally manufactured boats, and 1,085 surface tanks were destroyed by the military in one community. "Additionally, 15 barges, 10 tanker trucks, 31 vehicles, 45 speed boats, 16 outboard engines, 41 pumping machines, 15 generating sets and 76 other items have been impounded,"

reports *The Cable*, one of Nigeria's most popular online news platforms.[6] As a result of this operation, two soldiers were reported dead, but no report indicated the number of artisanal refiners killed. As I was told by my interlocutors, during this incident, a few refiners were killed, and their weapons and ammunition were confiscated. While there is no way of confirming the exact number of casualties, because, as one interlocutor stated, "people die all the time when the army invades these sites," what does become clear is that casualties occur in the attempts to destroy the physical presence of these refineries.

Casualties can also often result in the social death of the environment. Three ideas of death thus emerge. The first is environmental death, which results from the persistent pollution of the creeks due to the activities of the JTF and the artisanal refiners. The second stems from physical death as a result of injuries sustained when there is an accident at the refineries or an attack by the JTF. The third type is psychological death as a result of the loss of livelihood by members of the community who rely on the creeks and other adjoining rivers for fishing and other aquatic practices.

Regarding environmental death, once the surveillance officers of the JTF return from their field operations and agree on which of the refining sites to attack, the following process occurs. At dawn the following day, officers who are assigned to the operation invade the creek site of the refineries. Sometimes they engage in gun battles with refiners, and then, once the refiners are subdued or have escaped, the entire infrastructure is set ablaze. This act in itself is not limited to the refinery operations but also includes oil-laden vessels that, when accosted on the water, are often either set ablaze or emptied into the river. When this happens, the entire creek is enveloped with black crude, which spreads to other rivers in the region. The effect of emptying crude oil into the creeks can be devastating to the environment and the communities that rely on these creeks as the source of fresh water necessary for their survival. While living in the region, I observed how women would wake up in the morning to fetch fresh water. However, they were often forced to either travel several miles in their canoe to find uncontaminated fresh water or to bring crude-laden water home that sometimes resulted in fire when boiled for purification. When crude is set ablaze, the fire can last for days without end, and the smog that results can constitute a serious health hazard. Military personnel are not trained in the art of crude oil management and disposal. Instead, their approach to fighting what has been designated by the state as a criminal act is as crude as the crude oil itself—invade the camps, throw all the oil out, and set the entire place on fire. To the soldiers, setting the place on fire is seen as completely incapacitating the operators, thereby preventing them from reorganizing the camp. While the approach of causing

incapacitating destruction might make sense to the state, the consequences of this tactic to the environment and its inhabitants can be devastating. In my encounters with some of the refinery operators, members of the communities, and elders who live where the refineries are located, the examples of Odi and Umuechem were often brought up to make sense of their experience. These examples exemplify the destructive effect of oil extraction on families, livelihood practices, and the environment.

Odi and Umuechem are two communities in the Niger Delta that experienced different levels of destruction at the hands of the state in Nigeria's recent history. The Umuechem community has two oil fields and several oil wells operated by Shell. On November 1, 1990, community members organized a protest against Shell and the Nigerian state, asking for greater benefit from the oil exploration on their land. In response, special police forces were deployed into the community. In what is known as the Umuechem massacre, the police invaded the community and, it has been said, killed every living thing they found. At an event marking the twenty-seventh anniversary of the massacre in 2017,[7] many community members recounted their experiences to those at the ceremony, describing how their livelihood, environment, and family members constituted what I call multiple casualties. This happened during the era of General Ibrahim Babangida's military dictatorship. The oil boom of the era as a result of the first Gulf war might have motivated the Nigerian state to enact this invasion, as it may have feared that any reduction in oil production as a result of the protest could result in loss of revenue. However, the event was repeated ten years later when a detachment of police and military officers invaded another oil-bearing community—Odi—again leaving multiple casualties in its wake.

It was thought that the advent of a civilian regime in May 1999 would usher in a new lease on life for the Niger Delta people. Resistance by youths reached a crescendo in the latter part of 1999 when seven police officers were kidnapped and their bodies later found in the creek. It was alleged that the Egbesu Boys, a resistance group within the Niger Delta, was responsible for this act, though they denied responsibility. In response, President Obasanjo issued an ultimatum to the governor of Bayelsa State, decreeing that the governor must deliver the youths to the police or a state of emergency would be declared. The ultimatum had hardly expired before troops were deployed to Odi, a village of about sixty thousand people. As it was in this village that the police officers were killed, the soldiers moved in and razed it to ashes in retribution. This act of reprisal has come to be known as the Odi genocide, as thousands of lives were lost. A fact-finding mission was dispatched to the area by the human rights community in Nigeria, and its findings were

released in a document titled "Genocide in Odi." This document has been widely publicized within and outside the country. It stated,

> We saw no single livestock, poultry or other domestic animals except a stray cat. The community's 60,000 inhabitants had fled into the forest [*sic*] or been arrested or killed. Only a few thoroughly traumatized old women, men and children could be seen around, some of them suffering from fractures and some other injuries while trying to escape from advancing soldiers. We also received information that the soldiers were particularly contemptuous of books. Several libraries and educational materials were particularly targeted and destroyed. The invasion was premeditated. It was carefully planned by the people in order to make things smooth and easy for the oil companies. The invasion was called operation Hakuri II by the Minister of Defense, General T. Y. Danjuma who said, "it was initiated with the mandate of protecting lives and property—particularly oil platforms flow stations, operating rig terminals and pipelines refineries and power installation in the Niger Delta." ... Some of the graffiti left on the walls of the building destroyed by the soldiers confirmed their genocidal mind. A few examples include: "we will kill all ijaws," "Bayelsa will be silent forever," "Worship only God not Egbesu," "Egbesu, why you run," "Our power pass Egbesu. Next time even the trees will not be spared." (Genocide in Odi, posted on www.africaaction.com, 1999)

The statement continued, expressing support for and solidarity with the people of the Niger Delta and identifying with their struggle. The human rights groups called for an independent judicial commission of inquiry, a complete reconstruction of Odi, and the immediate withdrawal of troops from the Niger Delta. The statement continued: "We support the legitimate struggles of the peoples of the Niger Delta for self-determination, resource control, environmental justice, cultural self-expression and genuine participation in determining the conditions under which oil companies operate in the area. We therefore endorse the Kaima declaration, Aklaka declaration for the Egi people, The Urhobo economic summit resolution, Oron Bill of Rights and other demands of peoples' organizations in the area" ("Genocide in Odi," posted on www.africaaction.com, 1999).

The destruction of these communities with a shared history of oil exploration has today become a reference point for how inhabitants of refinery communities react to military personnel invading refineries. Operation Restore Hope has been transformed into an operation that brings multiple casualties to Niger Delta communities.

"Let's Set Them Ablaze": Casualties, Connivance, and the Politics of Refinery Destruction

At the height of the 2019 general elections won by President Muhammadu Buhari, there were allegations of the involvement of the military in the

artisanal refinery business in the Niger Delta. Specifically, the governor of the oil-rich Rivers State, Nyesom Wike, accused the commander of the JTF of colluding with those engaged in the illicit oil business. The commander, General Jamil Sahar, refuted the allegation while simultaneously accusing Wike, who was running for a second term in office, of offering himself and his men billions to help manipulate the election in his favor.[8] Of course, in popular discourse in the Niger Delta and among many operators of the "illicit" oil business, members of the JTF are said to regularly collude through different forms of payment. In fact, the National Economic Council's ad hoc committee on petroleum, chaired by the governor of Edo State, Godwin Obaseki, stated at the end of one committee meeting that between January and June 2019, Nigeria lost about twenty-two million barrels of crude oil to oil theft, a figure that could double before the end of 2019. The Nigeria National Petroleum Corporation also reported a "77% rise in cases of oil pipeline vandalism across its network of pipeline infrastructure" during the same period.[9]

What becomes clear from this is that the artisanal refining and other associated oil businesses that Niger Delta youths engage in constitute a multimillion-dollar industry that thrives on negotiation and settlement between the youth (operators of the business) and JTF officers. *Settlement*, in Nigerian parlance, is a code word describing a process of bribery and corruption. When someone is paid a bribe, it is often said that he or she has been settled. This language entered the lexicon of popular discourse in Nigeria during the military dictatorship of the 1980s and 1990s, when bribery and corruption became pervasive. The practice continues today, hence the term's deployment by people in the Niger Delta in describing negotiations among players in the oil business. Thus, the security operatives in charge of ending what the state considers to be illicit business end up being complicit, through the setting up of artisanal refineries, in the practice of mimicking the state and its corporate allies. Negotiation and payment of an agreed fee (settlement) are mostly carried out when establishing the point—a hollow on the pipe carrying crude oil—a practice described in chapter 5. Settlement is also paid when the crude is going to be transported to either the international market or the campsite where the refining takes place. While these are two common sites for settling, a settlement can take place at every step of the crude business until the product gets to its final destination—the consumer.

It is when the settlement is not forthcoming that oil-laden vessels and artisanal refineries are confiscated and set ablaze by the JTF. When vessels are confiscated, security operatives allow a few hours or even days for negotiation with the owners. Once negotiations are complete, the vessels are released and escorted into the international waterways for safe passage to the

end consumers. The monitoring and enforcement unit of JTF, whose duty is to monitor the waterways and the movement of vessels, is largely responsible for negotiating settlements regarding captured oil-laden vessels. This unit and those in surveillance are responsible for monitoring and enforcing activities against the artisanal refineries. As one officer mentioned to me, "Some of our officers do connive with owners of vessels and artisanal refineries. This connivance is not just at the level of the soldiers and men on the ground but also at the very high level. So, if those people connive, it is at a very high level, and that means people who are highly connected in government or military or especially from the naval side. Since some of these activities happen offshore, it is sometimes almost beyond the observation of troops stationed on-shore."[10] Despite this person's claims that the majority of activities occur offshore, there are still onshore operations. The naval section of the JTF has been alleged to be directly involved in conniving with the artisanal refinery operators. Amaechi explains that "there is direct involvement of the naval section of the JTF because some time ago, we captured some vessels that later disappeared under the watchful eyes of the navy, and those responsible were apprehended and punished in our court-martial." Importantly, while the use of the terms *apprehended* and *punished* may make it sound like the JTF is working hard to combat what the state sees as a dent in its revenue base, this does not mean it is actually curtailing the practice of artisanal refining in the Delta.

Abbey is one of the operators who owns a refinery that was the target of the JTF while I was in the region in the summer of 2017. Abbey has been in the business for a few years, and he has seen some ups and downs, including being involved in an accident where one of the tanks they were using at his campsite exploded. The scars on his face and body attest to the fragility of and risks associated with the business. He suffered a second-degree burn so severe that he almost lost his left ear. That incident, however, was not a deterrent. In one of my discussions with Abbey regarding why the JTF set the camp where he operates ablaze, he said that the security personnel refused to accept settlement, and that was the reason there had been an increase in their setting refinery camps ablaze. This, Abbey suggested, hampered their businesses during that period, but they were still resolute in continuing their trade. When asked if he and the other enterprise owners have become hopeless as a result of this increase in JTF activities, Abbey responded with an emphatic no, saying that he and his colleagues are not hopeless because there are precedents for these actions by the JTF. Essentially, he says, any time there is a turnaround in personnel, the newly posted officers are initially hostile to the business and may sometimes be very brutal during this period.

Being hostile becomes a way of sending a message to the two interacting parties—the state and military hierarchy that positions them there and the operators of the refining business that they are instructed to curb. Hostility in this sense is not necessarily intended to end the practice of artisanal refining and selling of crude and refined oil but to show an expectation of negotiating new settlement deals with the enterprise owners. As Abbey told me, after a few months, it would become business as usual because things would return to normalcy. However, returning to normalcy, as Abbey suggests, also equates to the return of the devastation of the environment that occurs through artisanal refining practices that those in the creeks are forced to accept.

CRUDE EFFECTS: THE SOCIAL DEATH OF THE CREEKS OF OIL

The effects of artisanal refineries on the environment are enormous. The many sites of artisanal refineries in the Niger Delta clearly show the level of damage caused to the environment and livelihoods (see figs. 6.1 and 6.2). The camp at Okaiki exemplifies this social death of the environment. At the camp, the stench of crude oil permeates the entire site, which contains over forty-five enterprises. Workers at the site often wear only their underwear (99 percent of the workers are male). While in their underwear, they use their bare hands to ferry buckets full of crude oil into the cooking pot. When the bucket overflows, the contents are poured on the ground, so the entire campground looks like a road surfaced with asphalt. In most cases, some of the crude that has been left out for a long time has transformed into a solid state that resembles big stones inside and outside the campsite. Crude from the waste pot is emptied daily into the creeks. All over the camp, the trees that are left standing look like unfamiliar objects stained with a brown substance. Concerns about the environment are secondary to operators of the refineries. When asked if they are concerned about this damage, many respond that the major oil corporations have been doing the same for more than fifty years, and they are not seriously bothered by this degradation because they are simply earning income from the natural resource they are endowed with.

The environment is not the only casualty here. People, including those who work in the camps, are also victims of the social death of the environment. The health effects of daily exposure to crude oil that is cooked in the refining process cannot be overemphasized. While there has been no scientific study on possible causal relationships between exposure to naked fire from refinery operations and illness in the region, many workers have reported to me that, after much inhalation of the thick smog, they get sick. When they are sick, they spend their off days resting before returning to

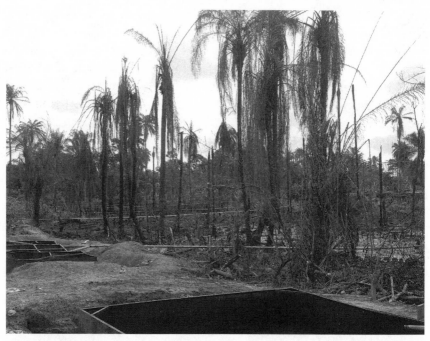

Fig. 6.1 The devastation of the environment in an artisanal refinery village. Source: Photograph by the author.

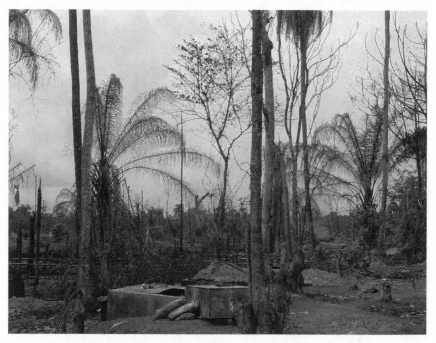

Fig. 6.2 Environmental degradation. Source: Photograph by the author.

work. Gabriel is one such worker who has experienced sickness several times. Gabriel is in his early twenties. His father was the breadwinner in their household but passed away the year Gabriel graduated from high school. As a result, Gabriel could not continue his education because the cost of college is highly prohibitive. He is the oldest son and has five other siblings, two girls and three boys, who are all younger than him. After his father's passing, he was left to shoulder the responsibility of the entire family because his mother's petty trading business could not sustain them. A mutual friend from high school introduced Gabriel to an artisanal refinery operator who hired him as one of the men entrusted with emptying buckets full of crude oil into the cooking pot. Through this activity, Gabriel earns enough to support his siblings. Since he started working at the refinery in 2016, he has been able to pay his siblings' school fees, give some allowance to his mother, and still have more than enough to take care of himself. Whenever he gets sick, his mother takes care of him. When asked if he is concerned about the health effects of exposing his near-naked self to crude refining every day, Gabriel responded thus: "Why should I be concerned? Life is all about risk. I only work four days a week, and I have three days to rest. It is not that I have not been sick before. I have been ill several times, just like many of my friends who work in our camp. That is part of the hazards of the job, and I do not have another job that can feed my family now."[11] The effect on health is just one of the hazards of the job, as Gabriel mentioned, but the risk also includes the possibility of explosions that can lead to death or injuries that leave scars on the body, like Abbey's. Abbey's body scar is permanent, and he was lucky to have survived it. There are numerous other instances where scores have died as a result of explosions in the camp. The practice of refining crude also constitutes a serious threat to the aquatic life in the region, particularly when the waste from the cooking pot is emptied into the creeks. Those who still fish complain about oil spills caused by the corporate practices of the major oil multinationals, such as Chevron, Shell, and ExxonMobil, but added to that now are complaints about artisanal refiners dumping waste into the creeks.

More importantly, one of the major devastating effects of oil exploration by oil corporations, which has also been further compounded by artisanal refineries, is the prevalence of soot in many Niger Delta communities. For example, displayed in one of the offices of Social Action, an environmental group in the Niger Delta, are two big bottles containing what is considered to be acid rain caused by soot. One of the officials of the nongovernmental organization, Basil Nkpordee, explained to me that soot flies around in many communities all the time, and these bottles—he pointed at the bottles laying in the visitor's area of the office—are what they show guests to demonstrate

the precarity of life in the Niger Delta. Basil Nkpordee narrated how he collected the water, saying, "The first day that I collected the rain in the bottle you are looking at there [*pointing at the bottle*], I put a big basin on top of a stool outside when it started raining. When the rain stopped, I poured the water in this big bottle. I wanted to confirm what I have heard about acid rain, and, pronto, the entire water turned black with a greenish coloration."[12] He told me he tried it again a few months after the first rain to see if there would be any difference, but there was none. Hence, as part of Nkpordee's environmental campaign for his organization, Social Action, he usually points out the two bottles to visitors as a way of demonstrating the consequences of pollution as a result of oil extraction in the Delta. What becomes clear is that one doesn't have to look into the bottles to see the effect of soot in many communities. In every community that I visited, I saw the impact of soot on the environment. Small particles of a blackish dust fly around and become concentrated on rooftops, walls, and any exposed objects.

Many of my interlocutors complained that while soot has been around in the Niger Delta since the inception of oil exploration, it has become worse in the last few years as a result of the activities of artisanal refiners. At the offices of Environmental Rights Action, Friends of the Earth International in Yenagoa, Bayelsa State, field officer Morris Alagoa showed me the walls of their new office location to demonstrate the presence of soot. Alagoa told me he had just moved into the office and had the entire place painted a few weeks before my arrival, but as I could see, the office didn't look like it had a new coat of paint. Many parts of the office were already turning black. To further confirm this, Alagoa and I took a tour of some areas in the city; he would occasionally gesture at me to look at newly constructed buildings, painted just a few months before, that had turned black. To Alagoa, such is the devastating effect of soot on the environment. He asked rhetorically during one of our conversations, "If a new building could suddenly turn black after a few weeks of being painted, what do you think is daily happening to our body in this environment?" While I have no answer to his question, I also know that some of the most functional artisanal refineries are located a few miles away from Yenagoa, the capital city of Bayelsa State. To Nkpordee, the most important thing he worries about on a daily basis is the number of the members of his community who depend on rainwater for their freshwater consumption. As Nkpordee says, anytime it rains, "you see children run outside to put their parents' basin in the rain in order to collect fresh water. Many adults will also do the same. Many in my community believe rainwater is made possible by God, and it is fresh and can be consumed right away. Now, when we tell them that rainwater can be dangerous because it is acidic, many would look at us

as crazy. When we connect it to environmental problems made possible by oil exploration, they get it."[13] As Weidman and Marshall (2012, 1) contend in an article for the Center for American Progress, "Soot is the common term for a type of particle pollution called PM 2.5—particulate matter that is 2.5 micrometers in diameter or smaller. Such fine particles are even smaller than dust and mold particles, or approximately 1/30 of the size of a human hair. It is comprised of a variety of pollutants, including chemicals, acids, metals, soils, and dust, which are suspended in the air after emission. Soot can come in solid, liquid, or gaseous ("aerosols") states."[14] Many of my interlocutors claim that the effect of soot on their health has been devastating, and they are right. For instance, the United States Environmental Protection Agency says of soot, "Microscopic particles can penetrate deep into the lungs and have been linked to a wide range of serious health effects, including premature death, heart attacks, and strokes, as well as acute bronchitis and aggravated asthma among children."[15] The American Lung Association corroborates this with its warning that exposure to soot can potentially cause "cancer and developmental and reproductive harm" (Weidman and Marshall 2012, 1). The effect on Niger Delta farming and fishing communities can be devastating: "Particle pollution is also correlated to acid rain. The same compounds from soot that react in the air to form haze—sulfur dioxides and nitrogen oxides—can mix with atmospheric moisture to acidify precipitation. Carried by the wind or in the water, this acidified pollution degrades water quality by making lakes and rivers more acidic, depleting the nutrients in the soil and damaging sensitive farm crops, and changing the nutrient balance in river basins, along coastlines, and in forests" (Weidman and Marshall 2012, 1–2).[16] The harmful impacts of corporate extraction of oil and artisanal refinery practices are enormous. The enormity of the environmental consequences is akin to being suffocated, hence the condemnation of the environment and the people who inhabit it to social death. Acid rain, cloudy skies that reduce visibility, and humidity all make life unbearable for humans and the environment.

While complaints about corporations can be loud within communities of extraction, such complaints about artisanal refiners are often muted for two reasons. First, many community members benefit from the refining process, either as participants or as end users of the products. Second, artisanal refiners have their own disciplinary apparatus, such as an effective surveillance system and the use of coercion through the force of arms. These methods help mute any loud complaints against such practices that might emerge within the enclaves. As described in chapters 4 and 5, benefits do accrue to communities of extraction in a variety of ways, including employment for women as traders, employment of youths as refinery workers and transporters, and

easy access to the product, which is used to power vehicles on a daily basis. It is these very participants in the refinery process who often serve as a surveillance system for the operators by either notifying refinery owners of an impending raid by the JTF or informing operators when community members are dissatisfied with their operations. Through this process, the operators are able to construct an organizational web that protects their business interest while still contributing to the devastation of the environment.

Therefore, the environment has become the Janus of the resource enclaves of the Niger Delta. Like the double-faced Greek god of beginnings and endings, the environment is constantly being defined and redefined through this constant struggle for its control—control by the state, its corporate partners, and the operators of artisanal refineries. Today, perception of nature has become an intertwined matrix that reinforces practices aimed at exploiting it to its own detriment. The environment has become a form of simulacra where state and corporate mimicry aimed at producing an original practice end up reinforcing practices that reshape what looks like the original thing while also condemning it to its social death, precluding any ability to create sustainable social change.[17] Extractive enclaves and their practices sometimes function as separate, emblematic, and thus pliable entities with the capacity to become sites for experimentation. It is this form of experimentation that enclaves such as the campsites at Okaiki, Jones Creek, Bodo, and Omadino have allowed in recent times. The emergence of Okaiki, Bodo, Omadino, and Jones Creeks as sites for artisanal refining practices provides an exceptional example of how the concepts of corporate mimicry can be appropriated in ways that can similarly result in the social death of the environment.

At the same time, the spaces of FTZs in Lagos and Ogun also provide environmental challenges akin to those of the artisanal refineries. Pollution is universal in meaning and practice to both types of sites of extraction. FTZs as sites of extraction of economic value that encompass refining and manufacturing as well as artisanal refineries as sites of extraction of purely oil are both detrimental to the environment and the people who inhabit them. As an elder in one of the communities told me, "We are dead, but we are also not dead." Death, in this sense, becomes a metaphor for how life can present itself as death to people even when they are still alive. Life in this sense becomes ephemeral for all intents and purposes. The environment that, for many hundreds of years, served as a site for livelihood practices and healthy living has now become a site where people, on a daily basis, think about the evanescence of life itself. From the creeks of oil to the enclaves of FTZs, the story remains the same—people and the environment experience social death with every passing day.

Notes

1. From a conversation at the home of Mr. and Mrs. Adebisi (not their real names), June 30, 2018.

2. For more on this, see, for example, "Lagos Government Has Not Returned Our Land as Falsely Claimed, Say Ibeju-Lekki Villagers," Sahara Reporters, July 6, 2014, http://saharareporters.com/2014/07/06/lagos-government-has-not-returned-our-land-falsely-claimed-say-ibeju-lekki-villagers.

3. For more on this, see, for example, "Oil Refineries, Your Health and the Environment: What You Need to Know," groundWork, accessed September 14, 2019, https://www.groundwork.org.za/factsheets/Oil%20Refineries.pdf.

4. Interview conducted on July 18, 2018.

5. Sunday Amaechi is not his real name because the military officer expressly asked that his identity be protected.

6. For more on this, see, for example, Femi Owolabi, "More Illegal Refineries Destroyed after Undercover Report," Cable, November 21, 2018, http://petrobarometer.thecable.ng/2018/11/21/more-illegal-refineries-destroyed-after-undercover-report-on-oil-theft.

7. See, for example, "Social Action Joins Umuechem Community in 27th Year Remembrance of Shell's Massacre," Social Action, November 2, 2017, http://saction.org/social-action-joins-umuechem-community-in-27th-year-remembrance-of-shells-massacre/.

8. See, for example, "Wike Insists Army Commander Is Involved in Oil Theft, Denies Bribery Allegation," Cable, May 22, 2019, https://www.thecable.ng/wike-insists-army-commander-is-involved-in-oil-theft-denies-bribery-allegation.

9. Oluwaseyi Awojulugbe, "NEC: 22 Million Barrels Crude Oil Stolen in First Six Months of 2019," Cable, August 30, 2019, http://petrobarometer.thecable.ng/2019/08/30/nec-22-million-barrels-crude-oil-stolen-six-months/.

10. Interview conducted in Warri, June 2018.

11. Interview conducted in Yenagoa, July 2018.

12. Interview conducted in the offices of Social Action, Bori, Ogoniland, Rivers State, July 18, 2018.

13. Interview conducted in the offices of Social Action, Bori, Ogoniland, Rivers State, July 18, 2018.

14. For more on this, see, for example, Weidman, Jackie, and Marshall 2012, "Soot Pollution 101, What You Need to Know and How You Can Prevent It," Energy and Environment, Center for American Progress, August 10, 2012, https://www.americanprogress.org/issues/green/news/2012/08/10/12007/soot-pollution-101/.

15. Ibid.

16. Ibid.

17. This is a reference to Jean Baudrillard's (2010) work, "Simulacra and Simulations (1981)," which defines simulacra as things that lack an original. This paper argues that nature is perpetually defined by its cultural context and thus has no "original."

CONCLUSION

Revisiting the Ancestors: Claim-Making
and the Crafting of an Oil Economy

"Lekki Free Zone, Nigeria's trade window to the world," the Lekki Free Trade Zone's April 2015 *Newsletter* boldly announces on its front page, which also shows three skyscrapers and a building that bears resemblance to one of the newly constructed World Trade Center buildings in New York City. All the buildings and other structures are positioned beside a flowing Atlantic Ocean and images of palm trees and a few other trees. Underneath the beautiful image is written, "Beneath the radiance of the rising sun, nestled within the shores of the Atlantic Ocean, evolves a beautiful business landmark symbolizing Lagos' newest milestone in its urban development history. Welcome to the Lekki Free Zone, the cradle of new dreams."[1] Throughout the newsletter, colorful images of what the trading site will look like when completed as well as pictures of major actors such as the political leaders of the state and the business leaders of the zone compete for space. All visitors to the zone get a copy of this newsletter in addition to other documents that are used to sell the project as both an idea and an object of value to potential investors. Images in newsletters such as this, as Riles (2000) reminds us, become an important parameter in the aesthetics of turning documents, brochures, and files into alluring objects of value in ways that make such objects more attractive—in this case, for business purposes. The beauty of the pictures in the newsletter is not necessarily intended to improve its circulation within the business community; it is about the aesthetics of the document itself and how it is used to showcase the supposed business-friendly community where the zone is located. The attractive images are being used to sell the zones to investors in ways that make it seem as if those who live in the community want the zone to be located there. The beauty of the newsletter is in the contradictions inherent in many of its images.

The most noticeable contradiction that is apparent in what I have demonstrated in this book is how palm trees adorn the newsletter as part of the aesthetics of business in Lagos—palm trees, which many community members in that particular location rely on for their livelihood practices but have been destroyed to make room for the zone, are here displayed as objects of beauty in that zone. The drilling of the Atlantic Ocean for the purpose of building a port aimed at shipping refined oil to the international market is not displayed in the front-page picture. Rather, the serene Atlantic Ocean is shown without the affordances of community living that epitomize the entire landscape of the region. Thus, the newsletter is crafted in a way that leads potential investors and other readers to the conclusion that the entire landscape being developed as a free-trade zone (FTZ) is completely devoid of history.

The cultural meaning of the communities around the FTZ, as I have demonstrated, extends beyond the infrastructure and structural components represented in the newsletter in particular and the entire project in general because life and livelihood encompass art, sacred sites, dance, and rituals. The recourse to ancestral claims as a way to reclaim land on the part of many of these communities has become an important trope. Many of the communities contend that ownership of property—land and natural resources— should derive solely from ancestral practices that predate the colonial state and postcolonial state. While many of these communities are not oblivious to the importance of the market to development strategies of the state, they also want an assured livelihood system that takes into consideration their sacred sites, such as spaces of ancestral worship that are significant to community life. The condemnation of these sites and their livelihood spaces to social death warrants the invocation of ancestral claims to reclaim their land and the social life they are attuned to. The astronomical increase in FTZs and their impact on community life and livelihood is not peculiar to Nigeria.

Free-trade zones in many African countries have grown exponentially in the last decade. China and consortiums from China, in collaboration with local governments, especially in countries such as Nigeria, have spearheaded many of these FTZs. While FTZs are not new in and of themselves, the introduction of different practices in their establishment has become a distinguishing factor in this new iteration. Nowhere is this new practice more prominent than in a country like Nigeria. The first iteration of FTZs emerged in the structural adjustment programs introduced as part of an economic recovery program prescribed by the international financial institutions, especially the International Monetary Fund and the World Bank, in the 1980s and 1990s. Known then as free export processing zones, their main

objectives were the opening up of the country's market to external investors and the establishment of specialized zones for processing exportable commodities. While today's FTZs are no longer limited to exportable commodities, resource extraction and exportable materials still dominate their practices. As I have shown in this book, infrastructure construction is today tied to the establishment of specialized zones where enclaves so created can enjoy some level of autonomy from the state. The autonomy enjoyed by these enclaves is shaped by the displacement of large populations to make way for their construction.

Therefore, as I have demonstrated, the construction of large trade zones on the outskirts of otherwise very impoverished megacities across many African countries opens up a Pandora's box of thorny questions. Free-trade zones, as well as adjoining satellite cities, are often marketed as self-contained units that purposefully separate themselves from the chaos and disorder of the rest of the city in which they are built while also providing much-needed manufacturing and infrastructure facilities for the state (Watson 2013). By investing in these projects, investors help to both perpetuate the inequality that the free-trade zones cause and displace large populations in the largest and poorest cities, such as Lagos. Free-trade zones cater to the needs of the state, whose intent is to create new revenue streams and benefit foreign investors who are presented with new opportunities for profit making while ignoring the concerns of communities where such zones are located. The symbolic and legal framework of FTZs is also tricky. By overemphasizing the independence and self-contained nature of FTZs, governments enter a slippery slope of sovereignty, such that FTZs are seen more as their own independent city-states than as part of the larger political system that defines the state. That is exactly how the FTZs in Nigeria are envisaged in their application and practice. While the aim of the zones is to develop the capacity of the state to increase its revenue base, expand on its physical infrastructure, and create environmentally sustainable jobs, the outcomes for the population have been deprivation, displacement, environmental devastation, and dispossession from livelihood and ancestral inheritance, resulting in the social death of the environment. While the FTZs represent an example of the social death of the environment in the enclave of special economic zones (SEZs), artisanal refineries illustrate another form of exclusion and dispossession in communities of extraction.

As I have shown in this book, an oil economy continually produces various structures of power within communities of extraction in Nigeria. These structures of power have implications for both state-regulated SEZs and the artisanal refineries regulated by youths and former insurgents. Both types

of SEZs—FTZs and artisanal refineries—help shape a new understanding of how businesses and the state complicate relationships with enclaves of extraction by revisiting the ownership claims of those communities. This complicated relationship also has implications for neoliberal economic and political practices and competition for control of natural resources in Nigeria and around the world. One such implication was recently tested with the COVID-19 pandemic that engulfed the entire world. In an attempt to control the pandemic, many nation-states sheltered in place, resulting in the closure of international borders. Nigeria being no exception, all its international flights were suspended and its borders closed. Interestingly, two interrelated events took place within that period, both connected to the operation of FTZs. In the first event, some expatriate workers engaged in the construction of Dangote petrochemical and refineries in the FTZ staged a protest over what they claimed was their neglect by the management. The protest, according to a report by *Punch*, one of Nigeria's major newspapers, was posted on YouTube, where one of the protesters said,

> We, the citizens of India, are speaking from Dangote Refinery, which is situated almost sixty kilometers away from Lagos in Nigeria. We are workers of the Dangote Refinery. The whole world is suffering from coronavirus, which is a global pandemic. Nigeria has also announced its lockdown. During this lockdown, the workers of Power Mech Company are being forced to work. The staff here are forcing us to work through physical violence. We request our home minister, Mr. Amit Shah, and prime minister, Mr. Narendra Modi, to kindly understand our problems and help us get out of this situation by taking necessary steps to protect and save our lives.[2]

Power Mech Company is in partnership with the Dangote Group to build the refinery. While Nigeria was implementing the lockdown, workers at the refinery were still at their desks and construction sites. What this clearly shows, as I have demonstrated in this book, is the level of sovereignty that FTZs enjoy because they operate through a different regulatory system from that of the state. While the rest of Nigeria was under a lockdown, the FTZs, considered spaces within Nigeria but also not of Nigeria, made their own rules. That is exactly how FTZs are conceptualized and implemented.

The second event was the arrival of a Chinese group to Nigeria while the lockdown was ongoing.[3] The Nigerian government had claimed that they were medics who had helped stabilize the pandemic in China and that they were in Nigeria to help the Nigerian government and people deal with the pandemic that had just started rising in the country. A few weeks after their arrival, at every daily media briefing organized by the Nigeria Center for

Disease Control and the presidential task force on the pandemic, journalists asked when the medics would start work. The response of the Nigerian government was always "very soon," until the minister for the interior, Rauf Aregbesola, said at one of the daily presidential task force briefings that the Chinese medics were not guests of the federal government of Nigeria. The minister claimed, "Indeed fifteen Chinese nationals came into Nigeria on April 8. From everything we have heard and said, they were here on the bill of CCECC, a Chinese company working in Nigeria, doing some work for us in several places."[4] As it turns out, the "medics" were staff of the China Civil Engineering Construction Corporation (CCECC), one of the consortiums that own the Lekki Free Trade Zone.[5] Many Nigerians questioned why some Chinese would be allowed into the country during a lockdown. As I have shown, FTZs operate within a different regulatory regime, but at the same time, it was going to be difficult for the Nigerian state to justify opening up the borders to some groups of foreign nationals during a pandemic, hence the justification that they were medics who were in the country to help combat the pandemic. While FTZs operate within a global economic system that prioritizes profit over people, communities of extraction bear the brunt of all the system's appurtenances. Communities of extraction in the state-regulated FTZs as well as the unregulated ones epitomized by artisanal refineries face environmental and human consequences of their practices. Such is the benchmark of an oil economy such as Nigeria's.

As I have shown throughout this book, the territory that is Nigeria today has made several transitions in the business of extraction. Beginning with the first encounter with the Europeans and the transformation of the entire coastal area into slave ports, the story has always been about extraction for profit. The same motivation that drove the inhuman commodification and shipment of human bodies to the New World through the port city of Lagos and that of Orimedu (Palma) is also what inspired the annexation and cession of land in Lagos and Epe by the British for the purpose of allowing European firms to set up shop for the production of palm oil and other agricultural materials. The story continues into the twentieth century with the discovery of oil in commercial quantities in the Niger Delta region of the country. The twenty-first century continues to witness the same manifestation of extractive practices, motivated by profit and shaped by oil, with devastating consequences for the people and the environment.

Oil and its materiality, engulfed in different contestations over the last few decades, are, as I have demonstrated, resulting in crude capture and recapture in many creeks of the Niger Delta. These contestations have sometimes involved struggles for the control of oil and the distribution of benefits

that accrue from its extraction. While oil has been instrumental in connecting countries rich in such resources to the international capitalist system, its ownership has often generated conflictual politics in the enclaves where it is located. No other enclave defines such claim-making politics better than the over two thousand artisanal refineries scattered all over the creeks of the Niger Delta region of Nigeria. The techniques of extraction deployed in the region to sidestep what former insurgents and youths consider obnoxious extractive practices that deny them the benefits accruing from oil exploration are today being reinvented to create spaces for new energy practices. Techniques of ogogoro extraction, borrowed largely from the technologies of extracting moonshine in the United States, have become instrumental in the development of an oil technology. The new techniques of oil refining in the Niger Delta have established a procedure for former insurgents and youths of the Niger Delta to participate in neoliberal economic activities in enclaves of SEZs. The enclaves of artisanal refineries bear semblance to the enclaves of FTZs in the ways in which both are choreographed and self-regulated. The development of this new crude processing and refining technology is not without its own complications.

The resultant effects of the new technology, innovative as it may be, have been dispossession, displacement, and the social death of the environment. While the state and the operators of the artisanal refineries compete for the capture of the enormous crude reserve many in the region claim they are blessed with by their ancestors, the environment, community members, and livelihoods are rendered vulnerable to unintended consequences of resource extraction. High levels of pollution, hazardous living conditions, and social displacement of people and sacred sites are aspects of life many are condemned to, though several operators of the refinery marvel at the innovation they have devised to derive benefits from oil.

The effect of pollution in many Niger Delta communities cannot be overemphasized. Life in the creeks has become abominable as a result of the double jeopardy that the communities are subjected to—environmental pollution by both multinational corporations (MNCs) and artisanal refineries. In the past, responsibility for pollution has often been placed at the feet of the MNCs alone, but now many of the community members who engage in artisanal refining of oil seem to be competing for that ignoble position. Getting the benefits of oil considered to have been passed to this generation by its ancestors is one thing, but the crude ways in which this is being done have unintended consequences for the environment and our climate. In the creeks, many of the youths are unconcerned with the effect of their business on the climate, but a future study of such concerns may not be far-fetched.

There is ample evidence of the effect of MNCs' global operations on climate change but none so far on that of the artisanal refineries whose crude extractive practices are much more devastating.

For example, in January 2015, the Royal Dutch Shell Company agreed to an $84 million settlement with the Bodo community in acknowledgment of the environmental damage sustained by the region as a result of two oil spills, which occurred in 2008 and 2009 (BBC 2015). The story is noteworthy not only because it represents the first major settlement to be reached between a major multinational oil company and the local community ravaged by the consequences of oil refining but also because of how it contributes to the persistent emerging narrative about oil and the Niger Delta. This prevailing narrative focuses on the "failed promise" of oil, whereby oil, rather than serving as the lifeblood of the state and the community from which it is extracted, impinges negatively on these communities in a myriad of ways that include environmental degradation and loss of livelihood. First is the inability of the region to benefit from this hidden wealth, as most of the capital moves beyond the local community to multinationals situated in more developed nations and to the elites of the state. Second, oil often creates environmental damage in these communities, which is also reflected in most of the news and press coverage about the region. The third narrative strand centers on the sociocultural consequences arising from the oil infrastructure, where illegal refining and resentment by local populations are cast as the primary villains and as the cause of much of the crime and environmental harm in the region. It is worth noting that even as Shell accepted liability for the oil spills, company executives were quick to assign blame for the environmental damage to the illegal refining process used by artisanal refineries.

While Shell, the Nigerian state, and other oil corporations would refer to artisanal practices as illegal, the youth who operate these refineries see their operations from a completely different perspective. To many of them, what they are doing is inserting themselves into a global neoliberal economic system that prioritizes entrepreneurship and businesses. The youths see themselves as entrepreneurs who are running business enterprises regulated by the system they have put in place in the different communities where they operate. These business enterprises, the youths and other practitioners claim, are contributing immensely to the Nigerian economy, just like businesses licensed by the state do. The youths are never shy about the campaigns waged by environmentalists and activists in the Niger Delta that often shape conversations about control of natural resources. Operators of the refineries argued, in many of my conversations with them, that what they have done is take control of the resources they were blessed with by their ancestors, taking

back resources that have been in the control of the Nigerian state and their corporate allies for many years. "Taking control" of natural resources such as oil is a form of discourse that permeates how youths who operate artisanal refineries in the Delta understand their participation. Thus, taking control is not shaped by what is licit or illicit but rather by an economic system that shapes understandings of sovereignty, space, belonging, property ownership, and the functionality of enterprises. All these are concerns that special economic zones contend with, whether in the FTZs that focus on the extraction of economic value or in those that aim at the extraction of oil resources. Both represent a form of capture and recapture, licit and illicit in ways that generate outcomes that can be, in some ways, devastating to communities that are host to the resources being extracted. Herein lies the failed promise of oil and other extractive practices.

The problems that emerge from these failed promises of oil deserve acknowledgment and are a crucial and critical area of concern for scholars, practitioners, and activists alike. These narratives highlight the undemocratic forms of governance that prevail within oil infrastructures and have thus been accorded significant attention. Yet, within the shadows of this overarching narrative of oil-as-undemocratic, narratives that are far more complex can be unearthed. The impulse toward binary thinking, which casts the illegal refiners against the multinationals, fails to account for how relationships are molded in ways that produce hybridized governance within local communities. It is this hybridized form that has turned the creeks, known for their access to fishing and farming, into crude creeks of a governance that manifests itself through natural resources but also through pushing back against neoliberal conceptions of innovation and agency. As this book shows, the Niger Delta has a long history of innovation and of technologies of extraction and techniques of governance. Technologies of extraction, in the historical annals of the Delta, have been epitomized by innovation that drives resistance to outsider influence and dictates. Ogogoro distilling technology helped shape new innovation and techniques of extraction when the economy shifted to crude extraction. It is this innovation that produced the artisanal refineries that litter the landscape of the Niger Delta. More importantly, close analysis of the artisanal refining process refutes any simplistic dismissal of these activities as unorganized or fueled solely by brigands and bandits. Instead, the politics of crude oil governance in the Niger Delta reveal a solid and complex structure, embedded in local relationships that allow for an integrated amassing of resources, both technological and cultural, coming together to create a vibrant socioeconomic infrastructure.

This same vibrant socioeconomic infrastructure created with the innovation introduced via ogogoro to producing refined oil is today creating a major environmental catastrophe for the Niger Delta region. The preponderance of soot and the associated health hazards in many communities today are the result not only of more than fifty years of oil exploitation by the major oil corporations, such as Shell, Chevron, ExxonMobil, and others, but also of over two thousand artisanal refineries operating in the creeks of the Delta. In revisiting the ancestors, I am reminded of what one of my interlocutors told me during our many conversations in Nigeria. My interlocutor had asked a rhetorical question: "What if our ancestors were to return today—what would they find?" The simple answer to this is a dispossessed population and an unlivable environment. My interlocutor's question captures the feelings of many community members in the creeks of the Delta, in Lagos and Ogun, and, indeed, in many communities that are host to the technologies of power and extraction that dispossess and displace. The ancestors may not have returned, but what becomes clear is that many community members are disappointed in the state, in corporate allies of the state, and in some in their communities. As one told me, the ancestors are always watching; you may not see them, but they see you, and one day everyone shall be held to account by the ancestors.

Notes

1. *Lekki Free Zone Newsletter*, Issue 1, April 2015.

2. For more on this, see, for example, Tobi Aworinde, "Lockdown: Indian Workers at Dangote Refinery Cry for Help," *Punch*, May 2, 2020, https://punchng.com/lockdown-indian-workers-at-dangote-refinery-cry-for-help/.

3. Abdur Rahman and Alfa Shaban, "Chinese Experts Arrive to Help Nigeria in Coronavirus Fight, Opposition Kicks," AfricaNews, April 9, 2020, https://www.africanews.com/2020/04/09/chinese-experts-arrive-to-help-nigeria-in-coronavirus-fight-opposition-kicks.

4. See, for example, Nike Adebowale, "Coronavirus: What Chinese Experts Came to Do in Nigeria—Minister," *Premium Times*, May 19, 2020, https://www.premiumtimesng.com/news/headlines/393659-coronavirus-what-chinese-experts-came-to-do-in-nigeria-minister.html.

5. Ibid.

BIBLIOGRAPHY

Abimbola, W. 1985. *Vice-Chancellor's Speech to Graduating Students of University of Ife*. Ife, Nigeria: University of Ife Press.

Achebe, Chinua. 2012. *There Was a Country*. New York: Penguin Press.

Ade-Ajayi, Joseph F. 1962. *Milestones in Nigerian History*. Ibadan, Nigeria: Ibadan University Press.

Ade-Ajayi, Joseph F., and E. J. Alagoa. 1980. "Nigeria before 1800: Aspects of Economic Development and Inter Group Relations." In *Groundwork of Nigerian History*, edited by Obaro Ikime, 224–35. Ibadan, Nigeria: Heinemann.

Ade-Ajayi, Joseph F., and Michael Crowder. 1971. *History of West Africa*. New York: Columbia University Press.

Ade-Ajayi, Joseph F., and Robert Smith. 1971. *Yoruba Warfare in the Nineteenth Century*. Ibadan, Nigeria: Ibadan University Press.

Adebanwi, Wale. 2012. *Authority Stealing: Anti-Corruption War and Democratic Politics in Post-Military Nigeria*. Durham, NC: Carolina Academic Press.

Adebanwi, Wale, and Ebenezer Obadare, eds. 2010. *Encountering the Nigerian State*. New York: Palgrave Macmillan.

———. 2013. *Democracy and Prebendalism in Nigeria: Critical Interpretations*. New York: Palgrave Macmillan.

Adetayo, Saheedat. 2020. "The Ethics of State Capture: Dangote and the Nigerian State." In *The Palgrave Handbook of African Social Ethics*, edited by N. Wariboko and T. Falola, 378–81. New York: Palgrave Macmillan.

Adunbi, Omolade. 2011. "Oil and the Production of Competing Subjectivities in Nigeria: 'Platforms of Possibilities' and 'Pipelines of Conflict.'" *African Studies Review* 54, no. 3 (December): 101–20.

———. 2013. "Mythic Oil: Resources, Belonging and the Politics of Claim Making among the Ìlàje Yorùbá of Nigeria." *Africa* 83, no. 2 (May): 293–313.

———. 2015. *Oil Wealth and Insurgency in Nigeria*. Bloomington: Indiana University Press.

———. 2016. "Embodying the Modern: Neoliberalism, NGOs, and the Culture of Human Rights Practices in Nigeria." *Anthropological Quarterly* 89, no. 2 (Spring): 399–432.

———. 2017. "'We Own This Oil': Artisanal Refineries, Extractive Industries, and the Politics of Oil in Nigeria." In *Governance in the Extractive Industries: Power, Cultural Politics and Regulation*, edited by Lori Loenard and Siba N. Grovogui, 77–94. Abingdon, UK: Routledge.

———. 2018. "The Rise and Decline (and Rise) of the Niger Delta Rebellion." In *The Oxford Handbook of Nigerian Politics*, edited by A. C. LeVan and P. Ukata, 636–51. New York: Oxford University Press.

———. 2019. "(Re)inventing Development: China, Infrastructure, Sustainability and Special Economic Zones in Nigeria." *Africa* 89, no. 4 (November): 662–79.

Adunbi, O., and Bilal Butt. 2019. "Afro-Chinese Engagements: Infrastructure, Land, Labour and Finance Introduction." *Africa* 89, no. 4 (November): 633–37.

Adunbi, Omolade, and Howard Stein. 2019. "The Political Economy of China's Investment in Nigeria: Prometheus or Leviathan?" In *China-Africa and an Economic Transformation*, edited by Arkebe Oqubay and Justin Yifu Lin, 192–215. New York: Oxford University Press.

Afeikhana, J. 1996. "Export Processing Zones and Nigeria's Economic Development: A Theoretical Construct." *Journal of Economic Management* 3 (1): 67–77.

Afigbo, Adiele. 2005. "The Consolidation of British Imperial Administration in Nigeria: 1900–1918." In *Nigerian History, Politics and Affairs: The Collected Essays of Adiele Afigbo*, edited by Toyin Falola, 213–36. Trenton, NJ: Africa World Press.

Agamben, Giorgio. 1998. *Homo Sacer: Sovereign Power and Bare Life*. Translated by Daniel Heller-Roazen. Stanford, CA: Stanford University Press.

———. 2005. *State of Exception*. Translated by Kevin Attell. Chicago: University of Chicago Press.

Agbu, O. 2005. "Oil and Environmental Conflicts." In *Nigeria under Democratic Rule, 1999–2003*. Vol. 2. Edited by A. Hassan Saliu, 81–94. Ibadan, Nigeria: Ibadan University Press.

Aggarwal, Aradhna. 2010. "Economic Impacts of SEZs: Theoretical Approaches and Analysis of Newly Notified SEZs in India." Unpublished manuscript, last modified September 26, 2019. https://mpra.ub.uni-muenchen.de/20902/2/MPRA_paper_20902.pdf.

Ahmad, Ehtisham, and Raju Singh. 2003. "Political Economy of Oil-Revenue Sharing in a Developing Country: Illustrations from Nigeria." IMF Working Paper WP/03/16. Washington, DC: International Monetary Fund.

Ajayi, J. F. A. 1986. "Nineteenth Century Wars and Yoruba Ethnicity." Unpublished manuscript.

Ake, Claude. 1996. *Democracy and Development in Africa*. Washington, DC: Brookings Institution.

Akindele, R. A. 1988. "The Domestic Structure and Natural Resources Profile of Nigeria's External Trade." In *Nigeria's Economic Relations with the Major Developed Market-Economy Countries, 1960–1985*, edited by R. A. Akindele and E. Bassey, 54–83. Lagos, Nigeria: Nigerian Institute of International Affairs / Nelson.

Akinjogbin, I. A., ed. 1992. *The Cradle of a Race: Ife from the Beginning to 1980*. Port Harcourt, Nigeria: Sunray.

Akinjogbin I. A., and E. A. Ayandele. 1980. "Yorubaland up to 1800." In *Groundwork of Nigerian History*, edited by Obaro Ikime, 121–43. Ibadan, Nigeria: Heinemann.

Akinrisola, F. 1965. "Ogun Festival." *Nigerian Magazine* 85:85–95.

Akintoye, S. A. 1971. *Revolution and Power Politics in Yorubaland 1840–1893: Ibadan Expansion and the Rise of Ekitiparapo*. London: Longman.

Akyeampong, Emmanuel. 1996. "What's in a Drink? Class Struggle, Popular Culture and the Politics of Akpeteshie (Local Gin) in Ghana, 1930–67." *Journal of African History* 37, no. 2 (July): 215–36.

Alagoa, E. J. 1980. "The Eastern Niger Delta and the Hinterland in the 19th Century." In *Groundwork of Nigerian History*, edited by Obaro Ikime, 249–61. Ibadan, Nigeria: Heinemann.

Alayande, Babatunde. 2003. "Decomposition of Inequality Reconsidered: Some Evidence from Nigeria." Paper submitted to the UNU–WIDER conference Inequality, Poverty, and Human Well-being, Helsinki, Finland, May 30–31.

Ali, Saleem H. 2009. *Treasures of the Earth: Need, Greed and a Sustainable Future.* New Haven, CT: Yale University Press.

Allen, Barry. 1991. "Government in Foucault." *Canadian Journal of Philosophy* 21, no. 4 (December): 421–40.

Allen, Chris. 1999. "Warfare, Endemic Violence and State Collapse." *Review of African Political Economy* 26 (81): 367–84.

Alonso, Ana Maria. 2004. "Conforming Disconformity: 'Mestizaje,' Hybridity, and the Aesthetics of Mexican Nationalism." *Cultural Anthropology* 19, no. 4 (November): 459–90.

Alves, A. C. 2013. "China's 'Win-Win' Cooperation: Unpacking the Impact of Infrastructure-for-Resources Deals in Africa." *South African Journal of International Affairs* 20, no. 2 (July): 207–26.

Alves, L. 2019. "Energy for Sustainability in Sub-Saharan Africa." In *Bioclimatic Architecture in Warm Climates: A Guide for Best Practices in Africa,* edited by M. C. Guedes and G. Cantuaria, 335–48. Cham, Switzerland: Springer.

Anand, Nikhil. 2017. *Hydraulic City: Water and the Infrastructures of Citizenship in Mumbai.* Durham, NC: Duke University Press.

Anand, Nikhil, Akhil Gupta, and Hannah Appel. 2018. *The Promise of Infrastructure.* Durham, NC: Duke University Press.

Anderson, Benedict. 1991. *Imagined Communities: Reflections on the Origin and Spread of Nationalism.* London: Verso.

Anusas M., and T. Ingold. 2015. "The Charge against Electricity." *Cultural Anthropology* 30, no. 4 (November): 540–54. https://doi.org/10.14506/ca30.4.03.

Appadurai, Arjun. 1996. *Modernity at Large: Cultural Dimensions of Globalization.* Minneapolis: University of Minnesota Press

Appel, H. 2012. "Offshore Work: Oil, Modularity, and the How of Capitalism in Equatorial Guinea." *American Ethnologist* 39, no. 4 (November): 692–709.

———. 2019. *The Licit Life of Capitalism: US Oil in Equatorial Guinea.* Durham, NC: Duke University Press.

Apter, Andrew. 1992. *Black Critics and Kings: The Hermeneutics of Power in Yoruba Society.* Chicago: University of Chicago Press.

———. 2005. *The Pan-African Nation: Oil and the Spectacle of Culture in Nigeria.* Chicago: University of Chicago Press.

Archambault, J. S. 2017. *Mobile Secrets: Youth, Intimacy, and the Politics of Pretense in Mozambique.* Chicago: University of Chicago Press.

Arendt, Hannah. 1970. *On Violence.* New York: Harcourt, Brace and World.

———. 2000. "Stateless Persons." In *The Portable Hannah Arendt,* edited by Peter Baehr, 23–72. New York: Penguin Putnam.

Arjona, A. 2015. *Civilian Resistance to Rebel Governance.* Vol. 1. Cambridge: Cambridge University Press.

———. 2016. *Rebelocracy: Social Order in the Colombian Civil War.* New York: Cambridge University Press.

———. 2017. "Rebelocracy: A Theory of Social Order in Civil War." Working Paper for the Helen Kellogg Institute for International Studies 2017.422, University of Notre Dame, Notre Dame, IN, June 2017. https://kellogg.nd.edu/sites/default/files/working_papers/422_0.pdf.

Arjona, A., N. Kasfir, and Z. Mampilly, eds. 2015. *Rebel Governance in Civil War*. New York: Cambridge University Press.

Arnold, Guy. 1977. *Modern Nigeria*. Thetford, UK: Lowe and Brydone.

Askew, Kelly M. 2002. *Performing the Nation: Swahili Music and Cultural Politics in Tanzania*. Chicago: University of Chicago Press.

Atanda, J. A. 1980. *An Introduction to Yorùbá History*. Ibadan, Nigeria: Ibadan University Press.

Auty, M. Richard, ed. 2001. *Resource Abundance and Economic Development*. New York: Oxford University Press.

Ayandele, A. E. 1966. *The Missionary Impact of Modern Nigeria, 1842–1914. A Political and Social Analysis*. London: Longman.

Ayanwale, A. B. 2007. "FDI and Economic Growth: Evidence from Nigeria." Nairobi, Kenya: African Economic Research Consortium. https://aercafrica.org/wp-content/uploads/2018/07/RP_165.pdf.

Ayers, A. J. 2013. "Beyond Myths, Lies and Stereotypes: The Political Economy of a 'New Scramble for Africa.'" *New Political Economy* 18, no. 2 (April): 227–57.

Baah, A. Y., and H. Jauch. 2009. *Chinese Investments in Africa: A Labour Perspective*. Accra, Ghana: African Labour Research Network.

Bakke, Gretchen. 2019. "Crude Thinking." In *The Rhetoric of Oil in the Twenty-First Century: Government, Corporate, and Activist Discourses*, edited by H. Graves and D. E. Beard, 34–55. New York: Routledge.

Balibar, Étienne. 1992. "Foucault and Marx: The Question of Nominalism." In *Michel Foucault Philosopher*, edited by Timothy J. Armstrong, 38–56. New York: Routledge.

Barber, K. 1982. "Popular Reactions to the Petro-Naira." *Journal of Modern African Studies* 20, no. 3 (September): 431–50.

Barnes, Sandra T., ed. 1989. "Introduction: The Many Faces of Ogun." In *Africa's Ogun: Old World and New*, 1–26. Bloomington: Indiana University Press.

———. 1997. *Africa's Ogun: Old World and New*. Bloomington: Indiana University Press.

Barry, Andrew, Thomas Osborne, and Nikolas Rose, eds. 1996. *Foucault and Political Reason: Liberalism, Neo-Liberalism, and Rationalities of Government*. Chicago: University of Chicago Press.

Bascom, William. 1969. *The Yoruba of Southwestern Nigeria*. New York: Holt, Rinehart and Winston.

———. 1991. *Ifa Divination: Communication between Gods and Men in West Africa*. Bloomington: Indiana University Press.

Bastien, R. 1971. "Vodoun and Politics in Haiti." In *Black Society in the New World*, edited by R. Frucht, 290–307. New York: Random House.

Basu, N., E. Renne, and R. Long. 2015. "An Integrated Assessment Approach to Address Artisanal and Small-Scale Gold Mining in Ghana." *International Journal of Environmental Research and Public Health* 12, no. 9 (September): 11683–98.

Bataille, G. 1991. *The Accursed Share*. Vol. 1. New York: Zone.

Baucom, Ian. 2005. *Specters of the Atlantic: Finance Capital, Slavery, and the Philosophy of History*. Durham, NC: Duke University Press.

Baudrillard, Jean. 1996. *The System of Objects*. Translated by J. Benedict. London: Verso.

———. 2010. "Simulacra and Simulations (1981)." In *Crime and Media*, edited by Chris Greer, 69–85. Abingdon, UK: Routledge.

Bayart, J. F. 1993. *The State in Africa: The Politics of the Belly*. London: Longman.

———. 2009. *The State in Africa*. Cambridge: Polity.

Bayart, J. F., and S. Ellis. 2000. "Africa in the World: A History of Extraversion." *African Affairs* 99, no. 395 (April): 217–67.

Bayart, Jean-François, Stephen Ellis, and Béatrice Hibou. 1999. *The Criminalisation of the State in Africa*. Oxford, UK: James Currey.

BBC. 2015. "Shell Agrees $84m Deal over Niger Delta Oil Spill." *BBC News*, January 7, 2015. http://www.bbc.com/news/world-30699787.

Beckman, Bjorn. 1992. "Empowerment or Repression? The World Bank and the Politics of African Adjustment in Bangura." In *Authoritarianism, Democracy and Adjustment: The Politics of Economic Reform in Africa*, edited by Yusuf Bangura, Peter Gibbon, and Arve Ofstad, 83–105. The Scandinavian Institute of African Studies.

Benjamin, D. 2017. *Embodied Energy and Design: Making Architecture between Metrics and Narratives*. Zurich: Lars Muller.

Benjamin, Walter. 1986. "Critique of Violence." In *Reflections: Essays, Aphorisms, Autobiographical Writings*, edited by Peter Demetz, translated by Edmund Jephcott, 277–300. New York: Random House.

Berger, R. 1968. "Ogun: God of War and Iron." *Nigerian Magazine* 99:309–15.

Berry, Sara. 1985. *Fathers Work for Their Sons: Accumulation, Mobility and Class Formation in an Extended Yoruba Community*. Berkeley: University of California Press.

———. 1993. *No Condition Is Permanent: The Social Dynamics of Agrarian Change in Sub-Saharan Africa*. Madison: University of Wisconsin Press.

Berry, Sara S., and Carl Liedholm. 1970. "Performance of the Nigerian Economy, 1950–1962." In *Growth and Development of the Nigerian Economy*, edited by Carl K. Eicher and Carl Liedholm, 67–85. East Lansing: Michigan State University Press.

Bienen, Henry. 1985. *Political Conflict and Economic Change in Nigeria*. London: Frank Cass.

Biersteker, T. J. 1983. "Indigenisation in Nigeria: Renationalisation or Denationalisation?" In *Nigerian Foreign Policy*, edited by Timothy Shaw and Olajide Oluko, 125–46. London: Palgrave Macmillan.

Billon, Philippe Le. 2001. "The Political Ecology of War: Natural Resources and Armed Conflicts." *Political Geography* 20, no. 5 (June): 561–84.

Biobaku, S. 1973. *Sources of Yoruba History*. Oxford: Clarendon.

Bodomo, A. 2010. "The African Trading Community in Guangzhou: An Emerging Bridge for Africa–China Relations." *China Quarterly* 203 (September): 693–707.

Bonnafous-Boucher, M. 2005. "From Government to Governance." In *Stakeholder Theory*, edited by M. Bonnafous-Boucher and Y. Pesqueux, 1–23. London: Palgrave Macmillan.

Bornstein, Erica. 2003. *The Spirit of Development: Protestant NGOs, Morality and Economics in Zimbabwe*. New York: Routledge.

Borradori, Giovanna. 2003. *Philosophy in a Time of Terror: Dialogues with Jürgen Habermas and Jacques Derrida*. Chicago: University of Chicago Press.

Bourdieu, Pierre. 1977. *Outline of a Theory of Practice*. Cambridge: Cambridge University Press.

———. 1994. "Rethinking the State: Genesis and Structure of the Bureaucratic Field." Translated by Loïc J. D. Wacquant and Samar Farage. *Sociological Theory* 12, no. 1 (March): 1–18.

Bourdieu, Pierre, and Loïc Wacquant. 1999. "On the Cunning of Imperialist Reason." *Theory, Culture and Society* 16, no. 1 (February): 41–58.

Boyer, D. 2014. "Energopower: An Introduction." *Anthropological Quarterly* 87, no. 2 (Spring): 309–33.

Bratton, Michael. 1997. "International versus Domestic Pressures for Democratization in Africa." In *After the Cold War: Security and Democracy in Africa and Asia*, edited by William Hale and Eberhard Kienle, 156–93. London: Tarris Academic Studies.

Brautigam, D. 2003. "Close Encounters: Chinese Business Networks as Industrial Catalyst in Sub-Saharan Africa." *African Affairs* 102, no. 408 (July): 447–67.

———. 2009. *The Dragon's Gift: The Real Story of China in Africa*. Oxford: Oxford University Press.

———. 2010. "Africa's Eastern Promise: What the West Can Learn from Chinese Investment in Africa." *Foreign Affairs* 5, no. 1 (January). https://www.foreignaffairs.com/articles /africa/2010-01-05/africas-eastern-promise.

———. 2011. "Aid 'with Chinese Characteristics': Chinese Foreign Aid and Development Finance Meet the OECD-DAC Aid Regime." *Journal of International Development* 23, no. 5 (July): 752–64.

Brautigam, D., and T. Xiaoyang. 2014. "'Going Global in Groups': Structural Transformation and China's Special Economic Zones Overseas." *World Development* 63 (November): 78–91.

Brennan, J. 2006. "Blood Enemies: Exploitation and Urban Citizenship in the Nationalist Political Thought of Tanzania, 1958–75." *Journal of African History* 47, no. 3 (November): 389–413. https://www.jstor.org/stable/4501070.

British Colonial Office. 1958. *Report of the Commission Appointed to Enquire into the Fears of Minorities and the Means of Allaying Them* (Sir Henry Willink, Chair). Cmnd. 505. London: H. M. Stationery Office.

Brown, Wendy. 1995. *States of Injury: Power and Freedom in Late Modernity*. Princeton, NJ: Princeton University Press.

———. 2001. *Politics Out of History*. Princeton, NJ: Princeton University Press.

———. 2004. "'The Most We Can Hope for . . .': Human Rights and the Politics of Fatalism." *South Atlantic Quarterly* 103, no. 2/3 (Spring/Summer): 451–63.

Buckley, A. D. 1985. "The God of Smallpox: Aspects of Yoruba Religious Knowledge." *Africa* 55, no. 2 (April): 187–200.

Bulte, E. H., R. Damania, and R. T. Deacon. 2005. "Resource Intensity, Institutions, and Development." *World Development* 33, no. 7 (July): 1029–44.

Burawoy, Michael. 1998. "The Extended Case Method." *Sociological Theory* 16, no. 1 (March): 4–29.

———. 2009. *The Extended Case Method: Four Countries, Four Decades, Four Great Transformations, and One Theoretical Tradition*. Berkeley: University of California Press.

Butler, Judith. 2006. *Precarious Life: The Power of Mourning and Violence*. London: Verso.

Butler, Judith, and Athena Athanasiou. 2013. *Dispossession: The Performative in the Political*. Cambridge: Polity.

Cahn, Jonathan. 1993. "Challenging the New Imperial Authority: The World Bank and the Democratisation of Development." *Harvard Human Rights Journal* 6 (Spring): 159–94.

Carmody, P. 2011. *The New Scramble for Africa*. Cambridge: Polity.

Carrington, D. 2019. "'Worrying' Rise in Global CO2 Forecast for 2019." *Guardian*, January 25, 2019. https://www.theguardian.com/environment/2019/jan/25/worrying-rise-in -global-co2-forecast-for-2019.

Chakrabarty, D. 2009. "The Climate of History: Four Theses." *Critical Inquiry* 35, no. 2 (Winter): 197–222. https://doi.org/10.1086/596640.

Chalfin, B. 2010. *Neoliberal Frontiers: An Ethnography of Sovereignty in West Africa*. Chicago: University of Chicago Press.

———. 2015. "Governing Offshore Oil: Mapping Maritime Political Space in Ghana and the Western Gulf of Guinea," *South Atlantic Quarterly* 114, no. 1 (January): 101–18

———. 2017. "'Wastelandia': Infrastructure and the Commonwealth of Waste in Urban Ghana." *Ethnos* 82, no. 4 (August): 648–71. https://doi.org/10.1080/00141844.2015.1119174.

Chatterjee, Partha. 1991. "Whose Imagined Community?" *Millennium—Journal of International Studies* 20, no. 3 (March): 521–525.

―――. 2005. "Empire and Nation Revisited: 50 Years after Bandung." *Inter-Asia Cultural Studies* 6, no. 4 (January): 487–96.

Chaundry, Kiren Aziz. 1994. "Economic Liberalization and the Lineages of the Rentier State." *Comparative Politics* 27, no. 1 (October): 1–25.

Chayes, Abram, and Antonia Handler Chayes. 1995. *The New Sovereignty: Compliance with International Regulatory Agreements*. Cambridge, MA: Harvard University Press.

Chazan, Naomi, Peter Lewis, Robert Mortimer, Donald Rothchild, and Stephen John Stedman, eds. 1999. *Politics and Society in Contemporary Africa*. Boulder, CO: Lynne Rienner.

Chege, Michael. 1999. "Politics of Development: Institutions and Governance." Background paper prepared for World Bank's "Africa in the 21st Century" project. Washington, DC: Global Coalition for Africa.

Chinda, C. Izeoma, D. Chinogonum Chuku, and Frank Amugo. 2016. "Colonial Policy on Nigerian Local Industries: The Ikwerre Gin Distillation." *Icheke, Journal of the Faculty of Humanities* 14, no. 2 (October): 73–87.

Christia, F. 2012. *Alliance Formation in Civil Wars*. New York: Cambridge University Press.

Chua, Amy. 2004. *The World on Fire: How Exporting Free Market Democracy Breeds Ethnic Hatred and Global Instability*. New York: Knopf.

Clapham, Christopher. 2000. *Africa and the International System: The Politics of State Survival*. Cambridge: Cambridge University Press.

Clarke, Kamari M. 2004. *Mapping Yorùbá Networks: Power and Agency in the Making of Transnational Communities*. Durham, NC: Duke University Press.

Cling, J. P., M. Razafindrakoto, and F. Roubaud. 2005. "Export Processing Zones in Madagascar: A Success Story under Threat?" *World Development* 33, no. 5 (May): 785–803.

Collier, Paul, and Anke Hoeffler. 1998. "On Economic Causes of Civil War." *Oxford Economic Papers* 50, no. 4 (October): 563–73.

Comaroff, Jean, and John Comaroff. 1991. *Of Revelation and Revolution*. Vol. 1 of *Christianity, Colonialism, and Consciousness in South Africa*. Chicago: University of Chicago Press.

―――, eds. 1993. *Modernity and Its Malcontents: Ritual Power in Postcolonial Africa*. Chicago: University of Chicago Press.

―――. 1999a. "Occult Economies and the Violence of Abstraction: Notes from the South African Postcolony." *American Ethnologist* 26, no. 2 (May): 279–303.

―――. 1999b. "Introduction." In *Civil Society and the Political Imagination in Africa: Critical Perspectives*, edited by John Comaroff and Jean Comaroff, 1–43. Chicago: University of Chicago Press.

Corkin, L. 2007. "The Strategic Entry of China's Emerging Multinationals into Africa." *China Report* 43, no. 3 (July): 309–22.

Coronil, Fernando. 1997. *The Magical State: Nature, Money and Modernity in Venezuela*. Chicago: University of Chicago Press.

Cross, J. 2014. *Dream Zones: Anticipating Capitalism and Development in India*. London: Pluto.

Croucher, L. Sheila. 2002. *Globalization and Belonging: The Politics of Identity in a Changing World*. New York: New Millennium Books in International Studies.

Cruikshank, Barbara. 1999. *The Will to Empower. Democratic Citizens and Other Subjects*. Ithaca, NY: Cornell University Press.

Davies, Rob, and James Thurlow. 2010. "Formal–Informal Economy Linkages and Unemployment in South Africa." *South African Journal of Economics* 78, no. 4 (December): 437–59.

D'Avignon, R. 2018. "Primitive Techniques: From 'Customary' to 'Artisanal' Mining in French West Africa." *Journal of African History* 59, no 2 (July): 179–97. https://doi.org/10.1017/S0021853718000361.

De Boeck, F. 2011. "Inhabiting Ocular Ground: Kinshasa's Future in the Light of Congo's Spectral Urban Politics." *Cultural Anthropology* 26, no. 2 (May): 263–86. https://doi.org/10.1111/j.1548-1360.2011.01099.x.

De Boeck, F., and M. F. Plissart. 2004. *Kinshasa: Tales of the Invisible City*. Ghent, Belgium: Ludion/Royal Museum for Central Africa.

de Morais, R. M. 2011. "The New Imperialism: China in Angola." *World Affairs* 173, no. 6 (March/April): 67–74.

Derrida, Jacques. 1994. *Specters of Marx: The State of the Debt, the Work of Mourning, and the New International*. Translated by Peggy Kamuf. London: Routledge.

———. 2004. "The Last of the Rogue States: The 'Democracy to Come,' Opening in Two Turns." Translated by Pascale-Anne Brault and Michael Naas. *South Atlantic Quarterly* 103, no. 2/3 (Spring/Summer): 323–41.

Dezalay, Yves, and Bryant G. Garth. 1995. "Merchants of Law as Moral Entrepreneurs: Constructing International Justice from the Competition for Transnational Business Disputes." *Law and Society Review* 29, no. 1 (January): 27–64.

———. 2002. *The Internationalization of the Palace Wars: Lawyers, Economists, and the Contest to Transform Latin American Studies*. Chicago: University of Chicago Press.

Donovan, K. P., and E. Park. 2019. "Perpetual Debt in the Silicon Savannah." *Boston Review*, August 14, 2019. http://bostonreview.net/class-inequality-global-justice/kevin-p-donovan-emma-park-perpetual-debt-silicon-savannah.

Dorward, D.C., ed. 1983. *The Igbo "Women's War" of 1929: Documents Relating to the Aba Riots in Eastern Nigeria*. Wakefield, UK: East Ardsley.

Doughty, K. 2019. "Cultural Anthropology in 2018: Captivity and Its Unruly Failures." *American Anthropologist* 121, no. 2 (June): 431–46. https://doi.org/10.1111/aman.13264.

Douglas, J. C. 2001. "Miners and Moonshiners: Historic Industrial Use of Tennessee Caves." *Journal of Midcontinental Archaeology* 26, no. 2 (Fall): 251–67.

Dudley, B. J. 1968. *Parties and Politics in Northern Nigeria*. London: Frank Cass.

———. 1974. *Instability and Political Order: Politics and Crisis in Nigeria*. Ibadan, Nigeria: Ibadan University Press.

Duffield, Mark. 2001. *Global Governance and the New Wars: The Merging of Development and Security*. London: Zed Books.

Dunning, Thad. 2008. *Crude Democracy: Natural Resource Wealth and Political Regimes*. Cambridge: Cambridge University Press.

Durand, L. 1956. "'Mountain Moonshining' in East Tennessee." *Geographical Review* 46, no. 2 (April): 168–81.

Durkheim, Emile. (1893) 1964. "Organic Solidarity Due to the Division of Labor." Translated by G. Simpson. In *Division of Labor in Society*, 111–32. New York: Free Press.

———. (1957) 1992. *Professional Ethics and Civic Morals*, 2nd ed. Translated by Cornelia Brookfield. London: Routledge.

Dworkin, Ronald. 2000. *Sovereign Virtue: The Theory and Practice of Equality*. Cambridge, MA: Harvard University Press.

Echeruo, Michael J. C. 1977. *Victorian Lagos: Aspects of Nineteenth Century Lagos Life*. London: Macmillan.

Eckstein, Harry. 1975. "Case Study and Theory in Political Science." In *Handbook of Political Science*, Vol. 7, edited by Fred Greenstein and Nelson Polsby, 79–137. Reading, MA: Addison-Wesley.

Eicher, Carl K., and Carl Liedholm, eds. 1971. *Growth and Development of the Nigerian Economy*. East Lansing: Michigan State University Press.

Ekechi, F. K. 1972. *Missionary Enterprise and Rivalry in Igboland 1857–1914*. London: Frank Cass.

Eleagu, Uma, ed. 1988. *Nigeria: The First 25 Years*. Ibadan, Nigeria: Heinemann.

Elias, Norbert. (1939) 1994. *The Civilizing Process*. Translated by E. Jephcott. Oxford: Basil Blackwell.

Ellis, S. 2016. *This Present Darkness: A History of Nigerian Organised Crime*. London: Hurst.

Erikson, Kai T. 1966. *Wayward Puritans: A Study in the Sociology of Deviance*. New York: John Wiley.

Escobar, A. 1988. "Power and Visibility: Development and the Invention and Management of the Third World." *Cultural Anthropology* 3, no. 4 (November): 428–43.

———. 1998. "Whose Knowledge, Whose Nature? Biodiversity, Conservation and the Political Ecology of Social Movements." *Journal of Political Ecology* 5, no. 1 (January): 53–82.

———. 2011. *Encountering Development: The Making and Unmaking of the Third World*. Princeton, NJ: Princeton University Press.

Fadipe, N. A. 1970. *The Sociology of the Yoruba*. Ibadan, Nigeria: Ibadan University Press.

Faier, Lieba. 2009. *Intimate Encounters: Filipina Migrants Remake Rural Japan*. Berkeley: University of California Press.

Fairhead, James, and Melissa Leach. 1999. *Misreading the African Landscape: Society and Ecology in a Forest Savannah-Mosaic*. London: Cambridge University Press.

Falola, T. 1985a. "The Ibadan Conference of 1855: Yoruba Diplomacy and Conflict Resolution." *Geneve-Afrique* 23 (2): 38–56.

———. 1985b. "From Hospitality to Hostility: Ibadan and Strangers, 1830–1904." *Journal of African History* 26, no. 1 (January): 51–68.

———. 2002. *Africa-Colonial Africa, 1885–1939*. Vol. 3. Dunham, NC: Carolina Academic Press.

Falola, T., A. Mahadi, M. Uhomoibhi, and U. Anyanwu. 1989. *History of Nigeria*. Vol. 1. Ikeja: Longman Nigeria.

Falola, T., and T. O. Avoseh. 1995. "T. O. Avoseh on the History of Epe and Its Environs." *History in Africa* 22 (January): 165–95.

Faluyi, K. 2001. "Migrants and the Socio-Economic Development of Lagos from the Earliest Times to 1880." *Lagos Historical Review* 1:68–83.

Fapohunda, Tinuke M. 2012. "Women and the Informal Sector in Nigeria: Implications for Development." *British Journal of Arts and Social Sciences* 4 (1): 35–45.

Farole, T. 2011. *Special Economic Zones in Africa: Comparing Performance and Learning from Global Experiences*. Washington, DC: International Bank for Reconstruction and Development and World Bank.

Felix Forae, Ovie. 2013. "Prohibition of Illicit Alcohol in Colonial Nigeria: A Study in the Tenacity of Ogogoro (Local Gin) in Urhoboland, Southern Nigeria, 1910–1950." *International Journal of Innovative Research and Development* 2, no. 3 (March): 1–12.

Ferguson, James. 1994. *The Anti-Politics Machine: "Development," Depoliticization, and Bureaucratic Power in Lesotho*. Minneapolis: University of Minnesota Press.

———. 1999. *Expectations of Modernity: Myths and Meanings of Urban Life on the Zambian Copperbelt*. Berkeley: University of California Press.

———. 2002a. "Is the 'Global' in 'Global Environmental Crisis' the Same as the 'Global' in 'Globalization'?" Paper presented at the Ford Foundation conference "Crossing Borders," Yale University, November 1–2, 2002.

———. 2002b. "Of Mimicry and Membership: Africans and the 'New World Society.'" *Cultural Anthropology* 17, no. 4 (November): 551–69.

———. 2005. "Seeing Like an Oil Company—Space, Security, and Global Capital in Neoliberal Africa." *American Anthropologist* 107, no. 3 (September): 377–82.

———. 2006. *Global Shadows: Africa in the Neoliberal World Order*. Durham, NC: Duke University Press.

———. 2010. "The Uses of Neoliberalism." *Antipode* 41, no. 1 (January): 166–84.

———. 2015. *Give a Man a Fish: Reflections on the New Politics of Distribution*. Durham, NC: Duke University Press.

Fioratta, S. 2019. "A World of Cheapness: Affordability, Shoddiness, and Second-Best Options in Guinea and China." *Economic Anthropology* 6, no. 1 (January): 86–97.

Fisher, E. 2007. "Occupying the Margins: Labour Integration and Social Exclusion in Artisanal Mining in Tanzania." *Development and Change* 38, no. 4 (July): 735–60.

Flyvbjerg, Bent. 2006. "Five Misunderstandings about Case-Study Research." *Qualitative Inquiry* 12, no. 2 (April): 219–45.

Forrest, T. 1977. "Notes on the Political Economy of State Intervention in Nigeria." *The IDS Bulletin* 9, no. 1 (July): 42–47.

———. 1982. "Recent Development in Nigerian Industrialization." In *Industry and Accumulation in Africa*, edited by Martin Fransman, 324–44. London: Heinemann.

———. 1993. *Politics and Economic Development in Nigeria*. Boulder, CO: Westview.

Foster, J. B. 1999. "Marx's Theory of Metabolic Rift: Classical Foundations for Environmental Sociology." *American Journal of Sociology* 105, no. 2 (September): 366–405. https://doi.org/10.1086/210315.

Foster, V., W. Butterfield, and C. Chen. 2009. *Building Bridges: China's Growing Role as Infrastructure Financier for Africa*. Washington, DC: World Bank.

Foucault, Michel. 1977. *Discipline and Punish: The Birth of the Prison*. Translated by Alan Sheridan. London: Penguin.

———. 1978. *The History of Sexuality: An Introduction*. Vol. 1. Translated by Robert Hurley. New York: Vintage.

———. 1980. "Two Lectures." In *Power/Knowledge: Selected Interviews and Other Writings, 1972–1977*, edited by Colin Gordon, 78–108. New York: Pantheon.

———. 1982. "The Subject and Power." In *Michel Foucault: Beyond Structuralism and Hermeneutics*, edited by Hubert L. Dreyfus and Paul Rabinow, 208–28. 2nd ed. Chicago: University of Chicago Press.

———. 1988a. "Technologies of the Self (A Seminar with Michel Foucault at the University of Vermont, October 1982)." In *Technologies of the Self. A Seminar with Michel Foucault*, edited by L. H. Martin, H. Gutman, and P. H. Hutton, 50–63. Amherst: University of Massachusetts Press.

———. 1988b. "The Ethic of Care for the Self as a Practice of Freedom." In *The Final Foucault*, edited by J. Bernauer and D. Rasmussen, 1–20. Boston: MIT Press.

———. 1993. "About the Beginning of the Hermeneutics of Self: Two Lectures at Dartmouth." *Political Theory* 21, no. 2 (May): 203–4.

———. 1994. "Governmentality." In *Power: The Essential Works of Michel Foucault, 1954–1984*. Vol. 3. Edited by J. D. Faubion, translated by R. Hurley et al., 201–24. New York: New Press.

———. 1995. *Discipline and Punish: The Birth of the Prison*. New York: Random House.

———. 1997. "Security, Territory, and Population." In *Ethics: Subjectivity and Truth*, edited by Paul Rabinow, 67–71. New York: New Press.

———. 2003. *"Society Must Be Defended": Lectures at the College de France 1975–1976*. Translated by Mauro Bertani. New York: Picador.

French, H. W. 2014. *China's Second Continent: How a Million Migrants Are Building a New Empire in Africa*. New York: Vintage Books.

French, Jan Hoffman. 2002. "Dancing for Land: Law-Making and Cultural Performance in Northeastern Brazil." *Political and Legal Anthropology Review (PoLAR)* 25, no. 1 (May): 19–36.

Frick, S. A., A. Rodríguez-Pose, and M. D. Wong. 2019. "Toward Economically Dynamic Special Economic Zones in Emerging Countries." *Economic Geography* 95, no. 1 (2019): 30–64.

Frynas, J. G. 2001. "Corporate and State Responses to Anti-Oil Protests in the Niger Delta." *African Affairs* 100, no. 398 (January): 27–54.

Frynas, J. G., and M. Paulo. 2006. "A New Scramble for African Oil? Historical, Political, and Business Perspectives." *African Affairs* 106, no. 423 (April): 229–51.

Gale, Thomas S. 1979. "Lagos: The History of British Colonial Neglect of Traditional African Cities." *African Urban Studies* no. 5 (Fall): 11–24.

Geertz, C. 1973. *The Interpretation of Cultures.* New York: Basic Books.

Geo-Jaja, Macleans A., and Garth Mangum. 2003. "Economic Adjustment, Education, and Human Resource Development in Africa: The Case of Nigeria." *International Review of Education* 49, no. 3–4 (July): 293–318.

Gerring, John. 2007. *Case Study Research: Principles and Practices.* New York: Cambridge University Press.

Glaeser, Andreas. 2005. "An Ontology for the Ethnographic Analysis of Social Processes: Extending the Extended-Case Method." *Social Analysis* 49, no. 3 (Winter): 16–45.

Gleason, J. 1971. *Orisha: The Gods of Yorubaland.* New York: Atheneum.

Gordon, Colin. 1991. "Governmental Rationality: An Introduction." In *The Foucault Effect: Studies in Governmentality,* edited by Graham Burchell, Colin Gordon, and Peter Miller, 1–51. Hemel Hempstead, UK: Harvester Wheatsheaf.

Gordon, J. U. 1979. "Yoruba Cosmology and Culture in Brazil: A Study of African Survivals in the New World." *Journal of Black Studies* 10, no. 2 (December): 231–44.

Gramsci, Antonio. 1971. *Selections from the Prison Notebooks.* London: Lawrence and Wishart.

Guangwen, M. 2015. "Establishment and Model Selection of Free Trade Zones in China Based on Graduated Sovereignty and Policy Geographical Differentiation." *Scientia Geographica Sinica* 35, no. 1 (2015): 19–29.

Gupta, Akhil, and James Ferguson. 1997. *Anthropological Locations: Boundaries and Grounds of a Field Science.* Berkeley: University of California Press.

Guyer, J. I. 1995. "Wealth in People, Wealth in Things–Introduction." *Journal of African History* 36, no. 1 (March): 83–90.

———. 2002. "'Kos' ona miran': No Other Way. Mechanized Farming in the Era of Devaluation." In *Money Struggles and City Life,* edited by J. Guyer, L. Denzer, and Adigun Agbaje, 115–32. Portsmouth, NH: Heinemann.

———. 2004. *Marginal Gains: Monetary Transactions in Atlantic Africa.* Chicago: University of Chicago Press.

Haas, Peter M. 1989. "Do Regimes Matter: Epistemic Communities and Mediterranean Pollution Control." *International Organization* 43, no. 3 (Summer): 377–403.

———. 1992a. "Introduction: Epistemic Communities and International Policy Coordination." *International Organization* 46, no. 1 (Winter): 1–35. Reprinted in *Knowledge, Power and International Policy Coordination,* edited by Peter M. Haas, 1–35. Columbia: University of South Carolina Press, 1997.

———. 1992b. "Banning Chlorofluorocarbons: Epistemic Community Efforts to Protect Stratospheric Ozone." *International Organization* 46, no. 1 (Winter): 187–224. Reprinted in *Knowledge, Power and International Policy Coordination,* edited by Peter M. Haas, 187–224. Columbia: University of South Carolina Press, 1997.

Habermas, Jürgen. 1989. *The Structural Transformation of the Public Sphere: An Inquiry into a Category of Bourgeois Society.* Translated by Thomas Burger with Frederick Lawrence. Cambridge, MA: MIT Press.

Habermas, Jürgen, and Jacques Derrida. 2005. "February 15; or, What Binds Europeans To-gether: Plea for a Common Foreign Policy, Beginning in Core Europe." In *Old Europe, New Europe, Core Europe: Transatlantic Relations after the Iraq War*, edited by Daniel Levy, Max Pensky, and John Torpey, 3–13. London: Verso Books.

Habiyaremye, A. 2016. "Is Sino-African Trade Exacerbating Resource Dependence in Africa?" *Structural Change and Economic Dynamics* 37 (June): 1–12.

Hafkin, Nancy J., and Edna G. Bay, eds. 1976. *Women in Africa: Studies in Social and Economic Change*. Stanford, CA: Stanford University Press.

Hall, Stuart, ed. 1997. *Representation: Cultural Representations and Signifying Practices*. London: Sage.

Hansen, Thomas Blom, and Finn Stepputat, eds. 2005. *Sovereign Bodies: Citizens, Migrants, and States in the Postcolonial World*. Princeton, NJ: Princeton University Press.

Harry, D. M. 2016. "Export Processing Zones and Economic Diversification in Nigeria, 2001–2013." *International Journal of Political and Administrative Studies* 2 (2): 24–27.

Harvey, David. 2003. *The New Imperialism*. Oxford: Oxford University Press.

Hatch, E. 2004. "The Margins of Civilization: Progressives and Moonshiners in the Late 19th-Century Mountain South." *Appalachian Journal* 32, no 1 (Fall): 68–99.

Heap, S. 1999. "The Quality of Liquor in Colonial Nigeria." *Itinerario: European Journal of Overseas History* 23, no. 2 (July): 29–47.

———. 2008. "'Those That Are Cooking the Gins': The Business of Ogogoro in Nigeria during the 1930s." *Contemporary Drug Problems* 35, no. 4 (December): 573–609.

Hecht, G. 2018. "Interscalar Vehicles for an African Anthropocene: On Waste, Temporality, and Violence." *Cultural Anthropology* 33 (1): 109–41.

Held, David. 1980. *Introduction to Critical Theory: From Horkheimer to Habermas*. Berkeley: University of California Press.

Herbst, Jeffrey. 2000. *States and Power in Africa: Comparative Lessons in Authority and Control*. Princeton, NJ: Princeton University Press.

Herskovits, M. J. 1937. "African Gods and Catholic Saints in New World Negro Belief." *American Anthropologist* 39, no. 4 (October–December): 635–43.

———. 1971. *Life in a Haitian Valley*. New York: Anchor Books.

Hicks, C. 2015. *Africa's New Oil: Power, Pipelines and Future Fortunes*. London: Zed Books.

Hopkins, Anthony Gerald. 1964. *An Economic History of Lagos, 1880–1914*. PhD diss., School of Oriental and African Studies, University of London.

Hsiung, D. C. 1992. "Geographic Determinism and Possibilism: Interpretations of the Appalachian Environment and Culture in the Last Century." *Journal of the Appalachian Studies Association* 4:14–23.

Huber, M. 2015. "Oil for Life: The Bureau of Mines and the Biopolitics of the Petroleum Market." In *Subterranean Estates: Life Worlds of Oil and Gas*, edited by H. Appel, A. Mason, and M. Watts, 31–44. Ithaca, NY: Cornell University Press.

Hughes, D. M. 2017. *Energy without Conscience: Oil, Climate Change, and Complicity*. Durham, NC: Duke University Press.

Humphreys, Macartan, Jeffrey D. Sachs, and Joseph E. Stiglitz, eds. 2007. *Escaping the Resource Curse*. New York: Columbia University Press.

Hydén, Göran. 1985. *Beyond Ujamaa in Tanzania: Underdevelopment and an Uncaptured Peasantry*. London: Heinemann.

Ihrig, Jane, and Karine S. Moe. 2004. "Lurking in the Shadows: The Informal Sector and Government Policy." *Journal of Development Economics* 73, no. 2 (April): 541–57.

Ikelegbe, A. 2006a. "Beyond the Threshold of Civil Struggle." *African Study Monographs* 27 (3): 87–122.

———. 2006b. "The Economics of Conflict in Oil Rich Niger Delta Region of Nigeria." *African and Asian Studies* 5 (1): 23–55.

Ikelegbe, Augustine. 2001a. *Civil Society, Oil and Conflict in the Niger Delta Region of Nigeria: Ramifications of Civil Society for Regional Resource Struggle.* Cambridge: Cambridge University Press.

———. 2001b. "Civil Society, Oil and Conflict in the Niger Delta Region of Nigeria." *Journal of Modern African Studies* 39, no. 3 (September): 437–69.

Ikime, Obaro. 1980a. "The Western Niger Delta and the Hinterland in the Nineteenth Century." In *Groundwork of Nigerian History*, edited by Obaro Ikime, 262–79. Ibadan, Nigeria: Heinemann.

———, ed. 1980b. *Groundwork of Nigerian History.* Ibadan, Nigeria: Heinemann.

Ikporokpu, C. 2004. "Petroleum, Fiscal Federalism and Environmental Justice in Nigeria." *Space and Polity* 8, no. 3 (December): 321–54.

Ilesanmi, T. M. 1982. "Orin Ogun: War Songs." Unpublished manuscript.

Irani, L. 2019. *Chasing Innovation: Making Entrepreneurial Citizens in Modern India.* Princeton, NJ: Princeton University Press.

Isaacman, A. 2005. "Displaced People, Displaced Energy, and Displaced Memories: The Case of Cahora Bassa, 1970–2004." *International Journal of African Historical Studies* 38 (2): 201–38.

Isidore, S. O. 2001. "Drug and Alcohol Consumption by Out of School Nigerian Adolescents." *African Journal of Drug and Alcohol Studies* 1 (2): 99.

Iwayemi, Akin, ed. 1995. *Macroeconomic Policy Issues in an Open Developing Economy: A Case Study of Nigeria.* Ibadan, Nigeria: National Centre for Economic Management and Administration.

Jauch, H. 2011. "Chinese Investments in Africa: Twenty-First Century Colonialism?" *New Labor Forum* 20, no. 2 (Spring): 49–55.

Jega, Attahiru. 2000. "The State and Identity Transformation under Structural Adjustment in Nigeria." In *Identity Transformation and Identity Politics under Structural Adjustment in Nigeria*, edited by Attahiru Jega, 24–40. Stockholm: Nordiska Afrikainstitutet and Center for Research and Documentation.

Joab-Peterside, Sofiri, Doug Porter, and Michael Watts. 2012. "Rethinking Conflict in the Niger Delta: Understanding Conflict Dynamics, Justice and Security." Working Paper for the Institute of International Studies, University of California, Berkeley.

Johnson, James. 1899. *Yoruba Heathenism.* Exeter, UK: Townsend.

Johnson, Samuel. 1921. *The History of the Yorubas.* London: Routledge.

Joseph, Richard A. 1987. *Democracy and Prebendal Politics in Nigeria: The Rise and Fall of the Second Republic.* Cambridge: Cambridge University Press.

———. 1996. "Nigeria: Inside the Dismal Tunnel." *Current History* 95, no. 601 (May): 193–200.

Joseph-Obi, Chioma. 2011. "Oil, Gender and Agricultural Child Labour in the Niger Delta Region of Nigeria: Implications for Sustainable Development." *Gender and Behaviour* 9, no. 2 (December): 4072A, 4073–99.

Klare, M., and D. Volman. 2006. "America, China and the Scramble for Africa's Oil." *Review of African Political Economy* 33 (108): 297–309.

Knauft, Bruce. 2002. *Critically Modern: Alternatives, Alterities, Anthropologies.* Bloomington: Indiana University Press.

Kopytoff, I., ed. 2006. *The African Frontier: The Reproduction of Traditional African Societies.* Bloomington: Indiana University Press.

Korieh, Chima J. 2003. "Alcohol and Empire: 'Illicit' Gin Prohibition and Control in Colonial Eastern Nigeria." *African Economic History* 31:111–34.

Lagos Standard. 1895. "Governor Carter and Bishop Tugwell on the Drink Traffick." July 3, 1895.

Laitin, David. 1986. *Hegemony and Culture: Politics and Religious Change among the Yoruba.* Chicago: University of Chicago Press.

Lal, Priya. 2012. "Self-Reliance and the State: The Multiple Meanings of Development in Early Post-Colonial Tanzania." *Africa* 82, no. 2 (May): 212–34. https://doi.org/10.1017/S0001972012000022.

———. 2013. "Popular Mobilization and the New Politics of Resource Sovereignty in Tanzania." *African Futures,* August 2, 2013. http://forums.ssrc.org/african-futures/2013/08/02/popular-mobilization-and-the-new-politics-of-resource-sovereignty-in-tanzania.

Laungaramsri, P. 2015. "Commodifying Sovereignty: Special Economic Zones and the Neoliberalization of the Lao Frontier." In *Impact of China's Rise on the Mekong Region,* edited by Yos Santasombat, 117–46. New York: Palgrave Macmillan.

Law, R. 1983. "Trade and Politics behind the Slave Coast: The Lagoon Traffic and the Rise of Lagos, 1500–1800." *Journal of African History* 24, no. 3 (January): 321–48.

Lawanson, T., and M. Agunbiade. 2018. "Land Governance and Megacity Projects in Lagos, Nigeria: The Case of Lekki Free Trade Zone." *Area Development and Policy* 3 (1): 114–31.

Lawuyi, Olatunde B. 1988. "Ogun: Diffusion across Boundaries and Identity Constructions." *African Studies Review* 31, no. 2 (September): 127–40.

Lee, C. K. 2009. "Raw Encounters: Chinese Managers, African Workers and the Politics of Casualization in Africa's Chinese Enclaves." *China Quarterly* 199 (September): 647–66.

———. 2015. "Chinese Outward Investment in Oil and Its Economic and Political Impact in Developing Countries." *Issues and Studies* 51, no. 3 (September): 131–63.

Lee, Margaret C. 2006. "The 21st Century Scramble for Africa." *Journal of Contemporary African Studies* 24, no. 3 (September): 303–30.

Leis, Philip E. 1964. "Palm Oil, Illicit Gin, and the Moral Order of the Ijaw." *American Anthropologist* 66, no. 4 (August): 828–38.

Lemke, Thomas. 2001. "'The Birth of Bio-Politics'—Michel Foucault's Lecture at the Collège de France on Neo-Liberal Governmentality." *Economy and Society* 30, no. 2 (May): 190–207.

Leonard, Lori. 2016. *Life in the Time of Oil: A Pipeline and Poverty in Chad.* Bloomington: Indiana University Press.

LeVan, A. C. 2019. *Contemporary Nigerian Politics: Competition in a Time of Transition and Terror.* New York: Cambridge University Press.

Lewis, Peter. 1998. *Africa: Dilemmas of Development and Change.* Boulder, CO: Westview.

———. 2007. *Growing Apart: Oil, Politics and Economic Change in Indonesia and Nigeria.* Ann Arbor: University of Michigan Press.

Lewis, Peter, Pearl T. Robinson, and Barnett R. Rubin, eds. 1998. *Stabilizing Nigeria: Sanctions, Incentives and Support for Civil Society.* New York: Century Foundation.

Lin, J., and Y. Wang. 2014. "China-Africa Co-operation in Structural Transformation: Ideas, Opportunities, and Finances." WIDER Working Paper 2014/046. Helsinki: UNU-WIDER.

Lindon, T. 1990. "Oríkì Orísa: The Yorùbá Prayer of Praise." *Journal of Religion in Africa* 20, no. 2 (January): 205–24.

Locke, John. (1689) 1988. *Two Treatises of Government.* Edited by Peter Laslett. Cambridge: Cambridge University Press.

Lubeck, Paul, Michael J. Watts, and Ronnie Lipschutz. 2007. *Convergent Interests: U.S. Energy Security and the "Securing" of Nigerian Democracy.* A Publication of the Center for International Policy. http://ciponline.org/NIGERIA_FINAL.pdf.

Lucas, J. O. 1948. *The Religion of the Yoruba*. Lagos, Nigeria: C.N.S. Bookshop.

Lugard, Frederick John Dealtry. 1907. *Northern Nigeria (Report for the Period from 1st January, 1906, to 31st March, 1907, By the High Commissioner of Northern Nigeria)*. London: H. M. Stationery Office.

———. 1965. *The Dual Mandate in British Tropical Africa*, 5th ed. London: Frank Cass.

Lynn, M. 1982. "Consul and Kings: British Policy, 'the Man on the Spot,' and the Seizure of Lagos, 1851." *Journal of Imperial and Commonwealth History* 10, no. 2 (January): 150–67.

Lyttleton, C., and P. Nyíri. 2011. "Dams, Casinos and Concessions: Chinese Megaprojects in Laos and Cambodia." In *Engineering Earth*, edited by Stanley Brunn, 1243–65. Dordrecht, Neth.: Springer.

Mabogunje, Akin L. 1968. *Urbanization in Nigeria*. London: University of London Press.

Macpherson, C. B. 1962. *The Political Theory of Possessive Individualism: Hobbes to Locke*. Oxford: Clarendon.

Mamdani, Mahmood. 1996. *Citizen and Subject: Contemporary Africa and the Legacy of Late Colonialism*. Princeton, NJ: Princeton University Press.

Mampilly, Z. C. 2012. *Rebel Rulers: Insurgent Governance and Civilian Life during War*. Ithaca, NY: Cornell University Press.

Mann, K. 1991. "Women, Landed Property, and the Accumulation of Wealth in Early Colonial Lagos." *Signs: Journal of Women in Culture and Society* 16, no. 4 (Summer): 682–706.

———. 2007. *Slavery and the Birth of an African City: Lagos, 1760–1900*. Bloomington: Indiana University Press.

Maurer, D. W. 2013. *Kentucky Moonshine*. Lexington: University Press of Kentucky.

Mba, Nina Emma. 1982. *Nigerian Women Mobilized: Women's Political Activity in Southern Nigeria, 1900–1965*. Berkeley: University of California Press.

Mbembe, A. 2016. "Africa in the New Century." *Massachusetts Review* 57, no. 1 (Spring): 91–104. https://doi.org/10.1353/mar.2016.0031.

Mbembe, Achille. 2003. "Necropolitics." Translated by Libby Meintjes. *Public Culture* 15, no. 1 (Winter): 11–40.

———. 2005. "Sovereignty as a Form of Expenditure." In *Sovereign Bodies: Citizens, Migrants, and States in the Postcolonial World*, edited by Thomas Blom Hansen and Finn Stepputat, 148–66. Philadelphia: University of Pennsylvania Press.

McGovern, Mike. 2010. *Making War in Côte d'Ivoire*. Chicago: University of Chicago Press.

———. 2017. *A Socialist Peace?: Explaining the Absence of War in an African Country*. Chicago: University of Chicago Press.

McGowan, Randall. 1989. "Punishing Violence, Sentencing Crime." In *The Violence of Representation: Literature and the History of Violence*, edited by Nancy Armstrong and Leonard Tennenhouse, 140–56. New York: Routledge.

Meagher, Kate. 1995. "Crisis, Informalization and the Urban Informal Sector in Sub-Saharan Africa." *Development and Change* 26, no. 2 (April): 259–84.

Mehta, Satish C. 1990. *Development Planning in an African Economy: The Experience of Nigeria: Vol. 1, 1950–1980*. Delhi: Kalinga.

Mendes, Ana Paula F., Mário A. Bertella, and Rudolph F. A. P. Teixeira. 2014. "Industrialization in Sub-Saharan Africa and Import Substitution Policy." *Brazilian Journal of Political Economy* 34, no. 1 (January/March): 120–38.

Merton, Robert K. 1968. *Social Theory and Social Structure*. New York: Free Press.

Meservey, Joshua. 2020. "Government Buildings in Africa Are a Likely Vector for Chinese Spying." *The Backgrounder*. The Heritage Foundation, no. 3476.

Milberg, W., and M. Amengual. 2008. "Economic Development and Working Conditions in Export Processing Zones: A Survey of Trends." Geneva: ILO.

Miller, Peter, and Nikolas Rose. 1990. "Governing Economic Life." *Economy and Society* 19, no. 1 (February): 1–31.

Ministry of Commerce, People's Republic of China. 2015. "Regular Press Conference of the Ministry of Commerce on December 2." December 4, 2015. http://english.mofcom.gov .cn/article/pressconferenceinyears/2015/201601/20160101230599.shtml.

Mitchell, Timothy. 2002. *Rule of Experts: Egypt, Techno-Politics, Modernity.* Berkeley: University of California Press.

———. 2009. "Carbon Democracy." *Economy and Society* 38, no. 3 (August): 399–432.

———. 2011. *Carbon Democracy: Political Power in the Age of Oil.* New York: Verso Books.

Mkandawire, T. 2001. "Thinking about Developmental States in Africa." *Cambridge Journal of Economics* 25, no. 3 (May): 289–314.

Mohan, G., and B. Lampert. 2013. "Negotiating China: Reinserting African Agency into China–Africa Relations." *African Affairs* 112, no. 446 (January): 92–110.

Mohan, G., and M. Tan-Mullins. 2009. "Chinese Migrants in Africa as New Agents of Development? An Analytical Framework." *European Journal of Development Research* 21, no. 4 (September): 588–605.

Monson, J. 2009. *Africa's Freedom Railway: How a Chinese Development Project Changed Lives and Livelihoods in Tanzania.* Bloomington: Indiana University Press.

Monson, J., and S. Rupp. 2013. "Africa and China: New Engagements, New Research." *African Studies Review* 56, no. 1 (April): 21–44.

Moyo, S., P. Yeros, and P. Jha. 2012. "Imperialism and Primitive Accumulation: Notes on the New Scramble for Africa." *Agrarian South: Journal of Political Economy* 1, no. 2 (August): 181–203.

Mthembu-Salter, G. 2009. "Chinese Investment in African Free Trade Zones: Lessons from Nigeria's Experience." Policy Briefing 10. Johannesburg: South African Institute of International Affairs, China in Africa Project.

Murphy, M. 1994. "Bootlegging Mothers and Drinking Daughters: Gender and Prohibition in Butte, Montana." *American Quarterly* 46, no. 2 (June): 174–94.

Murray, J. M. 2017. *The Urbanism of Exception: The Dynamics of Global City Building in the Twenty-First Century.* Cambridge: Cambridge University Press.

Naanen, B., and P. Tolani. 2014. *Private Gain, Public Disaster: Social Context of Illegal Oil Bunkering and Artisanal Refining in the Niger Delta.* Port Harcourt, Nigeria: NIDEREF.

Neumann, P. Roderick. 2002. *Imposing Wilderness: Struggles over Livelihood and Nature Preservation in Africa.* Berkeley: University of California Press.

Newman, C., and J. M. Page. 2017. "Industrial Clusters: The Case for Special Economic Zones in Africa (No. 2017/15)." WIDER Working Paper.

Nnoli, Okwudiba. 1978. *Ethnic Politics in Nigeria.* Enugu, Nigeria: Fourth Dimension.

Nyerges, A. Endre. 1992. "The Ecology of Wealth-in-People: Agriculture, Settlement, and Society on the Perpetual Frontier." *American Anthropologist* 94, no. 4 (December): 860–81. https://doi.org/10.1525/aa.1992.94.4.02a00050.

Nyíri, P. 2012. "Enclaves of Improvement: Sovereignty and Developmentalism in the Special Zones of the China-Lao Borderlands." *Comparative Studies in Society and History* 54, no. 3 (July): 533–62.

Obadare, Ebenezer, and Wale Adebanwi, eds. 2012. *Nigeria at Fifty: The Nation in Narration.* New York: Routledge.

Obeng-Odoom, F. 2015. "Africa: On the Rise, but to Where?" *Forum for Social Economics* 44 (3): 234–50.

Obi, C. I. 2010. "Oil Extraction, Dispossession, Resistance, and Conflict in Nigeria's Oil-Rich Niger Delta." *Canadian Journal of Development Studies/Revue canadienne d'études du développement* 30 (1–2): 219–36.

Odeyemi, F. 1980. "The Quality of the Nigerian Native Alcohol Beverage (Ogogoro)." *Kemia Kemi* 7:134–35.

Odoom, I. 2017. "Dam In, Cocoa Out; Pipes In, Oil Out: China's Engagement in Ghana's Energy Sector." *Journal of Asian and African Studies* 52, no. 5 (August): 598–620.

Ofodile, U. E. 2008. "Trade, Empires, and Subjects—China-Africa Trade: A New Fair Trade Arrangement, or the Third Scramble for Africa." *Vanderbilt Journal of Transnational Law* 41, no. 2 (March): 505.

Ojameruaye, Emmanuel O., and Adedoyin Soyibo. 1995. "Data and Economic Policy Management in Nigeria." In *Macroeconomic Policy Issues in an Open Developing Economy: A Case Study of Nigeria*, edited by Akin Iwayemi, 151–68. Ibadan, Nigeria: National Centre for Economic Management and Administration.

Okoko, Eno. 1999. "Women and Environmental Change in the Niger Delta, Nigeria: Evidence from Ibeno." *Gender, Place and Culture* 6 (4): 373–78.

Okonta, I. 2008. *When Citizens Revolt: Nigerian Elites, Big Oil, and the Ogoni Struggle for Self-Determination*. Trenton, NJ: Africa World Press.

Okonta, Ike, and Douglas Oronto. 2001. *Where Vultures Feast: 40 Years of Shell in the Niger Delta*. San Francisco: Sierra Club Books.

Ololajulo, B. O. 2011. "Rural Development Intervention and the Challenges of Sustainable Livelihood in an Oil Producing Area of Nigeria." *Kroeber Anthropological Society Papers* 99 (1): 184–200.

Olorunfemi, A. 1984. "The Liquor Traffic Dilemma in British West Africa: The Southern Nigerian Example, 1895–1918." *International Journal of African Historical Studies* 17 (2): 232–36.

Olupona, J. 2011. *City of 201 Gods: Ilé-Ifè in Time, Space, and the Imagination*. Berkeley: University of California Press.

Olupona, J. K. 1991. *Kinship, Religion and Rituals in a Nigerian Community: A Phenomenological Study of Ondo Yorùbá Festivals*. Stockholm: Almqvist and Wiksell International.

Olupona, K. 1983. *A Phenomenological/Anthropological Analysis of the Religion of the Ondo—Yoruba of Nigeria*. PhD diss., Boston University.

O'Malley, Pat. 1996. "Risk and Responsibility." In *Foucault and Political Reason. Liberalism, Neo-Liberalism and Rationalities of Government*, edited by Andrew Barry, Thomas Osborne, and Nikolas Rose, 189–207. London: UCL Press.

O'Malley, Pat, Lorna Weir, and Clifford Shearing. 1997. "Governmentality, Criticism, Politics." *Economy and Society* 26 (4): 501–17.

Omotola, J. Shola. 2007. "From the OMPADEC to the NDDC: An Assessment of State Responses to Environmental Insecurity in the Niger Delta, Nigeria." *Africa Today* 54, no. 1 (Fall): 73–89.

Ong, Aihwa. 1999. *Flexible Citizenship: The Cultural Logics of Transnationality*. Durham, NC: Duke University Press.

———. 2006. *Neoliberalism as Exception: Mutations in Citizenship and Sovereignty*. Durham, NC: Duke University Press.

Onuigbo, R. A., and E. O. Innocent. 2015. "State Governors and Revenue Allocation Formula in Nigeria: A Case of the Fourth Republic." *International Journal of Accounting Research* 42 (2437): 1–23.

Onuoha, Freedom C. 2008. "Vandals or Victims? Poverty, Risk Perception and Vulnerability of Women to Oil Pipeline Disasters in Nigeria." *Gender and Behaviour* 6, no. 2 (December): 1897–924.

———. 2016. "The Resurgence of Militancy in Nigeria's Oil-Rich Niger Delta and the Dangers of Militarisation." *Al Jazeera Center for Studies Report*, June 8, 2016. https://studies

.aljazeera.net/en/reports/2016/06/resurgence-militancy-nigerias-oil-rich-niger-delta
-dangers-militarisation-160608065729726.html.

Oriola, T. 2012. "The Delta Creeks, Women's Engagement and Nigeria's Oil Insurgency."
British Journal of Criminology 52, no. 3 (May): 534–55. https://doi.org/10.1093/bjc
/azs009.

Ovadia, J. S. 2013. "Accumulation with or without Dispossession? A 'Both/And' Approach
to China in Africa with Reference to Angola." *Review of African Political Economy* 40,
no. 136 (June): 233–50.

———. 2016. *The Petro-Developmental State in Africa: Making Oil Work in Angola, Nigeria and
the Gulf of Guinea.* London: Hurst.

Patterson, Orlando. 1982. *Slavery and Social Death: A Comparative Study.* Cambridge, MA:
Harvard University Press.

Patton, Paul. 1998. "Foucault's Subject of Power." In *The Later Foucault: Politics and Philosophy,*
edited by J. Moss, 64–77. London: Sage.

Peel, J. D. Y. 2000. *Religious Encounter and the Making of the Yoruba.* Bloomington: Indiana
University Press.

Peel, John David Yeaton. 1983. *Ijeshas and Nigerians: The Incorporation of a Yoruba Kingdom,
1890s–1970s.* Cambridge: Cambridge University Press.

Peil, Margaret. 1991. *Lagos: The City Is the People.* London: Belhaven.

Peine, E. K., and K. A. Schafft. 2012. "Moonshine, Mountaineers, and Modernity: Distilling
Cultural History in the Southern Appalachian Mountains." *Journal of Appalachian Stud-
ies* 18, no. 12 (Spring/Fall): 93–112.

Phillips, D. Kristin. 2018. *An Ethnography of Hunger: Politics, Subsistence, and the Unpredictable
Grace of the Sun.* Bloomington: Indiana University Press.

Pierre, Jemima. 2019. "The Racial Vernaculars of Development: A View from West Africa."
American Anthropologist 122, no. 1 (March): 86–98. https://doi.org/10.1111/aman.13352.

Plummer, A. 2019. "Kenya and China's Labour Relations: Infrastructural Development for
Whom, by Whom?" *Africa* 89, no. 4 (November): 680–95.

Powelson, John P. 1998. *The Moral Economy.* Ann Arbor: University of Michigan Press.

Proulx, A. 2016. *Barkskins: A Novel.* New York: Simon and Schuster.

Purvis, Malcolm J. 1970. "New Sources of Growth in a Stagnant Smallholder Economy in Ni-
geria: The Oil Palm Rehabilitation Scheme." In *Growth and Development of the Nigerian
Economy,* edited by Carl K. Eicher and Carl Liedholm, 267–81. East Lansing: Michigan
State University Press.

Ragin, Charles. 1992. "Introduction: 'What Is a Case?'" In *What Is a Case? Exploring the Foun-
dations of Social Inquiry,* edited by Charles Ragin and Howard Becker, 1–24. New York:
Cambridge University Press.

———. 2014. *The Comparative Method: Moving beyond Qualitative and Quantitative Strategies,*
2nd ed. Berkeley: University of California Press.

Ragin, Charles, and Lisa Amoroso. 2011. *Constructing Social Research: The Unity and Diversity
of Method.* 2nd ed. Los Angeles: Pine Forge.

Renne, Elisha P. 2015. "The Changing Contexts of Chinese-Nigerian Textile Production and
Trade, 1900-2015." *Textile* 13 (3): 212–33.

Reno, William. 1999. *Warlord Politics and African States.* London: Lynne Rienner.

———. 2001. "Foreign Firms, Natural Resources and Violent Political Economies." Leipzig:
University of Leipzig Papers on Africa, Politics and Economics series, no. 46.

Riches, David, ed. 1986. *The Anthropology of Violence.* Oxford: Blackwell.

Riles, Annelise. 2000. *The Network Inside Out.* Ann Arbor: University of Michigan Press.

Robson, Elsbeth. 1999. "Problematising Oil and Gender in Nigeria. Commentaries on Eno Okoko's Article, 'Women and Environmental Change in the Niger Delta, Nigeria: Evidence from Ibeno.'" *Gender, Place and Culture* 6 (4): 379–400.

Rodney, W. (1972) 2018. *How Europe Underdeveloped Africa.* New York: Verso.

Rogers, Douglas. 2005. "Moonshine, Money, and the Politics of Liquidity in Rural Russia." *American Ethnologist* 32, no. 1 (February): 63–81.

———. 2014. "Petrobarter: Oil, Inequality, and the Political Imagination in and after the Cold War." *Current Anthropology* 55, no. 2 (April): 131–53.

———. 2015. *The Depths of Russia: Oil, Power, and Culture after Socialism.* Ithaca, NY: Cornell University Press.

Roitman, J. 2005. *Fiscal Disobedience: An Anthropology of Economic Regulation in Central Africa.* Princeton, NJ: Princeton University Press.

Rolffs, P., D. Ockwell, and R. Byrne. 2015. "Beyond Technology and Finance: Pay-as-You-Go Sustainable Energy Access and Theories of Social Change." *Environment and Planning A: Economy and Space* 47, no. 12 (December): 2609–27. https://doi.org/10.1177/0308518X15615368.

Rose, Nikolas. 1996. "Governing 'Advanced' Liberal Democracies." In *Foucault and Political Reason: Liberalism, Neo-liberalism and Rationalities of Government*, edited by Andrew Barry, Thomas Osborne, and Nikolas Rose, 37–64. London: UCL Press.

Rose, Nikolas, and Peter Miller. 1992. "Political Power beyond the State: Problematics of Government." *British Journal of Sociology* 43, no. 2 (June): 173–205.

Rosko, Helen. 2015. "Drinking and Remaking Place: A Study of the Impact of Commercial Moonshine in East Tennessee." Master's thesis, University of Tennessee. https://trace.tennessee.edu/utk_gradthes/3603.

Ross, Jeffrey, A. 1979. "Language and the Mobilization of Ethnic Identity." In *Language and Ethnic Relations*, edited by Giles Howard and Bernard Saint-Jacques, 1–13. New York: Pergamon.

Ross, Michael. 2006. "A Closer Look at Oil, Diamonds, and Civil War." *Annual Review of Political Science* 9 (June): 265–300.

Ross, Michael L. 1999. "The Political Economy of the Resource Curse." *World Politics* 51, no. 2 (January): 297–322.

———. 2004. "How Do Natural Resources Influence Civil War? Evidence from Thirteen Cases." *International Organization* 58, no. 1 (February): 35–67.

Rupley, L. A. 1981. "Revenue Sharing in the Nigerian Federation." *Journal of Modern African Studies* 19, no. 2 (June): 257–77.

Rupp, S. 2013. "Ghana, China, and the Politics of Energy." *African Studies Review* 56, no. 1 (April): 103–30.

Russo, S., A. F. Marchese, J. Sillmann, and Giuseppina Immé. 2016. "When Will Unusual Heat Waves Become Normal in a Warming Africa?" *Environmental Research Letters* 11, no. 5 (May). https://doi.org/10.1088/1748-9326/11/5/054016.

Sachs, J., and A. Warner. 2001. "The Curse of Natural Resources." *European Economic Review* 45, no. 4–6 (May): 827–38.

Sanda, O. Akinade. 1992. *Public Administration in Periods of Uncertainty.* Ibadan, Nigeria: Fact Finders International.

Sanya, O. 2006. "Slow Death in the Niger Delta." *Africa Review of Books*, March 2006, 14. http://www.codesria.org/IMG/pdf/ARB_March_2006.pdf.

Sawyer, Suzana. 2004. *Crude Chronicles: Indigenous Politics, Multinational Oil and Neo-liberalism in Ecuador.* Durham, NC: Duke University Press.

Scott, James C. 1976. *The Moral Economy of the Peasant: Subsistence and Rebellion in Southeast Asia*. New Haven, CT: Yale University Press.

———. 1990. *Domination and the Arts of Resistance*. New Haven, CT: Yale University Press.

———. 1998. *Seeing Like a State: How Certain Schemes to Improve the Human Condition Have Failed*. New Haven, CT: Yale University Press.

Shaxson, Nicholas. 2007. *Poisoned Wells: The Dirty Politics of African Oil*. New York: Palgrave Macmillan.

———. 2014. "The Price of Offshore Revisited: New Estimates for Missing Global Private Wealth, Income, Inequality and Lost Taxes." *Tax Justice Network*, July 22, 2014. http://www.taxjustice.net/2014/01/17/price-offshore-revisited.

Shen, W., and M. Power. 2017. "Africa and the Export of China's Clean Energy Revolution." *Third World Quarterly* 38 (3): 678–97. https://doi.org/10.1080/01436597.2016.1199262.

Shever, E. 2012. *Resources for Reform: Oil and Neoliberalism in Argentina*. Stanford, CA: Stanford University Press.

Simone, A. M. 2004. *For the City Yet to Come: Changing African Life in Four Cities*. Durham, NC: Duke University Press.

Sina. 2006. "The 1st Ministerial Conference." Originally published by Xinhua News, October 26, 2006. http://english.sina.com/p/1/2006/1026/92709.html.

Sinenko, O., and I. Mayburov. 2017. "Comparative Analysis of the Effectiveness of Special Economic Zones and Their Influence on the Development of Territories." *International Journal of Economics and Financial Issues* 7 (1): 115–22.

Siu, Helen F. 2019. "Financing China's Engagement in Africa: New State Spaces Along a Variegated Landscape." *Africa* 89, no. 4 (November): 638–61.

Siu, Helen F., and Mike McGovern. 2017. "China–Africa Encounters: Historical Legacies and Contemporary Realities." *Annual Review of Anthropology* 46 (October): 337–55.

Slack, John. 2015. "Goodnight Moonshine: The Lasting Effects of Prohibition on the United States." Senior Honors Thesis, College of Arts and Sciences. University of Louisville. Paper 34. https://doi.org/10.18297/honors/34.

Slater, J. 2019. "'It Is Horrid': India Roasts under Heat Wave with Temperatures above 120 Degrees." *Washington Post*, June 5, 2019. https://www.washingtonpost.com/world/its-horrid-india-roasts-under-heat-wave-with-temperatures-above-120-degrees/2019/06/05/bd713dea-877c-11e9-b1a8-716c9f3332ce_story.html.

Smith, Daniel Jordan. 2004. "The Bakassi Boys: Vigilantism, Violence, and Political Imagination in Nigeria." *Cultural Anthropology* 19, no. 3 (August): 429–55.

———. 2007. *A Culture of Corruption: Everyday Deception and Popular Discontent in Nigeria*. Princeton, NJ: Princeton University Press.

Smith, R. 1969. "To the Palaver Islands: War and Diplomacy on the Lagos Lagoon in 1852–1854." *Journal of the Historical Society of Nigeria* 5, no. 1 (December): 3–25.

Social Action. 2014. "Crude Business: Oil Theft, Communities and Poverty in Nigeria." Port Harcourt, Nigeria: Social Development Integrated Center.

Southall, R., and H. Melber, eds. 2009. *A New Scramble for Africa?: Imperialism, Investment and Development*. Scottsville, VA: University of KwaZulu-Natal Press.

Soyinka, W. 1976. *Myth, Literature and the African World*. Cambridge: Cambridge University Press.

Spiro, Melford. 1978. "Culture and Human Nature." In *The Making of Psychological Anthropology*, edited by G. D. Spindler, 330–60. Berkeley: University of California Press.

Staniland, P. 2014. *Networks of Rebellion: Explaining Insurgent Cohesion and Collapse*. Ithaca, NY: Cornell University Press.

Stein, H. 1992. "Deindustrialization, Adjustment, the World Bank and the IMF in Africa." *World Development* 20, no. 1 (January): 83–95.

———. 1994. "The World Bank and the Application of Asian Industrial Policy to Africa: Theoretical Considerations." *Journal of International Development* 6, no. 3 (May/June): 287–305.

———. 2008. *Beyond the World Bank Agenda: An Institutional Approach to Development.* Chicago: University of Chicago Press.

———. 2013. "Africa and the Perversities of International Capital Flows." In *Economic Policies, Governance and the New Economics,* edited by P. Arestis and M. Sawyer, 165–208. Basingstoke, UK: Palgrave Macmillan.

Stein, Howard, O. Ajakaiye, and P. Lewis, eds. 2001. *Deregulation and the Banking Crisis in Nigeria: A Comparative Study.* New York: Palgrave Macmillan.

Stewart, B. E. 2006. "'This Country Improves in Cultivation, Wickedness, Mills, and Still': Distilling and Drinking in Antebellum Western North Carolina." *North Carolina Historical Review* 83, no. 4 (October): 447–78.

Stiglitz, J. 2008. "A Crisis of Confidence: Letting Financial Markets Run Wild Was Risky Business Indeed. Transparency, Oversight and Fair Competition Are Needed Now." *Guardian,* October 22, 2008. https://www.theguardian.com/commentisfree/cifamerica/2008/oct/22/economy-financial-crisis-regulation.

Tagliarino, N., Y. Bununu, M. Micheal, M. De Maria, and A. Olusanmi. 2018. "Compensation for Expropriated Community Farmland in Nigeria: An In-Depth Analysis of the Laws and Practices Related to Land Expropriation for the Lekki Free Trade Zone in Lagos." *Land* 7, no. 1 (February): 23.

Tamuno, T. N. 1970. *The Police in Modern Nigeria.* Ibadan, Nigeria: University Press.

Tamuno, Tekena N. 1980. "British Colonial Administration in Nigeria in the Twentieth Century." In *Groundwork of Nigerian History,* edited by Obaro Ikime, 393–409. Ibadan, Nigeria: Heinemann.

Taylor, Charles. 1989. *Sources of the Self: The Making of the Modern Identity.* Cambridge, MA: Harvard University Press.

Taylor, I. 2010. *The Forum on China-Africa Cooperation (FOCAC).* London: Routledge.

Taylor, Ian. 2016. "Dependency Redux: Why Africa Is Not Rising." *Review of African Political Economy* 43 (147): 8–25.

Tijani, H. I. 2007. "The Career of Akinpelu Ipossu in Lagos and Epe c. 1790–1879." In *African Agency and European Colonialism: Latitudes of Negotiation and Containment: Essays in Honor of AS Kanya-Forstner,* edited by Femi J. Kolapo and Kwabena O. Akurang-Perry, 17–24. Lanham, MD: University Press of America.

Tischler, J. 2014. "Cementing Uneven Development: The Central African Federation and the Kariba Dam Scheme." *Journal of Southern African Studies* 40 (5): 1047–64. https://doi.org/10.1080/03057070.2014.946221.

Trouillot, Michel-Rolph. 1995. *Silencing the Past: Power and the Production of History.* Boston: Beacon.

———. 2001. "The Anthropology of the State in the Age of Globalization." *Current Anthropology* 42, no. 1 (February): 125–38.

———. 2002. "North Atlantic Universals: Analytical Fictions, 1492–1945." *South Atlantic Quarterly* 101, no. 4 (Fall): 839–58.

———. 2003. *Global Transformations: Anthropology and the Modern World.* New York: Palgrave Macmillan.

———. 2016. *Global Transformations: Anthropology and the Modern World.* New York: Springer.

Tsing, Anna L. 2005. *Friction: An Ethnography of Global Connection.* Princeton, NJ: Princeton University Press.

Turner, V. 1969. *The Ritual Process.* New York: Cornell University Press.

Uche, C. 2008. "Oil, British Interests and the Nigerian Civil War." *Journal of African History* 49 (1): 111–35.

Udo, Reuben K. 1980. "Environments and Peoples of Nigeria: A Geographical Introduction to the History of Nigeria." In *Groundwork of Nigerian History*, edited by Obaro Ikime, 1–24. Ibadan, Nigeria: Heinemann.

Ugor, Paul U. 2013. "Survival Strategies and Citizenship Claims: Youth and the Underground Oil Economy in Post-Amnesty Niger Delta." *Africa* 83, no. 2 (May): 270–92. https://doi .org/10.1017/s0001972013000041.

Ukiwo, Ukoha. 2011. "The Nigerian State, Oil and the Niger Delta Crisis." In *Oil and Insurgency in the Niger Delta: Managing the Complex Politics of Petroviolence*, edited by Cyril I. Obi and Siri Aas Rustad, 17–27. London: Zed Books.

UN Environment Programme. 2011. Environmental Assessment of Ogoni Report. https:// www.unenvironment.org/explore-topics/disasters-conflicts/where-we-work/nigeria /environmental-assessment-ogoniland-report.

Unger, B. 2009. "Money Laundering: A Newly Emerging Topic on the International Agenda." *Review of Law and Economics* 5, no. 2 (January): 807–19.

United Nations Environment Programme. 2011. *Environmental Assessment of Ogoniland*. Nairobi, Kenya: United Nations Environment Programme. https://postconflict.unep.ch /publications/OEA/UNEP_OEA.pdf.

Urdal, Henrik. 2005. "People vs. Malthus: Population Pressure, Environmental Degradation, and Armed Conflict Revisited." *Journal of Peace Research* 42, no. 4 (July): 417–34.

Uwechue, R. 1971. *Reflections on the Nigerian Civil War: Facing the Future*. New York: Africana.

Valdivia, Gabriela. 2008. "Governing Relations between People and Things: Citizenship, Territory, and the Political Economy of Petroleum in Ecuador." *Political Geography* 27, no. 4 (May): 456–77.

Van Allen, Judith. 1971. *"Aba Riots" or "Women's War"?: British Ideology and Eastern Nigerian Women's Political Activism*. Waltham, MA: African Studies Association.

Van de Walle, Nicholas. 2001. *African Economies and the Politics of Permanent Crisis, 1979–1999*. Cambridge: Cambridge University Press.

Van Schendel, Willem, and Itty Abraham, eds. 2005. *Illicit Flows and Criminal Things: States, Borders, and the Other Side of Globalization*. Bloomington: Indiana University Press.

Verger, P. F. 1976. "The Status of Yoruba Religion in Brazil." In *Yoruba Civilization*, edited by I. A. AkinJogbin and G. O. Ekemode, 620–44. Ife, Nigeria: University of Ife Press.

WAC. 2003. *Peace and Security in the Niger Delta*. Port Harcourt, Nigeria: Global Services.

Wang, H. 2016. "A Deeper Look at China's 'Going Out' Policy." Centre for International Governance Innovation, March 8, 2016. https://www.cigionline.org/publications/deeper -look-chinas-going-out-policy.

Watson, V. 2013. "Planning and the 'Stubborn Realities' of Global South-east Cities: Some Emerging Ideas." *Planning Theory* 12, no. 1 (February): 81–100.

Watts, Jonathan. 2018. "We Have 12 Years to Limit Climate Change Catastrophe, Warns UN." *Guardian*, October 8, 2018. https://www.theguardian.com/environment/2018/oct/08 /global-warming-must-not-exceed-15c-warns-landmark-un-report.

Watts, Michael. 2003. "Petro-Violence: Community Extraction and Political Ecology of a Mythic Commodity." In *Violent Environments*, edited by M. Watts and N. Peluso, 189–212. Ithaca, NY: Cornell University Press.

———. 2004a. "Resource Curse? Governmentality, Oil and Power in the Niger Delta, Nigeria." *Geopolitics* 9 (1): 50–80.

———. 2004b. "Antinomies of Community: Some Thoughts on Geography, Resources and Empire." *Transactions of the Institute of British Geographers* 29, no. 2 (June): 195–216.

———. 2005. "Righteous Oil? Human Rights, the Oil Complex and Corporate Social Responsibility." *Annual Review of Environment and Resources* 30:373–407.

Weidman, Jackie, and Susannah Marshall. 2012. "Soot Pollution 101: What You Need to Know and How You Can Help Prevent It." Center for American Progress, August 10, 2012. https://www.americanprogress.org/issues/green/news/2012/08/10/12007/soot-pollution-101/.

Weinstein, J. M. 2006. *Inside Rebellion: The Politics of Insurgent Violence.* New York: Cambridge University Press.

Wellington, B. 2007. "Weapons of War in the Niger Delta." *Terrorism Monitor* 10 (May 24): 8–10.

Wenar, Leif. 2008. "Property Rights and the Resource Curse." *Philosophy and Public Affairs* 36 (1): 2–32.

Whyte, K. P. 2018. "Indigenous Science (Fiction) for the Anthropocene: Ancestral Dystopias and Fantasies of Climate Change Crises." *Environment and Planning E: Nature and Space* 1, no. 1–2 (March): 224–42. https://doi.org/10.1177/2514848618777621.

Williams, Frieda-Nela. 1991. *Precolonial Communities of Southwestern Africa: A History of Owambo Kingdoms, 1600–1920.* Windhoek: National Archives of Namibia.

Williams, Gavin. 1991. *Capitalists, Peasants and Land in Africa: A Comparative Perspective.* Johannesburg, South Africa: University of the Witwatersrand, African Studies Institute.

Willis, Paul, and Mats Trondman. 2000. "Manifesto for Ethnography." *Ethnography* 1, no. 1 (July): 5–16.

Wilson, David C., Adebisi O. Araba, Kaine Chinwah, and Christopher R. Cheeseman. 2009. "Building Recycling Rates through the Informal Sector." *Waste Management* 29, no. 2 (February): 629–35.

Woolfrey, S. 2013. *Special Economic Zones and Regional Integration in Africa.* Tralac Working Paper. https://www.tralac.org/files/2013/07/S13WP102013-Woolfrey-Special-economic-zones-regional-integration-in-Africa-20130710-fin.pdf.

Worby, Eric. 1998. "Inscribing the State at the Edge of Beyond: Danger and Development in Northwestern Zimbabwe." *PoLAR* 21, no. 2 (November): 55–70.

———. 2000. "Discipline without Oppression: Sequence, Timing and Marginality in Southern Rhodesia's Post-War Development Regime." *Journal of African History* 41, no. 1 (March): 101–25.

———. 2001. "Tyranny, Parody, and Ethnic Polarity: Ritual Engagements with the State in Northwestern Zimbabwe." *Journal of Southern African Studies* 24 (3): 337–54.

———. 2003. "The End of Modernity in Zimbabwe? Passages from Development to Sovereignty." In *Zimbabwe's Unfinished Business: Rethinking Land, State and Nation in the Context of Crisis,* edited by Amanda Hammar, Brian Raftopoulos, and Stig Jensen, 49–81. Harare, Zimbabwe: Weaver.

Yin, Robert K. 2008. *Case Study Research: Design and Methods.* Thousand Oaks, CA: Sage Public.

Yongmei, Y. 2004. "UN Report: China Becoming Major Investor Abroad." *People's Daily,* January 7, 2004. http://en.people.cn/200401/07/eng20040107_132003.shtml.

Young, A. 1991. "Learning by Doing and the Dynamic Effects of International Trade." *Quarterly Journal of Economics* 106, no. 2 (May): 369–405.

Yesufu, Tijani M. 1996. *The Nigerian Economy: Growth without Development.* Benin City, Nigeria: University of Benin, Kraft Books, Ibadan.

Yusuff, M. A., and M. A. Akinde. 2015. "Tourism Development and Economic Growth Nexus: Nigeria's Experience." *European Journal of Hospitality and Tourism Research* 3, no. 4 (November): 1–10.

Zalik, A. 2004. "The Peace of the Graveyard: The Voluntary Principles on Security and Human Rights in the Niger Delta." In *Global Regulation: Managing Crisis after the Imperial Turn*, edited by Kees van der Pijl, L. Assasi, and D. Wigan, 111–127. London: Palgrave.

———. 2015. "Vicious Transparency: Contesting Canada's Hydrocarbon Future." In *Subterranean Estates: Life Worlds of Oil and Gas*, edited by H. Appel, A. Mason, M. Huber, and M. Watts, 354–70. Ithaca, NY: Cornell University Press.

Zartman, I. William, ed. 1983. *The Political Economy of Nigeria*. New York: Praeger.

Zeitlin, Jonathan, and David M. Trubek, eds. 2003. *Governing Work and Welfare in a New Economy: European and American Experiments*. Oxford: Oxford University Press.

Zeleza, P. T. 2008. "Dancing with the Dragon: Africa's Courtship with China." *Global South* 2, no. 2 (Fall): 171–87.

Zeng, D. Z. 2016. "Special Economic Zones: Lessons from the Global Experience." *PEDL Synthesis Paper Series* 1:1–9.

ARCHIVAL MATERIALS

COMCOL 1–15-3, Alcohol Duties, 1952/53. File number 3712. National Archive, University of Ibadan.

COMCOL 1–15-3, Liquor Licenses, 1927/28. File number 273. National Archive, University of Ibadan.

COMCOL 1–15-3, Liquor licenses, 1950–1958. File number 277, vols. v–ix. National Archive, University of Ibadan.

COMCOL 1–15-3, Liquor licenses, 1953. File number 277/s.2, vol. 1. National Archive, University of Ibadan.

COMCOL 1–15-3, Liquor licenses, 1956/58. File number 277/s.3. National Archive, University of Ibadan.

COMCOL 1–15-3, Liquor, 1929/54. File number A.C. 808. National Archive, University of Ibadan.

COMCOL 1–15-3, Liquor prices, 1941. File number 2283/s.15, vol. 3. National Archive, University of Ibadan.

COMCOL 1–15-3, Native liquor, 1933–49. File number 1520. National Archive, University of Ibadan.

COMCOL 1–15-3, Native liquor, 1933–45. File number 152/s.1. National Archive, University of Ibadan.

COMCOL 1–15-3, Native liquor, 1933–57. File number 152/s.2. National Archive, University of Ibadan.

COMCOL 1-15-3, Native liquor, 1952–56. File number 1520/s.3, vol. 2. National Archive, University of Ibadan.

CSO 26: 14962. *Papers Relating to the Family Dynasty in Lagos*. Exhibit D (M. H. Macauly Evidence), 1933. National Archives, University of Ibadan.

Simple list of Oyo Provincial papers, Oyo prof. 1. File number 1375, vols. 1–3. National Archive, University of Ibadan.

Simple list of Oyo Provincial papers, Oyo prof. 1. File number 1375/1, vol. 1. National Archive, University of Ibadan.

Simple list of Oyo Provincial papers, Oyo prof. 1. File No. 2026, vols. 1–2. National Archive, University of Ibadan.

Simple list of Oyo Provincial papers, Oyo prof. 3. File number 1902/1. National Archive, University of Ibadan.

INDEX

223

OMOLADE ADUNBI is Associate Professor in the Department of Afroamerican and African Studies, the Honors Program in the College of Literature, Science, and the Arts, and Program in the Environment at the University of Michigan, Ann Arbor. A political and environmental anthropologist, Adunbi is also Distinguished Faculty Fellow at the Graham Sustainability Institute and Faculty Associate at the Energy Institute, Donia Human Rights Center, and the African Studies Center at the University of Michigan. He is author of *Oil Wealth and Insurgency in Nigeria*, the 2017 winner of the Amaury Talbot Prize for African Anthropology of the Royal Anthropological Society of Great Britain and Ireland.